MEET THE NEVER-ENDING CHALLENGES OF MODERN PHOTOGRAPHY

Designed for the photographer who is ready to move beyond the snapshot stage, this state-of-the-art guide gives all the latest information about today's vast variety of cameras, films, lenses, lights, developing and printing methods. It also offers invaluable technical advice on getting the most out of your equipment, whether you are working indoors or out, with still-lifes or live action, with landscapes or people.

With a superbly illustrated text covering all aspects of photography from selecting the right camera to mounting finished photos, this authoritative guide belongs on every photographer's shelf.

THE BASIC BOOK OF PHOTOGRAPHY

TOM GRIMM is a free-lance photographer and writer based in Laguna Beach, California. He has been a photography instructor at the University of California, Irvine. His work has taken him on assignments to more than 100 countries and has appeared in leading magazines and newspapers. He has written and illustrated 12 other adult and children's books with his wife, Michele. He also is the author of *The Basic Darkroom Book* and is co-author with Michele Grimm of *The Good Guide for Bad Photographers* (both available in Plume editions).

The cover shows an action zoom photograph of a windsurfer at a Southern California beach. To create the motion effect, I used a medium-speed film (Kodachrome 64) and a small lens opening (f/22) in order to shoot at a slow shutter speed (1/8 second) so there would be time to change the focal length of a telephoto zoom lens (from 80mm to 200mm) *during* the exposure. It was shot toward the sun in late afternoon (back lighting) so the zooming would add extra impact by producing bright streaks from sunlight sparkling on the water. Various techniques for putting action in still photographs are discussed in Chapter 10.

THE BASIC BOOK
OF PHOTOGRAPHY
SECOND REVISED EDITION

by

Tom Grimm

*Photographs by
Tom and Michele Grimm*

Drawings by Ezelda Garcia

A PLUME BOOK

NEW AMERICAN LIBRARY

NEW YORK AND SCARBOROUGH, ONTARIO

For Michele

For various reasons this book was possible
because of my wife, Michele,
my parents, Dr. and Mrs. W.W. Grimm,
and these friends—
Charles B. and Charles C. Adams,
George Day, Thomas R. Smith, Paul B. Snider,
Eugene J. Voss, Daniel Woodley.

Thanks.

NAL BOOKS ARE AVAILABLE AT QUANTITY DISCOUNTS WHEN USED TC
PROMOTE PRODUCTS OR SERVICES. FOR INFORMATION PLEASE WRITE
TO PREMIUM MARKETING DIVISION, NEW AMERICAN LIBRARY,
1633 BROADWAY, NEW YORK, NEW YORK 10019.

PLUME TRADEMARK REG. U.S. PAT. OFF. AND FOREIGN COUNTRIES
REG. TRADEMARK—MARCA REGISTRADA
HECHO EN HARRISONBURG, VA., U.S.A.

SIGNET, SIGNET CLASSIC, MENTOR, PLUME, MERIDIAN and NAL BOOKS
are published *in the United States* by New American Library
1633 Broadway, New York, New York 10019,
in Canada by The New American Library of Canada Limited,
81 Mack Avenue, Scarborough, Ontario M1L 1M8

First Printing, May, 1974
Sixth Printing (Revised Edition), October, 1979
Twelfth Printing (Second Revised Edition), November, 1985

13 14 15 16 17 18 19 20 21

PRINTED IN THE UNITED STATES OF AMERICA

Contents

Smile, Say "Cheese"

As a fellow photographer I hope you will help me clear up a popular misconception that we take pictures. We don't. Cameras *take* pictures; photographers *make* pictures. By deciding the composition of a photograph, and by selecting the film and focus and exposure, we decide what the picture shall be. Your camera is simply the tool that makes the photograph possible. In many ways it's the mechanical equivalent of an artist's palette and paintbrush. The resulting picture, not your equipment, reveals what kind of photographer you are.

And also remember that whether your picture is good or bad is a personal judgment. Even the esteemed professionals who judge photo contests have different criteria for deciding whether a photograph is a winner or loser. You'd be surprised at the behind-the-scenes arguments by contest judges over the merits of one picture versus another. The point is that if the final print or transparency is what you expected or wanted it to be, then the photograph is a good one. Winning a nationwide contest or a neighbor's praise does not determine if you're a good photographer. You do. There are, however, some valid criteria for you to use in judging your work.

I assume you are past the snapshot stage and want to be more creative with your camera in order to produce pictures which make you happy. And proud.

First I'll give a rundown on the factual and mechanical aspects of camera and equipment operation so you'll know best how to handle your photographic tools. You'll find out what you want to know about films and f/stops, lenses and light meters, filters and flash, and everything else. At the back of the book you'll find a glossary of photographic terms so you'll know what the lensman's lingo means and can look up unfamiliar terms as you go along.

And, very important, you'll find a discussion of composition and the elements of making a good, if not great, picture. When you learn and apply the ideas of leading lines, rule of thirds, size indicators, framing, and many other techniques of good composition, you'll be on your way to making effective photographs.

This book is especially valuable to photographers with cameras where you can 1) control the shutter speed, 2) set the lens opening, and 3) adjust the focus. If you have a simple or fully automatic camera where you just point

and shoot, you'll discover how a camera which can also be adjusted in the three ways listed above offers you much greater opportunity to make great photographs. However, automatic, pocket, and instant cameras will be discussed, too.

Finally, you'll discover this book presents a discussion of cameras and composition in an informal manner, not the usual technical approach. A scientific discourse and diagram on how a lens is made isn't as valuable to you as knowing the difference between a 35mm and a 135mm lens. This book gives you the practical information you need to become the photographer you want to be.

—T.G.
February, 1974

In the decade or so since writing the first edition of this book, photography has grown in stature as one of the most popular leisure activities for people of all ages. Stroll down any street in North America and you'll undoubtedly see someone carrying a camera.

One reason is that manufacturers have eagerly joined the computer-chip generation to produce cameras that are easy to operate and almost guarantee good results. Automation has enticed folks who once were klutzes with a camera to boast that photography is now their favorite hobby.

This third edition covers the latest in electronic achievements that make the mechanical aspect of photography so much easier—autoload, auto-advance and rewind, autofocusing, auto-exposure, and even autoflash. In this up-to-date book you'll also learn more about new compact 35mm cameras, a hand-size camera of novel design called the disc, and improvements in instant cameras.

Accompanying information about today's state-of-the-art cameras are details about faster color and black-and-white films, as well as the array of other improved photo products that range from zoom lenses to gadget bags. Most of all, this revised volume continues to show you how to put cameras and equipment of all types to practical use so you can become a better photographer. Welcome to the enjoyable "new" world of photography!

This guide is a companion volume to my book about processing and printing color and black-and-white photographs, *The Basic Darkroom Book*. If you want to make the best possible pictures, and finish the job you start when you press the shutter release, my darkroom book offers step-by-step instruction.

—Tom Grimm
Laguna Beach, California
October, 1985

1

Operating Your Camera

"Don't tell me how a camera works, just tell me how to take a good picture." Each term during the first meetings of my photography classes at the University of California, a few students would make that plea. I understand. To the novice, all those dials, levers, buttons, and other parts of an adjustable camera are frightening. But like the new driver who is learning about cars for the first time, you need to know how your camera functions. Only when you know how it works, and all its capabilities, will you be able to get the pictures you want. Did you know, for instance, that a night picture of a shining star can be made by shooting directly into the sun during the day? It can—if you know how your camera operates. This section will tell you how to work your camera and equipment. Information on how to compose effective photographs and utilize various photographic techniques begins with Chapter 10.

My first advice: Study and understand your camera's operation manual. And reread it often. In fact, several times a year you should look over your camera manual because there are special tips and directions particular to each camera that often are forgotten. If you've lost your manual, buy one or photocopy a friend's. Just be sure you have the manual, and read it often. And remember, if you buy a camera overseas, be sure to ask for the instructions in English. I've seen American tourists in Tokyo with new Nikons wondering what all those Japanese characters in their manuals really mean.

The "Best" Camera

"I want to buy a new camera and wonder which one you think is best?" Professional photographers get that inquiry all the time. When someone asks me what camera I think he should buy, I tell him I don't know. And I don't. Cameras are an individual thing, and whichever one makes you happy is the best camera for you. After reading this book, however, you should have a good basis for your decision.

[1]

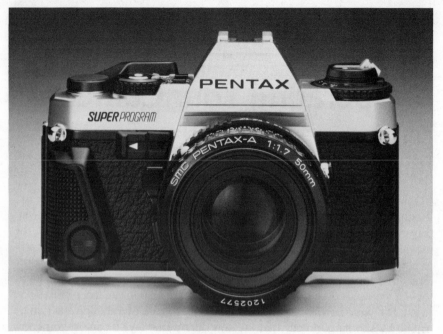

1. A trend in 35mm single lens reflex (SLR) cameras is toward automatic expo-
sure control. This is a multimode model that features a choice of programmed,
aperture-priority and shutter-priority auto-exposures, as well as manual exposure
control.

But like Ford owners who argue with Chevy owners, Pentax owners joust
with Minolta owners over the merits of their equipment. And as with cars, the
principles are the same but the options and accessories are often different.
And camera manufacturers are just as guilty as their car counterparts in bring-
ing out new models and intimidating the public into thinking they must have
the latest thing on the market. Some improvements are valid, others are sim-
ply gimmicks to boost sales.

Regardless of the type or age of your camera, whatever best serves your
needs is the camera to have. For instance, if you just do casual vacation pho-
tography, using a 35mm Olympus or Nikon would be more practical than
lugging a 4 × 5-inch view camera.

Cost is a determining factor, of course. But remember, while an $850 cam-
era may be better in quality than a $250 or a $15 camera, it is the person
behind the lens that usually makes the difference in results. I have little inter-
est in compulsive camera and equipment buyers; they are not photographers.
They're too busy discussing depth of field preview buttons and polishing their
camera cases to recognize and make a good picture.

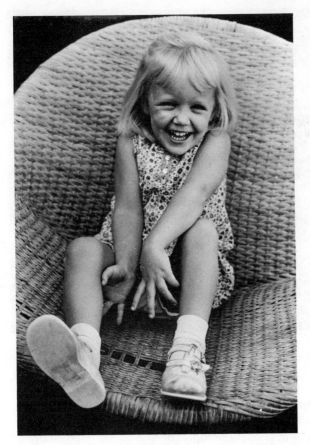

2. Pictures are more important than the camera or equipment the photographer uses to make them. Children and scenics are always popular subjects. This happy girl was photographed in her backyard.

The quality or price of equipment does not reflect the quality or worth of its owner as a photographer. Never be ashamed of your camera or be belittled by a guy with a gadget bag full of goodies. Ask him to show you his results, not his equipment. When someone starts bragging that he has a lot of equipment, I interrupt and ask to see some of his pictures instead. I hope you are a photographer and not just a camera and accessory collector.

The 35mm Revolution

If there is something in photography's history that was especially responsible for helping make the camera become an exciting part of today's creative society, it was the introduction of the 35mm camera. Excluding Polaroid's and Kodak's instant cameras, as well as disc and cartridge-loading pocket

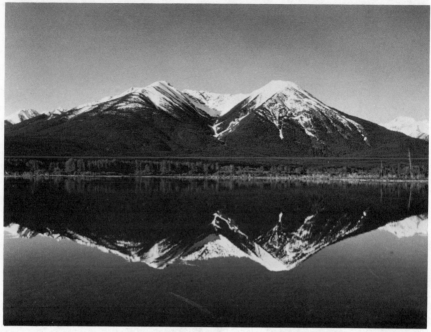

3. A lake in Norway offered this perfect reflection.

cameras, which also are very popular (and are discussed in separate chapters), the 35mm reflex and rangefinder cameras have become the favorite of most amateur and professional photographers. And for good reasons. The modern 35mm cameras are versatile, durable, economical, and give sharp results.

Cameras designated 35mm indicate the width of the film used in them. Actually, regular full-frame 35mm cameras produce a picture area measuring 24 × 36mm. The exposure frame size of half-frame 35mm cameras is 18 × 24mm.

A larger type of camera, the 6 × 7(cm), which looks like a 35mm reflex camera but offers a bigger picture area, takes size 120 or 220 roll film. It makes negatives and transparencies 2¼ × 2¾ inches. There are still many other types, like studio cameras some portrait photographers use with 5 × 7- or 8 × 10-inch sheet film. Or the square format Hasselblads, which astronauts took to the moon, and which yield exposures measuring 2¼ × 2¼ inches on size 120 roll film. Except for 35mm cameras, however, most are too large or too expensive for most casual camera users.

In general, unless you require or like a large negative or transparency for your purposes, the 35mm camera is probably ideal. Film for such cameras is readily available in black-and-white or color, negative or positive (for slides).

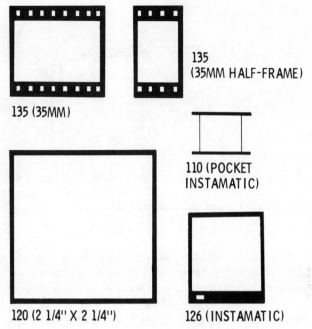

135 (35MM)

135
(35MM HALF-FRAME)

110 (POCKET INSTAMATIC)

120 (2 1/4" X 2 1/4")

126 (INSTAMATIC)

4. The relative size and image area of popular films can be compared.

Special films, like infrared, also are available in the 35mm format. Film for 35mm cameras comes in light-tight metal cassettes to make either 12, 20, 24, or 36 exposures. Or you can buy some films in bulk and load your own cassettes for the exact number of exposures desired.

If you make candid, unposed pictures, the 35mm is light enough to tote around, small enough to be unobtrusive, and simple enough to focus and use fast. Chances are you have a 35mm camera or eventually will purchase one for your photographic pursuits. Which one?

Rangefinder or Reflex?

While there are many manufacturers' models, the most popular 35mm cameras are of two basic types: reflex and rangefinder. The terms generally refer to the viewing and focusing systems. The older design 35mm is the rangefinder type. The photographer sees his subject through an optical view-finder, while the film records the scene through the main camera lens.

In the reflex models, termed *single lens reflex* (SLR) types, the photographer sees the subject through the same lens that presents the image to the film. This is done with a mirror and a prism. The mirror deflects the subject

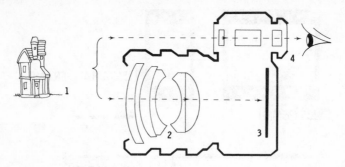

5. In the optical system of a rangefinder-type camera, the image of the subject (1) is transmitted by the main camera lens (2) to the film (3) while the photographer sees the subject through an optical viewfinder (4).

coming through the camera lens into a pentaprism that projects the image right-side-up into the photographer's eye. When the shutter release is pressed, the mirror instantly flips out of the way and the image is projected through the opened shutter onto the film. When the shutter closes, the mirror flips back and allows the photographer to see his subject again. These are often called instant-return mirrors.

At quick shutter speeds, such as 1/125 second and faster, this brief black-out of the subject is hardly noticed by the cameraman. Of course, with a range-finder type, the photographer always sees his subject, because the lens used to project the image to the film is independent of the viewing system.

Don't confuse single lens reflex cameras with *twin lens reflex cameras* (TLR). The latter features two lenses and commonly use size 120 or 220 (2¼ × 2¼-inch) film, although some TLR models can be adapted to take 35mm film. One lens of a twin lens reflex camera reflects the subject off a nonmove-able mirror to the camera's viewfinder. The other lens, located below the viewing lens, is used to project the subject onto the film. Just remember, 35mm cameras are either rangefinder or single lens reflex, not twin lens reflex.

Focusing of the two types of 35mm cameras is different. With a rangefin-der, two subject images are seen in the viewfinder until they are brought to-gether by turning the focusing ring on the camera lens. When the twin images become one, the subject is in focus. Usually with the reflex type, the photog-rapher turns the lens focusing ring until the image he sees looks sharp, like focusing binoculars or a microscope. Some SLR models, however, have fo-cusing screens that include a split image like that of rangefinder cameras.

Which 35mm type is best? The reason there are two types is that each has advantages. Because of the mirror, prism, and related mechanical apparatus in the reflex type, the rangefinder type is usually lighter in weight, smaller, and quieter. In situations where the light is dim, rangefinder cameras usually

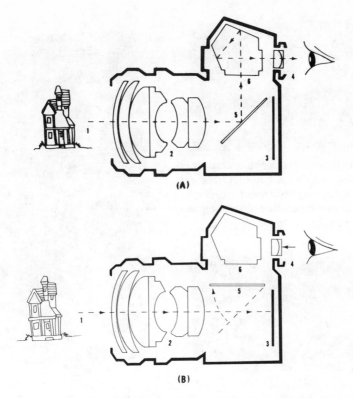

6. The optical system of a single lens reflex camera is shown for viewing and for exposing film. (A) For viewing, the image of the subject (1) is transmitted by the camera lens (2) to a mirror (5) that reflects it into a prism (6) which inverts the image correctly for the photographer, who sees it in the viewfinder (4). (B) For exposing film, the mirror (5) flips up, which allows the image of the subject to reach the film (3), and momentarily prevents the photographer from seeing the subject through the viewfinder (4).

are easier and faster to focus—simply bring the two images of the subject together. *Autofocusing* is a special feature in the most recent models and has spawned renewed interest in 35mm rangefinder cameras. When the shutter release button is depressed halfway, an invisible infrared beam of light bounces off the subject that you have centered in the viewfinder, activating a motor that focuses the lens on that distance. Models with an *autofocus lock* are best because you can focus on a subject that's off-center, lock in the focus at that distance, and re-aim the camera for the composition you desire.

The newest breed of 35mm rangefinder cameras, commonly called *35mm compact cameras,* have other automatic features that add to their popularity.

7. With most 35mm compact cameras featuring autofocus, two windows are used for sending and receiving an invisible infrared beam that reflects off the subject you center in the viewfinder.

8. With the rangefinder cameras, the photographer sees the subject through an off-center viewfinder, not through the lens as with single lens reflex cameras.

9. With a twin lens reflex camera, one lens (top) is used for viewing and the other lens transmits the subject image to the film.

Autoload is designed to make putting film in the camera foolproof, and *autowind* advances the film after every exposure so you won't miss any shots. Some have *autorewind* too. In addition to automatic exposure, these cameras most often feature *autoflash,* which turns on a built-in or accessory electronic flash (or signals you to do so) whenever the existing light is too low for a good exposure.

A major disadvantage of 35mm rangefinder cameras is that most (Leicas are exceptions) have their lenses permanently attached to the camera body. They cannot be changed to a wide-angle or telephoto. Another problem is called *parallax error.* When very close to subjects, the viewfinder gives a different view to the photographer's eye than the camera lens does to the film. Unless you have one of the better rangefinder cameras which automatically corrects this problem, you'll think you're getting a close-up of a rose but the filmed result shows the top of the blossom missing (see Illustration 11).

(A) **(B)** **(C)**

10. *In comparing focusing camera systems, when the subject is out of focus, range-finder cameras show a twin image (or split image) in a portion of the viewfinder (A). Viewfinders of reflex cameras, however, show a fuzzy image (B), which often is exaggerated in a center circle. With either type of camera, the subject is in focus when it appears sharply defined in the viewfinder (C).*

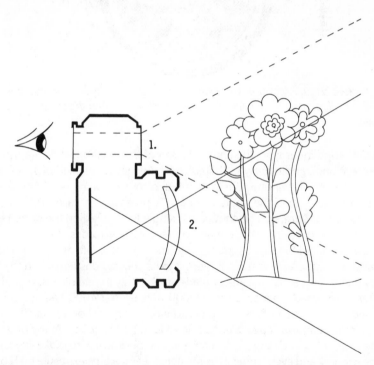

11. *Most rangefinder cameras have a problem called parallax error. When very close to a subject, the photographer sees a different portion of the subject through the viewfinder (1) than the film records through the camera lens (2). The camera must be tilted up, in this example, in order to film the flowers as desired. Some rangefinder cameras have parallax correction marks in the viewfinder to help the photographer frame the subject correctly.*

In the case of single lens reflex 35mm cameras, you see what the lens sees, so parallax error is not a concern. You get what your lens shows you. And since the lenses can be changed on reflex types, you see the subject exactly as the normal, wide-angle, or telephoto lens does.

Another advantage is that you can usually shoot at faster shutter speeds with a reflex because the shutter is built into the camera body. The shutter, of course, determines *how long* the film is exposed to the light coming through the lens.

12. *The leaf shutter found in most rangefinder cameras is built in the lens and features overlapping metal leaves that open and close when the shutter release is pressed.*

In the rangefinder type, the shutter is part of the lens (again, Leica models are exceptions), and usually is limited mechanically to a speed of 1/500 second or slower. The shutter has a number of overlapping metal leaves that open and close when the shutter release is pressed. It's called a *between-the-lens* or *leaf shutter.* The shutter in a single lens reflex, on the other hand, usually is a pair of flexible cloth curtains or a set of metal blades that travel across and just in front of the film's surface. They move right to left, or top to bottom.

Called a *focal plane shutter,* it returns to its starting position when the film is advanced. Since the curtains or blades travel only in one direction after the shutter is released, speeds up to 1/2000 and even 1/4000 second can be reached. Such speed often is needed to stop sports action or wildlife. Most 35mm reflex cameras have speeds at least to 1/1000 second. At the other extreme, both reflex and rangefinder cameras can be adjusted to make exposures of one second, and even longer if the shutter is set for a time exposure on B or T.

In summary, the most popular 35mm camera today is the single lens reflex type. The main reasons: the lenses on a reflex camera can be changed, and the photographer sees exactly what the lens sees. These factors make a big difference when you are composing your picture. Furthermore, recent technological improvements, including computer-chip microelectronic circuitry,

13. Focal plane shutters are found in single reflex cameras. This type of shutter is built into the camera body and features a pair of flexible curtains or a set of metal blades which travel in front of the film plane. In the case of curtains, when the shutter release is pressed, the first curtain (1) opens to allow light to reach the film, until followed by the second curtain (2). The time delay between the first and second curtains depends on the shutter speed that is set.

have permitted smaller and lighter-weight SLR models, with increasing emphasis on programmed and automatic exposure controls. Adding to their ease of use is new accessory equipment with automatic features, including autofocus lenses, autowind (or motor drive) attachments to advance the film, and *dedicated flash units* that set the correct flash exposure automatically.

Protecting the Camera

Regardless of the camera you use, there are some things you should know and practice immediately. One is so simple that many people don't think about it and later have regrets. Use a *camera strap.*

Whether or not your camera is in a case, you should have it attached to a strap that can be attached to you. A dropped camera means disaster. The easiest means of prevention is to have a strap attached to the camera that can be hung around your neck or wrapped around your wrist. Make sure the strap is a good one, and attach it to the camera with "O" rings rather than clips that snap on.

Those that break or become unfastened easily mean disaster, too. Someone is bound to bump you when you least expect it. Or suddenly you need both hands free and have to release your camera. So get a camera strap, and use it.

14. Smart photographers always use a camera strap.

Another way to protect your camera is with a case. But if the case gets in your way while shooting, take it off. You must make sure your camera is easy to use; dangling case covers can slip in front of your lens or viewfinder and you'll miss pictures.

While I never recommend that you abuse your camera, don't baby it either. Use it. Remember your camera is only your tool for making pictures. Respect it, but don't be so afraid it will get harmed that you fail to get your pictures.

However, don't inadvertently damage your camera when not using it. Keep it out of direct sunlight or hot storage places, such as car glove compartments and rear window ledges. Heat can loosen the lens elements and affect your camera's lubrication. Heat harms film, too. Sunlight coming through an uncapped lens may focus its rays on the curtain of your focal plane shutter and burn it. Remember in your youth how you set dry leaves on fire by focusing the sun's rays through a magnifying glass?

A good suggestion: If you carry camera equipment in your car's trunk, which can get very hot during the summer, place the equipment in an inexpensive styrofoam ice chest (without ice) for insulation from heat.

Also remember to keep your camera and equipment away from damp storage areas where mildew might develop. When storing cameras in high-humidity areas, prevent moisture damage by including a desiccating agent, such as

silica gel, in the storage area. Wipe off any moisture from rain or snow. And especially be careful to clean off salt water or spray when you're at the beach or on a boat. Moisture, which condenses when you go from air conditioning to humid outdoor conditions, or when you escape from a cold winter's day into a heated house, should be allowed to evaporate or else be wiped off.

15. To keep moisture from condensing on a cold camera, seal it in a plastic bag before entering a warm building or car; moisture will condense on the bag instead of the camera.

At the beach, guard against sand. Keep your camera in a gadget bag or other sand-free protection. Dust should be cleaned off. And brush the dust from inside your camera occasionally, too. This is very important after a dusty day in the field or at a motorcycle race, for instance.

Don't bang your camera unnecessarily. And if you carry your camera and equipment in a gadget bag, make sure the case is well padded to absorb bumps and rough handling.

One maintenance tip: check all exposed screws periodically. High-speed vibration, especially during jet airplane flights, can loosen the screws on your camera. A set of small jeweler's screwdrivers will allow you to tighten them. Otherwise, you should not attempt any camera repairs yourself; the insides are more complicated than you can imagine.

By the way, if you have your camera repaired or routinely cleaned by a photo service shop, afterward always shoot a test roll of film to make sure everything is working okay. Occasionally something goes wrong and important pictures can be lost if you haven't tested the camera after it comes back from the shop. Many an overseas trip has been ruined by a recently repaired camera that suddenly jams.

In regard to traveling, a good gadget bag offers worthwhile protection. There are many different kinds and many different prices. Some are too bulky or heavy to carry comfortably. Try yours before the trip.

One plea. Don't casually discard your film boxes—the countryside is too cluttered as it is. Many tourist areas seem to be ankle-deep in film cartons, so don't contribute your photographic litter. And remember to keep your film can to protect your exposed roll of 35mm film.

Protecting the Lens

Another major error of unknowing photographers is that they fail to keep their lenses clean. Or they clean them too much. A dirty lens diffuses the light coming through the lens and the result is an unsharp picture. A clean lens means clearer pictures. On the other hand, cleaning a lens too often, or improperly, can damage its special coating. This coating cuts down the flare that sometimes occurs when light hits a lens.

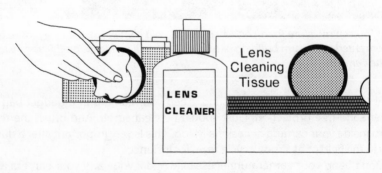

16. *Camera lens cleaner and tissue are the only safe materials to use for cleaning lenses.*

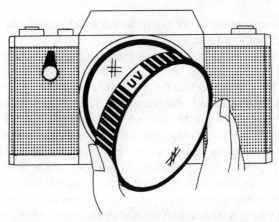

17. *To protect a camera lens from dirt and scratches, use an ultraviolet (UV) filter. The seemingly clear filter requires no increase in exposure. Sometimes called a haze filter, it also reduces ultraviolet radiation to improve picture quality, especially of scenic views.*

A lens should never be cleaned with your finger, a handkerchief, or by spitting on it. Even regular eyeglass tissues must be avoided. Some are chemically treated and will damage the lens coating. The only safe way is to use the photographic *lens tissue* made especially for cleaning camera lenses. It is inexpensive and available at every camera store.

A special liquid photographic *lens cleaner* can be used when the lens is especially dirty, as when fingerprinted. Camel's hair brushes are okay unless they themselves are dirty. If used to clean other parts of the camera, such brushes may pick up enough grease to smear the lens. Restrict your lens brush to your lens. Some photographers blow away the dust, fog the lens with their breath (careful, saliva is harmful), and wipe it with the photo lens tissue.

Some protection from physical harm can be given to a lens by using a *lens shade*. Sometimes called a lens hood, this metal or rubber ring attaches to the lens. It helps keep away rain, snow, and fingerprints. Such shades keep light from falling directly on the lens surface, too, and help prevent flare. However, some photographers, myself included, find lens shades bothersome at times, and so do without them.

In any case, almost full protection of your lens can be assured by using an *ultraviolet filter*. Secured in front of the lens, this seemingly clear filter protects it from dirt and possible scratching. Inexpensive ($10-$15) compared to the cost of your lens, the filter can be cleaned with less caution. When in a hurry, I often blow the dust away, fog the filter with my breath, then wipe it with a piece of cloth, such as a cotton shirt or handkerchief.

Known as a *UV* or *haze filter*, the ultraviolet filter actually is designed to

reduce the ever-present ultraviolet radiation which is invisible to the human eye but not to photographic film.

The UV filter reduces such radiation and improves picture quality, especially distant scenes. It does not decrease the effects of smog, fog, or mist. *Polarizing filters,* which reduce the glare and help darken pale blue skies, are different and are discussed in the chapter on filters. Some manufacturers produce what they call a *skylight filter,* which is similar to the UV filter and recommended for color films; either one can be used for lens protection. I buy a UV filter for each of my lenses, except close-up lenses, and keep them at all times (except when using a polarizing or other type of filter). I'd rather replace a damaged UV filter than a much more expensive lens.

Of course, a *lens cap* offers very good protection too. However, it may get bothersome taking a lens cap off for a shot and then putting it back on. You avoid this inconvenience by using a UV or skylight filter instead. No change in exposure is required when using such filters.

Holding the Camera

Another simple rule to remember regarding the use of your camera is to hold it steady. *More pictures are ruined by camera movement than any other reason.* You can avoid this with a little practice.

The easiest way to start is by shooting at a shutter speed of 1/125 second, or faster. That way your shutter helps cancel any movement you might make. Some photographrs prefer 1/250 second for this reason. Other shutter speeds can and should be used, but keeping your shutter at 1/125 second for average situations helps avoid camera movement mistakes.

Another common mistake is to jab at the shutter release, which can result in camera movement. The *shutter release button* should be *pressed* gently. Practice in front of a mirror and see if you're moving your camera when you press the shutter release. You may have to arch your finger more. Try it.

Another thing you can do in front of a mirror is practice holding your camera. It should be comfortable in your hands, easy to turn from horizontal to vertical position, and held in a manner which enables you to use the controls (f/stops, focus, shutter release) without difficulty.

Most important, you should learn to hold it steady. Think of your body as a tripod. Stand with your feet slightly apart for best support. Keep the arm of the hand which supports the camera next to your body, preferably resting on your ribs for more support.

With practice you should be able to shoot at speeds as slow as 1/30 sec-

18. For the most effective composition, photographers must be able to hold their cameras steady in both horizontal and vertical positions. A vertical camera position was appropriate for these tall palm trees in Honolulu.

ond, sometimes less, without moving your camera. Practice. If your ribs are being used for support at slow speeds, exhale your breath before pressing the shutter release.

The longer and heavier telephoto lenses require faster shutter speeds or something other than human support. For support at slow speeds, press the camera against a tree or the side of a building, rest it on a chair or floor or fence post. Or use a tripod (see Chapter 7).

At slow shutter speeds, with or without a tripod, try the *self-timer*. First, find a support for your camera, frame your picture, set the exposure, and then release the shutter by tripping the self-timer. Most good 35mm cameras have a built-in self-timer which, when cocked, will release the shutter about ten seconds after you trip it. Thus you are not touching the camera when the shutter is released, and if the camera is firmly supported, there will be no camera movement.

19. *For these young fishermen in Florida, a horizontal camera position produced the best composition. Both pictures were purposely underexposed to create silhouettes.*

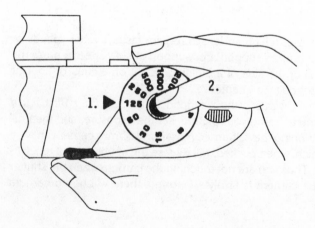

20. *The best ways to avoid camera movement are to (1) shoot at a fairly fast shutter speed, such as 1/125 second, and (2) press, don't jab, the shutter release with an arched finger.*

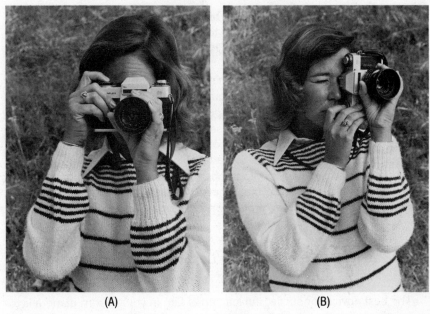

(A) (B)

21. Fingers for adjusting the lens controls and pressing the shutter release button also must be able to hold the camera steady, whether it is in a horizontal (A) or vertical (B) position.

22. For delayed release of the shutter, cock the camera's self-timer and activate it by pressing the shutter release button or special self-timer release button. A shutter release delay up to 10 seconds is common, although the time varies with the camera model.

A *cable release* can be used, too. This flexible cable screws into the shutter release and allows the photographer to trip the shutter without pressing the release on the camera with his finger. Chances of camera movement are greatly reduced.

Generally, a cable release is necessary for long (time) exposures. Releases with a lock screw are preferred because the photographer doesn't have to hold the plunger in when making exposures longer than a second with the camera shutter set on the B position (see page 33).

After learning how to protect, support, and hold your camera and its lens, the best thing to conquer is how to load film in your camera—and make sure it is loaded correctly. Many photographers, even the pros, occasionally shoot a roll of film only to discover that it never wound on the take-up spool. The result: a blank roll, and some profanity perhaps.

Loading the Camera—For Sure

The best advice for successful loading of film in your 35mm camera is to follow the instructions in your camera manual. While the procedure is basic, different cameras have different take-up mechanisms. (See Illustration 23 for general details). Most have a permanent *take-up spool* to which you attach the *leader* of the film. But some have removable spools, and others thread automatically. Autoload cameras are supposed to load film easily and properly but they're not always foolproof; make sure you follow specific directions in the camera's instruction book.

For loading film manually, the basic procedure is to open the camera back and insert the 35mm *film cassette* or container (or magazine, as Kodak calls it) in the space on the left-hand side. You usually have to pull up the *rewind knob* or *crank* to do this. You then draw the film's end, the leader, which comes from the light-tight film cassette, and insert it in the take-up spool.

Make sure the *emulsion,* the light-sensitive (dull) side of the film, is facing the lens. Advance the film and release the shutter until the *sprocket holes* on *both* sides of the film are engaged in their sprockets.

It seems that economy-minded photographers always try to get an extra frame on their 36- or 24-exposure rolls and close the camera back after engaging only the film leader's single set of sprocket holes. Sometimes the film slips, and the result is no photographs at all! So give up that extra frame and save a whole roll. Make sure sprocket holes on *both* sides of the film are engaged before closing the camera's back.

You can always check whether your film is advancing properly. After closing the camera back, advance the film and release the shutter once more. Next, because the film is not tightly wound in the cassette, *carefully* take up tension on the film by slowly winding the rewind knob or crank in the direc-

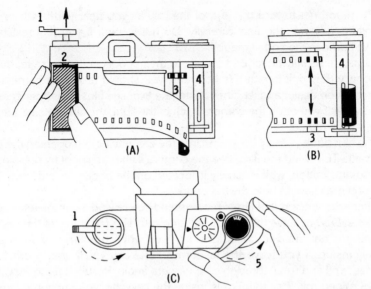

23. A 35mm camera must be loaded carefully to be sure the film will be drawn from the cassette. Follow these steps: (A) Pull up the film rewind crank (1) and insert the film cassette (2) into the camera with the film's emulsion (dull) side facing the lens. Push down the film rewind crank. (B) Insert the film leader in the take-up spool (4), and advance the film, making sure the film's sprocket holes are engaged in both camera sprockets (3). (C) Close the camera back and continue advancing the film by cocking the shutter (5) until the film rewind crank (1) moves. This indicates the film is correctly loaded and is winding onto the take-up spool.

tion of its arrow. Do not press the *film rewind button.* When the slack is gone, advance the film and watch the rewind knob or crank to see if it moves. If it does, then the film is being properly advanced onto the take-up spool. If not, the leader has slipped off the spool or the film has come off the sprockets. Open the camera back and see what's wrong. As they shoot a roll of film, some photographers also make it a habit to occasionally watch the rewind crank to make sure the film is still advancing. A few of the newer models have a *film transport indicator* which visually shows the photographer that film is advancing.

You should remember that the *film frame counter* does not indicate whether there is film in the camera, or whether film is advancing. The film frame counter on most 35mm cameras, with or without film inside, automatically begins counting when the camera back is closed. If you are unsure if there is film in a 35mm camera, make several turns on the rewind crank to check for tension that will be evident if the camera is loaded. Some models have a *film load indicator* which shows when a film cassette is in the camera.

When you get toward the end of the roll, as you near your 24th or 36th exposure, advance the film carefully. Do not force it if you feel resistance; you've come to the end of the roll.

Films are usually attached securely to their spools in the cassette, but occasionally they pull free. If this happens, you should take your camera to a camera shop dealer and let him transfer the exposed film to another cassette. Otherwise, if you open the camera back in the light, the film outside the cassette will be ruined.

The film *always* must be wound into the cassette before opening the camera back. To rewind the film, free the camera's take-up spool by pressing the film rewind button, which usually is located on the bottom of a 35mm camera. You may have to hold the button in.

After exposing a roll of film, I recommend you rewind it completely into the cassette. Do not leave the leader hanging out. The felt lining of the cassette opening is designed to keep light out even when the film is wound completely inside. If you leave the leader out, one day you'll grab a previously exposed roll and run it through your camera again. Result: double exposures and a ruined roll. If all the film is inside the cassette, you know the film has been exposed.

Here are a few tips when loading your film. Make sure the camera is clean inside. The *pressure plate,* which holds your film flat against the opening, must be free of dust and grit to prevent scratching of the film's shiny protective backing. Check any rollers or surfaces which come in contact with the film's emulsion (dull) side, too.

Secondly, load film in subdued light. Simply find some shade or at least turn your back against the sun. Bright sunlight may leak into the cassette and fog your film, especially if the film is of high speed and very sensitive to light.

And I repeat: Most film frame counters on 35mm cameras are activated when the camera back is closed, whether there is film in the camera or not. This automatic frame counter is designed to tell you how many exposures have been made. Unfortunately, an advancing frame counter does not indicate whether there is film being advanced as well.

So, if you pick up your camera after a period of disuse and note the film frame counter is other than zero, try to take up the tension on the film rewind crank or knob to determine if there is actually film inside. If not, the crank will turn freely. Do not press the film rewind button during this test.

Changing Partially Exposed Rolls

While many camera manuals fail to mention it, occasionally you'll want to change the film in your camera to another type. Must you shoot the remain-

ing frames or waste them by rewinding the film back into the cassette? No. The procedure to save the unused film in your camera is simple.

First, note on your film frame counter the number of exposures already made on the roll. Then press the film rewind button and *slowly* rewind the film until you *hear* the leader pull free from the take-up spool or *feel* the film tension relax when the leader pulls free. Stop!

Open the camera back and the film leader should be visible. If not, you rewound the film too fast and it all returned inside the cassette. If so, you have lost the use of your unexposed frames, unless you take the cassette to a camera shop where they'll transfer the film to another cassette for a small charge.

On the other hand, if you don't rewind all but the leader and first inch or two of film into the cassette, the film still on the camera's take-up spool will be exposed to light and ruined when you open the camera back. If you are uncertain, open the camera back in a totally dark room or inside a *changing bag.*

Such a bag serves as a portable darkroom. The camera is zipped into the black, double-layered bag. The photographer puts his arms into the bag through two sleeve openings that use elastic to keep a light-tight seal. As long as the bag has not been damaged by careless handling, the inside provides total darkness. For total safety against light leaks, however, you should not use the bag in direct sunlight. Besides being used to check his camera and film whenever or wherever he wishes, some photographers use a changing bag to load film into a developing tank for home processing.

After rewinding the film, write or scratch on the leader the number of exposures made on that roll. Also mark the cassette to remind you that it has been partially exposed. When you're ready to use this roll again, note the number of previous exposures marked on the leader and reload it in the normal manner.

Then keep advancing the film and releasing the shutter until you are *two* frames past the number of previously exposed frames. Do this without reexposing the film by using the light-tight lens cap to keep light from striking the film. Or press the front of the camera lens against your body to keep the light out when the shutter is released.

For more protection against reexposure, set your shutter to its fastest speed (at least 1/500 second) and the lens aperture to its smallest opening (f/16 or f/22). In order to prevent double exposure of the last pictures you shot before removing the roll, advance the film until the frame counter shows the film has gone two frames past its previously exposed portion.

Making Multiple Exposures

Reexposing the same film frame more than once may be desired for special creative effects. Several of the newer 35mm cameras have a provision for

making multiple exposures easily, usually by pressing a *multiple exposure lever* which permits the shutter to be cocked without advancing the film or the film frame counter. However, many 35mm cameras are designed to prevent accidental double exposures by advancing the film every time the shutter is cocked. With a little experimentation and practice, you can bypass this protection feature and cock the shutter without advancing the film in order to make additional exposures on the same frame. The following procedure (Illustration 24) works for most 35mm cameras, but check your camera manual for specific multiple exposure instructions.

First, take up the slack on the film in the cassette by carefully turning the rewind knob or crank. Next, *holding* the crank or knob in position so the film's tension is not lost, press in the film rewind button to free the take-up spool, and then cock the shutter. You're now ready to reexpose the same film frame.

Sometimes, however, the film pressure plate is weak, and too much film tension or slack allows the frame to move slightly. The result is that the frames are not perfectly aligned and your two images will not overlap as you expected. Always take some practice shots to see how your camera performs using this method of double (or triple, et cetera) exposure. Other methods and additional tips on how to properly expose for double or multiple exposures are discussed on page 244.

In proceeding with the operation of your camera, it is important to become familiar with its various parts and features. Diagrams with numbered identification are usually provided in your camera manual. The example here (Illustration 25, page 26) can be used for reference. Study it. But remember, not all cameras have the same features, nor are these in the same positions. It's better to have the identification diagram for your specific camera.

As mentioned, currently the most popular 35mm camera for professionals and amateurs alike is the single lens reflex type with a built-in exposure meter. Most of the remarks which follow are applicable to rangefinder types, too, as well as many other kinds of cameras. Instant, disc, and pocket cameras, however, are discussed thoroughly in separate chapters.

Nevertheless, regardless of the type of camera you use, one of the most basic and important factors of a successful photograph is proper exposure. Does the result look as you intended it to? Or is the transparency or print too dark or too light? Of course, you can create a certain mood by purposely overexposing or underexposing.

However, most photographs are meant to represent the scene as the photographer saw it. And proper exposure is necessary to make this possible. Except for the concept of depth of field, understanding the three major factors concerned with exposure is the most difficult but most important aspect of making effective photographs. These factors are film speed, shutter speed, and lens opening.

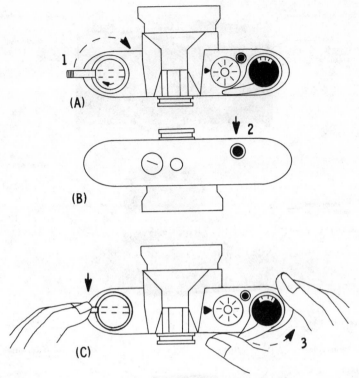

24. *Unless the camera has a multiple exposure control, follow these steps to make double exposures with most 35mm cameras: (A) After making the first exposure, take up the tension of the film in the cassette by turning the film rewind crank (1). (B) Depress the film rewind button (2), usually located on the bottom of the camera. (C) Hold the film rewind crank firmly and cock the shutter (3), making sure the film rewind button is still depressed. The second exposure can now be made.*

Understanding Film Speeds (ISO/ASA)

Foregoing technical details, all film, whether black-and-white or color, is basically a piece of acetate that is coated on one side with light-sensitive chemicals. Light striking that coating, called the emulsion, makes an invisible *latent image* that is only seen after being acted on by other chemicals during processing. How sensitive the film's coating is to light determines the *speed of the film.* A *fast* film requires less light to make an image than a *slow* film.

How fast or slow is a film? A set of numbers to indicate its relative speed, meaning sensitivity to light, was determined by the American Standards As-

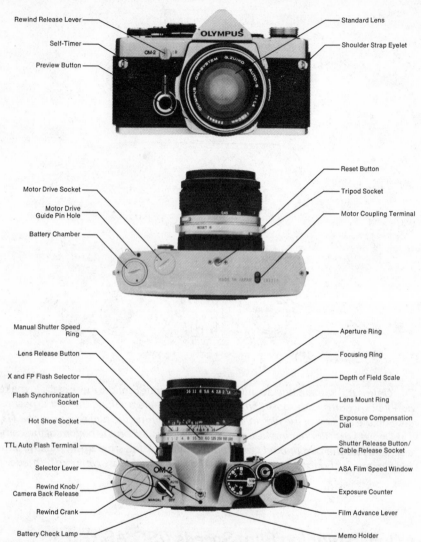

Rewind Release Lever

Self-Timer

Preview Button

Standard Lens

Shoulder Strap Eyelet

Motor Drive Socket

Motor Drive Guide Pin Hole

Battery Chamber

Reset Button

Tripod Socket

Motor Coupling Terminal

Manual Shutter Speed Ring

Lens Release Button

X and FP Flash Selector

Flash Synchronization Socket

Hot Shoe Socket

TTL Auto Flash Terminal

Selector Lever

Rewind Knob/ Camera Back Release

Rewind Crank

Battery Check Lamp

Aperture Ring

Focusing Ring

Depth of Field Scale

Lens Mount Ring

Exposure Compensation Dial

Shutter Release Button/ Cable Release Socket

ASA Film Speed Window

Exposure Counter

Film Advance Lever

Memo Holder

25. Modern 35mm single lens reflex cameras have numerous features and controls (illustration courtesy of Olympus Camera Corporation).

sociation. This rating was abbreviated ASA and became the standard in the United States. Overseas, the Deutsche Industrie Norm rated films with a different scale, abbreviated DIN.

Both systems, even though the ASA and DIN numbers vary for the same films, indicate the relative sensitivity of all films. Early in the 1980s many film

manufacturers, including Kodak, adopted the International Standards Organization (ISO) designations for film speeds. The ISO number is simply a combination of ASA and DIN numbers for film of the same speed. For example, a film rated ASA 100, which is identical in speed to 21 DIN, is now identified as ISO 100/21°.

Since many people have long recognized film speeds by their ASA numbers, the newer ISO designation may seem confusing. **For clarity, in this book film speeds will be indicated only by the ASA value of the ISO number and be written, for example, as ISO/ASA 100.**

Because older cameras or exposure meters purchased in Europe may carry only the DIN film speed designations, you may need to know the ASA equivalents. They're listed in the following chart.

DIN	=	ASA	DIN	=	ASA	DIN	=	ASA
15		25	24		200	33		1600
16		32	25		250	34		2000
17		40	26		320	35		2500
18		50	27		400	36		3200
19		64	28		500	37		4000
20		80	29		640	38		5000
21		100	30		800	39		6400
22		125	31		1000	40		8000
23		160	32		1250			

Photographers must know the speed of the film they are using in order to determine proper exposure, whether with daylight or with artificial light, such as electronic flash. *Exposure meters* must be set with the correct ISO/ASA speed for the film you are using if proper exposures are to be indicated by the meter. A good rule to remember is that the *higher* the film speed number, the *faster* the film, i.e., the more sensitive it is to light.

The ISO/ASA for black-and-white film usually applies to all types of illumination, outdoors or indoors. Color film, however, is designed either for use with daylight (plus electronic flash and blue flashbulbs or cubes) *or* artificial light, which is often termed *tungsten* light. Whether it is daylight- or tungsten-type film, each can give good color results under other light conditions if the proper conversion filter is used and the film speed is changed accordingly (see page 152).

Current ISO/ASA film speeds for popular 35mm black-and-white and color film are listed on the following page. These films are *not* available in all sizes for use in all cameras (see page 138). By the way, regarding color film names, in most instances the suffix "chrome" indicates a positive film for making slide transparencies, while "color" indicates a negative film for making prints.

Early films were not very sensitive to light and required long exposures. Remember the neck braces old-time portrait photographers used on their subjects to keep their heads steady? Among other things, advances in chemistry enabled faster films to be produced so pictures could be made more easily in dim light. Likewise, since the faster films needed very little exposure to register an image on the emulsion, a faster shutter speed could be used to enable the photographer to stop action and clearly capture moving objects.

Manufacturer/Film Name	ISO/ASA Film Speed Daylight/Tungsten*
Color Films	
KODAK	
Kodachrome 25	25
Kodachrome 64	64
Kodachrome 40 (Type A)	— / 40
Ektachrome 64	64
Ektachrome 100	100
Ektachrome 200	200
Ektachrome 400	400
Ektachrome 160 (Tungsten)	— / 160
Kodacolor VR 100	100
Kodacolor VR 200	200
Kodacolor VR 400	400
Kodacolor VR 1000	1000
Kodacolor VR Disc	200
FUJI	
Fujichrome 50	50
Fujichrome 100	100
Fujichrome 400	400
Fujicolor 100	100
Fujicolor 200	200
Fujicolor 400	400
Fujicolor 1600	1600
Fujicolor Disc	200
AGFA	
Agfachrome 50	50
Agfachrome 100	100
Agfachrome 200	200
Agfachrome 1000	1000
Agfacolor 100	100
Agfacolor 200	200
Agfacolor 400	400
Agfacolor 1000	1000
3M	
Color Slide 100	100

Manufacturer/Film Name	ISO/ASA Film Speed Daylight/Tungsten*
Color Slide 400	400
Color Slide 1000	1000
Color Slide 640T	— / 640
Color Print 100	100
Color Print 200	200
Color Print 400	400
KONICA	
Color Print 100	100
Color Print 200	200
Color Print 400	400
Color Print Disc	200
Black-and-White Films	
KODAK	
Panatomic-X	32
Plus-X Pan	125
Verichrome-Pan	125
Tri-X Pan	400
Recording 2475	1000
Royal-X Pan	1250
ILFORD	
Pan F	50
FP4	125
HP5	400
XP1	400
AGFA	
Agfapan	25
Agfapan	100
Agfapan	400
Agfapan Vario-XL	125-1600

*Black-and-white films have the same ISO/ASA for both daylight and tungsten light; if a filter is used to achieve correct color balance when shooting daylight color film under tungsten light, the effective ISO/ASA will be less that listed (see film's instructions for specific filter and film speed to use). See also Chapters 5 and 6.

Of course, films have other characteristics, and that's why there are so many different types on the market. For now I'll deal only with film speeds. Keep in mind that the ISO/ASA numbers tell you how fast a film is in relation to all other films. (Film manufacturers determine the ISO/ASA ratings for their own films.) For instance, a film rated ISO/ASA 50 is twice as sensitive to light as an ISO/ASA 25 film. Similarly, film of ISO/ASA 400 is twice as fast as one rated ISO/ASA 200.

That means it takes twice as much light to make an exposure with ISO/ASA 200 film as it does with one rated ISO/ASA 400 if the camera settings (lens opening and shutter speed) remain the same for both films. But with light conditions remaining constant, that means a photographer will increase the exposure of the ISO/ASA 200 film to twice the exposure of the ISO/ASA 400 film by changing camera settings.

These camera settings, and their relationship to one another as well as to film speed, must be understood in order to know the capabilities of your camera and film. Lens openings and shutter speeds determine the amount of light that is allowed to strike or expose the film. Miscalculated, the camera settings will cause an improper exposure—one that is too dark (underexposed) or too light (overexposed).

An *exposure meter* "reads" the amount of light falling on or reflected by your subject. Setting your film's ISO/ASA on the exposure meter indicates how sensitive your film is to the available light, and the meter calibrates the lens opening and shutter speeds that will give you the proper exposure. For accurate exposures, an exposure meter is a must. Some are separate hand-held devices, but the majority of exposure meters today are built into the cameras themselves. Besides giving you exposure information for setting the correct lens opening and shutter speed, many are designed to set the camera's exposure controls automatically. (A discussion of how to use exposure meters begins on page 56.)

Comprehending Shutter Speeds

Of the two basic camera settings, shutter speeds are more easily understood than the lens openings. Normally indicated on a dial on top of SLR cameras, shutter speeds indicate *how long* light is allowed through the opened shutter onto the film. On rangefinder cameras and others with leaf-type shutters, shutter speeds usually are indicated on the lens barrel. You turn the shutter speed dial to indicate how long you want the shutter open. The speeds usually range from 1 second to 1/500 or 1/1000 second. Some focal plane shutters on 35mm cameras reach a top speed of 1/2000 and even 1/4000 second.

Unless your camera manual states otherwise, the shutter speed dial should not be set *between* the marked shutter speed positions. Inaccurate exposures, and sometimes mechanical damage to the shutter, can result. Electronically controlled shutters, however, usually can be set anywhere on the shutter speed scale.

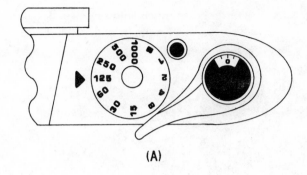

(A)

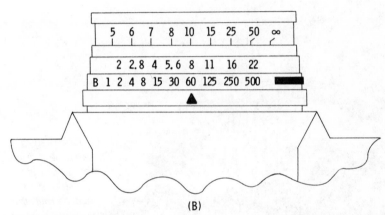

(B)

26. (A) With a single lens reflex camera, because its focal plane shutter is built into the camera's body, the shutter speed dial usually is located on the top side of the camera. On a few models, the shutter speed control surrounds the lens mount. (B) With a rangefinder camera, because most have a between-the-lens leaf shutter built into the camera's lens, the shutter speed control is on the lens.

Depending on which direction you turn the dial to the next shutter position, you either double (2 X) or halve (½ X) the amount of light which reached the film at the previous setting. Thus, switching from 1/125 to 1/250 second, you cut in half the amount of time the light has to reach the film. As such, you decrease the amount of light by one-half (½ X).

Or, switching from 1/125 to 1/60 second, you double the amount of time the light has to reach the film. Therefore, you increase the amount of light two times (2 X). You need to know the interrelationships of shutter speeds because these also are interrelated with lens openings and film speeds.

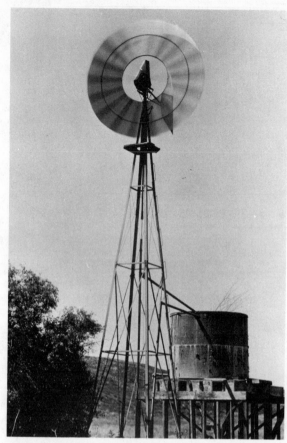

27. One way to show motion in still photographs is to use a slow shutter speed, as with the spinning vanes of this windmill on a ranch in California.

On modern cameras, shutter speeds include the following: 1 second, 1/2 second, 1/4 second, 1/8, 1/15, 1/30, 1/60, 1/125, 1/250, 1/500, 1/1000, and sometimes 1/2000 or 1/4000 second. Older cameras had standard shutter speeds of 1/25, 1/50, 1/100, and 1/200 second. Obviously, the higher the number, the faster the shutter speed. That means to stop action, such as a football game shot from the sidelines, a fast shutter speed of 1/500 or 1/1000

B	1	2	4	8	15	30	60	125	250	500	1000

2X 1/2X

28. Light-admitting relationships of shutter speeds (see text).

second would be best. If you want the action to be blurred, a slow shutter speed such as 1/15 or 1/30 second would give that result.

For speeds longer than one second, you must set the dial to B or T. Most cameras today only have the B setting, which means *Bulb*. The T setting means *Time*. Both are used for time exposures.

The difference is that with a B setting, you must hold the shutter release button down to keep the shutter open. If you release the pressure on the button, the shutter closes.

The B setting traces its history to olden-day photography, when the photographer had to squeeze a rubber bulb connected by an air hose to the shutter. The length of time the cameraman kept the bulb squeezed determined the length of time the shutter would remain open. *Note that the Bulb setting does not refer to flashbulbs.*

When the shutter release is pressed with the dial on a T setting, the shutter will remain open until the photographer presses the shutter button a second time. This frees the photographer from keeping the shutter release depressed.

However, when using either a B or T shutter setting, a cable release is always recommended to help prevent accidental camera movement by the photographer during a long exposure. It screws into or onto the shutter release button. The best cable releases have a screw at the plunger end which can be tightened to hold the shutter open on the B setting. When the photographer completes his exposure, he releases the screw and the plunger pops out to close the shutter.

With cameras having *automatic exposure control,* the scale on the shutter may continue past B with other numbers: 2, 4, 8, 16, 32, et cetera, to indicate longer exposure times in terms of seconds. Electronically controlled shutters are used in most automatic cameras. On aperture-priority models, these operate automatically at a shutter speed determined by the camera's built-in exposure metering system after the photographer first sets the lens opening (i.e., f/stop) he desires.

Adjusting Lens Openings

Companion to the shutter speed in regard to exposure is the lens opening (known also as the *aperture* or *diaphragm*). The relative size of the lens opening is indicated by numbers called *f/stops*.

Modern cameras have identical f/stop numbers, but the range of f/stops depends on the particular lens design and manufacturer. Most common are f/2, f/2.8, f/4, f/5.6, f/8, f/11, f/16. Some lenses may also have f/22 and f/32. At the other end of the scale, they may have an f/1.2 or f/1.4 opening or a nearby

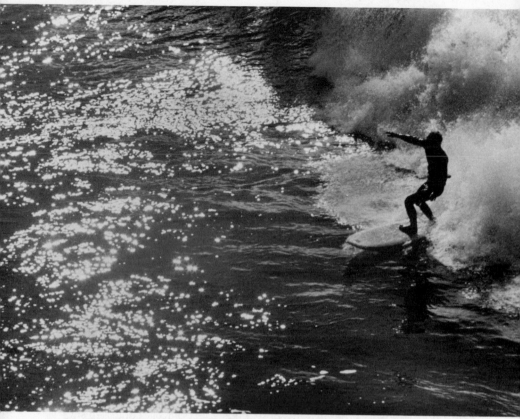

29. The lens aperture, indicated by numbers called f/stops, is adjusted to help control the amount of light which reaches the film. A small f/stop was used to create this dramatic shot of a surfer, taken from a nearby fishing pier.

number such as f/1.5 or f/1.7. Older lenses often had standard f/stop markings of f/3.5, f/4.5, f/6.3, and f/8.

Basically, the f/ number indicates the relative amount of light which is allowed to pass through the lens. The lower the number the greater the amount of light passing through the lens. A high number, such as f/16, indicates a small amount of light is passing through the lens. In this regard, it is easiest to think of the f/stop numbers as fractions.

How much light passes through the lens is relative to the change from one f/stop to another. Moving from one f/stop number to the next closest f/stop either doubles (2 X) the amount of light passing through the lens or cuts the amount of light in half (½ X). It depends on which direction you move the

f/stop, toward the wider lens opening (smaller f/stop number) or toward the smaller lens opening (larger f/stop number).

For example, if you are at f/8 and move the f/stop to the next larger opening, f/5.6, you double the amount of light that passes through the lens. Thus the film receives twice (2 X) the amount of light at f/5.6 as it does at f/8.

Going from f/8 to the next smaller opening, f/11, cuts the light coming through the lens in half. So you get one-half (½ X) the amount of light reaching the film at f/11 as you did at f/8.

2.8 4 5.6 8 11 16

2X 1/2X

30. Light-admitting relationships of f/stops (see text).

You recall how moving from one *shutter speed* to the next closest one either doubles or halves the amount of light. Because changing the *lens opening* from one f/stop to the next closest one also doubles or halves the amount of light, by now you should see how f/stops and shutter speeds are mathematically interrelated in regard to exposure.

However, while you might easily recognize how the next closest shutter speeds either double or halve the length of time that light is allowed through the shutter onto the film, the f/ numbers may not be as clearly understood. Don't you double the amount of light that passes through the lens at f/8 by moving the f/stop to f/4, instead of f/5.6 as indicated in the illustration? No.

That's because the light transmission is determined by the ratio of the diameter of the lens opening to the *focal length* of the lens. The f/ number indicates what fraction the lens diameter is in regard to its focal length. Technically, focal length is the distance from optical center of a lens to the point beyond the lens where the light rays from an object at infinity are brought into focus.

For example, a lens set at f/8 has a diameter ⅛ its focal length. And a lens set at f/4 has a diameter ¼ its focal length. Since the diameter of an f/4 lens is twice that of an f/8 lens (with the same focal length), its area is four times as great. That means a lens set at f/4 allows *four* times as much light to pass through than when it is set at f/8. So if you only want to *double* the amount of light passing through at f/8, f/5.6 would be the correct setting.

Confused? Don't worry about it; better mathematicians than we have worked out the f/stop number scale. Just accept it as fact. And remember that moving the f/stop to the next closest number either doubles or halves the amount of light passing through the lens, depending on which direction you move the f/stop.

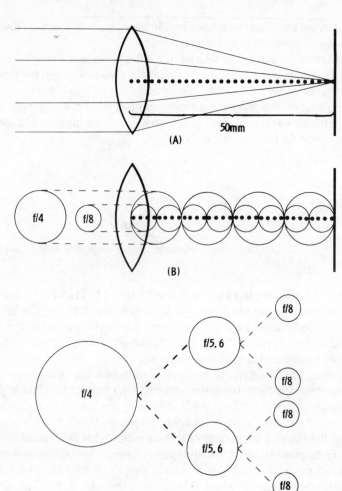

31. *It's worthwhile to understand the relationships between focal lengths and f/ stops. (A) The focal length of any lens is determined by measuring the distance from the optical center of the lens to the point behind it where light rays from an object at infinity are brought into focus (as on the camera's film plane). The example shows a 50mm lens. (B) Regarding f/numbers, they indicate what fraction of the focal length the lens diameter is. As illustrated, the diameter of an f/4 lens opening is one-fourth the focal length of the lens, while the diameter of an f/8 lens opening is one-eighth the focal length. Thus the diameter of a lens set at f/4 is twice that of an f/8 lens opening. (C) Because the diameter of an f/4 lens is twice that of an f/8, the area of an f/4 lens opening is four times as great as the area of an f/8 opening. Therefore a lens set at f/4 admits four times as much light as a lens set at f/8. The area of an f/4 lens opening is twice as great as an f/5.6 opening, and thus doubles the amount of light admitted. Similarly, the area of an f/5.6 lens opening is twice as great as an f/8 opening, and admits double the amount of light.*

Going toward a wider opening (a smaller f/number) is called "opening up" your lens, or "going to a wider stop." Selecting a smaller opening (a larger f/number) is called "stopping down" your lens or "going to a smaller stop."

A *full stop* means any one of the major stops listed previously. A *half-stop* means the midpoint between any two major stops. Actually, the f/stop can be set *anywhere* on the scale; it does not have to be set exactly on or between the marked f/numbers, even though some lenses "click" when the aperture is moved to a full or half-stop position. Since it can be varied by any amount, think of adjusting the lens opening (f/stop) as using a car's accelerator. Shutter speeds, on the other hand, would be similar to a car's gear shift—they should be set at marked positions to assure accurate speeds and to avoid mechanical damage. (Electronically controlled shutters do not have such restrictions; read your camera instruction manual for specific advice and/or warnings about setting shutter speeds.)

Why should you care about f/stops? As I mentioned, they are interrelated with shutter speeds and help determine the proper exposure for your film. And, very important, they determine *depth of field*—how much of your picture will be in focus.

A lens that is capable of a very wide f/stop, such as f/1.4, is considered a *fast* lens, because it allows exposures to be made in low light at faster shutter speeds than a lens that has a smaller maximum opening, such as f/2.8.

It would take four times as much light to make a proper exposure with an f/2.8 lens as with an f/1.4 lens. So to compensate, if f/2.8 is the maximum f/stop and you cannot open up the lens any more than that, you'll have to slow down the shutter speed to increase the light by four times. If the picture to be made was properly exposed at shutter and lens settings of 1/60 second at f/1.4, then at f/2.8 the shutter would have to be set 1/15 second. (Since 1/30 second lets in twice as much light as 1/60 second and 1/15 lets in twice as much light as 1/30 second, then you let in four times as much light slowing the shutter from 1/60 to 1/15.)

Knowing the interrelationship of the lens opening and shutter speed is very practical and necessary. For instance, if you get a manual exposure meter reading for a proper exposure of 1/125 second at f/5.6, you can easily adjust your f/stops and shutter speeds without additional meter readings. Using the matching scale on the following page, you can see how various combinations of shutter speeds and f/stops will produce the identical exposure.

Among the reasons for changing shutter speeds is to show motion in your photographs. This can be done by blurring the action with a slow shutter speed or stopping the action with a fast shutter speed. Also, in poor light situations you may need a slow shutter speed to allow enough time for an image to be recorded on the film. And if sharp focus is required, a small f/stop opening should be used, and that often means a slower shutter speed is required.

With *shutter-priority automatic cameras,* the photographer chooses a shut-

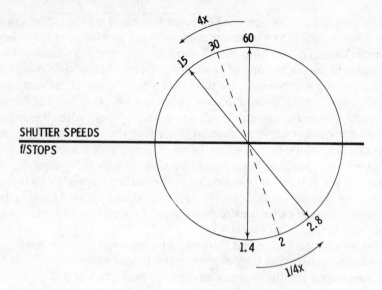

32. Study the light-admitting relationships of 1/60 second at f/1.4 and 1/15 second at f/2.8. Both give the same exposure, as does 1/30 second at f/2.

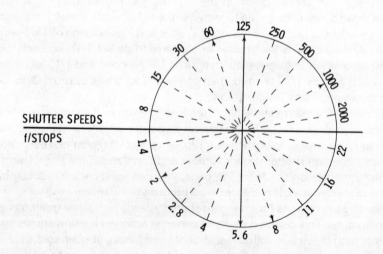

33. As the illustration shows, various shutter speed and f/stop combinations give the same exposure as 1/125 second at f/5.6. For example, 1/60 second at f/8 and 1/1000 second at f/2 admit the same amount of light as 1/125 second at f/5.6.

ter speed and the camera's exposure metering system automatically sets the f/stop. With *aperture-priority automatic cameras,* however, the procedure is reversed; the photographer selects an f/stop and the electronically controlled shutter automatically adjusts to provide the exposure indicated by the camera's built-in exposure meter. There also are *multimode automatic cameras,* which allow you to select either aperture-priority or shutter-priority exposure control.

Most 35mm compact cameras and a number of the newer 35mm SLR cameras feature a *programmed automatic mode* which automatically determines and sets *both* the shutter speed and f/stop for a proper exposure. The shutter speed/aperture combinations are programmed by computer chips, allowing you to literally "point and shoot" the camera without any concern for exposure settings. (When using the program mode on an SLR camera, you also must preset the aperture of the lens to its smallest f/stop opening.) Programmed auto-exposure allows you to react instantly to photo situations that suddenly occur, although you still must focus the lens (unless the camera also features autofocus).

Figuring Focus

What does knowledge of shutter speeds and f/stops have to do with focus or sharpness of detail in your photographs? Plenty. Linked with another important aspect of making effective pictures, focus, depth of field is one of the most misunderstood and infrequently used aspects of photography.

To really have full control over your camera and equipment, and to enhance your ability to become a photographer who knows what he is doing, understanding depth of field is a necessity.

First, focus. Unless done for a specific purpose, out-of-focus photographs are disturbing if not altogether worthless. Focusing is not the problem some people think it is. But in general, the closer you are to a subject, the more critical focusing becomes. Focusing objects some distance away is not such a serious task.

Sometimes a fuzzy photo may be a result of camera movement rather than bad focusing, but proper focusing often is neglected. The basic rule: focus on the most important part of the picture. In portraits, for instance, focus should be on the eyes of the subject.

With a single lens reflex camera you will see the scene directly through the viewfinder and should turn the focusing ring of your lens until the main subject appears sharp to your eye (see Illustration 10). This is more difficult in dim light. However, most modern SLR cameras offer a bright *focusing screen* within the viewfinder, and an *automatic aperture* which keeps the lens open

to its widest f/stop for easiest focusing. If your lens aperture is not automatic, open it manually to the widest f/stop for best focusing. Then stop down to the correct f/stop for proper exposure.

Rangefinder cameras are generally easier and quicker to focus. A *split image,* or double image, is seen within the viewfinder and the focusing ring on the lens is turned until the twin images come together (see Illustration 10). Rangefinders often are best for sports and other action situations where focus must be changed quickly as the center of interest moves. And focusing in low-light situations is not so much a problem with a rangefinder. Some SLR focusing screens also incorporate a split-image feature similar to that found in rangefinder cameras.

Autofocus is an increasingly popular feature that first appeared on a small Konica rangefinder camera and some of Polaroid's instant camera models in 1978. Polaroid uses an inaudible high-frequency sound echoing device, but many other autofocus cameras, particularly the 35mm compact models, utilize invisible infrared light beams to sense the subject's distance from the camera and activate a motor to focus the camera lens. With most compact 35mm models, you depress the shutter release button halfway to turn on the autofocus mechanism, which brings your subject into focus in a matter of milliseconds. When you fully depress the shutter release, the film is exposed.

Because most autofocus cameras focus on the subject that's in the center of the viewfinder, the best models have an *autofocus lock* to hold the prefocused distance. That permits you to recompose the picture in the viewfinder with the subject off-center but still in focus.

Autofocus cameras are not foolproof. The popular 35mm compact models send an infrared beam out to the subject and receive its reflection back through two windows at the front of the camera, and if you inadvertently cover up a window with your hand or other object, the autofocusing goes awry. Even when operating properly, they also are incapable of focusing at distances of less than 3 feet or sometimes even 4 feet. Other drawbacks of which the photographer should be aware are the camera's general inability to focus sharply when aiming toward dull black or highly reflective surfaces or through a glass window. Look in the compact camera's instruction booklet for warnings about autofocus limitations and ways to overcome them.

Autofocusing is a special challenge to manufacturers of 35mm SLR cameras because these cameras don't have permanently affixed lenses like the 35mm compact models. You can change the lenses on SLRs to wide-angle, telephoto, zoom, and other types. Among the first to move toward SLR autofocusing were Pentax and Canon with the introduction in the early 1980s of two models with *in-focus indicators* in the viewfinder. As the photographer manually turns any lens, a system of optical sensors and computer-chip circuitry in the camera turns on a green light-emitting diode (LED) to indicate when the lens is in sharp focus. Red LED arrows point the direction in which to turn the *lens focusing ring* until it triggers the green in-focus indicator.

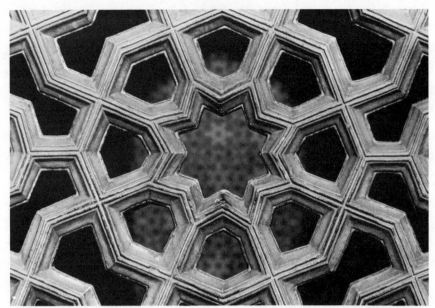

34. *A simple adjustment in focus can make a great change in a photograph. The grillwork in the windows of a temple in India was shot in two ways. Here the camera was focused on the closest window in order to show the grill's detail.*

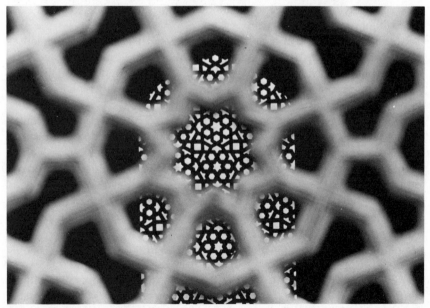

35. *In this case, the camera was focused on the window on the opposite side in order to show patterns in the grillwork. Such selective focusing is an example of the many ways to use a camera creatively.*

The next advancement in SLR autofocusing was the appearance of auto-focus lenses specifically designed by camera manufacturers to be used with their particular camera bodies that had autofocus capability. Powered by extra batteries in the lens housing or enlarged camera viewfinder, the autofocus lens turns forward or backward until a system of optical sensors detects that the subject in the center of the viewfinder is in sharp focus. Then came a big step toward popularizing SLR autofocus, the production in 1984 of the first self-contained autofocus lens that can be mounted on most of the popular SLR cameras. In Chapter 3 you'll read more details about the abilities of SLR autofocus lenses, as well as their limitations.

For all lenses that you can focus manually, whether looking directly through the lens or matching twin rangefinder images, the lens focusing ring has a scale of distances engraved on its surface to indicate your point of focus. If necessary, you can guess or measure the distance to your subject and set the result on that scale, which usually is marked in both feet and meters.

Most cameras give both scales, and eventually the metric system may replace our methods of measurement. Meanwhile, since we are accustomed to the foot scale, use it. And to avoid being confused by the adjoining meter scale, cover it with tape or temporarily hide it with nail polish or ink from a felt-tipped pen.

On the *focusing distance scale,* you'll notice that the greater the distance from the camera, the fewer footage designations given. The point or distance at which everything beyond will be in focus, *infinity,* is indicated by an elongated eight on its side, ∞, or INF.

Some inexpensive cameras have *fixed focus.* Their nonadjustable lenses are set to keep everything in focus from a minimum distance of three, four, or five feet to infinity. As long as the photographer is no closer than the minimum distance indicated by the camera's instructions, everything in his viewfinder will be in focus.

Other inexpensive cameras feature *zone focus.* Three symbols are marked on the lens focusing ring instead of exact distances. The photographer sets the ring according to whether his subjects are very close, nearby, or at a distance. The first symbol would be for portraits, the second for group shots, and the third for scenics. Often the symbols are an outline of a single head (portraits), heads and shoulders of three persons (groups), and a mountain outline (scenics). Another type of zone focusing is discussed in the following section dealing with depth of field.

In regard to close-up focusing, your camera's *film plane indicator* should be noted. Not all cameras have one. Usually it is a symbol like this ⊖, engraved on the top side of the camera. It indicates the location, or plane, of the film within your camera. When making close-ups, especially with accessory lenses or equipment like bellows, sometimes it is necessary to know the exact distance the subject or the front camera lens is from the film plane. This symbol helps you make an accurate measurement.

Focusing for infrared photography also should be mentioned. Infrared film is available for 35mm cameras. Technically it records not only light energy but infrared radiation. Therefore the point of focus for subjects recorded by black-and-white infrared film is slightly different from the focus point with regular films. To compensate for this, some camera lenses are marked with an *infrared focus indicator,* a red R or small red line to indicate where to set the focusing ring scale for the distance of your subject. Focus as you would normally, then reset the distance to the red R or line. Generally this change is so slight that normal lenses set at the regular focus point will also make sharp images on infrared film if stopped down to at least f/8. Disregard the infrared focus indicator when using *color* infrared films.

Finally, a common focusing problem—also related to the problem of framing subjects in the viewfinder—concerns photographers who wear glasses. It is imperative that you get your eye as close to the viewfinder as possible. Eyeglasses wearers are rightly concerned about scratching their eyeglass lenses. But rubber *eyeglass protectors* that clip to the viewfinder can be purchased for many makes of cameras. They also act as blinders to reduce distractions and light that enter your peripheral vision. Without such a protector, you can stick tape or glue felt around the viewfinder to protect your glasses.

Whatever method you choose, you must be able to see the full image within the viewfinder in order to focus and frame properly. Put the camera back flat against one cheek and don't let your nose get in the way.

Dealing with Depth of Field

Aside from basic focusing, the concept of depth of field plays a very big role in the outcome of your pictures. You can assume that the point on which you've focused will turn out sharp in the resulting photograph, but how much more of the picture will also be in focus? The *depth of field scale,* which is part of all good camera lenses, will tell you. And it is quite accurate.

Some photographers trust only their eyes to tell them what will be sharply focused, and they like to use the *depth of field preview device* that is a part of some SLR cameras. Since many modern SLRs have automatic apertures that always open the lens to its widest f/stop for easy focusing and viewing, many manufacturers have included a special button, lever, or switch that will stop down the lens to any preselected f/ number.

Because a smaller f/stop opening increases depth of field (the picture area that will be in focus), photographers get an idea of how much of their subject area from foreground to background will be sharp. However, it is a guess at best. The smaller f/openings also mean a darker view in the finder and that it

is more difficult for the photographer to see his overall subject area. And the sharpness of a person's own vision varies too.

The only way to know exactly how much of your picture area will be in focus is by using the depth of field scale. The scale consists of nonmoving numbers which correspond to f/stops engraved on the lens barrel. The matched pairs of numbers are located on either side of the permanent focusing point. Because of space limitations, not all the corresponding f/stop numbers are always included. Some are represented by lines. Others you'll have to imagine being there. For instance, if f/5.6 is missing, you know it falls between f/8 and f/4.

36. Depth of field plays an important role in the impact of a picture. To make this young lion stand out from the background, a telephoto lens and wide lens opening were used in order to limit the depth of field.

Some camera lenses, like Nikon's, use a color-coded depth of field scale. Colored lines on the lens barrel correspond to colors of the f/stops on the aperture ring.

Locate your depth of field scale and study it. A duplicate should appear in your camera manual. Remember that the scales vary according to the lens. Some lenses, such as wide-angle, have better depth of field than others, and the scale is more spread out. For lenses with limited depth of field the scale will appear jammed together, as in the case with telephoto lenses. Regardless, the scale will tell you how much of your photograph will be in focus. (A

37. Great depth of field was required for this shot of a lock in the Panama Canal. In order to have both the ship and the control gate in focus, a wide-angle lens and small lens opening were used.

few lenses, including some zoom lenses, do not have depth of field scales engraved on their lens barrels.)

After focusing on your center of interest and setting your f/stop and shutter settings according to your exposure meter reading, check your depth of field scale. First note the f/stop you've selected for proper exposure, and find the corresponding *pair* of numbers on the depth of field scale. Then look opposite those numbers to the distance scale on the focusing ring. The footage markings which appear indicate the range or depth of focus.

38. By using the lens' depth of field scale, the photographer can determine how much of his picture will be in focus from foreground to background.

For instance, in the diagram of the 50mm lens on the opposite page, with the focus at 15 feet and the f/stop set at f/8, reading opposite the two 8s on the depth of field scale indicates the area from 10 to 30 feet will be in focus.

Change the point of focus and the *zone of sharpness* also will change. Similarly, change the f/stop and the depth of field will increase or decrease. Using the diagram in Illustration 39 and stopping down to f/16, everything from 8 feet to infinity will be in focus. Opening the lens to its widest f/stop, f/2, reduces the in-focus area to subjects at 15 feet. At f/4 the zone of sharpness increases and includes everything from 13 to 20 feet. Thus the smaller the

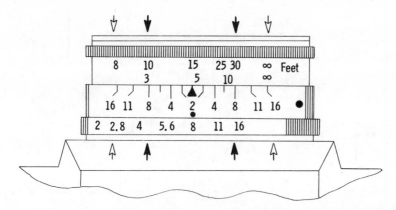

39. Figure the depth of field on this 50mm lens. With the lens focused at 15 feet and its opening at f/8, the subject area from 10 to 30 feet away will be in focus (see black arrows). If the f/stop is reduced to f/16, depth of field increases and subjects from 8 feet to infinity (∞) will be sharply focused (see white arrows).

f/stop the greater the depth of field. And conversely, the wider your f/stop the less depth of field you'll get.

Some photographers favor a system of *zone focusing*. They use their lens depth of field scale to see how much of the subject area will be sharp when the focusing ring is set at a certain distance and a certain f/stop. They memorize these distances and f/stops to use for subjects in three general zones: distant, nearby, and very close. When the cameraman is a good judge of distance, zone focusing can be fast and accurate.

To utilize a zone focusing system, find and memorize three (or more) points of focus that will keep your subjects sharp according to the zone they are in. These focus points will depend on the focal length and f/stop of the lens being used.

For instance, say you often use a 50mm lens and make exposures at f/8. According to the depth of field scale, a lens of 50mm focal length with an opening of f/8 will sharply focus a close subject area 5 to 7½ feet away when the focusing ring is set at 6 feet. Moving the focusing ring to 10 feet will put nearby subjects 8 through 15 feet from the camera in focus. Setting the focusing ring at 30 feet focuses a distant subject area from 15 feet to infinity. Thus you can establish three points of focus on a lens, 6, 10, and 30 feet, for just three zones of focus that will cover subjects at a variety of distances.

It is logical that lenses of the same focal length and the same f/stop should have depth of field scales indicating the same distances. However, these distances will vary slightly from lens to lens because of other characteristics of the specific lens and the manner in which the manufacturer marked the depth

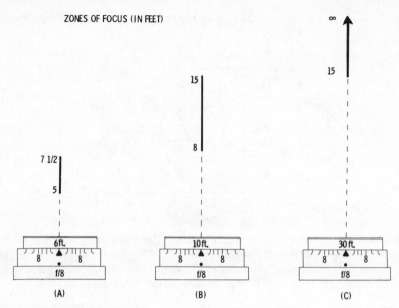

40. *For fast and accurate focusing, three zones of focus—for subjects very close, nearby, or distant—can be predetermined according to the focal length of the lens and the f/stop used. The example shows a 50mm lens at f/8. (A) For very close subjects, setting the focusing ring at 6 feet will put subjects from 5 to 7½ feet away in focus. (B) For nearby subjects, setting the focusing ring at 10 feet will put subjects in focus from 8 to 15 feet away. (C) And for distant subjects, setting the focusing ring at 30 feet will sharply focus subjects from 15 feet to infinity.*

of field scale and focusing ring. Learn the exact zones and points of focus for your specific lens. Of course, changing the f/stop or changing to a lens of a different focal length would alter the zones and points of focus. Zone focusing is a quick way to accurately set the lens focusing ring without visually focusing through the camera's viewfinder.

Even if they don't regularly use the zone system of focusing, many photographers like to know the *hyperfocal distance* of their lens in order to make a fast focus setting when necessary. Hyperfocal distance is the point of focus at which subjects from half that distance to infinity are in focus. It varies according to focal length of a lens and the f/stop used. Hyperfocal distance informs the photographer how close he can get to a subject to keep it and everything beyond it in focus.

Hyperfocal distance can easily be determined by setting the f/stop desired, and then turning the lens focusing scale until its infinity mark is opposite that f/stop number on the depth of field scale. The hyperfocal distance is now opposite the point of focus indicator. The distance on the focusing ring op-

41. In order to be ready for sudden action shots at a cattle roundup, the photographer had his camera prefocused and the exposure preset. Such preparation paid off when he quickly caught this cowboy twirling a lasso.

posite the other identical f/stop number on the depth of field scale will indicate the closest point to the camera that will be in focus. It will be half the hyperfocal distance.

For example, with a 50mm focal length lens and its opening at f/8, turn the focusing ring until the infinity mark is opposite 8 on the depth of field scale. The distance opposite the point of focus indicator on the lens is 30 feet. This is the hyperfocal distance of that lens at f/8. Looking opposite the other 8 on the depth of field scale shows that 15 feet is the closest point to the camera that will be in focus. Correctly, it is half the hyperfocal distance of 30 feet.

Knowing the hyperfocal distance of a lens at often-used f/stops is worthwhile. For instance, if a shooting situation does not give the photographer enough time to focus through the viewfinder, he can set his f/stop and the appropriate hyperfocal distance and know how much of his subject area will be in focus. With the example above, he could quickly set the lens opening to f/8 and the focusing ring to 30 feet, and he would know that everything in his picture from 15 feet to infinity would be in focus.

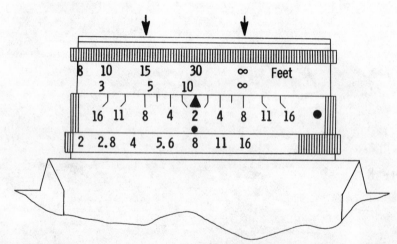

42. *Hyperfocal distance is the point of focus at which subjects from half that distance to infinity are in focus. In this illustration, with a 50mm lens set at f/8, the hyperfocal distance is 30 feet.*

The depth of field scale is not just a way to check how much of your picture will be in focus. You can use it creatively. For instance, if it is necessary to have only a specific area in focus, focus first on the *closest* object you want to be sharp and note that distance on the focusing scale. Then refocus on the

FOCUS/FEET
DEPTH OF FIELD SCALE
f/STOP

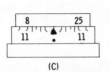

(A)

(B)

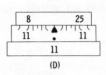

(C)

(D)

43. In order to be sure that only a specific subject area will be in focus, put depth of field to use. (A) First focus on the nearest object (8 feet) wanted in focus. (B) Then focus on the most distant object (25 feet) wanted in focus. (C) Next turn the lens focusing ring until those two distances (8 and 25 feet) fall within a matched set of numbers on the depth of field scale (11). (D) And set the f/stop to the corres-ponding number (f/11). Make an exposure reading to determine the correct shut-ter speed to use with the f/stop required.

most *distant* object you want in focus and note that footage on the fo-cusing scale.

Now turn the focusing ring until the two distances you noted fall within a *matched* set of numbers on the depth of field scale. Set your lens opening to the f/stop number corresponding to the selected pair of numbers on the depth of field scale.

Finally, with an exposure meter, determine the correct shutter speed for the f/stop you're using. Frame and shoot. You've got the picture you wanted with the focus you needed.

Remember, of course, not to refocus through the viewfinder after you've set the focusing ring to accommodate the two limits of focus within the depth of field scale. All the subjects in your viewfinder may not *look* sharp, but the area indicated on the depth of field scale by the f/stop you've selected *will* be in focus.

Sometimes, regardless of how much you stop down (to f/16, for example), the area from foreground to background may be too vast to get completely in focus. To overcome this, move back from the nearest foreground subject you require in focus, or change to a lens with greater depth of field.

Here's another creative use of depth of field. That is, to isolate and there-fore emphasize your center of interest by having it in focus alone. Just deter-mine the depth of the area you need in focus and set your focusing ring and f/stop (and shutter speed for proper exposure) accordingly.

Likewise, to separate a subject from an unwanted background, focus only on it and open your lens to its widest f/stop. Don't forget to adjust for the correct shutter speed with that f/stop.

Always remember that under the same lighting conditions, after setting a proper exposure as determined by your meter, whenever you change the f/stop you must change the shutter speed, and vice versa. Change one and you must change the other. Of course, cameras with auto-exposure will automatically compensate and readjust for a proper exposure when either the shutter speed or f/stop is changed.

2

DETERMINING
EXPOSURE

I've continually mentioned the need to use an exposure meter (whether built into the camera or a hand-held model) to obtain the proper exposure for your picture. There are exceptions, however. While an exposure meter is one of your most valuable tools for making effective photographs, exposure can be determined in other ways.

Most commonly, the *instruction information* packed with every roll of film gives you exposure guidelines for different light situations: bright or hazy sun with distinct shadows, cloudy and bright but no shadows, heavy overcast, and shade. You'll find the information printed directly on the inside of the film box, as with most Kodak films, or on a separate sheet. The suggested exposures given with these film instructions are always for *average* subjects which are not too light or too dark.

Color slide film has less leeway, called *latitude,* for exposure mistakes than black-and-white film or color negative film. And with black-and-white or color negative films, if the resulting negative is very contrasty or without much contrast, correction to obtain a print of average or near-normal contrast can be done in the darkroom during the printing or enlarging process.

Another method of determining exposure is by an experienced guess. If you consistently shoot the same type of subject in the same type of light on the same type of film, your exposure settings should be much the same too. But don't trust your luck to just one shot.

Some photographers, caught without a meter or the film instruction info, take an experienced guess and then shoot at various exposures. This is called *bracketing* your exposure. To bracket, you make two or more exposures that are over and under the exposure you think is correct.

For instance, if 1/125 second at f/8 is your estimate of the correct exposure, you also shoot frames at f/5.6 and f/11. This minimizes the chance of missing a picture because of improper exposure. Bracketing *two* stops each way is even better insurance. Then you would also make exposures at f/4 and f/16, as well as at f/8, f/5.6, and f/11.

Bracketing also can be done by varying shutter speeds. Thus you could

bracket an exposure of 1/125 second at f/8 by shooting two more frames at 1/60 and 1/250 second. To bracket with shutter speeds the equivalent of two f/stops each way, you would keep the lens opening at f/8 and make additional exposures at 1/30 and 1/500 second, as well as at 1/125, 1/60, and 1/250 second.

Bracketing at half-stops is sometimes advised, especially with color slide film since it has less latitude for exposure mistakes. As a rule, however, you should use only the lens aperture to achieve bracketing at half-stops; setting the shutter speed dial between marked shutter positions may cause mechanical damage to your shutter, unless it is electronically controlled. Check your camera manual for additional advice.

Even with the use of an exposure meter, bracketing is often done by professional photographers to ensure getting the correct exposure. It may seem

44. *When a photographer is uncertain of the correct exposure, it's wise to bracket a few exposures (see text). The girl was hiking along a trail in the Swiss Alps.*

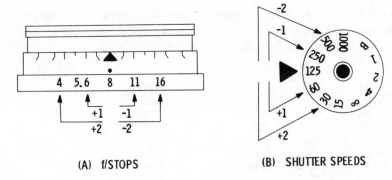

(A) f/STOPS (B) SHUTTER SPEEDS

45. Bracketing is a good way to avoid missing a picture because of poor expo-
sure. (A) To bracket with f/stops, shoot at the calculated exposure (f/8 in this ex-
ample), and then make exposures at one f/stop more (f/5.6) and at one f/stop less
(f/11). Keep the shutter speed constant. Bracketing by two f/stops or more also may
be wise. (B) To bracket with shutter speeds, shoot at the calculated exposure (1/
125 second in this example), and then make exposures at one shutter speed slower
(1/60 second, the equivalent of one f/stop more) and at one shutter speed faster
(1/250 second, the equivalent of one f/stop less). Keep the lens f/stop constant. Brack-
eting by additional shutter speed changes also may be wise.

expensive to make two or four more exposures of the same subject, but it may mean the difference between getting or missing a great picture.

What is the correct exposure? Quite simply, it is the f/stop and shutter speed combination that gives the photographer the result he wants. An exposure meter—which is much more accurate than the photographer's educated guess—is still only a tool. The final photographic result depends on how the photographer uses the meter and interprets the suggested exposure settings.

As I have already stated, setting the ISO/ASA (your film's speed) on the meter indicates to the meter how sensitive your film is to light, and the meter calibrates exposure settings accordingly. To put it another way, the exposure meter does not know the speed of the film in your camera, so you must tell the meter by setting the proper ISO/ASA.

Failure to adjust the meter for the correct ISO/ASA of your film will result in improper exposure calculations. Caution: Some exposure meter ISO/ASA dials easily slip or can be knocked off the correct setting. Tape the dial in position, if necessary.

The space available to list various ISO/ASA numbers on exposure meters is sometimes limited, especially with the ISO/ASA dials used on cameras with built-in meters. Often just a few ISO/ASA numbers are listed, with dots or lines to indicate the rest. In order to set your meter correctly, check the full range of ISO/ASA settings given on the following page. Those numbers in boldface

type are the ones most often printed on meter ISO/ASA scales, while the itali-
cized figures represent those usually indicated only by dots or lines.

8	64	500	4000
10	80	640	5000
12	100	800	6400
16	125	1000	
20	160	1250	
25	200	1600	
32	250	2000	
40	320	2500	
50	400	3200	

Before shooting, always check to be sure the ISO/ASA speed on your me-
ter is correct for the film in your camera. Remembering to change the meter
to the proper ISO/ASA is especially important when you change from one
type of film to another with a different speed. Forgetting to change the ISO/
ASA is a common mistake of many photographers.

Exposure Meter Facts

Exposure meters are generally of three types: 1) meters that are separate
from the camera, called *hand-held* meters; 2) meters that are *built into* the
camera and indicate the correct exposure when the photographer manually
turns the f/stop and shutter speed controls; and 3) *automatic* or *electric eye
(EE)* meters in the camera that electronically set the shutter speed or f/stop,
or both. In all cases, the meters must read and react to the light present.

The earlier types of light meters were limited to hand-held types. They had
a long-lasting light-sensitive *selenium cell* that required no batteries. Light
striking the cell would cause a current that moved the meter's needle to indi-
cate exposure possibilities on an adjustable scale. These selenium cells were
also used in the first electric eye automatic cameras in 1938 by Kodak and
later in 1956 by Agfa. Hand-held selenium cell exposure meters are still man-
ufactured but are considered by many photographers to be obsolete.

That's because progress in electronics and chemistry yielded a battery-
operated *cadmium sulfide (CdS) cell,* and it was incorporated in cameras
as part of built-in exposure meters. In fact, CdS-type meters built in the camera
were the most common light-reading devices until newer exposure-reading
cells, like the *silicon photo diode (SPD)* and *gallium photo diode (GPD),*
began to replace them in 1978. The SPD, GPD, and CdS cells have been
further utilized to control shutter speeds and f/stops, and thus they have be-
come key elements in cameras with automatic exposure control.

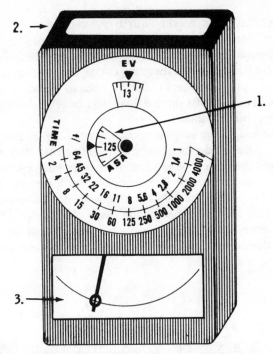

46. *To make correct light readings with a hand-held exposure meter, the film's speed must first be set on the meter's ISO/ASA dial (1). The meter, if it is a reflected-light type, must be pointed so its light-sensitive cell (2) is aimed at the subject area to be read. (With an incident-light type, the meter is aimed from the subject area toward the camera's position.) Finally, the meter's pointers (3) are lined up, indicating the shutter speed (time) and f/stop combinations that can be used for a correct exposure. One advantage of hand-held meters over built-in camera meters is that the photographer can easily see such exposure combinations, and quickly choose the one best for his purposes. Some meters indicate the proper exposures with digital readouts using liquid crystal display (LCD) or light-emitting diodes (LEDs).*

One or two small silver oxide or mercury batteries or a larger lithium battery, ranging from 1.5 to 6 volts, powers the exposure metering cells. Some cameras that have other automatic features, such as autowind and autoflash, use larger alkaline or nickel-cadmium (ni-cad) batteries that also operate their exposure metering cells. The battery life in such models usually depends on the number of rolls of film run through the camera and the number of times the flash goes off. Most cameras have a method for checking the batteries so

you can see if they are strong enough to give accurate readings and/or oper-
ate automatic exposure controls. The mercury batteries for exposure read-
ings are supposed to last at least one year. In cameras where there is an
automatic on-off switch in the metering circuit, the batteries often last longer.
However, many photographers make it a habit to replace these relatively in-
expensive batteries at least once a year. The battery's location will be indi-
cated in your camera manual.

Battery manufacturers are still at work to produce an even longer-lasting
cell to power metering devices. Some batteries also are affected by cold tem-
peratures, and that is a problem battery makers have been trying to over-
come. Of greater priority, the batteries designed for meters have to assure
immediate failure when the cells become worn out. Otherwise, like a flash-
light whose beam fades as the batteries wear out, exposure readings would
vary as the battery lost its power. This would prove disastrous to all photogra-
phers who depend on their built-in meters for proper exposure readings or
automatic exposure control.

47. *Regardless of the type of light-sensitive cell it incorporates, an exposure meter
averages the light it receives, and suggests the f/stop and shutter speed to use for
making a proper exposure.*

If your meter or automatic exposure controls cease to operate, a worn-out battery usually is the problem. Most cameras have an on-off switch for the metering system, and if left on for an extended period, battery drain can be excessive. This especially is a problem for models in which the batteries also power light-emitting diodes (LEDs) in the viewfinder to indicate exposure settings. Cameras with automatic exposure control can cause considerable battery drain, too. Smart photographers carry spare batteries, especially if they have important pictures to make and don't want to chance sudden meter failure or inoperation of automatic exposure controls. The batteries are available in nearly every camera store, even overseas.

If your meter fails, and the battery is still fresh, check the metal contacts. A thin chemical film often develops on the battery's surfaces and breaks the electrical circuit. You may not see evidence of battery leakage or corrosion, but the whitish chemical coating which develops on the battery is enough to cause your meter to operate erratically or not at all.

Wipe the battery and contacts with a clean handkerchief, not your fingers. Replace it properly according to polarity markings (+ and −) and then check the meter. If it still doesn't work, a faulty switch or a break in the internal electrical circuit is probably the trouble. You'll need a camera repair service. Never disassemble a meter yourself unless you never want to use it again.

One thing to remember about battery-operated CdS cells is that they can suffer temporary fatigue under certain exposure conditions. The most common mistake is pointing the meter directly at the sun for an extended period of time; the bright light overwhelms the cell's circuitry and can result in faulty meter readings for minutes to hours afterward. It will recover, however.

Here's how to check your CdS meter if you are going to make a reading directly toward the sun. First take a reading of a nearby subject in the normal manner. Remember the exposure setting. After taking your reading of the sun, and your pictures, take another reading of the same subject read earlier. If the meter results are the same, and lighting conditions have not changed, your meter is okay. If it gives a different reading from the first time, the sun has affected your meter. Give it a few minutes to recover, then check it again.

A CdS meter also may take a few seconds to adjust if you read a bright scene and then take a reading in the shade. Ultraviolet "black" light, such as the kind used for stage effects, will affect the CdS meter, too. Once affected by such light, recovery time may be a day or longer.

The problem of CdS cell fatigue and less than instantaneous reaction to changes in light has prompted many manufacturers of cameras with automatic exposure control to use the newer photo diodes for measuring the light that passes through the lens. These silicon and gallium diodes provide faster and more accurate response to light, and they are considerably more sensitive than CdS cells when light levels are low. Since a trend with 35mm cameras is toward the use of autowind or motor drive mechanisms that automatically cock the shutter and advance the film, and thus allow the photo-

grapher to expose from one to five frames per second, instant response of the meter to changes in light is necessary for correct automatic exposures.

Photo diodes vary slightly in their characteristics, and camera manufacturers favor different types. Since silicon photo diodes are sensitive to infrared rays, they are fitted with a filter to prevent the infrared from causing improper exposures. *Silicon blue diodes* incorporate this filtration and are said to give more accurate readings in all kinds of light. Another type, *silicum,* is said to give an even more reliable response to the different colors in the spectrum. Users of gallium photo diodes, sometimes described as gallium arsenide phosphide photo diodes, claim that the GPDs are completely insensitive to infrared rays, and that they are more accurate in low light levels and are less affected by hot or cold temperature extremes than the silicon cells. From a practical standpoint, the minute differences in diodes will not be evident in the exposure readings they give, but remember that the gallium and silicon diodes have significant advantages over CdS cells because they react more quickly to changes in light and are more sensitive in low levels of light. If you have a newer-model 35mm camera, chances are it features GPDs or SPDs.

Since selenium meters require no batteries, some photographers feel more assured using this type of hand-held meter to make exposure readings. A

48. *This unusual sculpture is silhouetted against a bright sky. If an exposure meter that uses a cadmium sulfide (CdS) cell is pointed at a bright light source, like the sun, it may suffer "fatigue" and give inaccurate readings for a short time afterward (see text).*

booster, an additional light-sensitive screen, usually can be attached when the light level is low. Other selenium meters have built-in high and low adjustments to set for bright or dim lighting conditions. However, GPD, SPD, and even CdS meters are better than selenium cell meters for making accurate readings in low light situations.

Most hand-held meters can be readjusted if the needle which indicates the light reading gets out of register. A screw is turned until the needle remains on the zero position when no light is reaching the cell. When making this *zero adjustment,* cover the cell opening completely. With battery-operated meters, remove the battery. If you are careful not to drop or abuse the hand-held meter, such realignment is rarely necessary. Keep any meter on a strap around your neck. But don't let the meter bang against your body or camera equipment. And keep the meter's case on when it is not being used. Zero correction is not possible with built-in meters, except by a repairman. Some hand-held meters indicate exposure with digital readouts using liquid-crystal display (LCD) or LEDs instead of a needle indicator, and most can be recalibrated by the photographer for accurate light readings without going to a repairman.

Regardless of the type, exposure meters have proven to be the most popular and accurate devices for determining exposure. The major limitation of any meter is really the person operating it. If you don't know how to make meter readings under a variety of lighting conditions, any poor results are your fault. The meter should not be blamed, although it frequently is.

Center-weighted Versus Averaging Versus Spot Meters

The first step to accurate light reading is to know the type of exposure meter you are using. Whether a separate hand-held type or built into your camera, the meter is usually one of three kinds: a *center-weighted meter,* which reads an overall area but is more sensitive to the middle of that area; an *averaging meter,* which reads the light intensity for an overall area; or a *spot meter,* which gives the light value for a limited area. Some center-weighted or averaging meters also can be switched to spot metering.

Remember that proper exposure is the correct combination of shutter speed and f/stop. Those two judgments determine the amount of light that reaches the film. With manually operated meters, generally the photographer selects the shutter speed and then turns the aperture of his lens until a pointer in his viewfinder aligns with another needle or is centered between two brackets to indicate that the correct exposure has been set. On some models a light-

49. *A spot meter was pointed directly at the duck in order to get an exposure meter reading that would give detail to the duck and not be influenced by the dark background.*

emitting diode (LED) or liquid-crystal display (LCD) will signal when the exposure is correct.

If an exposure meter's pointer is not located within the viewfinder, as with exterior-mounted camera meters, the photographer checks the needle's position on the meter's scale and then sets the exposure. Good hand-held meters feature an *exposure lock* to hold the light-reading indicator (needle, LED, or LCD) for the photographer's reference until another light reading is made.

There is no reason the photographer has to set his shutter speed first and f/stop second, although most do out of habit. A desired f/stop can be selected first, and it should be if depth of field is a concern. Then the shutter speed dial is rotated until the meter needle, LED, or LCD indicates a correct exposure. However, if stopping or blurring the action is important to your picture, selecting the shutter speed first would be best. Of course, a camera with auto-

matic exposure control may feature aperture-priority (you set the f/stop first, the camera adjusts the shutter speed) or shutter-priority (you choose the shutter speed, the camera sets the f/stop) or a choice of either type if the camera is a multimode model.

For manual exposure control, turning shutter speed and aperture controls to correctly align the exposure indicator on a camera's built-in meter is not really a problem. Nor is it difficult to read the exposure scale of a hand-held meter. Then what is the most common error concerning exposure meters, whether hand-held or built-in and manual or automatic? When the photographer fails to *aim* his meter properly, poor meter readings occur. And poor photographs are the result. First the cameraman must know his meter's *angle of acceptance*. That is the degree or amount of the subject his meter is reading. This angle is measured in degrees (°) and should be indicated in the operating instructions issued by the meter's manufacturer. Some hand-held meters can be adjusted to vary the angle of acceptance.

Through-the-lens center-weighted meters and averaging meters take in the full field of view seen by the photographer in his viewfinder. These meters have their photocells inside the camera and read only the light admitted by the lens. They generally compensate for the specific lens being used, whereas camera meters with an exterior-mounted photocell cannot.

While a through-the-lens averaging meter usually gives a reading for everything the lens take in, a center-weighted meter places primary importance on the portion of the subject that appears in the central area of the viewfinder. Frequently a diagram in the camera's manual indicates the patterns and percentages of sensitivity in various areas of the viewfinder. A spot meter reads just a small portion of the subject that is seen through the lens. This limited angle of acceptance is usually marked on the camera's focusing screen to show the photographer the exact area of the subject being read by the exposure meter.

Which meter is best—center-weighted, averaging, or spot? Each has its advantages, and a few camera manufacturers have designed built-in meters that will read either the full scene or a portion of it, as the photographer desires. A switch is flipped to change center-weighted or averaging metering to spot metering. Center-weighted and averaging meters are the most common types built into today's cameras, with center-weighted meters especially preferred for models that feature automatic exposure control. A few multimode automatic cameras incorporate a choice of metering systems, usually center-weighted and spot.

Regardless of their type, all exposure meters read and average the light and dark areas of a scene or subject. Problems can arise, however. If too much of the less-important picture area is dark, the meter calls for a greater exposure than is actually needed. Likewise, a scene or subject that is bright in much of the picture area may give a meter reading that results in an underexposure.

When a scene or subject includes both very dark and very bright areas, the

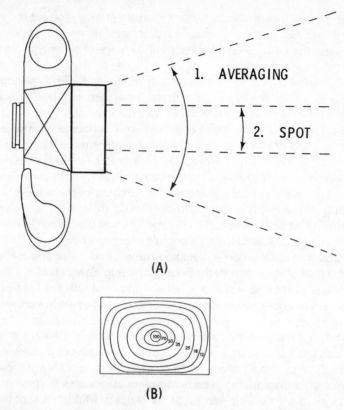

(A)

(B)

50. Different types of exposure meters read the subject area differently. (A) Through-the-lens exposure meters built into a camera may be an averaging type (1), which reads the entire subject area seen by the lens, or a spot type (2), which reads only a small portion of the subject area, usually indicated by a circle or rectangle in the viewfinder. Some cameras feature both types and include a switch for selecting either averaging or spot metering. (B) An increasing number of cameras, especially those with automatic exposure control, have center-weighted meters. These read the entire subject area covered by the lens, but they are more sensitive to the portion of the subject area which appears in the middle of the viewfinder. Some camera manuals have a diagram, like this one, to indicate the meter's percent of sensitivity in the various areas of its coverage.

photographer must decide on the portion of the picture he wants most. And he should base his exposure on the meter reading of that area. For instance, if you're photographing the Grand Canyon, your viewfinder may include a bright and uninteresting sky, so don't read the sky. If the canyon itself is the main subject, an exposure reading must be made for the canyon. Otherwise the

meter averages the dark of the canyon and the bright of the sky, and neither is emphasized. Exposing for the canyon will lighten the sky somewhat but give detail to the canyon, the most important part of your picture.

If, however, a vivid blue sky with fleecy white clouds hovering over the canyon becomes the center of interest for your picture, exposing for the sky and cloud area would be best. Because the canyon would turn out darker, the emphasis would switch appropriately to the sky and clouds.

When subjects in your picture are of *extreme* contrast (some very light and some very dark), generally it's best to aim your meter at the most important part of the picture to take an exposure reading. With a *less extreme* contrast range, separate readings of the dark and light areas can be made and then averaged to determine the exposure setting. Of course, when your subject

51. In order to expose for the terrain of Easter Island, the photographer aimed his exposure meter to the left to make a reading. If the exposure meter reading had included the statue, which is in shadow, the rest of the picture would have been overexposed.

52. *A common problem of unknowing photographers is inadvertently aiming an exposure meter, hand-held or built into the camera, at the sky when making a light reading. The bright sky indicates an exposure that will make subjects below the horizon too dark. Tilt the meter down from the sky to avoid readings which result in underexposures.*

area has little variation in contrast, an overall reading will do. *Learn to read the light with your eyes before reading it with your exposure meter.*

I must reemphasize: Be alert for extremes in contrast. For example, in making a portrait of a fair-skinned person in dark clothing against a dark background, reading the area seen in your viewfinder would indicate an exposure greater than required to get detail in the person's face, the picture's center of interest. Unless a meter reading is made for the face, the excessive dark clothing and background will give an exposure reading that overexposes and lightens the face too much. However, you may want to increase exposure somewhat, in order to add some detail to the dark clothes and background.

By the way, a very common reason for poor exposures is inadvertently pointing the meter, especially a hand-held type, toward the sky. The result is an underexposed picture. Aimed above the horizon, the meter thinks the scene is bright and indicates this. And the picture area you want, below the horizon, turns out too dark. That's your fault and not the fault of the meter.

Spot meters read a minimum portion of the overall scene. They give you an accurate exposure reading of a particular spot. This can be helpful. For instance, in making a portrait of a person in dark clothing against a dark background, the spot meter can be pointed solely at the face for a light measurement. The excessive dark areas surrounding the light face will not influence the exposure reading. Again, however, you may want to increase exposure somewhat, in order to add some detail to the dark clothes and background.

Alternatively, and often recommended in the owners' manuals for cameras with through-the-lens meters, you can include in one spot reading equal portions of a light area and a dark area. Use the exposure indicated.

Photographers with spot meters also will want to take readings that give the best overall exposure for a subject that includes both light and dark areas. A common way to do this is to make separate readings of the dark areas and light areas in the picture, then average the results and set your exposure.

A spot meter is especially useful when there is strong back lighting on a subject. Also, when a subject is too far away to approach for a close reading with a center-weighted or averaging meter, a spot meter will do the job. Without a spot meter, and if you're unable to get close enough to your subject for a reading, try reading an area nearby that is similar in lighting and contrast.

For instance, taking a reading off the palm of your hand is a good substitute for reading the face of a person of similar skin tone who is some distance away. This *hand reading* can be helpful for determining exposure, especially if you are making candid pictures of people with a telephoto lens. Make sure the angle and amount of light falling on your palm is the same as that falling on your subject.

4 TO 6 INCHES

53. *When a subject is too far away to make a close-up reading, the photographer's hand can be substituted if it is similar in tone or color to the subject. Be sure the meter or camera does not cause shadows on the hand that's being read by the meter.*

Regardless of the meter, you must know its limitations and abilities, and how to use it. Experience tells you the results you can expect with a certain meter. Nevertheless, bracketing can save the day if you are uncertain about the exposure of some subjects. This is especially true when using color slide film, because it has less latitude for underexposure or overexposure than does

54. A huge hat shades this Balinese farmer from the hot sun. The photographer
got very close and was careful that his meter reading did not include the bright
sky, or else the man would have been underexposed.

black-and-white film or color negative film. Try several exposures of the same
subject and compare your results to determine the best exposure for your
purposes.

So far the discussion of meters, hand-held and built-in, has referred to their
use as *reflected-light meters.* As such, the meters read the light reflected off
the subject. The other type, *incident-light meters,* read the light shining *on*
the subject. In this case, the meter is placed at the subject's position and pointed
at the camera. The exposure reading indicates how much light is reaching
the subject.

(A)

(B)

55. *Depending on the type of meter, exposure readings are made in different ways.*
(A) With a reflected-light exposure meter, the meter is kept at the camera position
and aimed toward the subject area to read the light reflected by the subject. Most
meters, hand-held or built into the camera, are of the reflected-light type. (B) With
an incident-light exposure meter, the meter is aimed toward the camera position
from the subject area and reads the light falling on the subject.

Many hand-held reflective-type meters are designed to be incident meters,
too. A piece of white translucent plastic snaps on or slides in front of the me-
ter's light-sensitive cell. When this is in position, the meter can be used to
make incident readings.

A reflective meter reading is, however, by far the most common method of
determining exposure. This is because with a reflected-light meter you can
read the various areas of contrast (lightness and darkness) in your picture
area and set your exposure accordingly. An incident meter, on the other hand,
measures only the strength of light falling on the subject. It doesn't tell you
how much of that light the colors of your subject are absorbing or reflecting.
Incident meters are most often used in studio and indoor situations where
the lighting can be controlled by the photographer. Also, some exposure me-
ters are specially designed to make readings for flash exposures. (Details are
given in Chapter 4.) Regardless of your meter type, study its instructions and
then make some practice exposures. This will save you much film and frus-
tration later.

Making Accurate Exposures

Be aware that an exposure meter always reports the *average* light intensity of the subjects included in its angle of acceptance. With black-and-white films, if that subject area includes equal areas of light and dark contrast, the resulting reading will render a picture with a full range of normal tones, from blacks to grays to whites. Appropriately, shadows will be dark and highlights will be bright.

However, if *detail* is wanted in the shadow area, an exposure reading of this dark area alone should be made. Since the meter always averages the light it reads, shadows will not be recorded dark or black (as with a reading of *both* dark and light areas) but a shade of gray, thus giving more detail to the shadowed area.

Similarly, if *detail* is desired in a highlight area, a meter reading should be made of this bright area alone. Again, since the meter always averages the light it reads, highlights will not be recorded white (as with a reading of *both* light and dark areas) but a shade of gray, thus giving more detail to the highlight area.

56. *In order to get some detail in the bright snow, a meter reading was made mostly of the snow instead of the bundled-up boy (see text).*

Normally, with subjects offering a full range of light contrasts, black-and-white film users prefer to expose more for the darker areas in order to get shadow detail on their film. Highlight areas, which will be recorded too bright, can be darkened to more natural tones during the development or enlarging processes.

Always remember: The photographer should not expect his exposure meter to know the results he wants. He must be able to use the meter skillfully and interpret its readings carefully in order to get the picture desired. For instance, a meter reading of snow will indicate an "average" exposure that gives *detail* to the snow. But if you want to represent snow as it more naturally appears, bright and without much detail, the exposure must be *increased* more than the meter reading. Likewise, a reading of a coal mine tunnel will give an "average" exposure that gives *detail* to the tunnel. However, if you want the tunnel to be represented in your photograph as it more naturally appears, dark and without much detail, the exposure must be *decreased* more than the meter reading.

For more exacting exposure guidance for black-and-white films, photographers can use the *Zone System* created by well-known photographer Ansel Adams. His exposure system requires thorough understanding and extensive practice, but it gives the photographer excellent exposure help, and confidence. Basically, Adams divided the range of subject brightness, or contrast, into ten zones, 0 through 9. Zones 0 and 1 represent black (no detail), while Zone 9 represents white (no detail). The other zones represent various shades of gray, with Zone 5 indicating middle gray, the average tone of a subject as always read by an exposure meter.

This tone (Zone 5—middle gray) can be darkened or lightened to any degree desired by the photographer. Since each change of zone is equivalent to one f/stop, the photographer decides the zone (tone) he wants and adjusts his lens opening (or shutter speed) accordingly. Always decrease exposure to change to a lower zone number (darker tone), and increase exposure to change to a higher zone number (lighter tone).

Obviously, to use this Zone System, the tonal value of each zone must be understood. For example, an exposure meter reading of a person's face will be equal to Zone 5 (middle gray tone), but average skin tones reproduce best as medium light gray, Zone 6. Thus the photographer would adjust his exposure reading by opening up one f/stop. Books are available on the Adams' Zone System of exposure, and one should be studied for a thorough understanding of its rules and applications.

Remember that black-and-white films have more exposure latitude, a greater ability to reproduce a wide range of subject brightness or contrast, than do color films. And negative color film (for prints) has a greater exposure latitude than color positive film (for slide transparencies). Depending on the kind of film you use, experience is the best guide as to what exposure meter type and light-reading techniques will give you the results you want. For instance, since

color slide film has such limited exposure latitude, many photographers find the results more pleasing if they expose for the brighter colors of a subject which has a very great contrast range. If they exposed for the darker colors, the brighter colors would be washed out, and thus be very distracting when projected.

57. *Black-and-white films and color negative films have more exposure latitude than color slide films. This pretty snorkeler was photographed with black-and-white film, and you'll notice that despite the strong side light, there is still some detail in the shadowed side of her face.*

Hand-held Versus Built-in Meters

While many photographers feel there is no substitute for a hand-held meter, most amateur photographers, and many professionals, rely solely on the exposure meters built in their cameras. Certainly there are advantages and disadvantages to both. The built-in camera meter is quick and less cumbersome since you don't have another piece of photo gear to carry. However, if

the photographer does much of his work using a tripod, a hand-held meter gives him the flexibility he needs to make exposure readings away from the camera position. Another plus for a hand-held meter is that the full range of exposure possibilities is offered to the photographer. After taking a light reading, he simply looks at the meter's calibrated scale and selects the f/stop and shutter speed combination that is best for his purposes (see Illustration 46, page 57).

Regarding exposure meters, I suggest that if you buy a camera with a built-in meter and you can make all the types of pictures you want, then the camera's meter is all you need. But if that built-in meter limits the range of photographs you want to make, you had better get a hand-held meter to help you do the job.

58. *Exposure meters incorporated in cameras are both convenient and accurate. A built-in meter gave the proper exposure for this scene at the early California mission in Carmel. An arch was effectively used to frame the mission's church; see Chapter 10.*

Methods of setting exposures on cameras with built-in light meters vary according to the camera design. Of special interest are through-the-lens meters used with single lens reflex cameras. Light passing through the lens is measured by an internal meter and indicated for the photographer on a scale within the viewfinder.

While seeking the correct f/stop, the viewfinder on some SLRs will get darker if the photographer decreases the amount of light coming through it by stopping down the lens. If a small f/stop is needed, say f/11 or f/16, the image the photographer sees will be very dim. He may need to open up to the widest f/stop to focus accurately, and afterward stop down again to get the correct exposure. Setting the exposure on cameras requiring such *stop-down metering* is both time-consuming and a nuisance. Fortunately, lenses on most modern SLR cameras are equipped with *automatic apertures* which permit what is termed *open-aperture* or *full-aperture metering*.

With such a lens diaphragm control, the lens stays at its widest opening for accurate focusing and viewing, and then closes down to the selected f/stop when the shutter release is pressed. After exposure, the lens automatically opens up to its widest f/stop again. This automatic stopping down and reopening of the lens is instantaneous.

Some cameras have an automatic aperture override, activated by the depth of field preview device, which allows the photographer to stop down to the selected f/stop without releasing the shutter. This way he can view the scene at the f/stop chosen for exposure of the film and not make a picture.

It is well to remember if you have automatic lens control that when pressing the shutter release to make an exposure, the lens will automatically adjust to the f/stop you've chosen. This is mechanical and should occur even if your built-in exposure meter, which is electrical, is turned off. On cameras with automatic exposure control, however, the lens may not stop down if the meter is turned off or its batteries are exhausted. Check the camera manual for such warnings.

Automatic Exposure Cameras

The introduction of an *electric eye (EE)* camera nearly a half-century ago sparked interest in automatic exposure control that finally culminated during the last decade or so in a wonderful array of *auto-exposure (AE)* cameras. They helped sweep aside the past frustrations of getting properly exposed pictures and prompted a worldwide boom in amateur photography. Most of today's popular cameras—disc, instant, 35mm compact, and even SLRs—utilize automatic exposure systems.

In general, such cameras have photocells which read the light and then set

the exposure for the photographer. The simplest cameras take total control of exposure; just set the ISO/ASA dial or lever to indicate the speed of the film you're using and the camera's computer chips do the rest. (Some models even set the film speed themselves, according to electronic codes on the film's container.)

As for 35mm SLR cameras with automatic exposure, depending on the manufacturer's design, usually either the f/stop *or* shutter speed must first be set by the photographer. If the f/stop is preset, the camera is said to have aperture-priority (or aperture-preferred) automatic exposure control; when the shutter speed dial is turned to A or Auto position, the shutter speed is automatically set as the shutter release is pressed.

Automatic exposure cameras where the shutter speed is preset are said to have shutter-priority (or shutter-preferred) exposure control; when the lens ring is turned to A or EE position, the f/stop is set automatically as the shutter release is pressed.

Some 35mm SLR cameras feature a *programmed mode* for automatic exposure control, which sets both the aperture and shutter speed for the photographer. And a few models incorporate automatic *multimode exposure control,* which permits a choice of aperture-priority or shutter-priority modes, and sometimes even a programmed mode. Often the multimode models also include a manual mode so you can forgo all automatic exposure controls and set the f/stop and shutter speed yourself.

Automatic exposure cameras have improved greatly since Kodak introduced the first EE camera back in 1938, but they are still not foolproof. More and more are being introduced every year, however, and some photographic experts talk of total automation some day, even for hard-to-convince professional photographers. While many of the pros would rather stick by their f/stops and shutter speeds, new generations of photographers are being raised on automatic exposure cameras and come to depend on them. The trend toward automation will continue; the camera manufacturers will see to that.

However, with a camera in an automatic exposure mode, an incorrect exposure or no exposure at all will result if the metering system is faulty or turned off. Batteries power the shutter or f/stop mechanisms of such cameras, and they must be operating if the exposure is to be automatically made. Of course, manual operation of f/stops and shutter speeds also is possible with many automatic models. This arrangement, offering a choice between automatic and manual, gives the photographer the flexibility he needs.

For every photographer who understands his exposure system, there are a hundred more who do not—and don't want to. "We just want to shoot," they say, "and not fiddle with camera dials." As long as their results are what they expect them to be, okay. But if a photographer has to sacrifice a good picture because his camera was too automated for him to use creatively, then cameras with automatic exposure control and their future refinements, such as autofocusing, will hinder photographic progress, not help it.

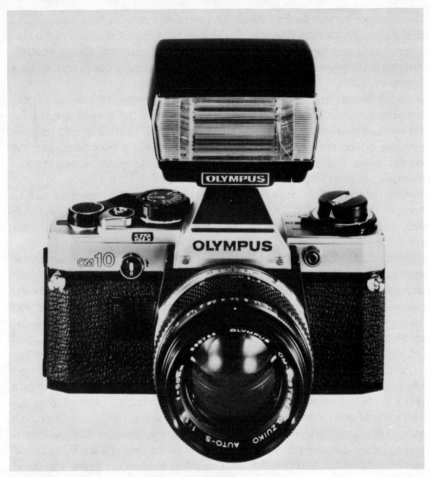

59. *Many of the modern 35mm cameras feature automatic exposure control. This compact model even determines the proper exposure for flash pictures when its special electronic flash unit is attached to the camera's hot shoe (see also Chapter 4).*

If your camera results in poor automatic exposures, operate it manually until you can have it checked or repaired. Or check *yourself.* You may be operating the camera incorrectly. Study the camera manual again.

Automatic cameras have special problems concerning exposure. As previously explained, after you set the desired f/stop *or* shutter speed and frame your subject, the exposure meter system automatically sets the appropriate shutter speed or f/stop for the correct exposure. And some cameras are programmed to set *both* the f/stop and shutter speed automatically. However,

the meter can be fooled by the light conditions, and the resulting picture may not be what you had anticipated.

For this reason, the better automatic cameras have an *automatic exposure override* so you can read and set the exposures manually. On these models there is an exposure control lock so you can preset an f/stop and shutter speed different from the automatic exposure which would result with the scene you've framed. After aiming the camera to read an alternate area that you determine *will* give the proper exposure, slightly depress the shutter release or push a special memory lock lever or button to lock in the f/stop and shutter speed at this camera position. Then reframe your original picture through the viewfinder and fully press the shutter release. This system is convenient once you get used to it.

A useful exposure override feature on some of the more simple cameras with automatic exposure control is often called a *backlight button.* With the sun at the back of your subject and shining toward the camera, the camera's metering system may underexpose the photograph. By pressing the backlight button when you take the picture, the camera automatically overexposes the film by about 1 ½ f/stops to compensate for the bright light that's adversely affecting the exposure reading.

Versatile 35mm SLR models have an *exposure compensator,* a dial that is adjusted to automatically underexpose (−) or overexpose (+) from one-half to two f/stops. For example, if you shoot on automatic exposure at the beach or on a ski slope, the light reflecting brightly from the sand or snow can trick your meter into underexposed scenes. To compensate, you would set the exposure compensation dial to + 1 or + 2 (overexposure) to increase exposure of the film automatically by one or two f/stops. Always remember to reset the compensator to its normal (0) position before you resume taking pictures under normal light conditions.

Exposure with automatic cameras also can be altered by setting the ISO/ASA speed on the camera higher or lower than the film's actual speed. This means you can utilize any camera's ISO/ASA dial as a substitute exposure compensator. For instance, if you're using an ISO/ASA 100 film but set the camera to ISO/ASA 200, the film will be automatically underexposed by one f/stop. Or, using the same film but setting the camera to ISO/ASA 50, the film will be automatically overexposed by one f/stop.

Correction for Exposure Errors

Here's more exposure advice: If your results are *consistently* too light or too dark, either your meter is inaccurate or your camera's shutter speeds may

be mechanically faulty. Less commonly, your lens f/stop positions may be inaccurate or the automatic aperture may be sticking. Of course, meter and camera mechanisms can be repaired to eliminate exposure mistakes.

But it also helps to know that you can change the meter's ISO/ASA setting to adjust for exposure error. You'll be able to get correct exposures without visiting a camera repair shop. Here's how. If, for example, your photographs are consistently too dark, you need to let more light reach the film. Make some test exposures to see just how much more light will give you the results you like.

First shoot at the f/stop indicated by your meter. Next, keeping the shutter at the same speed, open the f/stop a *half-stop* and shoot again. Then make another exposure a *full stop* wider than the original meter reading. Continue bracketing with two more exposures at half-stop and full-stop positions. Keep a written record of the f/stop according to the numbers on your film frame counter so you can compare the results correctly.

Thus, for example, if your exposure meter reading was 1/125 second at f/8, first shoot at that setting. Then keeping the shutter speed at 1/125 second, make four more exposures: between f/8 and f/5.6, at f/5.6, between f/5.6 and f/4, and at f/4. Repeat this procedure with several different subjects under varied lighting conditions. Then compare your results to determine how much to readjust the ISO/ASA setting on your meter.

Computing how much to change the exposure meter's ISO/ASA setting is done by determining how much more light is needed. For instance, in the example above, if the exposures at f/5.6 give the best results on your test subjects, you need to double the amount of light originally indicated by your meter. (Remember, opening from one f/stop to the next widest f/stop doubles the amount of light coming through the lens. And in this example, opening the lens from the meter's suggested exposure of f/8 to the better exposure of f/5.6 would double the amount of light.)

Now, to avoid having to remember to open one f/stop for every exposure reading given by your meter, readjust the ISO/ASA setting on your meter to compensate for the one f/stop difference. Simply divide the ISO/ASA number of your film in half and set the resulting number on the ISO/ASA scale of your meter.

If you recall, film rated ISO/ASA 64 is twice as sensitive to light as one rated ISO/ASA 32. Similarly, one of ISO/ASA 400 is twice as sensitive as an ISO/ASA 200 film. In both instances, the difference in film speeds is the equivalent of one f/stop. Therefore, say you are shooting with an ISO/ASA 64 film and your usual result is one stop too dark. Then you will need to change the ISO/ASA setting on your meter to indicate a less sensitive film is being used that requires more light (a greater exposure). By adjusting the meter to ISO/ASA 32, indicating a film that needs double the amount of light of one rated ISO/ASA 64, the new meter calibration will give you the correct exposure settings.

60. When light conditions are unusual, as on this misty trail in the Black Forest, it may be best to override the camera's automatic exposure control (see text).

Thus, whatever the ISO/ASA of your film, if it is giving results that have been determined to be one f/stop too dark (underexposed), reset the meter for one-half of your film's normal ISO/ASA. With results consistently two stops underexposed, reduce the film's regular ISO/ASA to one-fourth and set the new figure on your meter. Underexposures of a half-stop can be recalculated for the exposure meter's ISO/ASA setting by dividing the film's normal speed by three-fourths.

Conversely, if your results are consistently one f/stop too light (overexposed), double the ISO/ASA originally indicated on your meter. That will cut the meter calculations in half and give a correct f/stop reading that is one stop smaller than before. For example, say a meter set at ISO/ASA 400 gives a reading of f/8, which is determined by your tests to be one f/stop too light. By resetting the meter to ISO/ASA 800, you'll get a reading of f/11, the desired exposure.

61. Unless they've been damaged by careless handling, today's exposure meters give accurate readings indoors as well as outdoors. This farm couple in Utah still enjoys freshly baked bread made in their old but trusty oven.

Summarizing, to adjust for one-stop overexposures, multiply the film's ISO/ASA by two. If your results are always two stops overexposed, increase the film's ISO/ASA four times and adjust your meter to this revised ISO/ASA number. Overexposures of a half-stop will be corrected by increasing the meter's ISO/ASA setting 1½ times.

By now you may be discouraged, or at least confused. Don't worry. All this about ISO/ASA, f/stops, shutter speeds, and depth of field will come clear to you, especially after some practical experience.

I suggest you make some pictures and judge the results. Then analyze what went wrong. And even with the good results, figure out how the pictures might be even better. Always be critical of your work. The more critical you are, the less critical your viewers will be. After a while you'll learn how to "read" a photograph to determine how and why it was made. You'll begin to judge other photographers' work with a more discerning eye. But you must understand the abilities and limits of a camera and its equipment. So don't give up. Read on.

3

Choosing Lenses

Early amateur cameras were made with the lenses built in. These lenses were pieces of optically corrected glass that made an image on film similar to what the photographer saw. However, early-day photographers soon wanted to record images larger than they normally appeared. They knew how telescopes could bring a distant subject close up, and how microscopes could enlarge a subject to a bigger-than-life image. Why not cameras?

Eventually cameras and lenses were made for those purposes, and more. Today's camera stores have row upon row of supplementary lenses, and many photographers' gadget bags have several, too. Are they all necessary?

Like auto enthusiasts who prefer an engine with fuel injection rather than an ordinary carburetor, photographers have special preferences and reasons for using certain lenses. Many agree extra lenses can be a big help getting the results they want, while others think the camera's basic lens is all that is needed. Even professionals. Well-known photographer Henri Cartier-Bresson shoots mainly with a normal 50mm lens on his 35mm camera.

Too many amateurs buy supplementary lenses because they think the extra gear makes them *look* more like photographers should look. Telephoto and wide-angle lenses have become common. Zoom lenses are especially popular. Macro and close-up lenses fill out the list of the "usual" extra lenses. Just what are the differences in lens types?

First, you should know that all lenses are classified by their *focal length*. As you recall, that's the distance from the optical center of a lens focused at infinity to the point behind it where a sharp image results. With a camera, that distance would be measured from the lens optical center to the film. The distance is measured in millimeters (mm) and is engraved on the front mount of your lens. Occasionally the focal length appears in centimeters (cm). Multiply by 10 to determine millimeters. The focal length of lenses used with projectors, or with cameras using very large film sizes, often is indicated in inches.

The millimeter of a camera lens indicates its *field of view* (the area it covers), and helps tell you what size image it will produce. The greater the focal length (mm), the greater the subject's image size. Currently, focal lengths for 35mm cameras range from 6mm to 2000mm. Once you know the millimeter of a lens, you'll know what general type of lens it is considered to be: nor-

62. *A wide selection of lenses is available for all brands of 35mm single lens reflex cameras. Some are made by camera companies for their specific models, others by independent manufacturers for a variety of cameras.*

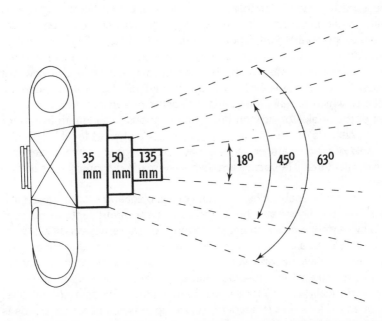

63. *The subject area covered by a lens, which is called its angle or field of view, is figured in degrees (°) and varies according to the focal length of the lens. In this example of lenses for a 35mm camera, a 35mm (wide-angle) lens has an angle of view of 63°, a 50mm (normal) lens covers a 45° angle, and a 135mm (telephoto) lens has a field of view of only 18°.*

mal, telephoto, or wide-angle. However, these categories of lens types vary according to the film size of the camera.

A *normal lens* for a 35mm camera is different in terms of focal length from a normal lens of a 2¼ × 2¼-inch camera, for instance. While the normal lens of a 35mm camera might be 50mm, the normal lens for a camera using 2¼ × 2¼-inch film can be 80mm. The exact millimeter depends on manufacturer's design and the camera model. Normal lenses for 35mm cameras are often 50mm or 55mm, but they can range from 38mm to 58mm.

A *telephoto lens* is one of longer focal length than a normal lens. For 35mm cameras, these generally range from 85mm up to 2000mm. Lenses of 90mm, 105mm, and 135mm are very popular telephoto types for 35mm cameras. Simply stated, shooting from the same spot, with a telephoto lens you'll get a larger subject image than with a normal lens. The greater the millimeter, the greater the image size. For example, a 1000mm lens would give an image scale 20 times greater than a 50mm lens. That's because with the longer focal length, the field of view gets smaller and the subject image appears proportionately greater on the film.

Wide-angle lenses, on the other hand, have a shorter focal length than normal lenses. Popular sizes include 35mm, 28mm, 24mm, and 21mm. They include a greater field of view than a normal lens, and so subject image size is less with a wide-angle than a normal or telephoto lens. Some extreme wide-angle lenses are on the market now, including one of 6mm. These are called *fish-eye lenses* because the lens surface bulges out like a fish's eye, and the field of view is similar, too. Fish-eye lenses can cover a 220° field of view, but with most the coverage is 180°. With a fish-eye lens, the camera records a subject area which appears round on the negative or transparency.

A list of the angles of view (in degrees) of various focal length lenses for 35mm cameras is on the facing page. With lenses of short focal length, the exact angle of view of a specific lens may vary a degree or two, depending on its manufacturer. These measurements are made diagonally on a 35mm film frame.

Close-up lenses enable close focusing of a subject and a large subject image size. They usually are attached to the front of a normal, telephoto, or zoom lens. To increase the close-up magnification even more, *extension tubes,* or *extension bellows,* are inserted between the camera body and camera lens.

Macro lenses have become very popular. These allow the photographer to focus near his subject for close-ups and also make photographs at regular distances. Basically, macro lenses will do the same work as a normal, telephoto, or zoom lens that is fitted with close-up lenses, but a macro lens is easier to use and gives sharper close-up results. With some you can focus from infinity down to 2 inches. Generally, however, because of its optical design, the maximum f/stop of a macro lens is less than the maximum opening of a standard lens. For example, some macro lenses open only to f/3.5, while a normal lens may be as wide as f/1.4, a difference of 2½ f/stops.

Lens Focal Length (in millimeters)	Angle of View (in degrees)
21mm	90°
24	84
28	75
35	63
50	45
90	27
105	23
135	18
180	14
200	12
250	10
300	8
400	6
500	5
600	4
800	3
1200	2

Zoom lenses first became popular with movie cameras, and then photographers adopted them for still cameras. A zoom lens allows you to vary the focal length. That means you can increase or decrease your field of view, and the subject's image size, without moving your position or changing lenses. This makes them very convenient. And composition becomes easier, too. The zoom range varies according to the lens. Most common are focal lengths which range from a minimum wide-angle lens to a minimum telephoto lens, like 35-70mm, and also those of a greater telephoto range, such as 85mm-210mm. Newer types cover extensive wide-angle to telephoto ranges, such as 28mm-135mm. The major drawback of zoom lenses is that their maximum f/stop is limited, often in the f/3.5 to f/4.5 range. This means it's harder to see through the lens and focus in dim light. Some zooms have a *variable maximum aperture,* such as f/4-4.5; it gets smaller as you zoom to a longer focal length.

Autofocus lenses are the latest lens innovation for SLR cameras. Optical sensors in the lens or camera activate a motor to automatically adjust the lens until it is in sharp focus on the subject appearing in the middle of the viewfinder. Some autofocus lenses can be used only on a specific autofocus-model camera, while others have been designed for mounting on a number of the major brands of SLR cameras.

Before discussing the various types of supplemental lenses more completely, here are some general facts to know. Some cameras have permanent lenses and these cannot be changed. Rangefinder cameras with between-the-lens leaf-type shutters are of this kind. Close-up lenses usually can be attached to

64. *Shooting with lenses of different focal lengths from the same camera position effectively changes the subject's image size. For this overall view of an abandoned building and wagon on the Nebraska plains, a 35mm (wide-angle) lens was used.*

65. *Photographed with a 50mm (normal) lens.*

66. *Photographed with a 135mm (medium telephoto) lens.*

them, however. Full interchangeability of lenses is possible with single lens reflex cameras, as well as with the few rangefinder types which have focal plane shutters (such as Leica cameras).

Mounting Lenses

Mounting lenses to your camera body is accomplished by one of two methods. Cameras have either a *bayonet* or *screw* mount. Screw-mounted lenses are less expensive but less convenient. The photographer must turn the lens to screw it to the camera, and quick alignment of the grooves is not always easy. With the more common and convenient bayonet mount, the lens is aligned and inserted according to markings on the lens and camera and then a quick twist of the lens locks it in position. On a few models, like Canon's, a *breech-lock mount* is used; after the lens is properly positioned on the camera, a ring on the lens is turned to secure the lens to the camera. Some lenses with a screw base can be fitted with an adapter so they can be used on a camera using a bayonet or breech-lock mount.

Many supplementary lenses can be adapted for use on a number of camera models. Some lens manufacturers design their products for interchangeable use on a variety of camera bodies. Unfortunately, there is no industry-wide standardization regarding lens mounting. This is partly because camera-makers want you to buy the lenses they make especially for their cameras.

Also, automatic aperture and exposure controls vary according to the manufacturer, and some will couple only to the lens designed for the camera. When buying an extra lens, always take your camera to the store to make certain the lens attaches properly and also makes the necessary mechanical and electrical connections to operate the aperture and display exposure information in the viewfinder.

Pricing Lenses

The cost of lenses varies considerably. Making fine optics is neither easy nor inexpensive, and much of the cost of a camera is determined by the quality of its lens. Technical ability and labor costs are price factors. Japan produces more camera lenses less expensively than any other country. Germany also manufactures lenses for cameras, and the Germans' reputation for quality optics is high. So are their prices.

Lens quality often varies according to price. Usually the more you pay for a lens, the better it is. Sometimes, however, you are also paying for the vast amount of advertising done by some lens and camera manufacturers. How precisely the glass elements within the lens are ground, polished, and mounted determine the real value of a lens. The ruggedness of the lens barrel and the durability of its mount are considerations, too. Some are easily damaged.

The major consideration regarding the quality of a lens is its sharpness. Is the picture it produces sharp corner to corner? Inexpensive lenses, especially telephoto or zoom types, tend to produce pictures with fuzzy edges. The manner in which a lens is designed and coated to reduce flare and eliminate distortion also is important.

Another cost and value factor concerns the maximum lens opening. Generally, the wider the maximum f/stop, the greater the lens price. Maintaining sharpness with a wide f/stop is optically difficult. But photographers seem to prefer lenses with wide f/stops, such as f/1.4, to use when light levels are low. And they pay a higher price for this lens feature.

In general, you'll get a good-quality normal lens with your camera. The decisions come when you purchase a supplemental lens. First, how much will you use the extra lens? If your answer is often, a more expensive type is the best investment. For occasional use, a less costly lens should be adequate. Whatever lens you purchase, if you find it does not produce sharp images, return it to the camera store for replacement.

Some inexpensive lens-makers, for fast production and to cut costs, have little or no quality control. They do not test the lenses after making them. You are the first person to see photographic images made by the lens. So study them carefully. One quick check is to see how sharp the image is when the lens is focused at infinity. A better check can be made by photographing a page of classified newspaper ads taped flat to a wall. Keep the camera's film plane parallel to the wall. Check the results for overall sharpness (watch for edges of the picture that may be out of focus) and uniform exposure (look for edges that may be darker than the center). Make several test exposures at different f/stops.

Telephoto Tips

Sooner or later you'll consider buying a supplemental lens. Which type of extra lens is best for you? The answer depends on the type of photography you do. For many photographers the most common extra lens is a telephoto

lens or a zoom lens. Its focal length, how much it limits the field of view, will vary according to personal preference and purpose. The choice depends on the distance to your subjects and how large you want their images to appear on the film.

Since 35mm cameras are designed to be small and convenient, a bulky telephoto lens will alter those features. From 200mm upward, they can get heavy and awkward. Such lenses of great focal length are said to be *powerful, extreme,* or *long telephoto lenses.* Often a tripod is needed to support them and keep them steady. Since only a small picture area is encompassed by a lens of great focal length, even slight camera movement will cause a blurred picture. And if hand-held, a camera with a telephoto lens requires a fast shutter speed to avoid this problem. Even then, other support is often needed to get sharp photographic results. Some cameramen use a pistol grip or shoulder brace to help steady their telephoto lenses when making candid pictures.

A telephoto with a fast lens, one that has a wide maximum f/stop, such as f/2.8, is bigger, heavier, and costlier than those telephotos with lens speeds of f/4 or f/5.6 or less. For further comparison it should be mentioned that normal lenses almost always have a larger maximum f/stop opening than telephoto lenses, and thus normal lenses are considered to be faster of the two types. Often you'll have more of a problem shooting in low light situations with a telephoto lens. That's because its limited maximum f/stop dims the subject you're trying to focus in the viewfinder, and slow shutter speeds are required for correct exposures unless you're using a fast film of ISO/ASA 400 or higher.

Another consideration with telephoto lenses is that the greater their focal length, the less depth of field. The area of the picture that it is possible to get into sharp focus is reduced as the millimeter of a lens increases. Thus, focusing with a 300mm telephoto lens is more critical, and there is less depth of field possible, than with a 90mm telephoto. Of course, the distance the subject is from the camera and the f/stop used also affect focus and depth of field. The limited depth of field characteristic of telephoto lenses can be used creatively. For instance, such a narrow zone of sharpness enables a photographer to easily isolate and therefore emphasize his subject by keeping an unwanted foreground or background, or both, out of focus.

Although you must use a camera support and/or fast shutter speed to get sharp results, and although you must focus critically because of limited depth of field, telephoto lenses offer many advantages.

The most popular—90mm, 105mm, and 135mm—enable portraits to be made without distortion of the subject's features and without getting uncomfortably close. Telephoto lenses also put you where the action is, especially at sports events where fans and photographers are required to keep their distance. Nature photographers count on telephoto lenses to get near subjects without disturbing them, a necessity for bird and wildlife pictures. Travel pho-

67. *When using lenses of different focal lengths, changes in perspective should be considered. Notice how the car is altered by shooting with four different lenses, after repositioning the camera each time so the front of the subject stays nearly the same width. Look for changes in the car top and background. The most distorted view (above) was made with a 28mm (wide-angle) lens.*

68. *Photographed with a 50mm (normal) lens.*

69. *Photographed with a 90mm (minimum telephoto) lens.*

70. *Photographed with a 180mm (medium telephoto) lens.*

71. *Telephoto lenses offer photographers some special advantages. They make it possible to get closer views of a subject without moving closer with the camera. Some subjects, like this parachutist in Canada, would be impossible to reach without a telephoto lens.*

tographers utilize telephotos to capture informal portraits of people without their being aware of the camera. Distant scenes, or portions of them, can be brought closer for detailed and dramatic effects. Filling your frame with the subject is a basic rule for making an effective picture, and telephoto lenses allow this quite easily.

I would advise against purchasing an extremely powerful telephoto. It is too impractical and cumbersome for general photography. You'll find you are too close to most subjects with it. Its weight and size, plus f/stop and depth of field limitations, as well as cost, make a telephoto lens of great focal length a luxury.

There is an inexpensive way to increase focal length and therefore obtain a telephoto effect. This is with the use of *lens extenders,* also called *lens con-*

72. *A telephoto also changes the normal perspective and makes the foreground and background subjects appear closer to each other. For that reason, a telephoto lens was purposely used for this shot of a beach in India to contrast its traditional use by fishermen with its newer role as the location of a vacation resort.*

verters and *teleconverters*. These are optical devices inserted between a lens and the camera body which increase the focal length two or three times and thus enlarge the subject image. As such, a 2X extender doubles the focal length of a lens. A 3X extender triples it. Thus a normal 50mm lens becomes a 100mm or 150mm, depending on whether a 2X or 3X extender is used.

However, because focal length is increased, light must travel a greater distance from lens to film, and exposure must be increased accordingly. A through-the-lens light meter accomplishes this. With an external or hand-held meter, information for increasing exposure is given with the extenders and should be applied. Generally it indicates that two additional f/stops are required when using a 2X extender, while a wider opening equal to three f/stops is required for 3X extender use. With some cameras, the extenders will couple to the automatic aperture f/stop control. Otherwise, f/stops must be set manually.

One caution: Since the extenders can be fairly inexpensive, the quality of the optics varies. Overall sharpness may be lacking, and the edges of your pictures may be slightly darker than its center area. Nevertheless, if your need for a telephoto is only occasional, extenders can be an inexpensive answer.

Mention must be made of *reflex-type telephoto lenses,* commonly called mirror lenses and formally called catadioptric lenses. Most are of the greater focal lengths, from 500mm to 2000mm. They were designed to reduce the length, weight, and price of long telephoto lenses. To do this, the image coming into the lens is bounced off a mirror at the rear of the lens to a mirror at the front of the lens that reflects it to the film.

Because of this unique design, a mirror lens has a fixed aperture, often f/8, that cannot be changed. In order to get proper exposures, the only thing you can do is adjust the shutter speed control (or use neutral density filters to reduce the intensity of light reaching the film).

Another limitation of mirror telephoto lenses is that depth of field cannot be controlled because the f/stop is always the same. Also, bright spots in the out-of-focus background often appear as donut-shaped images, which can be appealing or distracting, depending on the picture's subject.

Zoom Lenses

A zoom lens, which allows you to vary focal length, can be very convenient. There are no delays or missed pictures, as may be the case when having to change from one lens to another. Photographers making color slides for projection especially like zoom lenses because they can easily fill the frame with exactly the picture they want to show on the screen. They get closer (zoom in) to or farther (zoom out) from their subjects simply by adjusting the lens.

Other photographers create interesting photographic effects, including one of motion, by zooming the lens in or out during the actual exposure. To allow time for this, the shutter speed must be relatively slow.

Early zoom lenses were criticized for producing unsharp images, but the recent generations of computer-designed zooms produce excellent pictures and are a favorite choice of amateur and professional photographers. The main reason for their popularity is that one zoom lens will do the work of several lenses of fixed focal lengths. Unfortunately, many zoom lenses are heavy and bulky compared to those of fixed focal lengths. Also, comparing the minimum focal length of a zoom lens to a regular lens of that same focal length, the zoom lens usually will have a smaller maximum f/stop opening. This means that in situations where the light level is low, some zoom lenses are less useful than lenses of fixed focal lengths. Because of their limited maximum apertures, often f/3.5 to f/4.5, zoom lenses are not as easy to focus in dim light, and slower shutter speeds (or a faster film) must be used for proper exposures. The minimum distance you can get from your subject when using a zoom lens is limited, too, although some zooms feature macro or close focusing capabilities.

Another consideration with some so-called zoom lenses is that they do not maintain their sharpness as you change the focal length. Thus, after zooming in or out to frame your subject, you may have to refocus in order to get the sharpest possible image. Actually, lenses which do not hold their focus are not truly zoom lenses; more accurately, they are termed *variable focal length lenses*. They must be refocused after every change of focal length. When using quality zoom lenses which stay in focus whenever the focal length is changed, photographers frequently focus while at the greatest focal length because the subject will be larger in the viewfinder and can be focused more critically.

Controls for focusing and changing the focal length of a zoom lens are of two types. A so-called *one-touch zoom* has a single ring that you push and pull to change the focal length and also twist to focus. A *two-touch zoom* has two control rings: one you push and pull or twist to adjust the focal length, another you twist to focus. Many photographers prefer one-touch zooms because they can be operated more quickly, although you have to be careful not to inadvertently change the focal length when focusing or twist the ring out of focus when zooming. You avoid such problems with a two-touch zoom, but it takes longer to make focal length and focus adjustments because you have to move your fingers from one ring to another.

I regularly use a one-touch zoom lens of medium focal length, 43-86mm, because it makes composing a picture in my viewfinder very quick and easy. Try out several zoom lenses before deciding which one would be a good investment. They vary considerably in features and prices, according to the manufacturer.

73. *Zoom lenses are versatile and can be used creatively by changing their focal lengths while the shutter is open. One result is to give a feeling of motion to a stationary subject, such as this parked car.*

Working with Wide-angle Lenses

The other popular supplemental lenses are of the wide-angle type. They have focal lengths less than a normal lens, often 35mm, 28mm, 24mm, or 21mm, and give a wider field of view than normal lenses. The smaller the focal length, the wider the view—which means the subject's image size will be smaller in the viewfinder and on the film.

Wide-angle lenses especially are useful when working in close quarters, such as room interiors or narrow streets. When you cannot move back to include more of your subject, a wide-angle lens will do the trick. Panoramic landscapes

74. *Zooming while the shutter is open also can produce abstract images or interesting patterns, as with this Ferris wheel exposed at night.*

also are possible, but the image size of the subject becomes smaller. Towering mountain scenery can be overwhelming when you photograph it, but if shot with an extreme wide-angle lens, the result shows smaller mountains and a less impressive picture than you expected. Many travel photographers become disenchanted with wide-angle lenses after trying to make dramatic scenic shots.

Distortion with a wide-angle lens is also evident when it is close to the subject. Therefore, portraits of people made with wide-angle lenses are usually unflattering. The portions of a subject closest to the lens are exaggerated. The results can be startling. For example, when taken with an extreme wide-angle lens, a picture of a pig's snout can result in the animal looking like an anteater.

A plus factor for wide-angle lenses is that because they have great depth of field, focusing is less critical and sometimes even unnecessary. A 28mm lens, for example, will be in focus from 5 feet to infinity at an average f/stop of f/8. At f/16, the range increases down to 2½ feet through infinity. For comparison, a normal 50mm lens at f/8 has a depth of field of only 15 feet to infinity.

75. *Wide-angle lenses cover greater angles of view than normal or telephoto lenses, but distortion may be evident. When the camera is pointed upward, parallel lines tend to converge inward toward the top, as occurred with these buildings in downtown Los Angeles.*

76. *When a camera with a wide-angle lens is aimed downward, distortion occurs in the opposite direction. Notice how the buildings at the top of the picture tilt outward in this view of Miami that was taken from a helicopter.*

Wide-angle lenses are also smaller and lighter in weight than the telephotos. However, because the lens is designed to take in a great field of view, wide-angles often have a front lens element that bulges out. A UV or skylight light filter will help protect it, as well as lens shade that also can block direct sunlight from the lens and avoid flare. Whenever you attach a filter or lens shade to the front of a wide-angle lens, always check in the viewfinder to be sure that it does not obscure the corners of the image.

Because of their short focal length, some extreme wide-angle lenses must be so close to the film that they prevent use of the viewfinder in single lens reflex cameras. The reason is that the camera's mirror must be locked up out of the way, thus cutting off the reflected subject image seen by the photographer. But since focusing and framing is not a problem with such extreme wide-angles, notably the fish-eye lens, most photographers adapt to this limitation.

A partial reason is because shooting with extreme wide-angle lenses is an occasional thing. Most photographers save them for a unique shot. Too many wide-angle pictures, with their bothersome distortion and tiny subject images, become monotonous if not displeasing. However, the more nominal wide-angles, such as the 35mm, 28mm, 24mm, and 21mm, are popular with many cameramen, including news photographers. Any of these would be a

good choice if you're considering purchasing a wide-angle lens. Try them out to see which you prefer for the type of photography you do. Make some test shots.

And remember, in addition to exaggeration of close-up subjects, distortion caused by a wide-angle lens also is very noticeable in regard to parallel lines. Shooting horizontally and level with the subject, any vertical lines will appear straight. But if the camera is tilted up, these vertical lines or objects seem to bend inward at the top of the picture. Thus, shooting upward, square building exteriors will narrow at the top. Tilting the camera down tends to bend such lines of objects inward at the bottom of the picture. Corners of rooms also tilt inward or outward depending on the angle of the camera.

Larger view cameras with tilting lenses, and some special 35mm cameras, are designed to enable the photographer to prevent such distortion. But unless you use a *perspective-correction (PC) lens,* it is a problem most wide-angle users with 35mm cameras must tolerate. Correction of distorted lines can be accomplished somewhat in the enlarging process, and photographers who make their own prints are less concerned with this problem.

Autofocus Lenses

In its infancy in 1978, autofocusing was limited to cameras with nonremovable lenses. Then the feature became available for 35mm single lens reflex cameras. At first the SLRs with autofocus capability required a particular lens, like the Pentax ME-F camera that was designed for use with the Pentax f/2.8 35-70mm autofocus zoom. Later, Nikon improved autofocus possibilities with its F3AF model and a special autofocus teleconverter that accepts 15 regular Nikon lenses—from 28mm wide-angle to 300mm telephoto—for automatic focusing by the camera. In 1984 another giant step was made by an innovative lens maker, Vivitar, with the introduction of its f/3.5 200mm autofocus lens, which can be attached to most popular 35mm SLR cameras.

Despite considerable progress in a short span of time, autofocus lenses for 35mm single lens reflex cameras still face some hurdles before photographers adopt them with enthusiasm. Common complaints have been that autofocus lenses can be fooled by subjects that are too dark or too bright or that have too little or too much detail. Slow focusing response time has been another concern. With accurate and quick autofocusing as their ultimate goals, manufacturers of the new generations of autofocus lenses must also try to reduce the extra size, weight, and cost of such lenses in order to guarantee their future popularity.

Macro Lenses

Macro lenses are dual-purpose lenses because they can be used for making close-ups in addition to their regular role as a normal lens or telephoto lens or zoom lens. Some manufacturers call their macro lenses *micro* or *close-focus lenses.* Close-up photography is very convenient because you don't have to bother with additional close-up lenses or other attachments. Many macro lenses will even produce life-size images, but the addition of an extension tube may be required in order to permit one-to-one (1:1) reproduction ratios. Before purchase, study technical literature about any specific macro lens to see how close you can focus and the maximum reproduction ratio the lens will achieve. Since focus is critical in close-up work, a macro lens with a minimum aperture of f/22 or f/32 is advantageous because the smaller the lens opening, the greater the depth of field. If you do close-up photography infrequently, a drawback to having a macro lens, instead of a normal, telephoto, or zoom lens, is that its maximum aperture is usually one or two f/stops *less* than the widest lens opening available on a regular nonmacro lens.

77. *Macro lenses enable a photographer to make close-ups without bothering with lens attachments.*

Close-up Lens Concerns

Close-up lenses are another category of supplemental lenses. They are especially popular with photographers who like full-frame pictures of small subjects—flowers and insects are examples. They also are useful for copying, although the image may not be uniformly sharp unless a small f/stop is used. They allow the camera to get closer to the subject than usual. These close-up lenses screw or snap on a normal, telephoto, or zoom lens; using them requires no increase in exposure.

The main concern with close-up lenses is the lack of depth of field. The closer the subject, the more critical focus becomes. For this reason, and that of parallax errors, single lens reflex cameras are preferred to rangefinder cameras for making close-ups. With an SLR you see what the lens sees, and you can frame and focus accordingly. With a rangefinder camera, focusing and framing cannot be done visually in the usual manner. Distances are measured with a ruler and the lens focusing scale is set according to the strength or power of the close-up lens being added.

The strength or power of a close-up lens is referred to as its *diopter,* and is indicated by a plus sign with a number, such as +2. The higher this number, the closer you can get to your subject and thus the larger the image size which results on the film. How close you can get to your subject depends on the close-up lens being used. The following chart indicates focusing ranges according to lens diopters.

Close-up Lens (diopters)	Focusing Range from Subject (in inches)
+1	20⅜ to 38¾
+2	13⅜ to 19½
+3 (+1 and +2)	10 to 13
+4	8 to 9⅞
+5 (+1 and +4)	6½ to 7⅞
+6 (+2 and +4)	5⅝ to 6½
+8	4⅝ to 5⅛
+10	4¼ to 5

The most popular set of such lenses is of three powers, +1, +2, and +4. They can be used alone or two in combination. For example, a +1 and a +4 equal a diopter of +5. Put the strongest of the two lenses closest to the camera lens. The maximum strength of a single close-up lens is +10. Some zoom-type close-up lenses are available, offering a range of powers from +3 to +7 diopters, for example. Such *variable focal length close-up lenses* can be

adjusted to vary magnification and thus alter the subject's image size with ease. After each adjustment, however, these lenses must be refocused.

To fit correctly, close-up lenses should be purchased according to the millimeter of your lens. These screw onto the lens directly. Others come in *series* numbers to fit into a lens adapter. These adapters screw in or snap on the camera lens to accommodate close-up lenses or filters. Close-up lens series numbers range from 4 through 9. Do not confuse them with the identifying numbers some camera manufacturers have given to their close-up lenses. Before buying a close-up lens, check that it fits on your camera.

Manufacturers of close-up lenses provide a chart to indicate where to set the distance on the camera lens focusing scale, depending on how far the close-up lens is from the subject. Then the subject will be sharply focused. The size of the resulting picture area, the field of view, also is indicated. A depth of field scale should accompany the close-up lens instructions, too. Remember, use of close-up lenses requires no increase in exposure.

At close range to a subject, the rangefinder camera's viewfinder may not see what the film's lens does. Parallax error results. Unless his rangefinder camera features automatic parallax correction, the cameraman must disregard the viewfinder and frame his picture in another way. This is often a homemade device that extends from the close-up lens to the subject. It can be made of wire fastened to the camera, or a cardboard diagram can be held from the lens to the subject during framing. A tripod helps keep the distance and framing position exact. Some rangefinder cameras, however, do have an attachment for use with close-up lenses that mounts on the viewfinder and gives the photographer visual correction for focusing, field of view, and parallax.

By far, however, the SLR camera is the most convenient and accurate to use with close-up lenses. With the close-up lens in position, you simply focus and frame through the lens as you would normally. Built-in light meters make direct and correct exposure readings through the attached lens, too.

The sharpness of these supplemental lenses is important because in working so close to the subject the depth of field is very limited. For this reason a smaller f/stop is always recommended. This usually means a slower shutter speed, and thus some support is needed to keep the camera steady. Use a tripod. Such a support is also valuable when making close-ups to help maintain lens-to-subject distance after focusing.

With or without support, flash will provide extra light so a faster shutter speed or smaller f/stop can be used. Light from an electronic flash is bright but brief and generally will stop any movement of the subject. For extreme close-ups with no-shadow results, *ring lights,* special electronic flash units which encircle the lens, are available.

An interesting and inexpensive way to get close-ups is to use your normal or wide-angle SLR camera lens in reverse position. Many photographers have made emergency close-up shots by removing their normal or wide-angle lens and turning it end for end. This allows a decrease in the distance be-

78. When a subject is used with close-up attachments, such as supplemental lenses or extension tubes or bellows, the subject's image size changes considerably. This sunflower was photographed with a 50mm lens at its minimum focusing distance.

79. The same sunflower photographed with a 50mm lens with a +1 close-up lens attached.

80. Details of the sunflower's center are seen when photographed with a 50mm lens with a +1 close-up lens and a 1-inch extension tube attached.

tween subject and camera, and thus an increase in the subject's image size on the film.

For instance, a normal 50mm lens that can be focused in the regular manner only as close as 18 inches from film plane to subject will cover a subject area measuring 6¼ × 10 inches. Reversing that lens allows the photographer to get his film just 8 inches from the subject. And now the subject area included by the lens is only 1¼ × 2 inches. Thus, by reversing his lens the photographer has increased the image size of his subject five times.

Special *lens reverser rings* are available for some 35mm cameras in order to mount the lens in reversed position. Without one, you'll have to hold the lens in place. Use your fingers to make as great a light-tight collar as possible between the lens and camera body. Prefocus at infinity, and then move your head and camera slowly back and forth to bring the subject into focus through the viewfinder of your SLR. Try it.

Of course, the automatic exposure control of the lens will not work when it is in reversed position. The f/stop must be adjusted manually for the proper exposure. The built-in light meters of SLR cameras will give an accurate reading as you turn the f/stop control ring. The picture you see through the viewfinder will get dimmer as the lens is stopped down. Despite what may seem a strange procedure, reversing a normal or wide-angle lens is a good way to make occasional quick close-ups.

Nonoptical attachments also allow more extreme close-ups to be made. The least expensive and most common are *extension tubes.* These metal rings are placed between the normal lens and the camera body. In this way the camera lens is moved away from the film, allowing you to get closer to your subject and increase its image size on the film. A close-up lens can also be attached for even greater magnification. *Extension bellows* act on the same principle. These flexible extension devices fit between the camera body and its lens, too. By turning knobs the bellows can easily be extended to increase the subject's image size. Although far more versatile than extension tubes, bellows are more expensive and cumbersome.

With either one, exposure is affected because the lens is moved farther from the film. Since the light has to travel a greater distance from the lens to the film, a longer exposure is needed. Built-in through-the-lens meters will compensate. Otherwise you have to increase the exposure according to how great the lens-to-film distance is. Charts come with extension bellows and tubes and give the increased exposure factors for the degree of magnification with the lens being used. Some extension bellows and extension tubes allow use of the camera's automatic lens aperture control. Otherwise, f/stops must be set manually for correct exposures. Additional facts about close-up photography and equipment are given in Chapter 12.

4

Figuring Flash

To fully understand and utilize your camera and equipment, you should learn next about flash and how it operates. In most instances you will count on the natural light from the sun to provide illumination for your photographs. In other cases artificial light, such as that from indoor lamps or fluorescent fixtures, supplies the illumination. However, there are occasions when little or no light is present, and you have to provide some quickly in order to make your pictures. This is done most easily with the use of flash.

81. Because of its convenience and lower cost, electronic flash has become more popular than flashbulbs. Some cameras, like this 110-size pocket model, have an electronic flash built in.

There are basically two types of units that give a brief burst of light called flash. These are *electronic flash units* and *flashbulbs*. Flashbulbs can be used only once, while the other type can be flashed repeatedly. Such electronic flash has become the most popular source of instant artificial light for amateurs as well as professional photographers. With the proliferation of electronic flash, bulbs are used rarely nowadays. Exceptions are with some simple, older-model cameras that were designed for a specific type of flashbulb system, such as the *flashcube,* an inch-square self-contained unit that has four small flashbulbs and reflectors. The flashcube revolves after each flash so a fresh bulb is in position and ready to fire. Almost identical is the *magicube,* which looks the same but does not require batteries to trigger it. Neither do two other flashbulb devices, *flipflash* and *flashbars,* which offer eight to ten flashes in a single slim pack.

Such flash devices appeared in the 1970s and were great improvements over the earlier flashbulb and reflector system that required the time-consuming chore of replacing the bulb after each flash. Electronic flash units solve the bulb-changing problem by using a gas-filled tube that's ignited by an electrical charge to provide at least 10,000 flashes before it needs replacement. Another important advantage is that fast action can be stopped easily because the duration of electronic flash is very brief, usually a minimum of 1/1000 of a second. The short burst of flash light also means you'll avoid blurred pictures caused by inadvertent camera movement. And you can bounce flash off a ceiling or wall to improve interior shots being exposed by natural light.

Besides its uses for indoor photography, flash is a big help outdoors in daytime to fill in any shadows on your subjects, especially their faces. The extra light will give detail to facial features and add a sparkle to the informal portraits you shoot in daylight. On dull days flash can be fired to brighten up nearby subjects. In some backlighted situations, such as photographing people in front of a sunset, flash will illuminate your foreground subjects so they won't be silhouettes.

At night, off the camera, flash can be fired several times during a time exposure to light up a large subject, like a statue or the front of a building. Flash also is valuable for close-up photography, because the bright flash light lets you use small lens openings for better depth of field. Before learning more about flash techniques, you should become familiar with electronic flash equipment.

Using Electronic Flash

Early electronic flash units were bulky and expensive, and they were used mostly in photographic studios. Because advances in electronics have pro-

duced smaller, more versatile, and less expensive units, shelves of camera stores are loaded with an overwhelming variety. (Most 35mm compact and 110-size pocket cameras now have built-in electronic flash.) Accessory electronic flash units are made by camera manufacturers for their specific models, as well as by photo equipment companies for use on various brands of cameras. Before purchasing any flash unit, consult the unit's instruction booklet for technical data and take the following information into consideration.

The two major types of electronic flash are manual and automatic. With a *manual electronic flash unit* you determine the exposure by setting the camera's lens opening. First you figure the distance between the flash and your main subject and then you refer to a chart on the flash unit that indicates the correct f/stop to use, according to the speed of the film in your camera.

More advanced and more popular is the *autoflash unit,* which automatically figures flash exposures. All you do is preset an f/stop, based on the flash range and speed of the film being used. When a picture is taken, light from the flash reflects off the subject and is received by a sensor at the front of the unit. It activates a tiny computer which determines the flash duration, usually in a range from 1/1000 to 1/30,000 of a second. Many autoflash units also include the option of setting flash exposures manually so the photographer can retain full control.

Two other features in advanced autoflash units are very welcome but your camera must be equipped for their use. A *dedicated autoflash* will automatically set the correct shutter speed for flash whenever the unit is turned on. Otherwise, you have to manually adjust the camera's shutter speed for proper synchronization with electronic flash, usually to 1/60 or 1/125 second. In addition, dedicated flash units often signal in the camera's viewfinder when the flash is fully charged and ready to fire. After the picture is taken a dedicated autoflash also can indicate with a visual or audible signal whether the flash light was sufficient for a proper exposure.

For very accurate flash exposures, a *TTL dedicated autoflash* is the choice. TTL means that the flash unit activates through-the-lens flash metering at the film plane inside the camera instead of relying on the unit's external sensor to determine exposure. That feature also allows you a wide choice of f/stops for better control of depth of field; with non-TTL units you may be limited to one or two f/stop settings for autoflash photography.

For proper exposures with any autoflash, whether an accessory type or built into the camera, the most important thing for you to know is the flash's *minimum-maximum automatic operating range.* That tells you how close and how far away your subjects can be in order for the autoflash to make correct exposures. Some units have a rather limited range, like 4 to 12 feet, while others offer more extensive coverage, such as 2 to 40 feet.

As you'll discover, if a subject is closer than the flash's minimum distance, the picture will be overexposed; if it's farther than the maximum distance, an underexposed picture will be the result. The unit's technical data will indicate

the automatic operating range in feet (or meters). With units that permit a choice of f/stops for better control of depth of field, the autoflash operating range will change according to the lens opening you choose.

Another important consideration in choosing an electronic flash unit is the width of its coverage, often called the *angle of illumination.* The flash should cover the angle of view of the lens you are using in order to provide uniform lighting. The angle of illumination may vary according to whether the flash unit is held horizontally or vertically (see the flash unit's instructions). Some units are designed especially for use with wide-angle lenses; others will accept a wide-angle attachment to spread the light. A few units feature a *zoom head,* which can be adjusted for use with either wide-angle, normal, or telephoto lenses so the flash will provide the proper angle of illumination.

Also consider the flash unit's *power supply.* Most units get their electrical energy from replaceable alkaline batteries or rechargeable nickel-cadmium (ni-cad) batteries, but some permit use of an AC adapter for 110-volt or 220-volt operation from a wall outlet. That's a convenient money-saver when you take flash pictures in a fixed location, such as a room at home you have set up for studio-type portraits of the family or for tabletop photography.

Regarding the more common source for power, batteries, check in the flash unit's instructions for two significant factors: the *recycle time* and the *number of flashes* before the batteries must be replaced or recharged. A short recycling time means you won't miss the action, or bore your subjects, while waiting for the unit to be ready to fire again. (The batteries must charge an electrical capacitor that provides the energy to create the bright burst of light.) Recycle times can range from one-half second to 15 seconds; the fresher the batteries, the faster the recycle time. Likewise, the greater the number of flashes, as indicated in the unit's technical data, the longer you can use the flash before installing new alkaline batteries or recharging ni-cad batteries.

As for the choice between using replaceable and rechargeable batteries (if the unit permits both types), it depends on your personal preference. Ni-cads recycle about 40 percent faster than alkalines, but they provide only about one-half the number of flashes that alkalines do before recharging is required. If you use flash only occasionally, rechargeable ni-cads may be the most economical because alkaline batteries also lose their charge over time and must be replaced whether or not you fire the flash.

Some autoflash units feature *power-saving thyristor circuitry* that provides faster recycling times and more flashes per recharge or new set of batteries. Such circuitry prevents the capacitor from losing all its electrical charge after the unit's sensor or TTL metering system cuts off the flash when sufficient light has been provided for an exposure.

All electronic flash units feature a *ready light* or audible signal to indicate when the capacitor is charged and ready for the flash to be fired. If you take a picture before the ready light comes on, the flash may go off but it probably won't have sufficient power to make a correct exposure. Cautious photogra-

phers even wait a few seconds after the ready light glows to be sure the capacitor is fully charged.

Most of the better autoflash units have a *sufficient light indicator* that lights or makes a sound to signal whether or not the flash light was adequate for a proper exposure. If it warns you that the light was insufficient, get closer to your subject or use a wider lens opening. To check exposure without taking a

82. An electronic autoflash unit has a sensor on its front to read the amount of light from the flash that's reflected by the subject. Then the sensor triggers a micro-computer in the unit, which controls the flash duration, to automatically produce the correct exposure. Even more sophisticated are dedicated autoflash units featuring TTL (through-the-lens) flash metering, where sensors in the camera at the film plane determine flash exposures.

picture, press the unit's *open flash button* to see if the sufficient light indicator signals that the autoflash output is adequate.

The most versatile units have a *tilting* and/or *twisting flash head*, which can be adjusted for bounce light and still allow automatic operation when mounted on the camera. Some feature TTL metering or have an accessory or detachable sensor that remains on the camera to provide autoflash exposures when the unit is removed from the camera position or aimed for bounce light.

You'll be confronted with a host of accessories for the more expensive automatic flash units, including separate *high-voltage battery packs* for faster recycle times and a greater number of flashes before new batteries are required. A *handle mount* and camera bracket permit quick detachment of the unit for off-camera flash; some handle mounts carry additional batteries to increase the number of flashes and cut recycle times. Color filters, bounce-light diffusers, and variable power controls to adjust the light output are among other accessories available for electronic flash units.

Flash Contacts and Cords

Unless electronic flash is built-in, 35mm cameras usually have a mount on top of the camera to hold a flash unit. Called a *hot shoe,* it's electrically wired and makes contact to the flash when the unit is inserted and locked into the shoe. Because the flash is triggered through the hot shoe contacts when you press the camera's shutter release, the hot shoe eliminates the need for a *flash connecting cord,* which can come loose, break, or get in your way. With dedicated autoflash units, the hot shoe also transmits the flash's signals to the viewfinder to indicate when the unit is ready to fire and if the flash light has been sufficient for a proper exposure.

A drawback of any hot shoe is that it holds your flash in one position on the camera and does not permit variation in lighting. Some units partially overcome this problem with a tilting and/or twisting head, which can be adjusted to change the direction of the flash, most often for bounce lighting. For complete control you need a flash connecting cord. With it the unit can be removed from the camera's hot shoe and still maintain electrical contact to fire the flash when the shutter release is pressed.

Most 35mm cameras have a small socket, sometimes marked with an X, where a flash cord can be connected. Other models require that a socket adapter or special flash cord be slipped in the hot shoe, especially if you want to utilize the features of an autoflash or dedicated unit when it's taken off the camera.

Flash cords come in various lengths, either straight or coiled. When buying one, take your equipment to the camera store to make certain the cord's plug fits your camera's flash socket and the flash unit. Flash cord sockets on 35mm cameras commonly take a PC (push contact) pin-type plug. Always check that the plug is firmly inserted in the socket so the flash will fire. If the plug is loose, its rounded tip can be squeezed carefully to make it fit better.

When frequently unwound and rewound, or twisted, flash cords can become damaged or broken. If your flash unit fails to work, its connecting cord may have been severed internally. To test for a faulty cord without taking a picture, disconnect and short-circuit the flash cord plug with a paper clip or pin. The unit should flash. If not, wiggle the cord while short-circuiting the plug. If it flashes then, the wires in the cord are probably broken and make contact only occasionally. Get a new cord.

Also be aware that the most common reason a flash does not fire, whether attached by a flash cord or mounted in a hot shoe, is because of poor electrical contact at the battery terminals. An almost invisible corrosive film can develop and break the electrical circuit. Prevent this by wiping the battery ends and flash contacts with a dry cloth or rub them with a pencil eraser.

Synchronizing Flash

Assuming that your flash unit is working properly and making electrical contact with the camera through a connecting cord or hot shoe, there's another consideration regarding the use of flash. This is synchronization of the flash with the camera's shutter. The shutter *must* be open when the flash goes off. Otherwise the film will not receive the reflected light from the flash, and the result is a dark or black picture.

Because electronic flash units and flashbulbs are different, synchronization for each is different. When fired, electronic flashes are instantly at their full brightness; bulbs take longer to reach their peak illumination. For this reason, cameras may have a pair of flash cord sockets, or a switch, to provide synchronization for each type.

Any socket or switch position marked X is synchronized for electronic flash. If there is another socket or switch position it is for use with flashbulbs.

A socket or switch position marked M refers to Class M bulbs, the flashbulbs most common today and reaching peak brilliance at a medium speed. Cameras with focal plane shutters, such as 35mm SLRs, occasionally have a flash cord socket or switch position marked FP for synchronization with the FP (focal plane) class of bulbs. These flashbulbs reach their peak quickly and maintain that light output for the time it takes the shutter to travel across the plane of the film.

Between-the-lens leaf-type shutters may have a V marking. This setting is the self-timer position, which causes a delayed-action shutter release. When set on V, such shutters provide X (electronic flash) synchronization.

What does all this mean? Simply that you must be sure your flash (whether electronic or bulb) is connected through the correct socket or switch position so it will fire at the appropriate moment when the shutter is open. (Read your camera's instructions for specific guidance.)

Your other concern regarding proper synchronization is shutter speed. The speeds you can use depend on whether you're shooting with electronic flash or flashbulbs and whether your camera has a focal plane or leaf-type shutter.

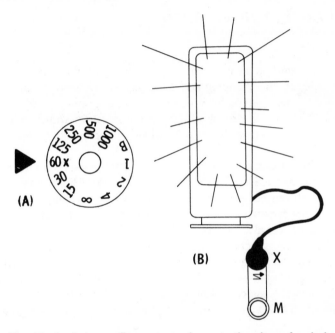

83. *Usually with single lens reflex cameras, because they have focal plane shutters, the maximum shutter speed that can be used with electronic flash is limited to 1/60 second (A), unless otherwise indicated in the camera's operation manual. Some models permit speeds to 1/125 and even 1/250 second. Also, to be sure the flash goes off only when the shutter is fully opened, the flash unit's connecting cord must be plugged into the X flash synchronization socket (B), unless the camera's hot shoe is used.*

Cameras with focal plane shutters include 35mm SLRs. Because the curtains of such shutters must be out of the way completely when the flash goes off, a relatively slow shutter speed usually is required. The maximum speed allowed varies according to camera design and often is no faster than 1/60

second. A few focal plane cameras are even limited to 1/30 second when using electronic flash, although newer models sometimes allow shutter speeds up to 1/125 and even 1/250 second.

Read the instruction book to learn the maximum shutter speed permitted for electronic flash with your camera model. And always remember to set the shutter speed dial to that speed (or slower) before taking a flash picture; dedicated autoflash units automatically set the correct shutter speed whenever the unit is turned on.

Testing Synchronization

If your camera has a focal plane shutter and your flash pictures are only partially exposed, the shutter speed is too fast. A simple synchronization test can be done when there is no film in the camera. Connect and turn on your electronic flash, set the maximum X synchronization shutter speed given in your manual, open the lens to its widest f/stop position, and open the camera back.

Face a white wall one to two feet away, look at the lens from the back, and press the shutter release. You should see a full circle of light if the shutter and flash are synchronized. A partial circle or star pattern of light, or no light at all, indicates faulty synchronization. Try it again at a slower shutter speed. This synchronization test also will work with flashbulbs.

With flashbulbs, synchronization is possible at the X switch position or X socket connection if the speed of the shutter, focal plane or leaf-type, does not exceed 1/30 of a second. Exceptions are the FP (focal plane) bulbs, and with them the synchronization should be M or FP. M-2 bulbs should always be used at X synchronization and at a shutter speed no greater than 1/30 second.

To use other flashbulbs at faster shutter speeds, the M socket or M switch position must be used. With leaf-type shutters on M synchronization, speeds up to 1/500 second can be used for all bulbs, except the M-2 as noted. With focal plane shutters, maximum shutter speeds vary according to the bulb type and the camera shutter design. Consult your camera manual.

Flashbulb types in current use today are M-2, M-3, M-5, M-25, AG1, flashcubes, magicubes, flipflash, and flashbars. Also FP 6 and 26 for use with focal plane shutters. Of course the other bulbs can be used with focal plane shutters, too. If a B follows the bulb number, i.e., AG1B, this indicates it is a blue bulb and is designed for use with color film. But it will work with black-and-white film, too.

In summary, synchronization is important because the burst of the flash

must occur with the shutter fully opened. Whether you use X, M, or FP synchronization depends on the type of flash unit (electronic or bulb), bulb characteristics, and the shutter speed desired.

Likewise, as one factor in determining proper exposure, shutter speeds with flash depend on whether an electronic unit or flashbulbs are being used, and whether your shutter is focal plane or leaf-type.

As a simple rule to remember, any type of electronic flash or flashbulb will work at a shutter speed of 1/30 second (or 1/25 on older cameras) in the X synchronization position.

Figuring Correct Flash Exposures

A common setup for flash photography these days is a 35mm SLR camera with an accessory autoflash unit mounted in the hot shoe. To take an autoflash picture with such equipment, these are the usual steps:

First the camera's shutter speed dial is set to the speed required for flash synchronization; this is done automatically by the flash if it is a dedicated unit. Next a *calculator dial* or microcomputer liquid crystal display (LCD) on the flash unit is set to the ISO/ASA speed of the film in the camera. The photographer uses it to select a lens opening for the minimum-maximum automatic operating range that covers the distance between his subject and the flash. Then that f/stop is set on the lens, and the lens is focused. Finally the flash unit is turned on, and when the ready light signals that it is recycled and ready to fire, the shutter release is pressed to take the flash photo.

As you recall, an autoflash unit determines the exposure automatically with a sensor that reads the flash light reflected back from the subject and controls the duration of the flash (from as long as 1/1000 to as brief as 1/30,000 of a second). In most situations an autoflash works well and produces well-exposed pictures. But it can be fooled.

For instance, if your subject or the background is very light, the bright reflection received by the sensor cuts off the flash light too quickly and the photo will be underexposed. Similarly, dark subjects or backgrounds will not reflect much light back to the sensor, permitting a longer flash duration that overexposes the photo.

You can avoid such autoflash exposure problems by analyzing the scene and then adjusting the lens opening to a larger or smaller f/stop than the calculator dial indicates. How much more or less exposure is required can be determined by taking several exposures at different f/stops, but a better way is to switch the autoflash to manual and calculate the exposure yourself. Shooting in the manual mode also can be worthwhile for bounce flash, fill-in, and multiple-flash photos.

When an autoflash is set to manual it overrides the sensor and produces the full flash output (usually a duration of 1/1000 second). To control exposure, you adjust the lens opening according to the distance between the flash and your subject. It's easy to determine the f/stop to use by referring to the flash unit's calculator dial. First make sure the dial is set to the flash-to-subject distance (one way is to focus your subject and check the distance on the lens focusing scale), then look on the dial just opposite that distance to find the f/stop to set on the lens.

84. *Usually flash units or reflectors feature an adjustable calculator dial to help the photographer determine the f/stop to use for correct manual flash exposure. First the film speed is set on the ISO/ASA indicator. Then the flash-to-subject distance is determined. Finally, the f/stop on the dial opposite this distance is set on the camera lens. In this example, using ISO/ASA 25 film, a flash-to-subject distance of 5 feet indicates that a lens opening of f/5.6 is required. For subjects 10 feet from the flash, f/2.8 would be the f/stop to use.*

Even without the convenience of a calculator dial, you can determine the correct f/stop for manual electronic flash exposures by using a *flash guide number*. The number varies according to the ISO/ASA speed of the film being used and the light output of the flash unit.

Once you know the guide number, just divide it by the distance between the flash and your subject, and the answer is the f/stop you set on the lens. Thus, if the flash guide number is 80, and the flash-to-subject distance is 10 feet, the correct lens opening is f/8. At 20 feet, the f/stop would be f/4.

Sales literature for flash units often lists specific guide numbers, or you can check in the flash instruction booklet. That's where you'll find the unit's light

output. It's a number rating indicating *BCPS (beam-candlepower-seconds),* and you can use it with the chart below to determine flash guide numbers for various film speeds.

To find the flash guide number, match the ISO/ASA film speed with the BCPS light output. For example, if an electronic flash unit has a BCPS of 2000, and you are shooting with ISO/ASA 64 film, the guide number is 80.

BCPS (beam-candlepower-seconds) light output of electronic flash unit										
	350	**500**	**700**	**1000**	**1400**	**2000**	**2800**	**4000**	**5600**	**8000**
25	20	24	30	35	40	50	60	70	85	100
ISO/ 32	24	28	32	40	50	55	65	80	95	110
ASA 64	32	40	45	55	65	80	95	110	130	160
film 80	35	45	55	65	75	90	110	130	150	180
speed 125	45	55	65	80	95	110	130	160	190	220
160	55	65	75	90	110	130	150	180	210	250
400	85	100	120	140	170	200	240	280	340	400

85. Instead of a calculator dial, some electronic autoflash units feature a micro-computer liquid crystal display (LCD) to indicate the f/stop and automatic operating range for correct flash exposures.

Please note that with electronic flash, guide numbers are not affected by the camera's shutter speed. However, if you are using flashbulbs, guide numbers vary according to the type of bulb, the reflector used, synchronization (X or M), and the shutter speed selected. Flashbulb cartons and some film instruction sheets give charts with flash guide numbers. Of course, as with electronic flash units, the easiest way to determine manual flash exposures is to use the calculator dial or chart you'll also find on many flashbulb reflector guns.

Figuring flash exposure is not difficult once you understand the concepts of synchronization and flash guide numbers. But actually getting correct exposures and good photographic results is somewhat more complicated. The problem is that the guide numbers are figured for "average" subjects under average conditions indoors. Exposure variations of one or two f/stops are possible if the subject is to be photographed in non-average conditions, such as a coal mine or a hospital room. If the subject is very dark or very light, or if the subject is in very light or very dark surroundings, exposure may be incorrect unless adjusted according to existing light and other conditions. Subjects outdoors at night, for instance, may require one-half to one f/stop more exposure than the calculator dial indicates for a manual flash shot. Always bracket flash exposures if you are uncertain of the results.

Professional photographers who frequently take flash pictures, especially in controlled studio situations or when using multiple flash techniques, often rely on a *flash meter* to determine exposures. When the meter is pointed toward or held at the subject's position and the flash is fired (using the unit's open flash button), the meter indicates the f/stop to set on the camera lens. The most versatile are multimode meters that also can be used to read the ambient light and calculate exposures for the existing light as well as flash.

Flash Techniques

Good flash pictures take more effort that just determining exposure. For instance, if part of your subject is closer to the flash than another part, it will be overexposed unless the flash or subject is repositioned. Techniques for making appealing flash photos vary. A few include flat flash, bounce flash, off-camera flash, open flash, multiple flash, and fill-in flash.

Flat-flash, or on-camera flash, is the most common type of flash lighting. It is most convenient for the photographer because the flash unit is mounted on his camera. Sometimes it is also the least pleasing because the direction of the light is from the front and seems unnatural. The resulting lighting would be similar to what you'd see if everyone walked around with coal miners' lamps on their heads. One way to avoid the harshness and directness of flash is to bounce it off the ceiling or a wall. *Bounce flash* gives soft illumination.

Exposure is figured by determining the distance the light travels from flash to ceiling (or wall) to subject, and then increasing the exposure by opening up the lens about two f/stops. When using an electronic autoflash unit with a tilting head, bounce light exposure will be figured automatically. Just make sure the automatic operating range for the f/stop you've selected covers the total distance the bounce light travels from flash to ceiling to subject. Also, check the unit's sufficient light indicator to see if the flash exposure was adequate; if not, use a larger lens opening, decrease the bounce flash distance, or switch from autoflash to manual. (You can test for sufficient light in advance by pressing the unit's open flash button to fire the flash without taking a picture.)

White or ivory ceilings or walls are best when using bounce flash with color film; light reflecting from colored surfaces can alter the color of the subjects. Remember, too, that if the ceiling or wall is too far from the subject, the bounced light from the flash may be too weak to be effective as a main source of illumination. Bounce light works well when your subjects are in front of a mirror or window because reflections are avoided. Similarly, objects of glass or behind glass often can be best photographed by bounce light. Sometimes bounced light from a flash is used simply to supplement the overall existing light in a room, or to add illumination to a dark area of a room.

86. *The correct technique for bouncing flash off a ceiling is to remove the flash unit from the camera or tilt the flash head up so that the light which reflects from the ceiling will fall on your subject, not behind it. Unless you are using autoflash, figure the exposure by determining the distance from the flash to the ceiling to the subject, and divide this distance into the flash guide number. The resulting f/stop should be increased by about two f/stops because the light reaching the subject is not direct and is scattered by the ceiling.*

When more direct light is desired, especially for portraits, often it's best to move the flash unit to one side of the camera and point it at the subject. Slightly high and to the right or left of the camera are the most popular *off-camera flash* positions. This gives shadow and depth to a subject's face instead of the usual flat, frontal lighting.

By moving the flash unit's position, different effects can be achieved. For instance, when the flash is placed below the subject's face, a criminal, almost evil look will result. Or, when flashed behind the subject at a wall or backdrop, a silhouette can be made.

If the area in which you are photographing is dark, *open flash* can be used. Here the flash and its cord are disconnected from the camera. While the shutter is held open by using its B or T position, the flash unit is taken to the desired position and manually flashed. Then the shutter is closed.

Most units have an open flash button to fire the flash manually, or the cord's plug can be shorted. Of course, if any other light enters the lens while the shutter is open, it will be recorded on the film, too. Open flash can be effective when trying to light a large, dark area with only one flash unit. While the shutter is open, the unit is moved and manually flashed at different areas of the subject to provide the illumination required.

Remember to determine the f/stop according to the distance between the flash and the subject. For even lighting when making multiple flashes, always keep the flash the same distance from the subject. Bracketing the f/stop will help ensure that you get the correct exposure for your purposes.

Multiple flash, other than that done with the open flash technique, also is possible if you have two or more flash units. These offer greater control of lighting and exposure, and very pleasing results. Often the secondary unit is referred to as an *extension flash.*

This extra unit is especially useful when making portraits. The second unit can be used to fill in any shadows caused by the main unit. Or, back-lighting of the subject is possible. Exposure is based on the distance between the subject and the main flash unit, which is closer to the subject than the fill-in light.

The multiple units can be connected to one another by cords. However, the most versatile, although more expensive, method of firing the units is with the use of a light-sensitive photocell. This remote triggering device picks up the light from the main flash when fired by the camera's shutter and then fires the secondary unit.

Such remotely fired flash units often are called *slave units.* It is easier to place and use these units because no long connecting cords are required. A stand, clamp, or friend to hold the extra flash unit usually is needed. For more complete flash lighting, several units may be connected to each other or fired remotely.

Another use of flash is termed *synchro-sunlight,* or more commonly, *fill-in flash.* Here the flash augments the sunlight, or main artificial source of

87. *To highlight the details of this flower, and make it stand out from the back-ground, electronic flash was used instead of daylight to make the exposure.*

light. Fill-in flash is very helpful when harsh shadows must be reduced or eliminated. Placement of the flash for proper exposure is important.

Because the main souce of light is not the flash, the exposure is first determined according to an exposure meter reading. Remember, however, that for proper synchronization the shutter speed chosen must be compatible with the type of flash unit used. Also, with daylight color film, remember only an electronic flash or blue flashbulbs will give the correct color balance. Do not use clear flashbulbs with daylight color film.

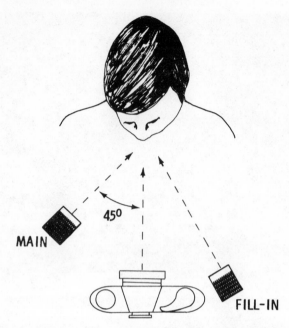

88. *When using two flash units to make a portrait, the main flash should be placed at a 45° angle to the direction of the camera lens. It also should be closer to the subject than the fill-in light, which usually is kept near the camera. Exposure is figured on the distance between the main flash unit and the subject.*

For fill-in flash, after the f/stop has been set according to the meter reading, it is divided into the flash guide number. The result is the distance in feet that the flash unit should be placed from the subject. Thus if the f/stop reading is f/8, and the flash guide number for the film being used is 80, place the flash 10 feet from the subject.

If the flash is placed any closer it will equal or overpower the sunlight. It will then provide the main souce of illumination, and the lighting effect will appear unnatural. Since the purpose of fill-in flash is to reduce the shadow area and give more detail to the subject, it must give a lower level of illumination than the sun or the main source of light.

Because flash guide numbers take into consideration a certain amount of reflected light that can be expected when flash is used in a room, outdoors the guide number gives about one f/stop less than would be needed for correct exposure if the flash were the only source of illumination. This means that figuring the distance of the fill-in flash unit from the subject according to the regular flash guide number will provide about half of the illumination of

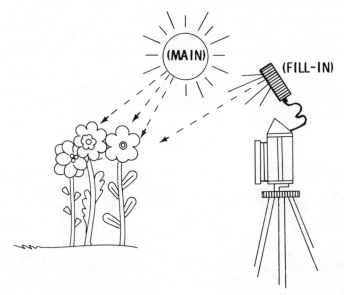

89. *To reduce or eliminate shadows caused by the sun, fill-in flash is used from a carefully calculated distance. If too close, it will overpower the sun's light. If too far away, its effect will be negligible.*

the sunlight—a fairly strong but usually good lighting ratio for fill-in flash. For less fill-in, the flash can be moved back from the subject even more.

There can be problems, of course. Most commonly the flash must be placed farther from the subject than the camera, and the flash unit's connecting cord is too short. One solution is an extension cord. For example, if the subject is 5 feet from the camera, and the distance of the fill-in flash should be 10 feet, you'll need a 5-foot extension cord for the flash.

However, if you are without the longer cord, there is a simple trick to cut down the light without moving the flash back. This is done by covering the flash reflector with a clean white handkerchief. One layer will generally cut the amount of flash in half, and thus is the equivalent of about one f/stop.

Here's how to figure how many handkerchief layers over the flash would be needed to keep the flash at the camera position. Divide the distance between the camera and subject into the flash unit's guide number to get the f/stop needed. For example, 5 feet into a guide number of 80 is f/16. If the proper exposure has been determined by an exposure meter reading to be f/8, the flash light output must be reduced by two stops. One handkerchief layer would reduce it one stop to f/11, another layer to f/16. So with two layers of a handkerchief over the reflector, the flash unit could be kept at the camera's distance of 5 feet and provide the proper amount of fill-in light.

Another way to reduce the flash light is to remove the unit's reflector. This is referred to as *bare bulb flash* and is commonly done only with flashbulbs. It is impossible with most electronic flash units because their reflectors are built-in, as is the case with flashcubes, magicubes, flipflash, and flashbars. Depending on the type of flashbulb reflector being removed (its diameter, shape, and reflecting surface), the illumination will be reduced by one or two f/stops for proper fill-in light.

90. To get rid of unpleasant shadows on faces in bright sunlight, fill-in flash adds light to the shadowed areas and makes a more pleasing picture.

Sometimes the flash light can be bounced off the photographer's shirt to reduce its output. Of course, if the flash unit must be closer to the subject than the camera to provide the necessary fill-in light, a longer cord will be required. Experimentation and bracketing are often necessary to obtain the best results with fill-in flash. Some of the more sophisticated electronic flash units, however, are equipped with a variable power control which can be adjusted to provide the appropriate amount of fill-in light from most any camera position. Even easier to use are dedicated autoflash units with TTL (through-the-lens) flash metering because they can be set to control the correct amount of fill-in flash light automatically.

Practical Considerations with Flash

Here are some practical considerations and tips for using flash. Flash is best for illuminating your subject if he would otherwise squint from the bright

sun or artificial light. With flash, your subject's eyes will be open naturally. Since babies often object to continuous bright light, the short burst of flash light is perfect for photographing them. Flash also makes it easier to capture babies' actions because babies move and change expression so quickly.

When using flash, remember proper exposure is based on the distance between the flash and the subject. If the subject varies in distance to the camera, the illumination will vary. So it is best to angle your subject, or flash, to provide *even illumination*. A Ping-Pong match photographed from one end of the table with the flash on the camera would result in one player being too light and the other too dark. Bouncing the flash off the ceiling to illuminate the entire table and playing area evenly is one solution. Another is to fire the flash from one side of the table to light both players equally. Always remember the depth and width of your subject are important considerations when figuring how to make effective flash pictures.

Common distractions caused by flash are the *shadows* in the background. A black outline of the subject is often cast on the wall behind. This can be avoided in several ways. If the flash is mounted or held directly above the camera lens, the shadows from the light will fall directly behind the subject and not be recorded on the film. Unfortunately some hot shoes or accessory shoes to hold flash units are mounted to the side of the camera lens. If possible, remove the unit so it can be held directly above the lens.

If your flash unit mounting is above the lens when the camera is held in a horizontal position, remember if you turn the camera to make a vertical picture, the flash will then be at the side. Unpleasant shadows can result. To avoid this, take the flash unit off the camera and hold it just above the lens.

Before making your picture, remember to check the angle of your flash unit so that it is pointed at the subject. Sometimes, while holding, setting, and then tripping your camera, you'll inadvertently direct the flash unit in the wrong direction. Check it just prior to shooting.

You also can avoid shadows on the background by bouncing the flash off the ceiling, if possible. Otherwise, move your subject away from the background so any shadows will be lost in the darkness behind the subject. If the flash light cannot reach the background, shadows from the subject cannot reflect back to the film in the camera.

Also beware of shiny objects in the background which may cause a glaring reflection of the flash light. Windows or mirrors are the worst. Highly polished wood paneling or furniture, or enamel-painted walls, throw back distracting light reflections, too. Move your subjects away from such shiny surfaces, or place your flash so the angle of reflected light will not return into the camera's lens and record on the film.

Do not tell your subjects when you are going to fire your flash or they may anticipate the bright light and close their eyes. If someone says they blinked during the picture, ask if they saw a pink or white light. If pink, they saw the flash light through their eyelids and so their eyes were probably closed during the exposure. Make another.

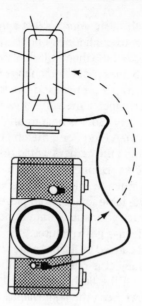

91. If a flash unit is attached to the camera's hot shoe or flash mount for horizontal pictures, when the camera is turned vertically the flash must be removed and again positioned above the lens in order to avoid unnatural side shadows.

Sometimes your color photographs reveal a subject with abnormal red or *pink eyes.* This is caused by the flash light reflecting off the retina or interior of the eyes back into the camera lens. Avoid this by changing the location of your flash. Hold it about a foot above your camera. The angle of light will then be different and will not reflect off the eyes' retinas into your lens. There are special *flash extenders* to raise camera-mounted flashcubes, magicubes, and some electronic flash units.

Likewise, if your subject wears glasses and is looking into the camera, keep the flash angle higher than the camera to avoid a reflection. With on-camera flash, have your subject wearing eyeglasses tilt his head down slightly so the flash reflection will be angled below the camera lens.

Your flash techniques will improve with practice. Just remember to try experiments using flash off your camera as bounce light or fill-in light. Frontal, flat lighting resulting with on-camera flash use will provide acceptable illumination. But other approaches to flash lighting will produce more creative photographs.

Even if you prefer to use only existing light, a flash can be valuable. Buy one and try it. An inexpensive electronic flash will get you started. Later, a

more powerful and versatile automatic electronic flash unit may fit into your photographic budget and be a worthwhile addition in your gadget bag.

But be sure to test your new flash equipment before you really need to use it. Otherwise you may miss an important picture. And always make sure your batteries are fresh or recharged.

5

Selecting Films

Regardless of the lighting you use, your subject usually is recorded on light-sensitive film in order to produce the picture you want. And your choice of film greatly determines the photograph that results. After some experimentation, photographers usually stick with a few favorite films. Personal taste helps determine which ones. Of course, there is much more to think about than just deciding between black-and-white and color films. With color films, for instance, you have a choice of two basic types: color negative films (designated by the suffix "color" in their names) for making prints, and color positive (or reversal) films (designated by the suffix "chrome" in their names) for making slide transparencies to project on a screen.

Although Eastman Kodak still sells about 90 percent of the film in the U.S., several other brands are popular today. With the introduction of numerous new and improved films in the early 1980s, Fuji, Agfa, Ilford, 3M, Konica, and others now offer worthy competition to films in the ubiquitous yellow box. Regardless of the brand or type you buy, there are two important characteristics to consider: film speed and the film's definition (which includes sharpness, graininess, and resolution). In addition, you must consider the film's color sensitivity when using black-and-white film, and color balance when it's a color film. Of course, you should use "fresh" film.

Since film qualities deteriorate with age, out-of-date film will not have the same manufacturer's characteristics regarding speed, contrast, and color as when it was fresh. An *expiration date* is printed on the film carton. Often called the "shelf life" of films, the expiration date supposes that the film will be kept in temperature conditions similar to those of films for sale in a camera store. If films are subjected to extreme heat or humidity, expiration of the film will occur before the date indicated.

Keeping film in a refrigerator or freezer may retard changes in film characteristics, but this does not prevent the inevitable changes in film speed, contrast, and color after the expiration date. The degree of deterioration of out-of-date film varies; some films will show little obvious change months or even a year or two past the expiration date. Because manufacturers do not guarantee film after the printed date, expired film is often sold at greatly re-

duced prices. Many photographers buy out-of-date film to save money or to experiment.

Some films are labeled *professional,* which means they should be refrigerated at 55°F. or less before use and processed promptly after exposure for the optimum results. Kodak and Fuji give extra attention to their pro films, especially regarding film speed and color balance. For instance, each batch of Kodak professional film is tested and exposure must be within 1/6 f/stop of its stated ISO/ASA rating. Although regular films also are carefully manufactured, pros expect perfect exposures and color balance and thus favor professional films, especially when shooting in a studio or other situations where the lighting is under their full control.

Speeds of Film

The film's speed, designated by an ISO/ASA number, indicates how sensitive the film is to light. The higher the ISO/ASA number, the more sensitive the film is. Contrast generally increases with film speed, too. Films for general photography have speeds varying from ISO/ASA 25 to 1000, with a few even faster.

Originally, film speeds were designated arithmetically in the U.S. by the American Standards Association (ASA) and logarithmically in Europe by a German standards group, Deutsche Industrie Norm (DIN). As a result, a film speed of ASA 100, for example, is the same as DIN 21. In an attempt to clear up any confusion, the International Standards Organization recently combined both numbers into an ISO designation for worldwide use. Thus a film speed of ASA 100/DIN 21 is now identified as ISO 100/21°. For clarity, in this book the DIN equivalent is dropped and film speed is indicated with only the ASA number, such as ISO/ASA 100. A recent trend by film manufacturers is to include the speed of a color film in its name, as Kodak does with Ektachrome 100, Kodacolor 400, and its many other color slide and negative films.

Films for black-and-white photography usually have just one film speed regardless of the type of lighting used, daylight (outdoor) or artificial (indoor) light. Such artificial illumination refers to light from incandescent lamps and is called tungsten light by film manufacturers. A few black-and-white films may have a special ISO/ASA number for tungsten light.

Films for color photography usually are designed for daylight *or* tungsten light, and ISO/ASA film speeds are indicated accordingly. In the event a daylight color film is used with a special filter to convert it for use with tungsten light, the original film speed must be changed. Film instructions usually indicate the revised ISO/ASA film speed when using such a filter. Tungsten color film also can be changed to daylight use with a filter. Again, the film's ISO/

ASA will change. Some of the newer color negative films, like Kodacolor VS, which is available at speeds of ISO/ASA 100, 200, 400, and 1000, produce good color results regardless of the type of light—daylight or tungsten (or fluorescent)—without filters or changes in film speed.

For proper exposure readings, film speed must be correctly set on your hand-held or built-in camera exposure meter. Always remember when you change to film of a different speed to also change the ISO/ASA number on your exposure meter. (You'll notice most Kodak 35mm films carry a symbol, DX, to indicate they have been electronically coded to program future automatic cameras for the film's specific ISO/ASA speed, exposure latitude, and number of exposures. Other bar codes on the cassette and film help to identify the type and length of film for developing and assist in automatic printing of negatives.)

What speed of film is best? It depends on the lighting situation and the results you want. The slower-speed films, such as those rated ISO/ASA 64 or 100, are admired for sharp images, minimal graininess, and excellent color renditions. For general photography a popular choice is film with a speed of ISO/ASA 200. (This is the speed of the color print films made for automatic disc cameras.)

For low-light situations, as when the weather is overcast, the faster ISO/ASA 400 speed films, or sometimes the supersensitive ISO/ASA 1000 films, are especially useful. Even on sunny days, high-speed films are welcome for a number of reasons. You can use a faster shutter speed to stop action and also avoid blurring caused by accidental camera movement. And that makes it easier to get sharp images when shooting with a telephoto lens, which is hard to hold steady. Another advantage of fast films is that you can shoot at smaller lens openings to improve depth of field and get more of your subject area in focus. They also extend the useful range of your electronic flash.

Sizes of Film

The film size for 35mm cameras is 135, and 24- and 36-exposure lengths loaded in light-tight metal *cassettes* are standard. Some 35mm film is available in bulk. Each bulk roll has 100 or more feet of film, and the photographer has to load his own cassettes to use it in the camera. All 35mm film has sprocket holes bordering both edges of the film.

Rolls of film in larger sizes are commonly designated 120, 220, 620, or 127. Such film is wrapped with paper backing onto a spool. The backing prevents light from exposing or fogging the film before and after the film is used in the camera. Roll films will make 8, 10, 12, 15, 16, 20, or 24 exposures, depending on the camera's format (square or rectangular) and the length of

the film roll. Size 120 roll film, for instance, allows fifteen 2¼ × 1¾-inch (6 × 4.5cm), twelve 2¼ × 2¼-inch, or ten 2¼ × 2¾-inch (6 × 7cm) exposures, while size 220 film gives twice as many exposures of the same size. Other spool-wound roll sizes include 828, 116, and 616.

92. A novel film format introduced by Kodak in 1982 is the disc, a wheel of 15 tiny images shown here after processing. A built-in camera motor automatically rotates the disc to the next frame after each exposure.

Some film comes in plastic *cartridges* and is designed to drop in the camera for loading, as with Kodak's Instamatics. The larger cartridge film size is 126, while the smaller, more popular pocket cameras take 110 film. Cartridge films also use a light-tight paper backing to prevent fogging of the film. The exposure frame number is printed on this backing and appears through a window in the cartridge and camera. The films come in 12-, 20-, and 24-exposure lengths. A film-speed code notch on the cartridge sets the appropriate ISO/ASA on automatic cameras when the cartridge is inserted.

There are also subminiature film sizes, including the revolutionary *disc* film, which is a wheel of fifteen minuscule 8 × 10mm images. (For comparison, 35mm film images measure 24 × 36mm, nearly eleven times as large.) Intro-

duced by Kodak in 1982, disc film images are even smaller than the 16mm or 9.5mm film cartridges used in tiny "spy" cameras like certain models of the Minox. Those larger-format subminiature cameras yield 18, 20, 24, or 26 exposures.

In addition, film comes in *sheets* which are put in light-tight film holders to use with view, studio, or older press cameras. Sheet film sizes are measured in inches, and standard sizes are 2¼ × 3¼, 3¼ × 4¼, 4 × 5, 5 × 7, 8 × 10, and 11 × 14. Also used in studio, view, and older press cameras are *film packs,* each containing sixteen thin sheets of film that are attached to paper tabs which the photographer pulls to advance each sheet. Common film pack sizes are 2¼ × 3¼, 3¼ × 4¼, and 4 × 5 inches.

Not all types of films are available in all sizes. Some may just be available in sheets, pack, cartridge, 35mm, roll, subminiature, or bulk form.

Types of Film

Why isn't there just one type of film? Quite simply, because each has certain characteristics, one film cannot do everything. For instance, there are special films for copying, others for infrared photography. While some films give very well defined pictures in low-light situations, others are considered to give grainy, less sharp results. Most black-and-white films produce negatives from which prints are made. But some will produce direct positives and can be used to make black-and-white slides. A remarkable 35mm black-and-white transparency film was introduced in 1983 by the pioneer in instant picture films, Polaroid. In less than 3 minutes after exposure in any 35mm camera, a 36-exposure roll of Polapan film can be processed by running it through Polaroid's portable AutoProcessor. The black-and-white slides can then be mounted and projected immediately.

Polaroid's 35mm instant slide system also features a color transparency film, Polachrome, available in 12- and 36-exposure rolls. While some of the traditional color films produce slide transparencies after being processed in the more conventional manner, many others yield negatives which are then used for making color prints. However, you should know that although a color film is designed to produce either slides or prints, there are other possibilities. Positive slide film, for example, can be used to make color prints, although with some increase in contrast. And color negative films can be used to make color slides and even black-and-white prints. For best results, however, choose the type of color film intended for the primary results you want, slides or prints.

Color balance is a consideration in the selection of a color film. A color film should accurately reproduce the colors seen with your eyes. So films are

balanced for certain light sources in order to reproduce faithfully the colors as you saw them. You'll find color films balanced for daylight or artificial tungsten light. Light sources vary and each has its own *color temperature,* which is measured in Kelvins, abbreviated K. Thus, different color films are designed for different light source color temperatures (Kelvins) to provide correct color balance. Daylight films, for instance, are balanced at 5500K, based on the color temperature of average noon sunlight.

Light from most electronic flash units, with a color temperature of 5500K, is thus balanced for use with daylight films too. As for other artificial light sources, many professional portrait studio lights have a color temperature of 3200K, while a No. 2 photoflood lamp, used by many amateurs, is rated 3400K. Therefore, for each tungsten light source of a different Kelvin (K) value, a different type of color film (or a filter) will be necessary in order to accurately reproduce the colors of your subject as you saw them. For example, Kodak makes Ektachrome 160 (Tungsten) film for use with 3200K studio lights and Kodachrome 40 (Type A) film for use with 3400K photoflood lights.

So be sure to use the type of film correctly balanced for your light source. When this is not possible, filters can be used to achieve the correct color balance. However, use of filters requires an increase in exposure, and a slower shutter speed or wider f/stop may not be possible with your photographic situation.

Another problem appears when exposures longer than 1 second are made. Since most color films in general use are designed for the more common short exposures, they lose their speed and the ability to reproduce colors correctly with exposures 1 second or longer. This is termed *reciprocity failure.* It varies according to the film, and you will be advised in the film's instructions how to compensate.

Correct exposure for color film is important, especially for color positive transparency (slide) film, which has less exposure latitude than color negative (print) film. Bracketing the exposure is often best in order to achieve the results you want.

One benefit of shooting black-and-white films is that they can be exposed in all light situations: in daylight or indoors with existing light, fluorescents, studio lights, photofloods, or flash. However, selection of a particular black-and-white film often depends on how big an enlargement you want to make from the negative. Big enlargements from a 4 × 5-inch negative should have greater definition than those from the smaller 35mm negatives.

Definition indicates the quality of detail evident everywhere in the photograph. And *sharpness* between the edges of the details in the picture is one indicator of definition. Does the edge between a dark and light subject area appear sharp, or does this line blend from one area to the other?

Another consideration of definition of a film is *grain.* Chemical action during development can give the light-sensitive coating of films a sand-pebble appearance in the resulting negative or slide. When enlargements are made,

these grains become larger and reduce the definition of a photograph (although not necessarily the effectiveness of the picture). The type of developer used, as well as the time and method of development, affect the graininess of a film. Remember that the faster the speed (ISO/ASA) of your film, the more the graininess becomes evident.

Definition is determined by the *resolving power* of a film, too. This refers to the fine detail that a film is able to record. Proper exposure helps maintain a film's resolution. Of course, an inexpensive camera lens with poor resolving power affects a film's resolution adversely.

Regarding definition, you'll hear photographers most often talk about the graininess of a film. This is because the more graininess, generally the less resolution and sharpness to a picture.

Color sensitivity also is a consideration in regard to the black-and-white film you choose to use. Light produces various wavelengths or colors, and films vary in sensitivity to them. Unless you're color-blind, your eyes are sensitive to all colors. Black-and-white films that also are sensitive to all colors of visible light are termed *panchromatic*. There are some, however, that are sensitive only to ultraviolet, blue, green, red, or infrared light.

93. *Modern black-and-white films are called panchromatic, which means they are sensitive to all colors of visible light. The Mexican couple, in colorful folkloric dance costumes, are reproduced on film in black, white, and various shades of gray.*

Panchromatic films record colors in a variety of gray tones. These colors should be reproduced with brightness similar to that which you saw with your eye. Understanding about color sensitivity of black-and-white film is important when it comes to using filters. Filters and their use will be discussed in the following chapter.

While their color sensitivity is similar to conventional black-and-white films, two newer black-and-white types made by Ilford and Agfa are called *chromogenic* films. That's because they utilize color film technology to produce images with chemical dyes instead of the metallic silver normally used in black-and-white films. The result is very fine grain and exceptional detail in both shadow and highlight areas of a picture. (Another bonus of these remarkable films is that you can expose them anywhere from ISO/ASA 100 to 1600, even changing the film speed in the middle of a roll! Set a low film speed when you want the least amount of grain and a high ISO/ASA when the light level is low and you need to build up contrast in a scene.)

Clarity of detail (definition) in regard to sharpness, grain, and resolution is a consideration with color film, too. So is the speed of the film. Whether you wish to process the color film yourself is another factor which will determine the type of color film to use. And, as with black-and-white film, not all color films are available in every film size. Of course, cost of film varies too, and this can be an important factor concerning the type of film you use.

Development of Films

Films are developed by the film's manufacturer, by independent processing laboratories, or by the photographer himself. Film manufacturers will develop only their own brands of film. Sometimes they do not offer a developing service for all types of their films. Because their reputation and subsequent film sales depend on the photographer being satisfied with the quality of his photographic results, film manufacturers who develop their own films usually do the best job possible. To accommodate their color film users more quickly, some film manufacturers have set up processing laboratories around the country. Kodak, for instance, has ten labs in the U.S.

The quality of developing ranges greatly with independent laboratories. Many, like the so-called *one-hour* or *fast-photo labs,* operate on a volume basis and do mostly snapshot processing, while some are called *custom labs* and usually give more attention to each order. Unfortunately, too many labs are sloppy and the results show scratches, streaks, stains, or dust marks. Worse, the customer does not complain, even continuing to send his film to the same processor. I think if you spend the money for a good camera and film,

plus the time to compose a good picture, your result should be the best possible. Don't let the final step, processing, ruin your investment and photographic effort.

Because they don't trust others to handle their films, many amateur and professional photographers develop their own. Even many color films can be processed at home, although Kodachrome is one exception. Regardless of the choice you make regarding who will develop your film, make sure results are what you expect them to be. If not, change processors.

Films should be developed according to the manufacturers' specifications, although do-it-yourself photographers occasionally prefer different chemicals and procedures than those recommended. Many films can be altered during development. This means that you can unintentionally or purposely over- or underexpose the film, and then compensate to get a good result by under- or over-developing the film.

Photographers do this in their own darkrooms, or they send incorrectly exposed film to a custom lab which will develop it according to special instructions. This is not as common with color films as with black-and-white. However, some manufacturers indicate a special ISO/ASA which can be used if a color slide film is to receive special development. This enables the photographer to shoot in low-light situations with a film speed greater than the normal ISO/ASA. This is called *"pushing"* the film.

For instance, Kodak's Ektachrome 400 has a regular film speed of ISO/ASA 400 but this can be "pushed" to ISO/ASA 800 if special processing is ordered. There is an extra charge for such special processing. Or you can "push process" when you develop the film at home, which allows the speed of Ektachrome 400 film to be rated as high as ISO/ASA 1600. A newer color slide film, Ektachrome P800/1600, is specially designed for push-processing. Its film speed range is ISO/ASA 400 to 3200, but you must expose the entire roll at the one setting you select: ISO/ASA 400, 800, 1600, or 3200. And don't forget to mark the cassette with the film speed you used so the processor can develop it accordingly.

The price of a few color films, like some Agfachrome, includes the cost of processing. Years ago Kodak also included processing in the purchase price of Kodachrome color slide film. This practice was dropped in the United States, but Kodak's Kodachrome film sold abroad still includes processing in the initial price. Such film is specially marked, and Kodak processing labs abroad or in the U.S. develop the film and mount slides without further cost.

Within the U.S., Kodak sells *prepaid processing mailers* which cover the cost of processing the film when it is sent to a Kodak laboratory. The processed film is returned to your home address postpaid. These mailers are available for Kodachrome and Ektachrome color slide films and Kodacolor print film. When traveling, using prepaid processing mailers is a good way to have your photographs ready and waiting on your return home (unless you don't trust the postal service in some of the foreign countries you're visiting).

94. *Like this tearful boy, photographers get upset if their pictures are ruined by careless processing. Whenever that happens, be sure to complain, and change to a lab that gives consistent quality in processing negatives, prints, and slides.*

Popular Films Currently Available

Following is a list of films popular with many photographers today. Included are film names, ISO/ASA speeds, and available sizes in cartridge, cassette, and roll film.

Sheet films are not included, nor are disc and subminiature cartridges. Such 9.5mm or 16mm cartridges usually are loaded with some of the same films given below, and are available only from the manufacturer of the subminiature camera.

In the chart, cartridge film refers to either 110- or 126-size film. Cassette refers to 135-size film for 35mm cameras. Roll film refers to 120-size only. To check if a particular film is available in other sizes, ask at a camera store.

Divisions are made between black-and-white films and color films, and the latter is again divided into color positive transparency film (for slides) and color negative film (for prints).

Film speeds are indicated for daylight or tungsten use. With black-and-white films, the ISO/ASA is the same for either type of illumination unless a different ISO/ASA number appears in the tungsten column. With color films, the film speeds under daylight also apply to electronic flash and blue flashbulbs, whether cubes, flipflash, or flashbars.

MANUFACTURER/ FILM NAME	ISO/ASA FILM SPEED Daylight/Tungsten	Cartridge (110)	Cartridge (126)	Cassette (135)	Roll (120)
Color Transparency Films					
KODAK					
Kodachrome 25	25			X	
Kodachrome 64	64	X	X	X	
Kodachrome 40 (Type A)	—/40			X	
Kodachrome 25 Pro	25			X	
Kodachrome 64 Pro	64			X	
Ektachrome 64	64	X	X		
Ektachrome 100	100			X	
Ektachrome 200	200			X	
Ektachrome 400	400			X	X
Ektachrome 160 Tungsten	—/160			X	
Ektachrome 50 Pro	50			X	X
Ektachrome 64 Pro	64			X	X
Ektachrome 100 Pro	100				X
Ektachrome 200 Pro	200			X	X
Ektachrome P800/1600 Pro	*			X	
Ektachrome 160 Pro Tung.	—/160			X	X
Ektachrome Infrared	100			X	
Photomicrography Film	16			X	
FUJI					
Fujichrome 50	50			X	X
Fujichrome 100	100			X	
Fujichrome 400	400			X	
Fujichrome 64 Pro-T	—/64				X
Fujichrome 400 Pro	400			X	
Fujichrome 1600 Pro	1600			X	
AGFA					
Agfachrome 50 Pro	50			X	X
Agfachrome 100 Pro	100			X	X
Agfachrome 200 Pro	200			X	X
Agfachrome 1000 Pro	1000			X	
3M					
Color Slide 100	100			X	
Color Slide 400	400			X	
Color Slide 1000	1000			X	
Color Slide 640T	—/640			X	
POLAROID					
Polachrome AutoProcess	40			X	

*Film speed can be ISO/ASA 800, 1600, or 3200 with push processing; nominal speed is ISO/ASA 400.

MANUFACTURER/ FILM NAME	ISO/ASA FILM SPEED Daylight	FILM SIZES			
		Cartridge (110)	(126)	Cassette (135)	Roll (120)
*Color Negative Films**					
KODAK					
Kodacolor VR 100	100	X	X	X	X
Kodacolor VR 200	200			X	
Kodacolor VR 400	400	X		X	X
Kodacolor VR 1000	1000			X	
Vericolor III Pro,					
Type S	160			X	X
FUJI					
Fujicolor 100	100	X	X	X	X
Fujicolor 200	200				X
Fujicolor 400	400	X		X	X
Fujicolor 1600	1600			X	
AGFA					
Agfacolor 100 Pro	100	X	X	X	X
Agfacolor 200 Pro	200			X	X
Agfacolor 400 Pro	400	X		X	X
Agfacolor 1000 Pro	1000			X	
3M					
Color Print 100	100			X	
Color Print 200	200			X	
Color Print 400	400			X	
KONICA					
Color Print 100	100			X	
Color Print 200	200			X	
Color Print 400	400			X	

*Color negative films are color balanced for use with daylight, electronic flash, blue flashbulbs, cubes, and flipflash. Filters should be used for best results with tungsten light, although some of the higher-speed films offer acceptable color balance without filtration.

MANUFACTURER/ FILM NAME	ISO/ASA FILM SPEED Daylight/Tungsten	Cartridge (110)	(126)	FILM SIZES Cassette (135)	Roll (120)
Black-and-White Films					
KODAK					
Technical Pan	25			X	X
Panatomic-X	32			X	
Plus-X Pan	125			X	
Verichrome-Pan	125	X	X		X
Tri-X Pan	400			X	X
Panatomic-X Pro	32				X
Plus-X Pan Pro	125				X
Tri-X Pan Pro	320				X
Recording 2475	1000			X	
Royal-X Pan	1250				X
High-Speed Infrared	50/125			X	
ILFORD					
Pan F	50			X	X
FP4	125			X	X
HP5	400			X	X
XP1	400			X	X
AGFA					
Agfapan Pro	25			X	X
Agfapan Pro	100			X	X
Agfapan Pro	400			X	X
Agfapan Vario-XL	125-1600			X	X
POLAROID					
Polapan AutoProcess	125			X	

6

Using Filters

Filters play an important role in photography. However, few amateur photographers are educated in the use and effect of filters. They might carry a gadget bag full of filters but rarely use them. Before you buy filters, know what they do and if they apply to the kinds of pictures you like to make. Descriptions of various filters for black-and-white and color photography follow. But first here are a few general facts.

Basically, filters alter the light reaching the film. They are used both to produce photographs identical in lighting contrast or color rendition to what you see in your viewfinder, and to make the result much different. Some filters are designed only for black-and-white film, others only for color, and some for both kinds of film. A polarizing filter, for instance, works with color and black-and-white films to reduce glare and reflections from subjects and give increased vividness to scenic pictures by diminishing haze.

Filters are placed between your subject and the camera's lens. They can be screwed, clamped, or taped to the lens. Filters for camera work usually are of dyed optical glass or colored gelatin cemented between two pieces of optical glass. Another filter material, acetate, is mostly used in color printing, not for photographing, unless it is placed over artificial light sources.

Common gelatin-in-glass filters are mounted in round metal holders and come in sizes to fit particular camera lenses. Their size is indicated in millimeters (mm) or a series number. The series size required by your lenses should be indicated in your camera manual or lens instructions. Most filters either screw directly into the threads on the front of your lens or are held on the camera by a *filter retaining ring* or a *lens adapter ring* that screws to the lens. On some lenses, the lens shade or hood must be removed to use a filter. Less common for general photography are square glass or gelatin filters. They are dropped into a filter holder that is screwed or clamped to the lens. Otherwise they are taped temporarily in place.

Before discussing the different filter types and their effects, here's more basic information about the use of filters.

Filter Factors

Because a filter alters the light coming from your subject, a change in exposure usually is necessary. Filters decrease the amount of light reaching the film, so an *increase* in exposure is required. How much the exposure must be increased is indicated by a number called the *filter factor*.

This number indicates the extra amount of light needed to make a correct exposure when using the filter. A filter factor of 2X, for example, means that twice the amount of light is required when using the filter. This means it needs twice the exposure of a meter reading made without the filter. Thus a regular exposure reading of 1/60 second at f/8 would have to be increased to f/5.6 when using a filter factor of 2X. Of course, the amount of light could also be increased two times by slowing the shutter speed to 1/30 second and keeping the lens opening at f/8 (see the chart on page 144).

Filter factors are usually written with an X to indicate "times" the number given. A filter with a factor of 2X requires twice the regular exposure; one that has a factor of 4X requires four times the exposure without a filter. It's important to remember that the filter factor number is *not* the number of f/stop or shutter speed positions to change. This is a common error. Some photographers think a filter with a factor of 2X means to open the lens up two f/stops or slow the shutter speed by two positions. It does not.

A filter factor of 2X indicates that two times the amount of light is needed compared to exposure without the filter. That means either open up one f/stop *or* cut the shutter speed in half. A 4X filter requires an exposure increase of either two stops *or* one-fourth of the shutter speed. Thus a no-filter exposure meter reading of 1/60 second at f/8 would mean, with the use of a 4X filter, a change to either 1/60 second at f/4 *or* 1/15 second at f/8.

Using a filter with a factor of 8X indicates that eight times more light is needed; increase the exposure 8 times. With the reading of 1/60 second at f/8, an 8X filter would alter the exposure to 1/60 second at f/2.8 *or* 1/8 second at f/8. The chart on the following page gives other examples of the exposure changes required when filters of different factors are used.

Filter factors are indicated on the instructions packed with the filter. Some are engraved on the filter's metal holder, such as 2X. A summary of different filters and their factors is given on pages 148, 152, and 154. Remember that filter factors are determined by the filters' manufacturers. They are only intended as a guide for exposure correction and may not give the results you want. Bracketing at various exposures is a good idea when trying out a new filter.

Filter factors are applied when an exposure reading is made by a hand-held meter or when using a through-the-lens meter without the filter in place. When a through-the-lens meter is used with a filter on the camera lens, normally it will compensate and indicate the correct exposure. Experience with

your particular meter and filter will indicate whether further exposure adjustment is necessary; also refer to your camera manual regarding exposure with filters.

Problems occur if your camera's through-the-lens meter is either more sensitive or less sensitive to one color or another. For instance, if your meter is less sensitive to red than other colors, taking a reading through a red filter may result in an incorrect exposure. Dense filters often cause incorrect exposures because it is more difficult for meters to make readings through them. Test your meter with the filters to determine the best procedure for making accurate exposure readings.

If they are unsure, some photographers take two readings with their through-the-lens meters, one without the filter and one with. Then they calculate an exposure according to the filter factor and the reading without the filter, and compare it to the exposure reading with the filter.

There are a few more things to keep in mind about filters. Protect them

CHANGES REQUIRED IN EXPOSURE BY VARIOUS FILTER FACTORS

Filter Factor	Increase f/stop by:	or Reduce Shutter Speed* to:
1.5X	$\frac{2}{3}$	
2X	1 f/stop	1/2 (1 speed slower)
2.5X	1$\frac{1}{3}$	
3X	1$\frac{2}{3}$	
4X	2 f/stops	1/4 (2 speeds slower)
5X	2$\frac{1}{3}$	
6X	2$\frac{2}{3}$	
8X	3 f/stops	1/8 (3 speeds slower)
10X	3$\frac{1}{3}$	
12X	3$\frac{2}{3}$	
16X	4 f/stops	1/16 (4 speeds slower)

*Setting the shutter speed *between* the marked positions on its dial may not give the supposed speed and may damage the shutter. Therefore, intermediate shutter positions are not recommended unless your camera manual states otherwise.

Example: If an exposure reading *without* a filter is 1/60 second at f/8, exposure can be corrected in the following ways, depending on the factor of the filter used:

Factor	Keep the shutter at 1/60 and change the f/stop from f/8 to:	or Keep the f/stop at f/8 and change the shutter speed from 1/60 second to:
2X	f/5.6	1/30 second
3X	between f/5.6 and f/4	
4X	f/4	1/15 second
6X	between f/4 and f/2.8	
8X	f/2.8	1/8 second
12X	between f/2.8 and f/2	
16X	f/2	1/4 second

when not in use. Scratched or dirty filters will decrease the quality of your photographs. Clean them spotless on both sides before use.

Filters come in a number of sizes, so make sure they will fit your lens or lenses. Screw the filter on before purchasing it. Loose-fitting filters will be lost. Also, a lens with damaged threads or a bent edge may not accept the filters designed for it; a clamp-on filter holder can be used in this case. By the way, instead of buying filters for every lens diameter, some photographers buy only a single set that fits their lens with the largest diameter. Then they use a filter holder with *step-up adapter rings* to attach those filters to the lenses of smaller diameter. This saves money, and it is also convenient because you don't need to have a gadget bag filled with filters of different sizes.

Most camera manufacturers make filters for their cameras and lenses. They often give their own code number to a filter which may be of the same type made by another company. There is a common but not universal filter numbering system. So when buying a filter, don't order just by the number of the filter but get a description of the filter color and what it is designed to do.

Three Filters for All Films

There are two filters commonly in use by 35mm photographers which should be a part of most everyone's equipment. These are the ultraviolet filter and the polarizing filter. They can be used with both color and black-and-white films.

The *ultraviolet filter* should be almost standard equipment on any camera lens. Commonly called a UV or haze filter, it cuts down the ultraviolet light unseen by the photographer but to which all photographic films are sensitive. Especially with scenic views, this filter also improves photographs by diminishing (but not eliminating) visible haze. Also see page 15.

Of great importance is that use of the UV filter does not require an increase in the normal exposure. Its filter factor is 1X and that means the exposure is the same as when not using the filter.

The haze filter is also popular because of its use as a lens protector. Many photographers, myself included, screw UV filters to their lenses and leave them there. Even camera manufacturers recommend it. What could be better than a filter that gets rid of unwanted ultraviolet light, requires no change in exposure, and can be used with both color and black-and-white films? The *skylight (1A) filter* has similar characteristics but is designed for use specifically with color films.

Polarizing filters act much the same way Polaroid sunglasses do to cancel glare and reflections from shiny surfaces. When used with color film, polarizing filters help to enrich the colors of the subject by removing or reducing

reflections. Minimizing reflections also is evident when using black-and-white film with a polarizing filter. Such a filter does not reduce the reflections from actual metal surfaces. But it will cut reflections from painted metal, as well as from glass, water, wood, plastic, and other reflective surfaces.

Polarizing filters also darken the sky, enriching it on color film and darkening it on black-and-white film. The amount of darkening and increase in blueness depend on the camera's angle to the sun; results are most effective when the camera lens is aimed at right angles to the sun.

Atmospheric haze is also reduced by a polarizing filter. Colors are not changed on color film, but landscape views appear more vivid because the filter cuts through some of the haze. With black-and-white film, other types of filters do a better job penetrating haze.

It is easiest to use a polarizing filter on a single lens reflex camera. The filter is in a rotating mount which screws to the camera lens. By looking through the viewfinder the photographer visually checks the effect of the filter as he turns it. Thus the amount of reflection, blue-sky darkening, or haze penetration can be controlled accordingly. For instance, if he is photographing fish in a shallow pond, the photographer may decide either to eliminate all the reflection in the water or to include a small amount of reflection to help indicate the depth of the swimming fish.

For use with rangefinder cameras the polarizing filter first is held to the photographer's eye and turned until the desired effect is seen. Then it is placed over the camera lens in exactly the same position. A mark made on the filter's metal holder will help the cameraman align the filter correctly.

Remember, regardless of the camera used, if you adjust the polarizing filter when the camera is in horizontal position and then you decide to turn the camera vertically, the filter must be readjusted, too.

Depending on the manufacturer, a polarizing filter has a filter factor from 2.5X to 3X. Check the filter's instructions. Through-the-lens meters will compensate automatically when a polarizing filter is used. Otherwise you must open the lens aperture an additional $1\frac{1}{3}$ f/stops if the filter factor is 2.5X, and $1\frac{2}{3}$ stops if the factor is 3X.

A third kind of filter is usable with both color and black-and-white film. It is called a *neutral density filter* and is used occasionally to reduce exposure. A neutral density filter appears gray and cuts the amount of light reaching the film. It does not alter light in any other way. Such filters are available in a variety of densities, depending on how much light you want to eliminate. For instance, it may not be possible to stop down your lens as much as required. A neutral density filter will effectively reduce the f/stop further according to its filter factor.

As an example, say you are using high-speed film and an electronic flash for close-up work. Your lens only stops down to f/16 but the short distance between flash and subject requires an exposure of two f/stops less. Using a

95. A polarizing filter eliminated the glare from the water in this tidepool and enabled the marine life to be photographed in better detail.

neutral density filter with a filter factor of 4X, the light will be cut the equivalent of the required two f/stops and the picture can be properly exposed with the lens set at f/16.

Other times a neutral density filter is used in bright light conditions to allow a wide f/stop when limited depth of field is required. Or use such a filter under bright conditions when fast film is in your camera, as at the beach with Tri-X (ISO/ASA 400) or Kodacolor 1000 (ISO/ASA 1000).

Filters for Black-and-White Photography

Other than the neutral density, polarizing, ultraviolet (or haze) filters, filters are made especially for either black-and-white or color film. Filters for black-and-white films are generally identified by a number, a letter, or a color. Common ones are listed below, along with their filter factors. The letters given were assigned long ago by Eastman Kodak Company and refer to their Wratten filters, originally named for an English manufacturer of filters. Today a Kodak Wratten filter K2 is also universally known as a No. 8, medium-yellow.

IDENTIFICATION OF FILTERS AND THEIR FACTORS FOR BLACK-AND-WHITE FILMS

Number	Letter (Kodak)	Color	Filter Factor Daylight	Tungsten
No. 6	K1	light-yellow	1.5	1.5
No. 8	K2	medium-yellow	2	1.5
No. 11	X1	yellow-green	4	4
No. 13	X2	dark yellow-green	5	4
No. 15	G	deep-yellow (orange)	2.5	1.5
No. 25	A	medium-red	8	5
No. 29	F	deep-red	16	8
No. 47	C5	blue	6	12
No. 58	B	green	6	6

As you'll note above, filter factors vary according to whether the light source is daylight (sunlight) or tungsten (artificial). These factors are intended only as a guide. For more exact filter factors, check the instructions packed with the specific filter. Also, make a series of test exposures by bracketing and de-

cide which exposure pleases you most. Note, too, that No. 15 (G) filter is called deep-yellow by some filter manufacturers and orange by others.

What do these filters do? Generally they are considered to fall into two categories, correction and contrast. *Correction filters* enable film to record the colors of your subject at the same relative brightness as seen by your eye. Today's popular black-and-white films record all colors and are called *panchromatic* films. But often they are unable to record the relative brightness of these colors as you see them. Two colors may appear to your eye to be of a *different* brightness, but will appear the same shade of gray in the picture. Thus the need for correction filters to give the picture a different range of gray tones to indicate the brightness of the various colors.

Contrast filters cause those colors seen by your eye to be of *similar* brightness to have different brightness when recorded by the film. Thus, if two colors appear to you to be of similar brightness, contrast filters will darken or lighten one color to record a different range of grays in the picture.

To decide which filter to use to achieve the effect desired, an understanding of the characteristics of light and color is needed. *White light* is a mixture of three basic (primary) colors: blue, green, and red. Objects which appear red have absorbed blue and green. Green objects have absorbed red and blue. And blue objects have absorbed red and green.

If any two of these primary colors are mixed, they produce one of three other (secondary) colors: yellow (red plus green), magenta (red plus blue), or cyan (blue plus green). These often are called the *complementary colors* of the primary colors.

A filter acts in a similar manner, absorbing some colors while allowing other colors to pass through. For this reason, photographers using filters with black-and-white films should memorize the following: 1) to make a color appear brighter than seen, use a filter which transmits that color, and 2) to make a color appear darker, use a filter which absorbs that color. Absorption characteristics of color are given on page 150.

Put this knowledge to use. For example, a red flower and its green foliage may appear as similar shades of gray in your picture. To increase contrast and make the red flower stand out, use a medium-red filter, No. 25. Because red transmits red, the flower now will appear lighter than its leaves. For another effect, a green filter, No. 58, could be used to lighten the green leaves and darken the red flower.

Here are some other attributes and uses of filters for black-and-white films. Correction filters like the medium-yellow No. 8 (K2) and yellow-green No. 11 (X1) often are used with many subjects to make them appear more natural on film; one example is more pleasing skin tones in portraiture work. The other filters are used more often to alter one color or another so the change in contrast on film will emphasize the desired subject.

Panchromatic film tends to be extra-sensitive to blue-violet and ultraviolet

96. *Overlapping color wheels show the primary and secondary colors for photography. White light is a mixture of red, blue, and green, called the primary colors. Secondary (or complementary) colors—magenta, yellow, and cyan—are a mixture of two primary colors.*

light. Since this light is prevalent in scenes where sky is visible, the sky looks brighter in your photograph than it did to your eye. To record the more natural scene, a correction filter that absorbs blue and ultraviolet light is needed. Most popular is a No. 8 (K2) filter, which is medium-yellow. This produces scenes with skies that record darker on black-and-white film than when such a filter is not used. A No. 11 (X1) yellow-green, will do likewise.

Since skies and clouds often are a part of pictures, they can be emphasized to various degrees by contrast filters. A No. 15 (G) filter, for instance, is

Color	Colors Absorbed	Colors Transmitted
red	blue and green (cyan)	red
blue	red and green (yellow)	blue
green	red and blue (magenta)	green
yellow	blue	red and green (yellow)
magenta	green	red and blue (magenta)
cyan	red	blue and green (cyan)

(A) (B)

97. (A) Colored filters change the tones of subjects shot with black-and-white film. Without a filter, the red leaves of this poinsettia plant photographed a dark gray. (B) When a red filter was placed over the camera lens, the leaves were recorded in a lighter tone.

deep-yellow or orange and will darken the sky even more than a No. 8 filter. A medium-red, No. 25 (A), filter will make the sky very dark, while the No. 29 (F) deep-red filter turns the sky almost black, giving a moonlight effect. Clouds are dramatically portrayed against such skies. These sky-darkening filters also help reduce haze in landscape scenes. A No. 25 or No. 29 filter will reduce haze the most, while use of the same filters with black-and-white infrared film will eliminate haze entirely. Haze can be added for special atmospheric effects by using No. 47 (C5) blue filter.

Filters for black-and-white photography often are used in copy work. They can emphasize or deemphasize colors in the original work being copied. Stains or unwanted lines can be eliminated by using a filter the same color as the stain or line. Or to darken and thus bring out a faint color, a filter which absorbs that color should be used. Filters are important for any photographer who wants to make creative photographs on black-and-white film. Color photography also has special filters for special uses.

Filters for Color Photography

As outlined previously, ultraviolet (UV), polarizing, and neutral density filters can be used with color as well as black-and-white film. But there are some filters designed only for color films. These are known variously as *conversion, light-balancing,* and *color compensating* filters.

Conversion filters are designed to allow color films balanced for one light source to be used with another light source. Remember, color films are specifically made for use with daylight or artificial light. But daylight color film can be used with artificial light when the proper conversion filter is used. For example, Kodachrome 25 daylight color film can be used with photoflood lights when a No. 80B conversion filter is used (see following chart).

To convert daylight color films for use with artificial light, use the appropriate bluish filter of the No. 80 series below:

Filter	Light Source
80A	3200 K light, such as professional studio lights
80B	3400 K light, such as photoflood or tungsten-halogen lights
80C	clear (non-blue) flashbulbs, except AG1 or M3
80D	AG1 or M3 clear flashbulbs

Of course, you can use a daylight film with artificial light without a filter, but the colors won't photograph the same as you saw them. Thus the need for a conversion filter. Some exceptions are high-speed color negative films, like Kodacolor 400, which have remarkably good color balance when shot indoors without a filter. Remember that some artificial light sources—electronic flash and blue flashbulbs, cubes, flipflash, and flashbars—are already balanced for use with all daylight color films, and no conversion filter is required.

Films designed for artificial light sources, Type A and Tungsten (Type B), also can be converted for use with daylight. Kodachrome 40 (Type A) film is balanced for photoflood light but gives good results with daylight if a No. 85 filter is used (see below).

To convert color films designed for artificial light for use with daylight, electronic flash, blue flashbulbs, or cubes, use the proper yellowish-orange filter of the No. 85 series indicated below:

Filter	Film Type
85	Type A film; normally used with 3400 K light, such as photofloods or tungsten-halogen lights
85B	Tungsten (Type B); normally used with 3200 K light

A variety of conversion filters is needed to accommodate a variety of light sources. Remember that light sources have different color temperatures (see page 133), which often are indicated in Kelvins (K). Color filters are identified by combined number and letter designations.

Use of conversion filters requires an increase in exposure. However, conversion filter factors are not applied as they normally would be. Instead, film manufacturers indicate a special reduced ISO/ASA film speed when a conversion filter is used. The lower ISO/ASA film speed therefore increases exposure correctly.

For instance, Kodachrome 40 (Type A) film is designed for use with 3400K illumination (photofloods) and has an ISO/ASA of 40. But when used with daylight and the required No. 85 conversion filter, the ISO/ASA will be reduced to 25. The exposure meter should be set accordingly.

Likewise, Kodachrome 25 daylight film has an ISO/ASA of 25. Used with a No. 80B filter to convert this film for 3400K photoflood light, the ISO/ASA is reduced to 8. An ISO/ASA 64 daylight film becomes ISO/ASA 20 with a No. 80B filter; an ISO/ASA 400 film drops to ISO/ASA 125. Because film speeds are reduced when converting daylight film, some photographers prefer simply to change to the appropriate film for the specific artificial light source instead of using a conversion filter.

Light-balancing filters are used to correct or balance the light from your subject so it is rendered on the film with the same coloration you see when making the photograph. Use of such filters may be necessary if the light from your subject is not exactly of the color temperature for which your film was designed.

For instance, with daylight film, electronic flash generally is used without a filter. But these flash units can vary according to their manufacturer. Sometimes electronic flash units produce pictures that are too blue. A light-balancing filter such as No. 81B (see following list), can be used to correct this bluish cast.

Light-balancing filters come in series No. 81 (yellowish) and No. 82 (bluish). Some of their general uses follow on page 154.

Filter factors for series No. 81 and No. 82 vary, and instructions packed with the filter should be consulted. Generally, such filters require an increase in exposure from 1/3 to 2/3 f/stops.

Quite truthfully, most nonprofessional photographers rarely bother to use conversion or light-balancing filters with their color films. They either purchase the type of film designed for the lighting they're using or they put up with a slight off-color result. However, it is good to remember that there is a filter (No. 81A or 81B) that will diminish the blue cast to photographs taken with electronic flashes used with daylight film.

Perhaps it is even more valuable to know that there now are filters which will give good color balance under *fluorescent light.* Fluorescent light has long been a problem for users of color film. People under such lighting look

Filter No.	Effects
81A	Balances tungsten (Type B) film (designed for 3200K light) for use with 3400K photoflood or tungsten-halogen lights. Diminishes bluish results of electronic flash used with daylight film.
81B	Diminishes blue of electronic flash more than No. 81A.
81C	Allows clear flashbulbs to be used with Type A or tungsten (Type B) film.
81D	Same as 81C but with slightly warmer results.
82A	Balances Type A film (designed for 3400K light) for use with 3200K light. Diminishes the red or yellow cast evident on daylight film used in the early morning or late afternoon.
82B	Allows household light bulbs of 60 watts or less to be used with tungsten (Type B) film.
82C	Allows household light bulbs of 100 or 150-watts to be used with tungsten (Type B) film.

green in the resulting pictures. Previously, using a complicated chart of filter combinations was the only way to correct this, and thus most photographers gave up shooting under fluorescent lights.

Finally, in 1971, single fluorescent light filters came on the market to solve the common problem. FL-D filters are designed for use with daylight films, and FL-B or FL-A filters for use with Tungsten (Type B) or Type A films. Their filter factor is 2X, the equivalent of one f/stop. Use them and say goodbye to the greenish cast you'd otherwise get with fluorescent lights and color film. (A reminder: Some high-speed color negative films produce acceptable color results under most types of lighting—including fluorescent—without the use of filters.)

Color-compensating (CC) filters are another type, but these are used most in the color printing process, not when photographing. These usually are available in various densities in photography's three primary colors (red, green, blue) and three secondary colors (yellow, magenta, cyan). Some photographers like to experiment with them for unusual color effects.

Filters for Special Effects

There are several other filters that do not alter the color of light as those discussed above. These filters are placed over the lens to create different light patterns or effects. Most interesting to use is a *cross-screen* or *star filter*. This

is basically clear glass with etched horizontal and vertical lines or a piece of window screen wire which breaks up bright spots of light into four-pointed stars. The larger the f/stops, the larger the star images.

You can buy such filters in mounts to screw to your camera lens, or make your own. Two wire screens turned 45° against each other will produce eight-pointed stars. Since the wire diffuses the entire image reaching the lens, the overall picture image is slightly unsharp. However, such cross-screen filters add dramatically to night scenes which include street lights or other bright spots of illumination.

By the way, a variation of the *star effect* can be achieved without a filter by simply using a small lens opening, f/16 or less, when your picture includes bright points of light. For instance, shooting into the sun with a small lens opening will turn the sun into a star and make your photograph look as if it were taken at night. Photographing the sun glittering off water, using a small f/stop, will produce a picture of many stars. All that is needed is a bright point of light and a small lens opening. Try it.

Other filters will also alter the light reaching your film. A so-called *spot filter* produces only a center area which is in sharp focus while the surrounding area is blurred. A similar effect can be achieved by applying a thin layer of Vaseline to a piece of glass or clear filter except in the center area. This will break up the light rays entering the lens and blur the image, except where there is no Vaseline.

There are also filters which will simply diffuse your overall image. These *soft-focus filters* often are used by portrait photographers to soften the features of a subject. Another variety is a *fog filter,* which gives a natural fog appearance to scenic photographs.

A different type of optical filter that also is attached to the front of the camera lens is called a *multiple-image lens.* It reproduces the subject in three, five, or six identical images in parallel, pyramid, or circular patterns, while one rotating style produces an even greater variety of multiple images.

Filters are produced by most camera manufacturers for their specific camera models. Or they are available from companies like Vivitar, Kodak, Cokin, Tiffen, Spiratone, Soligor, and Hoya. When being used, filters must be free of dust and fingerprints. When not in use, they must be protected against scratches and extremes in heat, or damage to the colored dyes or gelatin may result.

In summary, here are a few things to keep in mind about filters. First, and most important, they enable you to get photographs that otherwise would not have the desired contrast range (with black-and-white films) or give correct color rendition (with color films). Try using filters if your normal results are not satisfactory or when you want some special effect.

Nearly every filter requires an increase in exposure, and the amount is indicated by its filter factor. With this factor you determine how much of a wider f/stop or a slower shutter speed is needed. When photographers using hand-

98. To create a star effect without using a cross screen or star filter, stop down the lens to its smallest opening and point the camera at the sun or other bright light. This sculpture is located along the coast of northern California.

held exposure meters are using a filter for a number of exposures, they will reset the film speed on their meters to allow for the filter factor. This is done simply by dividing the ISO/ASA of the film by the filter factor. For example, using a filter with a factor of 2X and a film of ISO/ASA 400, the hand-held meter should be reset to ISO/ASA 200 for correct exposure readings.

Through-the-lens exposure meters usually will compensate for the loss of light when a filter is used and give a correct reading. The meter is set for the film's regular ISO/ASA. However, test exposures are recommended because some built-in meters are less sensitive to some colors or filter densities than to others. Check your camera manual for specific advice.

7

Buying Accessory Equipment

Unfortunately, some photographers think that the more accessory equipment they own, the better photographers they are. Actually, how good photographs are is more dependent on the photographer's creativity than his equipment. Of course, besides camera and film, a few more tools can be of help. However, the list of "extra" equipment is so long and varied that the photographer should carefully consider the type of accessories most valuable to him before purchasing any. Accessories often include a gadget bag and tripod, as well as extra lenses, an electronic flash, filters, close-up equipment, and a hand-held exposure meter. Before discussing the first two items in detail, let's review the accessory equipment that has already been described in earlier chapters.

Among the major pieces of supplemental equipment photographers buy are *lenses*. The choice is great—zoom, variable focal length, telephoto, wide-angle, fish-eye, close-up, and macro lenses all can play important roles in photography. But you should establish a priority list of lenses, depending on your needs.

Zoom lenses have become increasingly popular, although some photographers object to the extra weight and length of such lenses, and their small maximum apertures (usually f/3.5 to f/4.5). Of great importance is deciding which focal length range will be most valuable to you—perhaps a minimum wide-angle-to-telephoto range (such as 35 to 70mm) or a longer telephoto range (such as 70 to 210mm). Variable focal length lenses are similar to zoom lenses but must be refocused after each adjustment in focal length. To be a true zoom, a lens must hold the focus sharp during a change of focal lengths; watch out for lenses advertised as zoom types but which really are not.

As for telephoto lenses with a fixed focal length, one in the medium range, such as 105 to 135mm, often proves to be a useful extra lens for general photography. Less expensive are lens converters or extenders that will increase the focal length of your existing normal lens.

From the selection of wide-angle lenses, a 28mm or 24mm often is the best choice. That's because the angle of view of a 35mm wide-angle seems

to be limited (63°), while a 21mm lens has an angle of view so great (90°) that it often results in excessive distortion. The extreme wide-angle fish-eye lenses, which encompass at least a 180° angle of view, are fun but not very practical, especially considering their high cost. However, a fish-eye attachment that screws to an existing lens is a less expensive alternative.

99. To add extra motion and drama to this skateboard racer, the photographer panned with a telephoto-type zoom lens and changed its focal length during the exposure.

A variety of close-up lenses is also offered. Very popular is the macro lens, because it can be used as a regular lens for general shooting as well as for close-ups. Focal lengths of macro and macro-zoom lenses vary, as do their maximum close-up magnifications; one-half life-size (1:2) is common unless you add an extension tube for a one-to-one (1:1) reproduction ratio. Least expensive are individual lenses of predetermined magnification that attach to the front of an existing camera lens. Variable focal length close-up lenses, which can be adjusted to vary magnification, are more convenient to use.

Read Chapter 3, Choosing Lenses, to help you decide which supplemental lenses might be best for your photographic pursuits.

Flash is another accessory commonly purchased. As with lenses, the selection is great. Most favored are electronic flash units, although some cameras require flashbulb-type magicubes or flipflash. Electronic flash units vary greatly in their features. Some of them, including those built into the camera, determine exposure automatically, while others must be set manually. Light output, and therefore the units' effective range of illumination, can differ very much. And while some use replaceable batteries, others have rechargeable power cells. Recovery time between flashes varies significantly from unit to unit, too.

Before making a choice, read Chapter 4, Figuring Flash, for a full summary of flash equipment and its use.

Filters are important accessories, if not necessities, especially in black-and-white photography. They enable differences in contrast and colors to be suggested in black-and-white prints. There is a wide range of filters for very specific purposes, even in color photography. Before buying any filters, become familiar with the different types by reading Chapter 6, Using Filters.

Many photographers enjoy close-up photography, and there is a considerable array of *close-up equipment* to help them. Macro, variable focal length, and close-up lenses already have been mentioned. In addition, extension tubes and bellows, or lens reverser rings, can be used. Descriptions and applications of all these close-up accessories can be found in the sections about close-ups in Chapter 3, Choosing Lenses, and Chapter 12, Photographing Under Special Conditions.

Because an *exposure meter* is generally necessary for determining correct exposures, one is usually built into most cameras of recent manufacture. But an extra hand-held meter can be worthwhile, too. If you decide it is, you must also determine what features are best for your purposes: reflected-light or incident-light reading; selenium, CdS, SPD, or GPD cells; spot, averaging, or variable angle of acceptance. Read Chapter 2, Determining Exposure, for a description of these and other exposure meter considerations.

Gadget Bag Concerns

One of the most important accessories for photographers is a camera bag. Instead of being draped with individual cases holding your camera, lenses, and rolls of film, you can carry all your gear in a single bag, making it easily accessible. Hard cases were once the only choice, but now there is an abundance of soft-sided gadget bags on the market. Before you buy one, make certain the bag offers adequate protection for your photo equipment. It should be well constructed, as well as convenient to use.

Of course, a quality hard case is unbeatable for protection. A top-of-the-

line Zero Halliburton, for instance, is made of a tough aluminum alloy with a neoprene-lined tongue-and-groove lip to seal out dust and moisture. It comes with a solid foam-rubber insert that you cut out to cradle your specific camera and accessories. However, for most casual picture-takers a hard case is too heavy, too awkward, and too expensive. Besides, since it is most often used by professional photographers, a hard photo equipment case is a tempting target for thieves.

Soft camera bags now come in all shapes, sizes, colors, and prices. They are the favorite of professional news, sports, and outdoor photographers, as well as vacationers who want a convenient and lightweight carrying case for their camera gear. Among the popular brands available in camera stores are Tenba, Lowe Pro, Domke, Kiwi, and Quest. Compare the bags side by side before deciding which one is best for you.

Start by checking the material; especially durable is heavyweight Cordura nylon that has been treated with a water-resistant coating. Inspect the stitching, looking for double-stitched seams and box-X stitches at stress points, such as where the shoulder strap is attached. (Thread should be heavy-duty nylon.) For extra security this strap should wrap around the bottom of the bag.

If the shoulder strap is attached to the bag by metal D-rings, they should be welded shut or designed so the strap cannot slip off or accidentally become detached. Ease your burden by making sure the shoulder strap is a wide one; a padded and/or antislip section sewn to the strap where it rests on your shoulder will make you happier too.

Check that the zippers are heavy-duty and easy to operate. Exterior zippers should be covered with a flap of water-resistant material to keep out the rain. Flaps on exterior pockets also should be designed to fully protect the contents from rainy weather. If you like to tote a tripod, look for a bag with exterior straps to hold it securely. To best protect your equipment, the bag should be lined with shock-resistant foam. Some manufacturers also sew a piece of fiberboard or plywood into the bottom of the case for added durability.

When checking the usability of any bag, consider the ease of access to your equipment. The most flexible bags have adjustable inserts you can move around to custom design the interior with compartments that hold your specific camera, lenses, flash, filters, and other accessories, as well as a supply of film. Look for padded inserts with Velcro strips that keep the gear from bumping together and permit varied configurations. It's a good idea to take your photo gear to the camera store and see how well everything fits into the case before you buy it.

Whatever type of bag you choose, make sure it has an adjustable strap to suspend the bag from your shoulder so your hands will be free to operate your camera. A case with only handles has to be put down while you shoot, and it's difficult to keep your eye on your equipment and take pictures at the same time.

Take care that your camera gear is handy to reach but won't fall out if the

case accidentally opens. Also, as a precaution, carry the gadget bag so its opening catch is next to your body. That way, the top opens outward and there is less danger that it will flop down on the equipment you're trying to get out.

Of course, the price of a gadget bag may determine its desirability. The better soft-sided cases range from $35 to over $200, depending on their size, construction, and features. The more valuable your equipment, the higher the price you should be willing to pay for a quality case. Some manufacturers back their bags with a guarantee; every Tenba case, for instance, is guaranteed for five years.

Once you buy a new case, be sure to put identification on and in your gadget bag in case your photo gear is lost or stolen. (For extra security, some photographers use an electric pencil to etch their telephone or social security number on their camera, lenses, and accessories.) A final caution: Don't mistreat your case and its contents. A padded soft-sided bag absorbs many of the thumps and bumps of travel, but it can't protect equipment from a big fall or careless battering.

Tripod Facts and Uses

Photographers often need a sturdy and convenient means of support for their cameras, especially when exposures require a shutter speed of 1/15 second or slower. A tripod is the most common type of support accessory, although C-clamps and unipods will help steady the camera during exposure, too. All have a 1/4-inch threaded bolt which screws into the camera's tripod socket. Some large telephoto and zoom lenses also have a tripod socket for attaching such support devices.

The photographer has a great choice of tripods. You'll find several manufacturers, dozens of different models, and prices from $30 to more than $200. A survey of your needs is necessary to determine the type of tripod which will be of the greatest value. Most important is sturdiness. If a tripod fails to support the camera rigidly, it is not worth using. Therefore, the size of the camera helps determine the size of the tripod needed.

Basically a tripod consists of three extendible legs connected to a head that holds a screw to attach it to the camera. Some of these heads are mounted on an elevating post, which gives the tripod more versatility. Of great value are heads which also can be swiveled and tilted.

While some studio tripods are wooden, most tripods for general use are made of metal. Aluminum is most popular, since the carrying weight of the tripod is a major concern.

Methods of locking the legs at required height vary. The quickest to use is the flip-type clamp, snap, or pressure-release lock. More common is the twist locking ring. Set screws or wing nuts are sometimes used. Least satisfactory are the click locks that only engage when a section of the tripod leg is fully extended. These are common in the smallest tripods.

Extended height of the tripod should be considered. How high do you need to get your camera? Many have a range extending to 5 feet or more and collapsing to 2 feet, while the small tripods may extend to 4 feet and collapse to less than 1 foot.

To prevent slippage, you should be certain that the tripod legs spread to a preset angle. Tips of the legs are equally important. Rubber-tipped feet are preferable to plastic ends. For outdoor work, metal spike tips are sometimes advantageous. Several tripod models offer interchangeable rubber and spiked leg tips.

If the tripod has an adjustable head which allows you to pan and tilt your camera, the locking device should be strong enough to maintain the desired

(B)

(A)

100. (A) A ball-and-socket head on a tripod allows the camera to be angled easily to any position. This tripod also has an elevator column for easy height adjustment. (B) A cloth bag filled with styrofoam pellets can be used to cradle the camera on a solid support if a tripod is not available. Instead of a cable release, you can activate the camera's self-timer to trip the shutter and avoid camera movement during the exposure.

position. If the camera slips after tightening the head, the tripod is worthless. Also make sure the camera can be securely fastened to the head. The tripod screw for the camera's tripod socket must be long enough to provide a safe grip.

Finally, if an elevator post is part of the tripod, it should be geared to provide smooth operation and prevent slippage of the column. A welcome feature of some tripods is a reversible elevator post that can be used beneath the legs as well as above them. This allows easy tabletop copy work.

Bulkiness of a tripod is of great concern to traveling photographers. For this reason, a small tabletop tripod with a ball-and-socket head is often preferred by 35mm camera users. It can be conveniently carried in a gadget bag. And when properly adjusted, this tripod can be placed against the photographer's chest to provide extra support and steadiness when making long exposures or using telephoto lenses.

A *C-clamp,* with adjustable ball-and-socket head, is another favorite of photographers who travel light. It can be fastened to almost anything to provide support for a 35mm camera.

A *unipod,* which offers one-legged support, is the least versatile. It keeps the camera at a certain height but the photographer must hold it steady to prevent movement sideways. Besides, bringing the legs of a tripod together will substitute for a unipod when required.

More portable supports are the *pistol grip* and *shoulder brace,* preferred by some photographers using long telephoto or zoom lenses. These screw into the camera or lens tripod socket and often have built-in cable releases to operate the shutter. Also, a homemade *beanbag* filled with bits of styrofoam can be used to cushion and support the camera in awkward locations and positions.

When is a tripod or other support necessary? Photographers' needs vary, but most often they require a tripod for long nighttime exposures. A cable release should be used to make sure the camera isn't moved when tripping the shutter. If the shutter is set on B position for time exposures longer than 1 second, a cable release with a lock screw is recommended. Once the release is depressed and locked, the shutter will be held open without the photographer's help.

Without a cable release, and when exposures 1 second or less are required (or possibly longer if the camera has automatic exposure control), the shutter can be tripped by using the camera's self-timer control. This provides about a 10-second delay before the shutter opens, and thus the photographer is not touching the camera during exposure.

Remember always to use the tripod on a solid surface with the legs fully spread to give full and safe support to the camera.

A tripod is also worthwhile when long daytime exposures are required. This may be necessary when extreme depth of field is needed and the shutter speed must be slowed to compensate for the small f/stop that's used. Close-up and copy work often require tripods. Precise framing and focusing are then possible.

101. *A tripod was used to steady the camera so a small f/stop opening and slow shutter speed could be used to photograph the interior of this Hawaiian church. Notice the unusual hand-painted ceiling.*

Telephoto and zoom lenses may need a tripod support for sharp photographic results. The smaller the area covered by such a lens, the greater the camera steadiness required. For this reason, faster than normal shutter speeds are needed when using extreme telephoto or zoom lenses, too.

Tripods also are an asset when the photographer wants to include himself in the picture or use open flash at night. In the first instance, the self-timer delays the shutter release until the photographer gets himself positioned in front of the lens.

In the second situation, a tripod holds the camera while a locked cable release holds the shutter open. The photographer is then free to illuminate his subject by leaving the camera and firing his flash from the desired distance and angle. For off-camera flash, a tripod can be used to hold the flash unit away from the camera, or the photographer can hold the flash unit while his camera is on the tripod.

A tripod, or unipod, can be used when objects block the photographer's view. The camera is prefocused and the exposure set. After tripping the self-timer, he gathers and holds on to the tripod's legs so he can position the camera beyond the obstructing objects. The photographer frames by watching the angle of his lens. This technique is especially useful at parades where the crowd is too thick to allow a normal camera angle.

Extending the position of the camera by using a tripod allows a greater variety in camera angles. Suspending it over the side of a ship or a tall building, for instance, provides a camera angle that otherwise would be impractical, if not impossible.

Many photographers get too attached to their tripods. In doing so they lose the ability to photograph spontaneous situations. Constant use may make tripod operation easy but it is still time-consuming, and extending and leveling the legs is cumbersome. In close situations, tripods are awkward and inhibit other people. For this reason, and the fact they might purposely or accidentally damage paintings or other works of art, tripods often are forbidden in museums.

Nevertheless, they are valuable aids to camera users and are worth the investment. But care must be given to make a selection dependent on the photographer's needs, and especially, to make sure the unit offers sturdy support for the camera.

A number of other accessories—sometimes necessary, sometimes not—have been mentioned throughout this book. Refer to the Index for the page number on which specific items are described. In addition, major pieces of equipment required for your special purposes are described in various chapters. For instance, autowinders and motor drives are discussed in Chapter 12, Photographing Under Special Conditions. Black-and-white film users who do their own processing and printing will find a summary of darkroom equipment and its use in Chapter 14, Processing Films and Prints. And color slide

shooters should read Chapter 15, Showing Off Photographs, for a description of slide projectors, screens, and related equipment.

Purchasing *used accessory equipment* can be a good bargain, especially if you plan to use it only occasionally and cannot afford new equipment. Camera shops often carry a variety of used equipment taken as trade-in. Be sure to ask whether this equipment is guaranteed, and how long the guarantee is valid. Always test all used accessories and return faulty equipment immediately.

Also look for used equipment in newspaper classified ads. You may find equipment being sold by photographers who have lost interest or have switched to a different type of camera. Here you have a chance to ask the owner the actual amount of use the accessory items have had. But be sure to check carefully for worn or abused parts. Prices of used accessories in want-ads often are less than they are in camera stores. However, always compare prices and equipment to be sure you're getting the best deal.

Remember, ownership of a multitude of accessories doesn't make you a better photographer, although some carefully selected pieces of extra equipment can help you make better pictures.

8

Using Convenience Cameras

In recent years there has been a growing demand for what I call *convenience cameras,* ones that are easy to operate and small enough to fit in your pocket or purse. The Eastman Kodak Company started the ball rolling in 1963 by introducing drop-in film cartridges and a new line of small point-and-shoot cameras called Instamatics. The film in the plastic cartridges was 126-size, which produces a square negative or transparency that measures 28×28mm (for comparison, the image area of 35mm film is 24×36mm). Film cartridges of 126 size are sold in three lengths, 12, 20 and 24 exposures.

No longer did snapshot shooters have to fumble with a roll of film that had to be threaded onto the take-up spool in the camera, and they didn't have to remember to rewind the film after the roll was exposed. Now they could simply drop in the film cartridge, close the camera back, and start shooting. When all the film frames were exposed, they just opened the camera, removed the cartridge, and gave it to the processor.

The simple, convenient, and inexpensive cartridge-film cameras became so popular that nine years later Kodak issued a completely new line of even smaller models, the pocket Instamatic. Its reduced size requires a smaller film cartridge, 110-size. The images it produces are rectangular and measure 13 \times 17mm, which is about one-fourth the image area of 35mm negative or slide. The 110 cartridges were initially available in 12- or 20-exposure lengths, but most film manufacturers have switched to 24 exposures instead of 20.

As sales of pocket Instamatics increased, so did the number of manufacturers and models. While some people continue to call any camera with a drop-in film cartridge an Instamatic, it is Kodak's brand name; more accurately, any model or brand using 110-size film is called a *pocket camera.*

Kodak's Revolutionary Disc Cameras

A truly pocket-sized camera appeared in 1982, another Eastman Kodak Company invention that has greatly increased the popularity of convenience cameras and photography in general. It's called the *disc camera* and the name

refers to its revolutionary film cartridge, a small wheel of film that provides fifteen exposures.

An astounding 8 million disc cameras were sold in the first year, thanks to their compact size and almost foolproof operation. The three most welcome features are auto-exposure, built-in flash, and automatic film advance. The hand-size camera, which measures about 3 × 5 inches and is less than an inch thick, is a product of microcomputer technology. In a split second's time after you press the electronic shutter button, the camera reads the scene, sets the proper exposure, activates the flash if necessary, takes the picture, advances the film, and recharges the flash.

The film is of unique design, a thin light-tight cartridge about 3 inches square that drops in the camera and only fits one way. When you close the camera's back after loading, a motor advances the film to the first frame and you're ready to shoot. After each exposure the film disc automatically rotates to the

102. Convenience cameras use drop-in film cartridges. As part of its foolproof design, a flat disc cartridge holding 15 exposures only fits in the camera one way.

103. Pocket cameras are the most popular of the film cartridge models. They require 110-size film, which gives small rectangular images. This pocket model is equipped with a built-in electronic flash.

next frame; the shutter release locks when all fifteen exposures have been taken. Then you simply remove the exposed film cartridge from the camera for processing.

The film itself represents a remarkable achievement in photography because of its subminiature image size, 8 × 10mm. This means a frame of disc film is nearly eleven times smaller than the 24 × 36mm size of a 35mm film frame. New high resolution (HR) film emulsions were created to provide color pictures that would be sharp and show a minimum of grain when enlarged to the disc's standard print size, 3½ × 4½ inches. (Black-and-white and color slide films are not available for disc cameras.)

Some users were disappointed in the color print quality of the first disc films, so Kodak later adapted its high-quality ISO/ASA 200-speed Kodacolor VR film to the disc format for finer grain, increased contrast, and sharper images. Disc-camera photos in their nominal snapshot size have thus improved, but greater enlargements to 5 × 7 or 8 × 10 inches will be disappointing when compared to color prints of equal size made from 35mm negatives. (When

disc film is sent to Kodak for processing, borderless glossy prints are made unless you request a texture finish.)

Kodak now has competition from other disc film makers like Fuji, 3M, and Konica, as well as from other disc camera manufacturers. However, since Kodak was the camera's originator, here's an overview of that company's disc cameras.

Of those models available in 1985, most all have identical basic features, including an f/2.8 fixed focus lens that has a distance range from 4 feet to infinity. Subjects closer to the camera than 4 feet will be out of focus, unless you have an advanced model featuring a close-up lens that also sharply focuses on subjects 1½ to 4 feet from the camera.

Exposures with most Kodak disc cameras are made automatically at one of two settings, 1/200 second at f/6 under normal lighting conditions, or 1/100 at f/2.8 when light levels are low. In addition, the built-in flash automatically turns on and fires in low light; its nominal range is 4 to 18 feet. Unless you have the disc model with a close-up lens, subjects closer to the camera than 4 feet will be overexposed by the flash and will be out of focus.

The ISO/ASA 200-speed color print films that are standard for disc cameras have considerable latitude, so most all the pictures you take according to the camera's simple exposure guidelines will produce acceptable images.

Because the autoflash recycles quickly (in less than 2 seconds), and with the disc camera's automatic motorized film advance, you can shoot with little delay and not miss any photo opportunities. Also, the camera's relatively fast shutter speed of 1/200 second (or 1/100 in low light) reduces the chance of blurred pictures caused by camera movement or subjects in motion. Power for the automatic exposures, flash, and film advance is supplied by two long-lasting lithium cells that should give you over 2,000 exposures with normal use and are warranted by Kodak for five years of uninterrupted service. (Some models use a 9-volt alkaline battery, with an expected life of more than 450 exposures before you need to replace it.)

Because disc cameras are convenient to carry anywhere, Kodak has wisely designed them with a protective lens and viewfinder cover that slides open or swings down as a handle to give you a better grip on the camera. In the closed position the cover also locks the shutter to prevent accidental exposures.

Before offering a few tips on taking better pictures with convenience cameras, here's more information about the two older types—110 pocket models and Instamatics.

Kodak's Pocket Cameras

Kodak's announcement of a handy pocket-sized camera in 1972 included the introduction of a small cartridge-type film, size 110. Over the next decade

came many improvements in both the pocket camera and its films. Most pictures taken with 110 cameras, as they're sometimes called, are casual snapshots on color print film. The first cartridges were loaded with slow-speed films of the era, but now several brands of faster ISO/ASA 100 and 400 color print films are available. Kodak's is Kodacolor VS. You also can shoot color slides and black-and-white films in pocket cameras; Kodak makes two color slide films in 110 cartridges, Kodachrome 64 and Ektachrome 64 (both ISO/ASA 64), as well as Verichrome-Pan, a black-and-white film with ISO/ASA 125.

One of the keys to the simplicity of a pocket camera is that most models automatically adjust to the speed of the film when the cartridge is inserted. A notch in the specific cartridge sets the camera for exposure with the faster ISO/ASA 400 films or the slower ISO/ASA 100 and 64 films. A few advanced pocket cameras have an ISO/ASA film speed that the photographer adjusts manually.

Fans of 110-size cameras have been rewarded with several models that have greater versatility than the original pocket cameras. Foremost are the single lens reflex types featuring through-the-lens viewing and focusing, along with automatic electronic exposure control. In 1978 the first 110 with interchangeable lenses was introduced: the Pentax Auto 110 SLR, with a choice of three lenses—18mm wide-angle, 24mm normal, and 50mm telephoto—all with maximum aperture openings of f/2.8. Earlier, another small and sophisticated SLR was introduced, Minolta's 110 Zoom. Its permanent 25-50mm zoom lens will double the subject image size, and a built-in close-up lens allows you to focus the camera on subjects as close as 11¼ inches.

Although the father of pocket cameras once produced an array of models too, Kodak has since shifted its manufacturing and marketing emphasis to the newer disc cameras. However, the company has continued to make one pocket camera, the Ektalite 10. Its features include fixed focus from 5 feet to infinity, a built-in electronic flash with a range from 5 to 15 feet, and fixed exposure controls. You turn on the flash when you want to use it and manually advance the film with a thumb slide.

Older Instamatic Cameras

What about the first convenience cameras, notably the original Instamatic cameras made by Kodak, and the other imitations that followed? They'll be around for some time. The initial Instamatic was introduced in 1963, and it's estimated that many millions are still in use. The advanced models have good lenses and automatic exposure features. Photographers who use them like

the quality of the photographs they produce. And many prefer the larger, square-frame format of 126 film to the smaller disc or 110 pocket-camera film. (However, the rectangular format of the disc and 110 films permit more variety in composition because subjects can be shot horizontally or vertically.)

Kodak's full-size Instamatic line once featured eight models—from a very inexpensive aim-and-shoot type to a sophisticated reflex model with interchangeable lenses, fast rangefinder focusing, and an electronic shutter. Only one 126-size camera is manufactured by Kodak now, the inexpensive Instamatic X-15F. It has fixed focus (for subjects as close as 4 feet), no exposure settings, and can be used with flipflash for subjects that are 4 to 9 feet from the camera.

Tips for Using Convenience Cameras

Here are some tips for achieving better photographs with convenience cameras. First, be sure you know how your specific camera model operates by carefully studying the camera instruction booklet.

Always use the wrist strap to avoid dropping and breaking the camera. If you actually carry the camera in your pocket, be careful it doesn't slip out and get damaged. Also watch that lint or objects in your pocket or purse do not dirty or scratch the lens; make certain the cover for the lens and viewfinder is in place.

Despite their ease of use, disc, pocket, and Instamatic cameras must be held steady if you want to get the best photos possible. Blurred pictures can be a problem because the cameras are small and lightweight; many users inadvertently move them when pressing the shutter release. To avoid such trouble, get a good grip on the camera, then gently press the shutter release with your fingertip. Squeeze it, don't jab or snap it.

Finally, there are two other things you must remember: Be sure your subjects are no closer than the nearest focusing limit of your camera, and know the minimum-maximum distance range of the flash so your subjects are not too close or too far away for a proper exposure.

The Impact of Convenience Cameras

What effect will small-frame cameras have on photography? So far it has been a considerable one because these convenience cameras have encouraged more people to get into the field of photography.

As makers of photographic records, such convenience cameras are ideal. Whether they allow the photographer to develop his artistic potential is questionable. While Kodak and other companies are tapping the beginner market with their convenience cameras, most serious amateurs and professionals will hang on to their 35mm and larger-format cameras. However, they might carry a disc camera to make quick record shots or capture unexpected moments.

Often-missed pictures should be a thing of the past. No longer will you say after seeing something that's photographically exciting, "I wish I had my camera!" The compactness of disc and pocket cameras makes it convenient to have a camera with you always.

Part of such miniaturization in photography is due to advancements in electronics and microcircuitry. The tiny cameras may look simple from the outside, but their interiors are examples of technical ingenuity. And you can expect new mechanical, electronic, optical and chemical knowledge to change the future of practical photography, whether you use a disc, pocket, 35mm, self-processing, or any other type of camera.

9

Working with
Instant Cameras

For photographers who can't wait to see the pictures they have just shot, there are so-called instant cameras with films that self-process snapshot-size color photographs in a matter of minutes. The age of instant photography began in 1947, when Dr. Edwin Land announced the invention of his original Polaroid camera. In 1976, Kodak became Polaroid's first competitor by introducing its own instant camera models and a new self-processing film. Over the years, these two manufacturers greatly improved their films and the quality of instant pictures, and introduced easier-to-use cameras. Polaroid, for instance, brought out the first autofocusing model, which uses an inaudible sound echoing system to bring subjects into focus.

Polaroid and Kodak became intense competitors, each with its own instant camera models and color films to use specifically with them. However, a ruling in January, 1986, by a federal court judge suddenly altered the instant camera marketplace. Eastman Kodak Company was found guilty of violating seven Polaroid patents and ordered out of the instant photography business. That meant Kodak's instant cameras and films could no longer be manufactured or sold, and owners were offered a refund on any Kodak instant camera that they returned to the company. The result is that Polaroid once again plays the major role in instant photography.

Nowadays instant photography is a pleasure rather than the frustrating experience it was during its early era. For example, current instant camera models eject the film automatically after each exposure. This allows a faster series of photographs to be made than in the past. Equally important is that uniform development is assured by automatic ejection of the exposed film. As the film is forced through a pair of rollers during this motorized ejection procedure, chemical pods break and evenly cover the film for development. With earlier models, jerky manual pulling of the film from the camera by the photographer could cause an unevenly developed picture.

Also, in Polaroid's early days there were messy chemical-covered negatives

that had to be separated from the print after development and then discarded. Modern films emerge from the camera after exposure and turn into the finished photograph; there is nothing to throw away. Sticky prints are a thing of the past, too. Even as the print is developing, it is dry to the touch.

Considering Instant Print Films

Before discussing details of Polaroid's instant camera models, here is some information about the company's two major color print films, Polaroid 600 and Time-Zero Supercolor.

First, be aware that you must use Polaroid film in a Polaroid camera; it won't fit in any Kodak or other instant camera. Polaroid's instant color film packs offer 10 exposures. The prints are glossy and measure $3\frac{1}{2} \times 4\frac{1}{4}$ inches, although the actual image size is square and produces a picture $3\frac{1}{8} \times 3\frac{1}{8}$ inches.

Polaroid cameras in current production—the 600 series—use Polaroid 600 film, which has the fastest speed of all instant color films, ISO/ASA 600. The previous generation of Polaroid cameras—SX-70, One-Step, and Pronto! models—require Time-Zero Supercolor, rated at ISO/ASA 150. Earlier Polaroid cameras—the Colorpack series—use Polacolor color and Polaroid black-and-white films, but you must peel the prints from their negatives after timing the development.

As for the time it takes an instant print to self-develop, Polaroid's 600 film requires at least 90 seconds to turn into an image. Actually, the film continues to develop for several minutes, and you'll have to wait awhile to see the true colors. For the best print quality, Polaroid advises you to hold the print by its edges during development and not to bend, flex, or cut it.

Polaroid also recommends its 600 film for use at temperatures from 55°F (13°C) to 95°F (35°C). At colder temperatures, immediately put the film in a warm place, such as inside your coat, during development. If you shoot at the extremes of the film's temperature ranges, prints may be too dark at the higher limit and too light at the lower limits. Try compensating by adjusting the camera's lighten/darken exposure control accordingly.

Both instant films and cameras should be kept away from extreme heat (over 100°F), because it will have a detrimental effect on the undeveloped film emulsion and perhaps cause damage to the camera. If film and camera are inadvertently subjected to excessive heat, as in a closed car parked in the summer sun, be sure the camera and film cool off before taking any pictures.

Careful storage of the processed prints also is important, because heat and humidity can affect the dyes and cause changes in the colors. Long exposure to bright light is harmful, too. Keep your instant prints in a cool, dry place and away from direct sunlight so their color dyes and images won't fade.

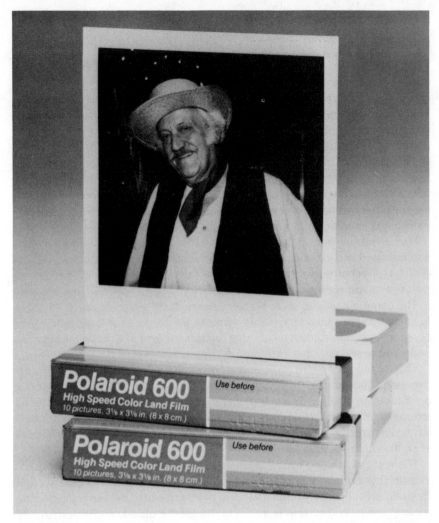

104. *Polaroid's most recent instant camera models use fast Polaroid 600 film. Each film pack produces 10 glossy prints in a square image format.*

Finally, here's another point regarding Polaroid's instant films. Each Polaroid 600 or Time-Zero film pack has a built-in, wafer-thin disposable 6-volt battery to power the camera's shutter speed, lens aperture, electronic flash, and film ejector. Thus the problem of testing or changing worn-out batteries is eliminated; you get fresh battery power every time you put in a 10-exposure film pack.

Polaroid Land Cameras

Dr. Land, the instant camera inventor, should be very proud of the innovations in instant photography during the past four decades. Today his Polaroid company's cameras make instant picture-taking as simple as ever could be imagined. Just aim, shoot, and then watch the image self-develop in a matter of minutes. Automation is the byword from the time you slip a 10-exposure pack of film into the camera to the moment an exposed photo is ejected.

Three of the four instant cameras in Polaroid's 600 series feature automatic exposure coupled with a built-in electronic flash that fires every time you take a picture. There's no worry about focus either; two are autofocus models, the other two have fixed focus. And after each exposure, the print is automatically ejected from the camera to begin self-processing.

Here's a more detailed review of Polaroid's recent instant cameras. Most sophisticated and expensive is the top-of-the-line SLR 680, a folding-type single lens reflex camera. You see in the viewfinder exactly what the film sees, so pictures can be composed with easy accuracy.

The camera's unique sonic autofocusing system ranges from 10.4 inches to infinity. It sends inaudible sound waves to the subject, measures the reverberation time, and starts a motor that focuses the lens in a matter of milliseconds. You see exactly what's in focus on a ground-glass screen in the viewfinder.

This autofocus system goes into action when the shutter button is slightly depressed, focusing on the nearest point of your subject. If you want to refocus on something else, remove your finger from the shutter button and the focus returns to infinity, its "resting" position. Then slightly depress the shutter button again to restart the autofocusing procedure. To take a picture, press harder on the shutter button.

There's a switch and focusing wheel in case you want to bypass the autofocusing system and focus the lens manually (which may be necessary when focusing on subjects through a window or in a mirror). One advantage of the sonic autofocusing system is that subjects can be quickly and automatically focused in dimly lighted or even dark rooms.

Exposure is controlled automatically, too, as is the ejector which drives the print through a slit at the bottom front of the camera. The camera's electronically controlled shutter makes automatic exposures as long as 14 seconds, and there's a socket for attaching a tripod to hold the camera steady during time exposures (the fastest shutter speed is 1/180 second).

The SLR 680's built-in electronic flash reaches up to 14 feet and has a brief duration of 1/3000 second to stop action. It rapidly recycles in about 3 seconds. To prevent underexposed pictures, the camera will not operate until the flash is fully charged. For close-focus photos, the flash automatically adjusts downward so the light is directed precisely at your nearby subject.

For the sharpest photos the camera has a four-element glass lens that's

105. A unique feature of some Polaroid instant cameras is autofocusing. A sound-sensing device activates a motor to focus the lens automatically when the shutter button is pressed.

116mm, a normal focal length for the camera's 3⅛-inch square picture image format. Auto-aperture lens openings range from f/8 to f/90, and there is a manual exposure control to lighten or darken the image by as much as 1½ f/stops from the normal automatic exposure.

Polaroid also has a lower-priced autofocus camera, the Sun 660, with a focusing range from 2 feet to infinity. It's a nonreflex, nonfolding model. Exposures are automatic, and there's a manual light/darken control you can adjust up to ¾ f/stop if a picture is underexposed or overexposed. The electronic

106. Polaroid's instant slide system features color and black-and-white films that be shot in any 35mm camera and developed on the spot in one minute. Each roll of 35mm instant film comes with a processing pack that's used in Polaroid's manual AutoProcessor or motorized Power Processor. The system also includes devices for mounting the slides.

shutter speeds range from 1/3 to 1/200 second. A built-in electronic flash automatically illuminates subjects 2 to 14 feet from the camera and recycles in about 3 seconds.

Polaroid's Sun 600 instant camera is similar to the 660 in features and design, except that it has a fixed focus from 4 feet to infinity and an electronic flash range from 4 to 10 feet. Least expensive in the 600-instant camera series is the OneStep, also with fixed focus from 4 feet to infinity but without an electronic flash. Instead, a 10-shot flashbar is attached to the top of the camera and can illuminate subjects 4 to 10 feet away.

All Polaroid cameras have a one-year warranty, although some models have a Special Edition (SE) designation which includes a five-year warranty for labor, parts, and service. In addition, the SE models have a no-fault photo guarantee. If any of your pictures don't turn out the way you'd like them, send the prints to Polaroid's headquarters in Cambridge, Massachusetts (together with one of the coupons that come with SE-designated cameras), and the company will replace the film you used.

In case you want additional prints of your instant pictures, Polaroid has a

copy service to make duplicates of the original prints. You can order exact copies or enlargements, from wallet size to 11 × 11 inches.

While many earlier models of Polaroid cameras are no longer manufactured, the company continues to make black-and-white and color films for them. They also manufacture 4 × 5-inch film packets for use with Polaroid 4 × 5-inch holders that attach to a 4 × 5-inch press and view cameras. Polaroid even makes large-format films for studio cameras that produce 8 × 10-inch and larger color pictures in 60 seconds.

Tips for Using Instant Cameras

When using an instant camera, keep in mind that prints can be unevenly developed or even jammed if the photographer's fingers are in the way of the print being ejected from the camera. The exposed print must exit through a pair of pressure rollers without hindrance if the chemicals within it are to do their job evenly. Be sure to hold the camera in such a way that you will not block the print's ejection. Also remember that the pressure rollers must be wiped clean, and dirt must be kept from the exposed gears connected to those rollers.

Another thing to keep in mind to avoid disappointment with instant prints is the distance range of the flash you are using. Often, subjects are incorrectly exposed because they are too close or too far from the camera and flash.

Today's instant cameras actually do not produce pictures as instantly as the older Polaroids, which yield color prints in one minute and black-and-white prints in 15 seconds. The delay in seeing the fully developed print is of some concern to photographers who may want to alter the exposure of their picture. This can be done by manually adjusting the lighten/darken dial on the camera, but it takes several minutes for the print to be developed enough to see if the automatically controlled exposure has to be changed in that manner.

Current instant cameras have limitations for making the variety of creative photographs many serious photographers desire. But such cameras suit the countless people who simply want an easy way to record the important events in their lives—and see the results within minutes.

Instant Pictures with 35mm Cameras

As mentioned earlier in the chapter on films, you also can take instant pictures with a 35mm camera. In 1983 Polaroid introduced three revolutionary

color and black-and-white 35mm films that produce slides in a matter of minutes. The positive images appear after the exposed film is manually wound through Polaroid's AutoProcessor. The film cassette is placed in that portable device with a throw-away processing pack that provides the chemical solution to develop the film. The processed roll is then put in another simple device for mounting each film frame in a plastic mount for immediate projection.

Polaroid's 35mm instant slide system was developed primarily for business, industrial, medical and other professional uses where fast results are desired, such as with audio-visual productions. But amateur photographers also have become intrigued by the opportunity to create positive slide images almost instantly. Polaroid even supplies its Polachrome color transparency film in 12-exposure rolls so you don't have to shoot the more standard length roll of 36 exposures before seeing the results. The popularity of its instant slide system prompted Polaroid to introduce two more films in 1986, as well as a motorized Power Processor.

The current selection of instant 35mm films includes Polachrome (12 or 36 exposures) for producing color transparencies, and Polapan (36 exposures) that creates black-and-white slide images. For more specialized uses the other choices are Polagraph, a high-contrast black-and-white slide film, Polalith, a high-contrast litho film producing black-and-white images without gray tones, and another litho film, Polalith Blue, yielding blue-and-white images.

In all cases, the instant film cassette is loaded in a 35mm camera in the normal manner. Exposures also are made as with regular 35mm films, first setting the camera's meter to ISO/ASA 40 for Polachrome (color) or ISO/ASA 125 for Polapan (black-and-white).

Once the roll is exposed, it is rewound into the cassette and ready for processing. To use the less expensive (under $100) manually operated AutoProcessor, the film cassette and processing pack that comes with each film are placed in the processor. After their leaders are attached to a take-up spool, the processor's cover is closed to make it lighttight. Then you turn a crank which coats the processing fluid onto a strip sheet from the processing pack and laminates it to the exposed film.

You wait one minute until the film develops, then turn the crank again to rewind the film back into its cassette and the used processing strip back into its pack. After opening the cover of the AutoProcessor, the disposable processing pack is removed and thrown away. And the cassette with its dry, developed film can be inserted in the Polaroid slide mounter where each film frame is cut from the roll and put into a plastic slide mount.

Of course, Polaroid's newer Power Processor makes it easier to process instant slide films because the film winding and timing is automatic. You just plug the processor into an electrical outlet, attach the film and processing pack leaders to the take-up spool, and close the cover. The processor signals with audible beeps when the film has been developed and wound back into

its cassette for mounting. Polaroid's newer Illuminated Cutter-Mounter also makes it easier to mount a roll of instant slides.

To produce a full color image, Polaroid adapted an additive color process instead of the subtractive color process common to non-instant slide films. The result is an image with noticeable grain but remarkable sharpness. Also, the film's high contrast and color rendition may be bothersome to some photographers when comparing Polachrome with regular slide films. Nonetheless, Polaroid deserves high praise for making it possible to create color or black-and-white slides in a matter of minutes with any 35mm camera.

10

Composing Effective Photographs

Knowing how to operate your camera and equipment prepares you mechanically to make photographs. Using your camera artistically is the next goal. Although some people are described as being born with a "photographic eye," learning how to compose effective pictures usually comes with practice.

This section outlines the elements of composition and techniques for applying them to your photographic pursuits. It will guide you toward making effective photographs that will please both you and other people who view your pictures.

Pictures with a Purpose

Many photographers fail to think about the stories they are trying to tell with their pictures. Every picture should have a purpose. Even so-called snapshots can be effective photographs if the photographer contemplates the story he wants to tell. At a Christmas gathering, is he trying to show the members of the family, or the presents they received, or both? His composition, the components of the picture and their arrangement, determine the message viewers get when they see the finished photographs. Unfortunately, many times photographers fail to tell a story.

A Chinese proverb says that a picture is worth 10,000 words. If that's true, you understand the responsibility you have when squeezing a shutter release. No one wants to read 10,000 poorly composed words, and no one wants to look at a poorly composed picture. A picture should have a reason for being taken. And it's up to the photographer to decide how to make a picture that creatively conveys his story.

What makes a good photograph? Judging is a selective thing. Every viewer has personal criteria for what he likes and dislikes. Sometimes, regardless of

its composition or technical perfection, the photograph may be judged poor because the viewer objects to the subject itself.

Most often, however, viewer reaction relates to the arrangement of the elements within the picture. And unless he is an accomplished photographer himself, the viewer rarely observes the techniques of effective composition incorporated in the photograph. Remember, when composing or studying any photograph, it's worthwhile to ask yourself what's wrong with the picture. Analyzing the negative aspects of the photograph will give you a more positive approach to utilizing the elements of good composition in your pictures.

Following are guidelines to help you make more effective photographs. Even so-called "record" shots that are made to help preserve regular events like birthdays can be more creative than the usual police line-up type of pictures.

Have a Center of Interest

There should be a main subject or center of interest in every picture. It should attract the viewer's eye. Other objects in the picture must not compete with what you intend to be the center of interest. When shooting, consider what is the main subject and if it will be obvious to the viewer.

Put the Main Subject Off-Center

Interestingly enough, as a general rule the center of interest should not be in the center of your picture. Centered subjects usually are less interesting than those placed according to the "rule of thirds." This basic concept of composition is used almost subconsciously by most successful photographers. Mentally divide the scene in your viewfinder into thirds, both horizontally and vertically. Place your main subject along one of the four imaginary lines or where two of the lines intersect. The subject should face or move toward the center of the picture, not away from it.

With scenic views, do not let the horizon divide the picture in half. Move the horizon to the upper or lower one-third of your viewfinder. In a scene with the sky as the main center of interest, the sky should occupy the upper two-thirds of the frame and the area below the horizon should be kept in the lower third. Conversely, if the sky is unimportant, the foreground subjects should fill the lower two-thirds of the frame and the sky the upper third.

107-110. *The same subject can be photographed in a variety of ways, as revealed in these four views of San Francisco's Golden Gate bridge. The "rules" of composition are guidelines to making the most effective photographs (see text).*

111. *Putting the subject off-center by following the "rule of thirds" is a simple way to improve composition.*

Get in Close

A key rule to remember is to get close to your subject. Fill your viewfinder only with what you want in the finished picture. This is especially important when shooting slides. Unless you mask and remount your slides, the transparencies will show on the screen everything that was included in your viewfinder. Although black-and-white and color negative film can be cropped during the enlarging process, it's always better to crop in the camera. Move in. Get rid of everything that is not necessary to your picture. Don't let unwanted objects distract the viewer. Get close with your camera to concentrate attention on your subjects.

(A) (B)

112. *A picture that's mediocre because the subject is too far away (A) will be improved considerably if the photographer gets closer and fills the viewfinder (B).*

113. Filling the viewfinder with the subject, by getting close or using a telephoto lens, can mean the difference between making an excellent picture and one that is rather ordinary.

Keep the Horizon Straight

Keeping the horizon straight in a picture is a simple rule that is often ignored. The result is a distracted viewer who is bothered by an unlevel horizon. When shooting any subject with a horizon, even if it is very distant, check just before you squeeze the shutter release to make sure the horizon is not tilted.

114. Photographers concerned with composition always look past their main subject, such as this Chinese junk in Singapore Harbor, to be sure the horizon appears level in the camera's viewfinder.

Watch the Background

Equally distracting, and an all too common composition error, is a poor background. One that is cluttered will draw attention away from your main

subject. A background that is too busy should be avoided. Change your camera angle or your subject's position. Get low and shoot your subject against the sky; it's plain enough to keep the viewer's attention on the subject and not the background. Alternatively, if the ground is attractive and simple, use it as the background by photographing your subject from a high angle.

By all means, avoid backgrounds where trees or poles seem to be growing out of people's heads.

Always study the background before you release the shutter. One way to eliminate a disturbing background is to throw it out of focus. If your subject is far enough from the background, opening up the f/stop minimizes depth of field and will keep your subject sharp while putting the background out of focus. Regardless, it's always a good idea to check your depth of field scale on your camera's lens to see how much of the background and foreground will be in focus. Unwanted foreground objects can upset your composition, too, so watch out for them.

115. Alert photographers make certain that objects in the background do not distract from their main subjects. A tree growing from a person's head is a common problem that can be easily avoided.

Check All Angles

Study your subject and check it from all angles. Even a slight change of angle can improve the composition of your picture tremendously. The height

of a photographer's eye is not always the best level for his camera. Kneel down or stand on your tiptoes. Some photographers get low by placing their cameras on the floor or ground. Others climb ladders and trees or extend the height of the camera by holding it on a tripod over their heads.

Shooting up from a low angle makes the subject look imposing and gives it a feeling of strength or power. Shooting down from a high angle tends to diminish the subject and make it appear weak or submissive. For these reasons, try taking pictures of babies, children, and animals at their own level, as well as small flowers and plants.

116. Many subjects are portrayed best when they are photographed at their own level.

Changing your angle will alter the lighting of your subject as seen by the camera. Walk around to see if your subject would look best with front, side, or back lighting. In bad weather, eliminate overcast and gray skies by shooting your subjects from a high angle. Always check to visualize your subject from every angle before selecting the angle best for your purposes.

Try Leading Lines

Direct the attention of your viewers to the center of interest of your picture with leading lines. Roads, fences, and rivers commonly are used as leading

117. Checking subjects from all angles helps improve composition and a picture's impact. This profile shot of two ducklings is rather dull.

118. A much more intriguing photograph was made from behind the little ducks as they face the vast ocean.

lines. They must lead and direct attention into the picture, never out of it. So, for more interesting composition, include leading lines in some of your pictures. Even shadows can serve this purpose. Study your subject area for all possibilities.

119. Including a leading line in a photograph, like this road that goes toward Alaska's Mt. McKinley, helps direct viewers to the picture's center of interest.

Frame the Subject

A natural frame also will direct viewers toward your main subject. Very common and effective is a tree or overhanging branch used to frame a scenic shot. Such a frame works well to hide an uninteresting sky, too. Frames are kept in the foreground and give a feeling of depth to pictures. They can surround the subject or just border the top or one side.

Generally, frames are kept in focus because a fuzzy foreground can be distracting. Sometimes, however, to isolate and emphasize the center of interest, the frame should be thrown out of focus by correctly figuring depth of field. Frames can be found at many levels and angles. Look around. Windows, natural arches, doorways, and fences are examples. By the way, ecolo-

120. A frame helps focus attention on the main subject, as shown in this photograph of Machu Picchu in Peru. A frame also can be used to block out a dull sky or other uninteresting aspect of the subject area.

gists and most photographers do not respect frame enthusiasts who cut flowers or tree branches to use as frames. Move your camera, not the frame.

Vary the Format

Unlike cameras which offer only a square format, such as 126-size Instamatics or 2¼ × 2¼-inch Rolleiflexes, 35mm, pocket, and disc cameras take rectangular pictures and can be turned to make horizontal or vertical images.

121. Framing the subject can be an effective way to compose a better picture.

Good composition usually calls for tall subjects to be shot vertically, wide sub-jects horizontally. For variety in your pictures, vary your format. Don't shoot everything horizontally. For an interesting effect, occasionally shoot tall objects, such as church steeples or flagpoles, on the diagonal. In the vertical camera position, frame them at an angle running from a top corner to the opposite bottom corner of your viewfinder.

Include Size Indicators

Too often photographers shoot scenes and other subjects without enabling viewers to comprehend their size. Use of size indicators, objects with which we are familiar, will help to tell the story. With scenery, for example, a person or a car included in the picture will help viewers understand the size of your main subject, whether it is a mountain or a waterfall. Check photographs in the *National Geographic* to see how often its top-flight photographers utilize size indicators.

Persons or objects often are used in the foreground looking or moving toward the center of interest. They help lead the viewer to the main subject. Don't let such foreground figures look at the camera or they will hinder, not help, your photographic composition.

(A) **(B)**

122. *Composition usually is improved when the camera is held so that its format is appropriate to the subject. Generally, a horizontal format is best for scenic views (A), while a vertical format works well with tall subjects that fill the frame (B).*

123. *For some subjects, like this Austrian church steeple, shooting on the diagonal makes a more interesting picture.*

124. *By including objects of a known size, the relative size of the main subject is easier to comprehend. Besides serving as size indicators, these people walking toward the Mt. Palomar Observatory help direct viewers to the picture's center of interest.*

More Elements of a Good Photograph

Besides the above guidelines for the selection and arrangement of subjects in your picture, there are other considerations which contribute to effective composition. Mastering these additional elements of making good photographs should be the goal of all photographers.

Focus for Effect

Most basic is focusing. All too often photographers simply focus on the main subject and shoot. There is little or no consideration of depth of field (for review of this subject, see page 43). The photographer can and must always determine how much of his subject area will be in focus. By using depth of field scales on camera lenses and understanding the effect of lenses relative to the position of the camera and subject, the photographer will have full control of focus.

125. Focusing for effect is a key to better photographs. Here the viewer's attention is drawn to the baby's delicate fingers, the only part of the picture in sharp focus.

126. As with the adjacent photograph, the camera was positioned close to the subject, a wide f/stop was used, and the lens was focused precisely—in this case, on the boy's eyes—in order to make a specific part of the subject stand out.

First, the photographer must decide what he wants in his picture and how much should be in focus. Next he considers which lens to use and the position of his camera. Then he checks depth of field to see if the focusing effect he wants is possible. If not, he must change the lens or camera position.

If the photographer wants only his main subject in focus, he can open up the lens aperture to the f/stop that will limit depth of field (the picture area in focus) of his subject. Determine this by reading the depth of field scale on the lens being used (see Illustration 39, page 47). Remember, for a lens without a depth of field scale, instructions provided with the camera or lens should include a chart indicating how much of the picture area will be in focus according to the f/stop and distances set on the focusing scale.

To put most or all of what he sees in the viewfinder in focus, the cameraman *stops down* his lens aperture to the f/stop which gives him the required depth of field. He does this by using the depth of field scale on his lens. If the focal length of his lens is too great to allow the required depth of field, he must switch to a lens of shorter focal length, such as a wide-angle lens. For instance, in a situation where the photographer's normal 50mm lens will not get all the desired subject area in focus even at the smallest f/stop, he should try a lens of short focal length, like a 35mm, 28mm, or 24mm. Such wide-angle lenses have great depth of field.

Alternatively, if he cannot change lenses, he must change his camera position and move back from the subject area he wants in focus. That's because the greater the distance the lens is from the subject area, the greater the depth of field.

Conversely, the closer the subject is to the camera, the less depth of field. To isolate the subject by keeping everything but the subject out of focus, move in close to shorten the distance between subject and camera lens and thus reduce the depth of field.

To achieve a similar effect without moving the camera position, change to a lens of greater focal length, such as a telephoto. For example, if a normal 50mm lens causes too much of the desired subject area to be in focus even at the widest f/stop, the photographer should switch to a longer focal-length lens, like 90mm, 105mm, or 135mm. Such telephoto lenses have less depth of field than normal lenses, which makes it easier to keep the foreground and background out of focus, and thus isolate the subject.

Expose Accurately

A potentially good picture can be ruined by poor exposure. Become competent in making exposure meter readings and setting the correct f/stop and

shutter speed (see Chapter 2). A photographer who is confident about how to determine the proper exposure can concentrate more on the other aspects of making good pictures. Remember, in unusual lighting situations, bracketing exposure is always suggested. Learn how your camera's exposure meter works and how to use it.

Include Some Action

Unless you're trying to produce a mood of stillness, include action in your pictures. Far too many photographs are static and lifeless. Even though you are making still pictures, that does not mean your subjects have to be still when you photograph them. Informal pictures of people are always better if your subjects are doing something. Candid shots are superior to posed pictures because they are lifelike and reveal natural expressions and action.

Even if you have to organize your subjects for a picture, don't let them become stilted. Make sure they are relaxed. Don't tire them out by making them wait for you to get your equipment ready and the exposure reading made. Plan as much in advance as possible and be set to shoot when your subject flashes the expression you want. Don't ask him to "hold it"; the result too often seems unnatural. With portraits of babies, children, or pets, give them something to keep them occupied and their attention off you. A toy or snack treat works well.

There are several ways to photograph action. And shutter speed is the key factor. You can shoot at a fast speed to stop the action or a slow speed to let it blur in your picture. *Stop-action* is very common and the purpose is to freeze the subject so the viewer can see it clearly. Stop-action is effective only when the viewer realizes that the subject was moving when the picture was made. A pole vaulter frozen in midair or a diver doing a backflip into a swimming pool are examples.

Be sure, of course, to include a *point of reference* so the viewer knows who the subject is and what he is doing. With a pole vaulter, include his pole or the crossbar he is vaulting. The diver's picture needs a diving board or a swimming pool for a reference. Otherwise the pole vaulter appears only as a man in a track suit suspended in midair. And the diver is simply a person in swimming trunks frozen in midair. The viewer does not know that they are a pole vaulter and a diver, or what they are doing. The photographer failed to tell his story. So always include a point of reference, when needed, in an action shot.

The easiest way to stop action is with a fast shutter speed. How fast a shutter speed depends on three interrelated factors: how fast the subject is moving, how far the subject is from the camera, and the direction of the subject's movement in relation to the camera.

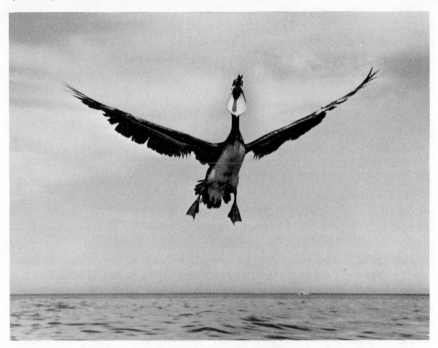

127. *Using a fast shutter speed is one way to stop the action of a moving subject. This pelican was captured in mid-air at 1/500 second.*

Obviously a speeding race car is going much faster than a running boy. So first consider the speed of the subject you want to stop.

A train passing near you seems to be going faster than one passing in the distance. The shutter speed must be faster for a subject close to you. Always remember the distance between subject and camera helps determine the shutter speed required to stop the action.

On a highway, the oncoming car or scenic view seen through the windshield appears to be moving slower than it does when you look through your side window and see the car or vista whiz past. A subject moving perpendicular to the camera is more difficult to stop than one moving directly toward or away from the camera. Therefore, subjects moving at a 90° angle to the camera require a faster shutter speed than those at other angles. The subject's direction in relation to the camera is the third consideration regarding the shutter speed to select to stop action.

The chart on the opposite page will help you determine the shutter speed to use depending on the three considerations given above: speed, distance, direction.

Another way to stop action is to trip your shutter at the *peak of action*. Shoot when the basketball players are at the highest point of their jump. Make

SUGGESTED SHUTTER SPEEDS (IN FRACTIONS OF A SECOND) TO STOP ACTION

SPEED of subject	DISTANCE of subject from camera (feet)	DIRECTION of subject in relation to camera		
		toward or away from camera	at 45° angle to lens	at 90° angle to lens
Less than 10 mph (People walking, children or pets playing)	25	1/125	1/250	1/500
	50	1/60	1/125	1/250
	100	1/30	1/60	1/125
Less than 30 mph (Athletic events, horseracing)	25	1/250	1/500	1/1000
	50	1/125	1/250	1/500
	75	1/60	1/125	1/250
More than 50 mph (Cars or boats racing, trains, airplanes)	25	1/500	1/1000	1/2000
	50	1/250	1/500	1/1000
	100	1/125	1/250	1/500
	200	1/60	1/125	1/250

(A)

(B)

(C)

128. *A moving subject's direction in relation to the camera must be considered in order to stop the action. Stopping the action of subjects moving toward or away from the camera (A) does not require as fast a shutter speed as when the subjects are moving diagonally (B) or parallel (C) to the film plane. Refer to the chart above.*

your exposure the instant the action is suspended. Photograph the child the moment his swing pauses to reverse its direction. Stopping action at its peak is possible with a nominal shutter speed. But the photographer's timing must be perfect.

Action can also be stopped by *panning* with the subject. This is one of the most effective techniques for portraying the feeling of motion in your photographs. To pan, the photographer follows the moving subject with his camera, carefully keeping it in his viewfinder. When he decides the moment is right, he squeezes the shutter release. Since the camera was keeping pace with the moving subject, the subject will be sharp and the background blurred. The blurring gives the feeling of speed. Slower than normal shutter speeds usually give a very action-packed effect.

Panning requires practice. Prefocus on the spot where you plan to photograph your subject. Stand firmly and pivot your body at the waist. Keep your camera level or the subject and blurred background will be tilted and distracting. Most important, follow through with your panning motion even *after* you release the shutter. If you don't get in the habit of following the action after shooting, unconsciously you'll stop panning an instant before tripping the shutter and the effect of panning will be lost.

Like a golfer or tennis player, always follow through when making a panning shot. Try panning with moving subjects. You'll discover it is an effective way to make eye-catching photographs. Remember, you can pan vertically as well as horizontally.

Another way to stop action is with electronic flash. Many electronic flash units currently on the market fire a burst of light that lasts from 1/1000 second up to speeds of 1/50,000 second, depending on the model and its design. By using electronic flash, stop-action shots are possible in interior or outside situations where the natural or other artificial light is not sufficient for the use of fast shutter speeds. Another use is stopping the quick expressions and movements of babies. Many professional baby photographers use electronic flash for this reason.

Don't forget when using electronic flash with cameras having focal plane shutters, the shutter speed usually must be set at 1/125 or 1/60 second or less, depending on camera instructions in your manual. This allows flash synchronization (see page 112). With electronic flash, the camera's shutter speed does not stop the action—the brief burst of light from the flash unit does.

Action in photographs also can be shown by having some part of the subject area blurred. Panning is one way to cause blurring and portray motion. Another approach is to use a slow shutter speed. At a car race, for example, you might pan with the speeding autos and blur the background of spectators in the stands. Emphasis will be on the race cars. But if you want to show the fans watching the race, frame the people in the stands and shoot at a slow enough shutter speed so the cars passing in the foreground will be blurred. Your main subject, the spectators, will then be emphasized. The blurred race

129. Panning is one of the most effective ways to show motion. In many situations, as with photographing this motorcycle, panning is preferred to stop-action. The photographer follows the subject in the camera viewfinder and releases the shutter while moving. The background blurs, while the subject is well defined. Vary the shutter speed for different effects. And remember that panning takes practice.

cars help set the scene but will not distract from the people in the stands.

Adjusting the focal length of a zoom lens *during* exposure also gives the feeling of motion. The subject is not actually moving. The camera should be on a tripod, and a slow shutter speed is used to allow the photographer time to zoom in or out during the exposure.

Slow shutter speeds can be used effectively in many ways to show action. Try them with flowers or leaves blowing in a breeze, children riding a merry-go-round, or a grandfather clock with its pendulum swinging. Look around. There are many subjects whose motion will enhance your pictures. The decision you'll need to make is how to suggest action to your viewers: stop it, blur it, or both. Whatever you decide, include action in your picture.

130. *When panning with a subject, be sure to follow through. To portray motion effectively by capturing the subject against a blurred background, begin panning with the subject at point A, press the shutter release at point B, and continue following the subject until point C.*

Use Good Timing

Too many photographers release their shutters immediately after framing, focusing, and setting their exposure. They fail to wait for the moment of greatest interest or impact. Timing is important to a successful photographer. Good timing takes patience and practice.

Study your subject and know what it does or might do. For instance, you spot an eagle sitting on the top of a nearby tree. A nice picture. Do you shoot it and go away? Or do you wait until the moment he extends his wings and begins to lift off from his perch, and shoot again. A dramatic picture. Anticipating a subject's actions is a necessary photographic habit.

Children eating ice cream cones sometimes drop them or at least get the ice cream on their faces or clothes. People in discussion gesture with their hands. Fishermen usually show excitement when they catch something. Waves splash higher on rocks with incoming tides. Consider what will be the right moment to shoot and wait for it.

A golfer blasting out of a sand trap is more exciting than one teeing off. A person blowing out birthday candles is more interesting than one just holding the cake. A horse galloping is much more dramatic than one grazing. Study your subjects and figure the best time to photograph them. Shooting a

131. The movement of water, like all active subjects, can be portrayed in various ways by adjusting the camera's shutter speed. A fast shutter speed freezes this wave as it crashes against a rock.

132. A medium shutter speed produces streaks as thermal water bounces off this bather at a spa in Germany.

133. A very slow shutter speed creates a foamy mist as an incoming tide tumbles over rocks and splashes upward.

134. Timing is an important consideration in photography. When this Peruvian mother and child each raised a hand to her mouth, the photographer tripped the shutter to make this captivating picture.

second too early, or too late, can make the difference between an ordinary and an unusual picture.

Time of day is another consideration. The long shadows of early morning or late afternoon often make pictures much more effective than if they were taken at noon with the sun overhead. Decide when you think the lighting will be best, and wait for that moment. Also consider whether a night shot would be more effective than one taken during the day. Las Vegas, for example, makes a much more impressive picture at night with the glow of its colorful casino lights.

135. *Downtown Las Vegas is rather dull to photograph during the day.*

136. *But it comes alive at night, which is the best time to photograph that city of signs and lights.*

What time of day will your subjects be at their best, or worst? If you want unhappy children, take photographs when they are tired or hungry. For pictures of active kids, wait until after their meals or naps. And be sure you're ready when your subjects are. Your camera and equipment should be set up and ready to fire the moment your subject makes the move or expression you want. Good pictures often result only because of the photographer's good timing.

Consider Color

Whether you shoot black-and-white or color film, the colors of your subject are important to the success of your photograph. Obviously, with color film you should make sure your subjects are colorful. Also, separation of foreground subjects from the background objects can be accomplished if they

are of different colors. And add impact to a dull scene by using subjects or objects of bright color. Always consider what colors in your picture might be added or eliminated before you trip the shutter. Look for color and use it in your photographs.

Black-and-white film users have other considerations. Their film records not colors but the brightness of various colors. These register as shades of gray. Understanding how black-and-white film responds to colors enables the photographer to obtain the contrasts desired in his picture.

For example, a dramatic scene includes fleecy white clouds against a vivid blue sky. But because most black-and-white film is very sensitive to blue, the sky appears a light gray in the photograph. The sky looks almost as bright as the clouds, and there is almost no contrast between them. The impact of the picture is lost. Photographers familiar with black-and-white films know that they can use filters to alter the brightness of the colors seen by the film. One result is an improvement in contrast in the resulting photograph. In this sky and cloud example, a yellow or red filter will darken the blue sky light so it will not register so brightly on the film. In the resulting print, the sky appears a darker gray than that of the clouds. And now the contrast between sky and clouds provides viewers the dramatic scene the photographer saw.

Filters were discussed in detail in Chapter 6. The basic concept a photographer must keep in mind is that a filter lightens its own color and darkens the complementary color on black-and-white film. Without a filter, a yellow flower against a blue sky will photograph without much contrast between sky and flower. To improve contrast and thus the picture, add a yellow filter, which will lighten the flower and darken the sky. To obtain effective photographic results, the photographer must always consider the colors in the intended picture.

Use Your Imagination

The composition techniques a photographer utilizes for his pictures often indicate how creative he is. The elements of a great picture may be present but the photographer must know how to compose them in order to make the most effective photograph. There is no right or wrong way to compose a picture. The techniques of composition outlined earlier in this chapter are intended only as guidelines.

Certainly these guides are time-tested and accepted by photographers. But there is another element that must be considered—imagination. The creative photographer is one who knows the "rules" but also dares to break them. He experiments. He tries different approaches with different subjects. The results

137. The color of this plant is all green, but different parts of the plant reflect the daylight differently, which is recorded on black-and-white film in various shades of gray. Also, filters can be used to portray the colors of subjects with more or less brightness.

may or may not please him, but at least he has attempted to satisfy his curiosity. Don't be too content with your photography. Use your imagination.

Ask yourself, what are the various ways to portray this subject? Then try them. Would a soft effect be best with your subject? Break the rule about having your main subject in sharp focus—try placing a piece of nylon stocking in front of your lens to make the image slightly fuzzy. Contrary to warnings about camera movement spoiling your pictures, should you purposely jostle your camera to give a feeling of motion to an otherwise static subject? Why not try it? How about creating a more somber mood in your photograph by underexposing and thereby darkening the subject? It's worth a frame or two of film to see if you get the effect you want. Or purposely overexpose to lighten the subject and give a bright feeling to the photograph.

The photographer has a variety of tools for his creative use. Lighting, films, lenses, f/stops, shutter speeds, and camera angles are a few examples. Regarding lighting, for instance, early morning or late afternoon gives long shadows and the sun's highlights to scenic landscapes. Back-lighting offers extra brilliance to a water fountain. Overcast days produce even and pleasant illumination for color portrait pictures outdoors.

As for lenses, to create images which seem natural in size and perspective to the viewer, the photographer chooses a normal lens for the picture. If he wants to include more of the subject than the viewer normally would see with his naked eye, the photographer uses a wide-angle lens. He knows such a lens will diminish the image size of his subjects, of course. Also, if he must work in cramped quarters close to his subjects, a wide-angle lens again would be his choice. When a larger than normal image of a distant subject is desired, the photographer automatically selects a telephoto lens. Knowing such a long focal length lens gives him limited depth of field, he can shoot through an obstructing foreground such as tree leaves or a wire fence and still record his subject. The foreground objects will be so out of focus they will seem to disappear. Also, the photographer knows his telephoto lens will throw a distracting background out of focus. By experimenting with his various lenses, the creative cameraman learns which one will give him the effect he wants when composing his pictures.

Similarly he knows how to control his composition with the use of shutter speeds. He automatically switches to a fast shutter speed when he wants to "freeze" the action of a moving subject. Or he slows down the shutter to let the subject blur and give the feeling of motion. He changes the focal length of his zoom lens during an exposure to create another motion effect. Or he tries panning with his subjects at both slow and fast shutter speeds.

Imagination also leads the photographer to variety in his photographs. He makes night as well as daytime exposures. He shoots inside buildings as well as outside. His pictures include scenes as well as people, and animals as well as wildflowers. He frames overall views, and moves in for close-ups, too. He varies his camera angles.

138. *A telephoto lens made it possible to capture a close-up view of these inquisitive animals in South America.*

Everything he sees is a photographic possibility. He composes pictures in his brain before he records them on film. Even without intending to stop and make a picture, he sees photographs of subjects while driving or walking. He becomes more aware of the world around him.

The creative cameraman photographs fish in his home aquarium, makes color pictures of actors on a television screen, and takes time exposures of fireworks. He shoots prayer candles in a church, and takes his camera to the theater for other existing light pictures. He tries tricks like creating a ghost in his house by making a double exposure. He does close-ups of flowers in his garden and remembers to sprinkle the flowers and leaves with water to give an after-the-rain effect.

Most important, he learns to cover his subject completely. A day at the horse races includes more than a few telephoto pictures of home stretch. He gets close and low to the track to fill his viewfinder with flying horses' hooves. He tries fast and slow shutter speeds, and panning, to portray the speed of the animals. He gets photographs of bouquet and trophy presentations in the winner's circle. He captures the grandstand spectators during and after a race. He shows the tote boards, the betting windows, and the discarded tickets of losing bettors. With luck, he sees and photographs the excitement of some-

one holding a winning ticket. To tell the story of a horse race he knows he must photograph more than just racing horses. To be sure his story is complete, he always asks hismelf, "What's missing?"

The creative photographer gets involved, uses his imagination, and has enthusiasm for telling his story. And he composes his pictures with care.

And remember, a photographer must know the capabilities of his camera. Make a point to try out your camera and equipment after you buy it, just as you would test-drive a new car. Invest in a roll or two of film and experiment with close focusing, depth of field ranges, and fast and slow shutter speeds. Use the self-timer, try the camera with flash, and make double exposures. Get to know your camera and equipment intimately so they become part of you, not just objects in your hands. Then you can devote your time to composing effective pictures, not fiddling with camera controls and wondering if you'll be able to get the pictures you want.

139. To convey the excitement of a Mexican folk dance, the photographer positioned himself on a balcony and used a medium shutter speed to show the dancers' swirling skirts.

11

Learning About Lighting

The word *photography* means "to write with light." Light is essential to making photographs, and the photographer must understand how to use it in order to make his results as interesting as possible. There are two basic types of light, natural and artificial. The first comes from the sun, the other from man-made sources.

Natural light generally refers to daylight, although moonlight qualifies, too. For photographers, light during the day can vary. There might be a bright or hazy sun that causes shadows. It could be bright but cloudy and no shadows evident. Or there might be a heavy overcast. Daylight also exists in the shade, where subjects are shielded from the direct rays of the sun. Daylight exists indoors, too, so not all natural-light shots are taken outside.

Artificial light is illumination produced by man. It may be an ordinary light bulb, a fluorescent tube, a bright photoflood, a tungsten-halogen light, a flashcube, an electronic flash, or many other types. Since these types of illumination can be used outdoors too, not all photographs shot with artificial light are taken inside.

Photographers also talk about *available* or *existing light.* This is light, whether natural or artificial, that already is present in the subject area. A photographer who shoots by existing light does not provide any of his own illumination unless it is a flash used to fill in any shadows.

Regardless of the lighting used, there are several considerations for the cameraman. With directional lighting, such as that provided by the sun, flash, or photofloods in reflectors, he must know about front, side, and back lighting.

Basic Types of Lighting

Front lighting is the most basic for photographers, although not necessarily the most appealing. The long-standing rule that says to put the sun at your back so it shines on the front of your subjects was established for good reasons. Earlier films and camera lenses were not as fast as those in use today.

140. The existing light coming through a side window provided most of the illumination for this informal portrait of father and son taken in their living room.

However, old-time camera and film manufacturers knew that bright and direct sunlight on the subject would provide an adequate image on the film, and so they recommended it. Also a subject illuminated directly from the front shows every detail because it is uniformly lighted.

Front lighting is still popular today, but many photographers find it unsatisfactory for portraits or other subjects. The reason is that front-lighted subjects appear "flat" because there are no shadows to give a feeling of depth. For this reason, front lighting is commonly referred to as *flat lighting*. Another disadvantage is that, because light is shining into their eyes, people often squint when front lighting is used. Photographers have found that changing their camera angle or the position of the subject so that the main illumination is from the side gives more depth and interest to many of their pictures. This is especially true with extreme close-ups of objects. Such *side lighting* can come from the left or the right, depending on the photographer's preference. Occasionally shadows caused by side lighting are too harsh, however. Then an additional fill-in light is suggested, or back lighting.

Back lighting refers to situations where the main source of illumination is

(A) FRONT (B) SIDE (C) BACK

141. The three basic types of directional lighting are front (A), side (B), and back (C).

behind the subject, shining in the direction of the camera. Back lighting requires careful exposure readings so that the front of the subject is properly exposed. If a reading is made of the back light itself, the subject will be a *silhouette*. With portraits outdoors, back lighting allows the subject to have a natural expression without squinting because bright light is not falling directly on his face or into his eyes.

When strong directional light comes from both sides, the technique is known as *cross lighting*. It normally is used in studio situations, not under daylight conditions.

142. Lighting must be carefully considered in order to achieve the best photographic results. Back lighting can create some eye-catching shadows, as with these parading flamingos.

Outdoor Lighting Concerns

Front, side, and back lighting can be used indoors or outdoors. Indoors with flash, studio, or photoflood lights, lighting is quite easy to control because the photographer can direct it himself. Outdoors he must change his camera angle or subject because there is no alternative when the sun is his source of direct light. On overcast days, directional lighting is not possible because the sunlight is diffused. On such days, many photographers, in fact, prefer *diffused lighting* for portraits made with color film because their results are not as contrasty as when the light is direct. Diffused lighting often is referred to as being "soft."

Of course, flash will provide directional lighting outdoors, and it can be aimed from the front, side, or back of the subject. Outdoors, flash also can be used for fill-in light to soften the otherwise harsh shadows caused by strong sunlight. Without flash, and if the sun causes unwanted shadows, photographers often prefer to place the subject in the shade. Care must be taken with the use of color film because the shaded area may transmit or reflect colors on your subject that are not desired.

For example, with portraits taken under the shade of trees, sunlight coming through the leaves may give a slightly green cast to your subjects. Similarly, with a person in the shade of a red barn's overhanging roof, light reflecting from the barn may add an unwanted reddish cast to your subject. Even if your

143. The diffused light of an overcast day provided "soft" illumination for a pleasant picture of two gossiping schoolgirls.

144. *These young cowboys were photographed near high noon, when the sun was almost directly overhead. Notice the shadows and bright highlights caused by top lighting.*

eye does not discern the added colors, your film may record them. Beware of this when photographing subject with color film in the shade.

What are other lighting considerations when shooting outdoors? The best advice is to walk around your subject to decide the camera angle that will give the best effect for the lighting present. The location of moveable subjects may need to be changed for the most effective lighting. Regardless, noontime is not the best time for making photographs in bright sunlight. If the sun is too much overhead, the effect will be one of *top lighting,* and unpleasant shadows result.

For this reason, many photographers prefer early morning and late afternoon shooting when the sun is closer to the horizon. Then a camera angle can be chosen for front, side, or back lighting. Of course, photographers using color film early or late in the day may experience a reddish cast to the subject, especially people, because of the color of the rising or descending sun.

With portraits in the sun, be careful shadows do not obscure the subject's eyes. This occurs when the sun is overhead and the light comes from the top of your picture. Better to wait until the sun's angle changes, or move your subject to a shaded area. If that's impossible, fill in the shadows with flash, or use a reflector, such as crinkled aluminum foil or white poster board.

Some subjects are best photographed with back lighting. As mentioned, pleasing portraits are often made with such lighting. Water or other translucent objects photograph dramatically with back lighting. Walk around a water fountain to see the effect back lighting gives. It offers special sparkle as the light is transmitted through the water. By comparison, water illuminated from the front simply reflects the light back to the camera and the effect is rather dull. Raindrops on flowers or leaves are best photographed with back lighting. Similarly, back lighting of rivers or lakes often causes dramatic bright pinpoints of light as the sunlight bounces into the camera from the water's surface. Star effects from these dots of light can be achieved if your lens opening is closed down to f/16 or less.

Back lighting also is used most effectively with stained-glass windows and some glassware. Light passing through such windows and glass offers sharp and vivid colors in comparison to the picture you would get from front lighting with the sun reflecting off the glass. Always consider how transparent or translucent your subjects are, and whether back lighting will give a better effect than front or side lighting.

Some outdoor lighting conditions make effective photographs in themselves. Rainbows and sunsets are two examples. No special exposure is required, although colors will be more vivid if you slightly underexpose. Bracketing will provide a variety of color ranges and moods. Light from a descending sun diminishes quickly. Make your exposure immediately after taking an exposure reading. Read the sky and clouds around the setting sun, or read the sun directly. With CdS meters, do this quickly so the direct sunlight does not affect your meter's cell, or subsequent meter readings may be incorrect until the

145. *Smart photographers study the light before they shoot. These grasses show almost no detail because the sunlight is falling on them from the front and is therefore "flat."*

146. *When shot from the opposite direction so the sunlight comes through them, the same grasses are highlighted and appear in much better detail in a photograph.*

cell recovers. Don't include dark foreground objects in your reading or the film may be overexposed.

Indoor lighting has other considerations. Front, side, and back lighting are possible, depending on the direction and brightness of the light source. Many times existing light is used. This produces a natural effect. Such lighting may be diffused and somewhat nondirectional, as when it comes from a number of ceiling lights. Or it may be more directional, as with sunlight coming through windows.

Often, however, light indoors is arranged by the photographer. He uses flash, photoflood, or studio lights to provide and control the light he needs. Sometimes he directs such light into an *umbrella reflector* or at a white ceiling, where it diffuses and reflects downward to provide soft and even illumination.

This *bounce lighting* gives a natural effect to photographs, since we are accustomed to light coming from above us.

Indoor Portrait Lighting

With more formal indoor portrait situations, the photographer often prefers to use more directional lighting. Depending on the number of lights he uses for the effect he desires, they can be arranged according to a commonly accepted lighting plan for portraiture. The two types of light most often used by amateurs are *photofloods* and *electronic flash*. Photofloods are less expensive, and you can see the lighting effect before taking the picture. Photofloods appear to be regular household lamp bulbs but give very bright light. Pros use electronic flash or expensive studio tungsten lights. But the arrangement of the lights is usually the same.

The simplest lighting setup for portraits involves two lights, the main *"modeling" light* and the *fill-in light.* To give depth and detail to your subject, the main light is placed to one side of the camera at about a 45° angle from the camera, and about 45° above the subject's head. Put the main light closer to the subject than the camera.

The fill-in light is kept by the camera on the side opposite the main light. It should be slightly higher than the camera's lens. Both lamps can be the same brightness (wattage) but the main light is always higher and closer to the subject than the fill-in light. The main light, because it is away from the camera, will shadow part of your subject, so the fill-in light is used to illuminate these shadows and keep them from being too dark. With photofloods, test the effect of the main light before turning on the fill-in light. The shadow of the subject's nose caused by the main light should not reach his lips. If it does, adjust the main light or ask your subject to lift his head. By the way, as a matter of courtesy, portrait photographers never touch their subject; they simply tell the subject which way to move his head or body.

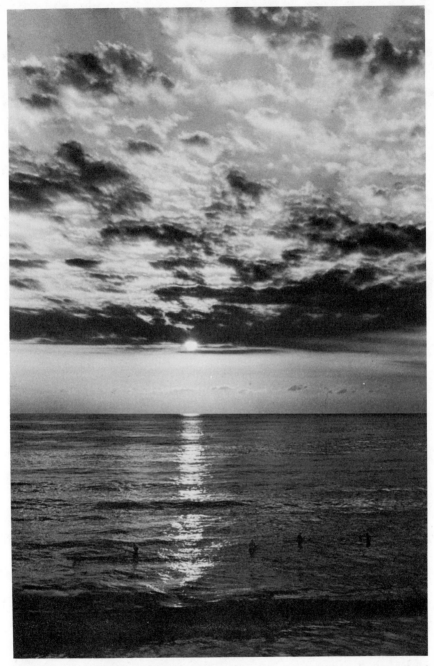

147. For this sunset over the Pacific Ocean, separate meter readings were made of the clouds and of the water, and the results were averaged to determine the exposure. Extra shots also were made while bracketing the exposure.

148. To make a portrait using two lights, arrange them in this manner (see text).

Until the portrait-lighting technique is understood and becomes second nature, it is advisable to use photofloods rather than flash in order to see the effect of the lights in regard to their placement. No. 2 photofloods in a reflector, a reflector spot, or a reflector flood are recommended. Of course, these very bright lights will disturb babies and children and may cause them to squint. For this reason flash is recommended for portraits of very young subjects. Sometimes normal household light bulbs in reflectors can be used to set up the portrait lighting positions and then flash is substituted for making the actual picture.

One or two more lights can be added to improve portrait lighting. One is called an accent or hair light, the other a background light. Most often the *accent light* is used to outline or add highlights to the hair of the subject. It also helps separate the subject from a dark background. The accent light is placed behind and high to one side of the subject, and should face but not shine into the camera lens. For this reason a spotlight is best. Cardboard can be cut and attached to the photoflood reflector, but not to the bulb itself, to direct the accent light and prevent it from shining into the lens.

A *background light* helps separate the subject from the background and give the portrait additional depth. This light is directed at the background and is kept low behind the subject. The brightness of the background is deter-

mined by how close the light is to the background. In studios, long, wide rolls of white, black, or colored *seamless paper* are often used for the background. Exposure meter readings should be made for the subject's face with the background light off so that it does not influence the reading.

This lighting design works not only with people but with most any other subject, including flowers. Only two lights are needed, but an accent or background light will add highlights. Additional lights are not needed and will decrease the impact of your photograph. There is one situation where two main lights, one on each side of the subject, are used for a cross-lighting effect. A fill-in light at the camera position will decrease the shadow which usually occurs down the middle of a cross-lighted subject.

Experiment with indoor lighting so you'll be familiar with equipment and methods before the occasion occurs when you need to make a picture under such conditions. Electrical cords must be long enough to avoid tripping over

149. For a more elaborate setup in making portraits, use four lights and arrange them in this manner (see text).

them. They should be heavy-duty cords to carry the current load required for photofloods or other bright lights. And they should be plugged into different circuits to prevent overloading, blown fuses, or trouble with circuit breakers. Remember, photofloods are extremely hot and should not touch any objects, your hands included, until the bulbs are turned off and cool. Since their life is relatively short (6 hours for a No. 2 photoflood), they should not be left on unnecessarily.

Lighting is a major consideration in photography. Learning how to use indoor and outdoor illumination effectively is an important goal for all photographers. Because you never know under what situations a great picture possibility suddenly will be presented, it is wise to get experience by making pictures under all lighting conditions. At least be sure your photographic capabilities include knowing how to make pictures inside buildings and after the sun goes down.

12

Photographing Under Special Conditions

There are some special categories of photography that may interest you. These often require a different approach for determining exposure, or some extra equipment. This chapter covers existing light photography, including night exposures. It also deals with close-up and copy work, infrared, aerial, and underwater photography. And you'll find comments on double and multiple exposures, as well as autowind, motor drive and remotely controlled cameras. The use of binoculars, telescopes, and microscopes for photography is discussed, too. Included are hints for successful shooting most often gained by experimentation and experience.

Shooting with Existing Light and at Night

While outdoor sunlight is the most common type of illumination for making photographs, many subjects must be photographed indoors by existing light or at night. Films and exposure vary according to the light and situation. Here are some guidelines for different subjects. If not mentioned in the text, suggested exposures for varied subjects will be found in a chart on pages 228-229. The chart refers to exposures with Kodak films, but any films of the same or similar ISO/ASA speeds can be used. Of course, where possible you should always use an exposure meter to read the light and determine the f/stop and shutter speed.

The slowest manual or automatic shutter speed in many cameras is 1 second, but sensitive built-in exposure meters in a number of modern 35mm models are able to make readings or automatic time exposures of several seconds. The shutter speed dial and/or camera instruction manual will indicate the range of specific times, such as 2, 4, 8, 16, and 32 seconds. For time exposures of other durations, or when exposures longer than 1 second are desired with other cameras, you'll have to set the shutter speed at B and manually hold the shutter open for the time required.

153. The chart on these facing pages indicates suggested exposures for making night and existing light photographs with Kodak films (courtesy of Eastman Kodak Company).

SUGGESTED EXPOSURES FOR KODAK FILMS

Picture Subject	KODACOLOR VR 100 ISO 100 / KODACHROME 64* (Daylight) ISO (ASA) 64 / EKTACHROME 100 (Daylight) ISO (ASA) 100	KODACOLOR VR 200 ISO 200 / EKTACHROME 200 (Daylight) ISO (ASA) 200 / EKTACHROME 160 (Tungsten) ISO (ASA) 160 normal processing / VERICHROME Pan ISO (ASA) 125 / PLUS-X Pan ISO (ASA) 125	KODACOLOR VR 400 ISO 400 / EKTACHROME 400 (Daylight) ISO (ASA) 400 — normal processing / EKTACHROME 200 (Daylight) ISO (ASA) 400 — / EKTACHROME 160 (Tungsten) ISO (ASA) 320 — Push Processing for 2 times normal film speed / TRI-X Pan ISO (ASA) 400	KODACOLOR VR 1000 ISO 1000 / EKTACHROME P800/1600 (Daylight) Push 1 Processing for speed of 800	EKTACHROME P800/1600 (Daylight) Push 2 Processing for speed of 1600 / ROYAL-X Pan ISO (ASA) 1250 / 2475 Recording (ESTAR-AH Base) speed 1000
AT HOME					
Home interiors at night — Areas with average light — Areas with bright light	1/4 sec f/2.8 / 1/15 sec f/2	1/15 sec f/2 / 1/30 sec f/2	1/30 sec f/2 / 1/30 sec f/2.8	1/30 sec f/2.8 / 1/30 sec f/4	1/30 sec f/4 / 1/60 sec f/4
Candlelighted close-ups	1/4 sec f/2	1/8 sec f/2	1/15 sec f/2	1/30 sec f/2	1/30 sec f/2.8
OUTDOORS AT NIGHT					
Indoor and outdoor holiday lighting at night, Christmas trees	1 sec f/4	1 sec f/5.6	1/15 sec f/2	1/30 sec f/2	1/30 sec f/2.8
Brightly lighted downtown street scenes (Wet streets add interesting reflections.)	1/30 sec f/2	1/30 sec f/2.8	1/60 sec f/2.8	1/60 sec f/4	1/125 sec f/4
Brightly lighted nightclub or theatre districts — Las Vegas or Times Square	1/30 sec f/2.8	1/30 sec f/4	1/60 sec f/4	1/125 sec f/4	1/125 sec f/5.6
Neon signs and other lighted signs	1/30 sec f/4	1/60 sec f/4	1/125 sec f/4	1/125 sec f/5.6	1/125 sec f/8
Store windows	1/30 sec f/2.8	1/30 sec f/4	1/60 sec f/4	1/60 sec f/5.6	1/60 sec f/8
Subjects lighted by streetlights	1/4 sec f/2	1/8 sec f/2	1/15 sec f/2	1/30 sec f/2	1/30 sec f/2.8
Floodlighted buildings, fountains, monuments	1 sec f/4	1/2 sec f/4	1/15 sec f/2	1/30 sec f/2	1/30 sec f/2.8
Skyline — distant view of lighted buildings at night	4 sec f/2.8	1 sec f/2	1 sec f/2.8	1 sec f/4	1 sec f/5.6
Skyline — 10 minutes after sunset	1/30 sec f/4	1/60 sec f/4	1/60 sec f/5.6	1/125 sec f/5.6	1/125 sec f/8

		20 sec f/16	10 sec f/16	10 sec f/22	10 sec f/32	5 sec f/32
OUTDOORS AT NIGHT	Moving auto traffic on expressways — light patterns	20 sec f/16	10 sec f/16	10 sec f/22	10 sec f/32	5 sec f/32
	Fairs, amusement parks	1/15 sec f/2	1/30 sec f/2	1/30 sec f/2.8	1/60 sec f/2.8	1/60 sec f/4
	Amusement park rides — light patterns	4 sec f/16	2 sec f/16	1 sec f/16	1 sec f/22	—
	Fireworks — aerial displays (Keep shutter open on Bulb for several bursts.)	f/8	f/11	f/16	f/22	f/32
	Lightning (Keep shutter open on Bulb for one or two streaks of lightning.)	f/5.6	f/8	f/11	f/16	f/22
	Burning buildings, campfires, bonfires	1/30 sec f/2.8	1/30 sec f/4	1/60 sec f/4	1/60 sec f/5.6	1/125 sec f/5.6
	Subjects by campfires, bonfires	1/8 sec f/2	1/15 sec f/2	1/30 sec f/2	1/30 sec f/2.8	1/30 sec f/4
	Night football, baseball, racetracks†	1/30 sec f/2.8	1/60 sec f/2.8	1/125 sec f/2.8	1/250 sec f/2.8	1/250 sec f/4
	Moonlighted — Landscapes / Snow scenes	30 sec f/2 / 15 sec f/2	15 sec f/2 / 8 sec f/2	8 sec f/2 / 4 sec f/2	4 sec f/2 / 4 sec f/2.8	4 sec f/2.8 / 4 sec f/4
INDOORS IN PUBLIC PLACES	Basketball, hockey, bowling	1/30 sec f/2	1/60 sec f/2	1/125 sec f/2	1/125 sec f/2.8	1/250 sec f/2.8
	Stage shows — Average / Bright	1/30 sec f/2 / 1/60 sec f/2.8	1/30 sec f/2.8 / 1/60 sec f/4	1/60 sec f/2.8 / 1/125 sec f/4	1/125 sec f/2.8 / 1/250 sec f/4	1/125 sec f/4 / 1/250 sec f/5.6
	Circuses — Floodlighted acts / Spotlighted acts (carbon arc)	1/30 sec f/2 / 1/60 sec f/2.8	1/30 sec f/2.8 / 1/125 sec f/2.8	1/60 sec f/2.8 / 1/250 sec f/2.8	1/125 sec f/2.8 / 1/250 sec f/4	1/250 sec f/2.8 / 1/250 sec f/5.6
	Ice shows — Floodlighted acts / Spotlighted acts (carbon arc)	1/30 sec f/2.8 / 1/60 sec f/2.8	1/60 sec f/2.8 / 1/125 sec f/2.8	1/125 sec f/2.8 / 1/250 sec f/2.8	1/250 sec f/2.8 / 1/250 sec f/4	1/250 sec f/4 / 1/250 sec f/5.6
	Interiors with bright fluorescent light	1/30 sec f/2.8	1/30 sec f/4	1/60 sec f/4	1/60 sec f/5.6	1/60 sec f/8
	School — stage and auditorium	—	1/15 sec f/2	1/30 sec f/2	1/30 sec f/2.8	1/30 sec f/4
	Church interiors — tungsten light	1 sec f/5.6	1/15 sec f/2	1/30 sec f/2	1/30 sec f/2.8	1/30 sec f/4
	Stained-glass windows, daytime — photographed from inside		Use 3 stops more exposure than for the outdoor lighting conditions.			

For color slides of these scenes, use Tungsten film for the most natural rendition. You can also use Daylight color film, but your slides will look yellow-red.

For color slides of these scenes, use Daylight film. You can also use Tungsten film with a No. 85B filter over your camera lens, giving 1 stop more exposure than that recommended for Daylight film.

For color slides of these scenes, you can use either Daylight or Tungsten film. Daylight film will produce colors with a yellowish look. Tungsten film produces colors with a bluish appearance.

With KODACOLOR Films you can take pictures of all these scenes listed in the tables and get acceptable color quality in your color prints.

*You can take pictures on KODACHROME 25 Film (Daylight) by using approximately 1 stop more exposure than recommended for KODACHROME 64 Film (Daylight).

†When the lighting at these events is provided by mercury-vapor lamps, you'll get better results by using Daylight film for color slides. However, your slides will still appear greenish.

Use a tripod or other firm support for shutter speeds slower than 1/30 second.

Pictures made with existing light will appear far more natural than those illuminated directly by flash or photoflood lamps. However, these two sources of artificial light will give the effect of existing light when used as bounce light. Aimed at a ceiling, their light bounces down on the subject to provide natural-looking illumination. Of course, in many situations flash is a poor illumination choice, as when the subject is too far away for the light output of the electronic flash unit or flashbulbs. At other times it is inappropriate, as during a wedding ceremony or stage performance. No wonder many photographers choose existing light for indoor and nighttime photography.

When using existing light, a main consideration is film speed. Because such light is less bright than sunlight, a high-speed film usually is preferred. In many cases a fast film allows the cameraman to hand-hold his camera instead of using a tripod. Also, it enables him to stop action. For action-stopping photography, very low light situations, or when a small f/stop is required for increased depth of field, the newer high-speed color slide and print films with a speed of ISO/ASA 1000 or faster are ideal films to use.

In addition to a fast film, a fast lens often is preferred. This allows more light to reach the film at faster shutter speeds. Again, this serves the photographer who hand-holds his camera or wants to stop action. Fast lenses with maximum lens openings of f/2.8, f/2, or f/1.4 often are the most versatile for existing light photography. Having a fast lens is not so important when the photographer wants a moving subject to blur on his film. That's because the shutter is held open for some time and the lens is stopped down to a small aperture opening to compensate and give the proper exposure. Favorite subjects at night to blur and thus produce colorful streaks of light on the film are moving cars and rotating Ferris wheels.

In regard to film speed, both black-and-white and some color slide films can be "pushed" to allow pictures to be made in less light than otherwise would be possible. You push a film by setting your exposure meter at two or four times the film's usual ISO/ASA film speed, then have the film overdeveloped accordingly. The amount a film can be pushed is limited. Kodak Ektachrome 400 film normally has an ISO/ASA of 400, but it can be increased to ISO/ASA 800 if the film receives special processing. This increase of two times the film speed allows use of one f/stop less than normal. The same is true for Ektachrome 160 (Tungsten). Its speed can be pushed from ISO/ASA 160 to ISO/ASA 320, with special processing.

Another Ektachrome slide film, P800/1600 Professional, is specifically designed for push processing. Its nominal film speed of ISO/ASA 400 can be exposed at ISO/ASA 800, 1600, or even 3200, when given extended development. The film cassette has a write-on area listing those four speeds so you can indicate to the processing laboratory the ISO/ASA at which the film was shot. A film that is to be push processed must be exposed at only one film speed; you can't change the exposure meter's ISO/ASA to a different film speed in the middle of a roll.

The speed of black-and-white film also can be doubled or even quadrupled to allow exposures equal to one or two f/stops less than required at the film's normal ISO/ASA rating. For instance, Kodak's fast Tri-X black-and-white film is rated at ISO/ASA 400 but can be pushed to ISO/ASA 800 or even ISO/ASA 1600 if overdeveloped in the darkroom to compensate for the decreased exposure. Of course, films that are pushed lose some of their quality. Notably, contrast and graininess increase. But the results often are very acceptable, and pushing film permits a picture to be made with very weak illumination.

Kodachrome color slide film cannot be pushed to a higher ISO/ASA, nor is it recommended to push color negative films, such as Kodacolor. However, color negative films normally have a greater exposure latitude (about one f/stop), and in low-light situations you can make exposures at double their film speeds and still get acceptable color prints without any push processing of the film.

While black-and-white and color negative films (for prints) generally can be used with most any type of illumination, color slide films are balanced for certain light sources in order to reproduce colors as you see them. Photographers shooting color slides thus must decide which type of film, daylight or tungsten, is best for the lighting situation. Daylight slide films are color balanced for sunlight, electronic flash, and blue flashbulbs, while tungsten slide films are designed to produce realistic colors when exposed by incandescent light, such as household bulbs, studio lamps, and photofloods.

When daylight films are shot indoors with artificial light (except electronic flash and blue flashbulbs), subjects take on an overall yellowish or reddish-orange look. And when tungsten (or Type A) slide films are shot outdoors in daylight, the images will have a bluish cast. Filters can be used to correct such color imbalance, but usually it's best to shoot with the type of slide film made for the specific light source.

A few special light sources should be noted. For instance, carbon-arc lights normally used to spotlight acts in theaters, circuses, and ice shows give best results when used with daylight, not tungsten, slide films. So do the mercury-vapor lights often used to illuminate athletic stadiums. Even so, daylight slide film used with mercury-vapor lights will give a slightly bluish-green cast to your pictures.

Fluorescent lights are very difficult to color-balance with color slide films unless a fluorescent filter is used on the camera lens. An FL-D filter should be used with daylight films, an FL-A or FL-B with tungsten types. Using fluorescent lights without a filter, daylight slide film will give better results than will tungsten film although the pictures still will be somewhat greenish.

If your light sources are mixed, use a color slide film which is balanced for the predominant source. For example, in a room where sunlight coming through windows provides most of the illumination, use a daylight color film. Of course, when you are shooting both outdoors and indoors under a wide variety of light sources, color negative films have an advantage over color

150. *Night photography can turn an uninteresting subject, like this sign at Disneyland, into a worthwhile picture.*

151. *To produce light streaks from the sign, which was illuminated after dark, the camera was tilted upward while the shutter was open.*

slide films because untrue colors can be corrected later when color prints are being made from the negatives.

Once light source and film type have been determined to be compatible, exposure must be figured. An exposure meter reading is suggested wherever possible. Indoors, make sure you read the most important part of your picture, especially if the illumination is uneven. Always get close enough to your subject so your meter is not misled by overly bright or overly dark areas. Often crinkled aluminum or a white piece of cloth or poster board can be used to reflect light into areas which are too dark. Avoid photographing your subjects against a bright light or window unless a silhouette effect is desired.

For nighttime exposures, a spot meter or center-weighted meter often is best to read the lighted areas of your picture. With an averaging meter the dark areas of the scene may influence the meter and the result is overexposure. This also can be true at an indoor theater or auditorium where the dark area surrounding the stage may mislead your meter. If possible, get close enough with your averaging meter to make a reading for the stage area, or use a spot meter or center-weighted meter.

With night exposures, try to "read" the light with your eye to determine if lights in any portion of your picture are too bright in comparison to the others. Squinting your eyes while looking at the scene sometimes helps determine overly bright light or areas. You may have to change your camera angle to eliminate this problem of uneven lighting. Regardless, bracketing is suggested.

Exposures for nighttime photography have more latitude than do those made in the sunlight. Even much-varied exposures at night will all produce interesting and pleasing pictures, unless you have greatly underexposed. Always remember to write down the exposures used for your night shots for later reference. On dark nights, a small flashlight will help you make notes and set your camera controls.

Regarding exposure technique for existing light and night shots, a tripod or other camera support is not necessary unless your exposures are 1/30 second or less. For exposures longer than 1 second (or whatever the time-exposure limit of your auto-exposure camera), set the shutter speed to B or T and use a cable release to avoid moving the camera while the shutter is open. To avoid camera movement at speeds of one second or faster, the camera's self-timer or a cable release can be used to trip the shutter.

There are a great number of subjects to be recorded at night or by existing light. Fireworks are a favorite. Place your camera on steady support and keep the shutter open during several bursts. Vary your f/stop. Colorfully lighted fountains are fun to photograph. Shoot at a fast shutter speed to freeze the water or at a slow speed to let it blur. Try filming illuminated monuments, buildings, and bridges. Downtown street scenes also are colorful. After a rain, concentrate on reflections. Photograph store window displays, and make a multiple exposure or lighted store signs. Film outdoor Christmas decorations, too.

152. *Fireworks are both interesting and challenging subjects. With Plus-X (ISO/ ASA 125) film, a lens opening of f/11, and the shutter set to B for a time exposure, the photographer followed the trajectory of the firework when it was sent skyward, and pressed the shutter release the moment it exploded.*

Try some shots of the moon. Also make some exposures by the light of the moon. Do the same things with campfire light. And don't forget nighttime sports events outdoors. Indoor sports activities also are good subjects and offer a chance to use existing light. With permission, photograph some church interiors, museum displays, or art gallery objects.

Even the television set is a possibility. Fill your frame with the TV screen image. Be careful of parallax problems with rangefinder cameras. Use black-and-white, color print, or daylight color slide film and adjust the controls for good color, brightness, and contrast. Avoid reflections by turning off room lights. Make an exposure meter reading of the screen area only—*after* you've set your shutter speed. Dark horizontal streaks will show up in your photograph if your shutter speed is too fast because it takes at least 1/30 second for the television set's electron beam to form a picture image. With leaf-type shutters, a speed of 1/30 second or slower should be used. Focal plane shutters should be set at a speed of 1/8 second or slower to avoid the dark lines.

The chart on pages 228-229 gives *suggested* exposures for a variety of night and existing light situations. You'll note all films grouped together in each column do not have the same ISO/ASA film speed. Because of the reciprocity effect which occurs when films are used with different illumination or longer exposure times than those for which they were designed, exposures only can be estimated, and so slight differences in film speeds are of little concern (see page 133).

Creating Close-ups and Making Copies

Getting close to subjects to portray their images life-size or much larger results in some exciting photographs. To do this you must extend the elements of your lens to get closer to the subject than would normally be possible. Several methods of making close-ups were discussed earlier (see pages 102-105). These include using close-up lenses, extension tubes and bellows, macro lenses, and lens reversing techniques.

Actually, when filming your subject at least life-size you are doing what is termed *photomacrography*. Making extreme close-ups with a camera attached to a microscope is called *photomicrography*. This is discussed later in the chapter.

Normal lenses for 35mm single lens reflex cameras may focus only as close as 3, 2, or 1½ feet. Thus the size of your subject's image on the film is limited. However, there are three easy ways to get close to your subject to enlarge its size.

155. *Electronic flash was used to highlight the water droplets in this close-up of a plant leaf pattern. For more interesting composition, the main stem was shot on the diagonal.*

By far the most convenient way to get close-up pictures with an SLR camera is by using a macro lens. It serves as a normal, telephoto, or zoom lens, but has built-in close-up capabilities as well. A macro lens allows you to focus within inches of your subject without additional lenses or equipment.

Another simple, but somewhat limiting, way to make close-ups is to reverse your normal or wide-angle lens end for end. A special reverser ring to reattach the lens to the camera is recommended. Reversing a normal or wide-angle lens allows you to get closer to the subject, but that distance depends on the actual focal length of your lens and is not variable.

A third way to get close-up photos is by attaching supplemental close-up lenses to the regular camera lens of either an SLR or rangefinder camera. These come in various strengths of powers, called *diopters,* and can be used singly or in combination. They range in magnification from + 1 to + 10 diopters (see page 102). With them the camera can get as close as a few inches to the subject and greatly increase its image size on the film.

With all three techniques listed, framing and focusing are critical. For this reason, a single lens reflex camera is especially valuable for making close-ups. That's because the photographer sees through his viewfinder exactly what the lens will see. As with all close-up photography, a small f/stop is recommended to provide as much depth of field as possible. A lens opening of f/8 or smaller is suggested.

Cameras with built-in through-the-lens exposure meters will give accurate exposure readings with the above close-up methods. Actually, use of supplemental close-up lenses does not alter exposure, so exposure readings made with hand-held meters will be accurate, too.

While macro lenses and lens-reversing techniques are limited to use with reflex or view cameras, supplemental close-up lenses can be used with rangefinder cameras as well. However, focusing and framing are problems with rangefinder cameras because these cannot be done directly through the camera's lens as in the case of reflex and view types. A chart comes with any particular close-up lens you buy, and it will be needed to determine focus with a rangefinder camera.

The focus point of your main lens depends on the power or diopter of the close-up lens attached, as well as the actual distance the front rim of your close-up lens is from the subject. Measure carefully. Use your chart to determine how much of the subject area will be included on the film. With the same power close-up lens, you can vary the subject area to be photographed by altering the lens-to-subject distance as you change the focus setting of your rangefinder camera lens. Accordingly, this changes the image size of the subject recorded by the film.

For example, with a + 1 close-up lens on a 50mm camera lens, a subject area 18 × 26¾ inches will be recorded when the close-up lens-to-subject distance is 39 inches and camera lens focus is set at infinity. By changing the camera lens focus to 3½ feet and reducing the lens-to-subject distance to

20⅜ inches, the subject area now included on the film will be reduced to 9⅜ × 13¾ inches. Study the data chart accompanying your close-up lens.

Framing also must be given special consideration when making close-ups with rangefinder cameras because of parallax error, which results when the subject is very close to the camera (see page 8). In brief, your camera lens and the film do not see what your viewfinder sees. You can fashion a camera framing device to correct for this, or simply tilt your camera up to *eliminate* from the viewfinder the top ⅛ of the picture area you want when using a +1 close-up lens, the top ⅙ with a +2 lens, and the top ¼ with a +3 close-up lens.

Lens extension devices can be used if you desire larger image sizes than those made with close-up lenses, a macro lens, or by reversing your normal or wide-angle lens. These are either a set of rigid extension tubes or a flexible bellows inserted between the camera body and its lens. The only cameras that can be used with lens extension devices are those which allow lenses to be interchanged, such as 35mm single lens reflex cameras.

Considerations when using extension tubes or bellows include the need for very critical focusing, the problem of extremely limited depth of field, and the fact an increase in exposure is required. All these factors are due to increasing the distance of the lens from the film. Bellows allow more flexibility in regard to varying the amount of extension than do the metal extension tubes. Bellows are therefore more versatile, and also more expensive.

As the camera lens gets closer to the subject, the subject's image is magnified on the film. This magnification can be figured by adding the focal length of the camera lens and the distance it has been extended. Whenever the extension distance *equals* the focal length, the subject will be recorded life-size.

Here are some examples. (Remember, measurement can be either in millimeters or inches.) When a normal lens of 50mm (2-inch) focal length is extended an equal length (50 + 50mm) to a total of 100mm (4 inches), the image on the film will be life-size. Extending a 50mm lens one-half its focal length (50 + 25mm) to a total lens-to-film distance of 75mm (3 inches), a subject will be photographed one-half life-size. A 50mm lens extended a total of three times its focal length (50 + 50 + 50 = 150mm or 6 inches) will produce an image two times life-size.

The greater the image magnification, the greater the exposure increase required. Either the f/stop or shutter speed can be changed according to the exposure factor. The chart on page 240 lists a few lens-to-film distances, subject magnifications, and exposure factors for any 50mm (2-inch) lens used with extension bellows or tubes. Remember, the lens-to-film distance equals the focal length of a lens plus its extension when the lens is set at infinity.

Most times a slow shutter speed is used to compensate for the exposure increase required. That's because the lens opening should be kept very small in order to provide some depth of field. Remember, however, even with an f/stop of f/16 or f/22, depth of field with greatly magnified subjects is minimal.

154. Focusing is very critical when using macro or close-up lenses to show tiny details of a subject, as with these strawberries.

Lens-to-film distance (inches)	Subject magnification in terms of life-size	Exposure factor
3	½	2×
4	life-size	4×
5	1½	6×
6	2	9×
8	3	16×

To figure the amount of exposure increase required, multiply the shutter speed by the exposure factor and keep the f/stop constant, *or* keep the shutter speed the same and open the f/stop as follows: 2× exposure factor open 1 f/stop; 4× open 2 f/stops; 6× open 2⅔ f/stops; 9× open 3¼ f/stops; 16× open 4 f/stops.

So focusing is critical. Use of a tripod will help the photographer maintain the focused distance, frame the subject, and avoid camera movement at slow shutter speeds. And by the way, if you have live subjects such as insects, slow them down by putting them in a refrigerator (not the freezer) for a while.

Because of greater magnifications desired for some close-up subjects, the additional exposure often calls for a bright source of illumination. With daylight, some photographers use mirrors or tinfoil reflectors to increase light on their subjects. Others prefer flash. A special electronic flash ring light which encircles the camera lens provides shadowless illumination at very close range. Off-camera flash, however, can be used for back or side lighting to produce shadows that will give dimension to your subjects. Also, using your flash off-camera may be necessary if the closeness of the flash makes it too bright for your subject. Alternatively, layers of white handkerchief can be placed in front of the flash to reduce its intensity. Some electronic flash units have a variable power control to reduce the light intensity.

With flash, the background will appear black and make your subjects stand out. With sunlighted close-ups, avoid a confusing background by using colored cloth or poster board behind your subject. When making close-ups, experiment with lighting and backgrounds to find the results which please you most.

Many times photographers want to copy a document, picture, map, or other flat, two-dimensional object. The close-up techniques just described can be used if the subject to be copied requires magnification greater than that possible with just the camera's lens. Reflex or view-type cameras are preferred for *photocopying* because they make framing and focusing easy. Always aim the camera squarely at the flat subject so it is parallel to the film plane. This allows uniformly sharp focus and no distortion. A tripod is suggested to maintain frame and focus.

Material to be copied can be mounted vertically on a wall or laid flat on a table or the ground. Some tripods have elevator posts which can be reversed to allow the camera to be mounted underneath the tripod. This keeps the tripod legs out of your picture when shooting down on flat copy work.

Lighting of copied subjects must be uniform. Often outdoor illumination is very good. Be careful no shadows fall on your subject. If the object to be copied is shiny or covered by glass, use a polarizing filter to diminish or eliminate reflections and glare. Indoors, two photoflood lamps can be used. They should be placed at equal distances on either side of the camera at a 45° angle to the subject. As a quick check for evenness of illumination, hold a pencil, ruler, or a similar object perpendicular against the copy work and see if the shadows it causes are equal in density. Always use an exposure meter, built into the camera or hand-held, to determine your exposure, and make sure it reads only the subject area to be copied.

Films suggested for copying documents or line drawings are those of a slow speed, such as black-and-white Panatomic-X. These give high contrast and sharp detail with very little graininess. Medium-speed films like Plus-X are preferred for copying photographs because they help preserve the highlights and shadow areas of the original.

Many photographers like to copy slides or portions of them. Although the color rendition never seems as vivid as the original, the results can be very good. Often the copy slide is more contrasty than the original, so exposures should be bracketed for best results. Filters can be tried to change color balance. Kodak has a special Ektachrome Slide Duplicating Film 5071 (36-exposure, 35mm size), although some photographers prefer Kodak's Kodachrome 25 film for making color slide duplicates.

Techniques for slide-copying vary. For direct copying, a special *slide-copier*

COPY WORK

156. To copy photographs or other flat artwork, lights should be placed in this manner (see text).

can be purchased to attach to your camera. Daylight, electronic flash, or photoflood lamps are used for illumination. Other photographers simply copy a reflected slide image projected on a normal screen or a piece of white poster board.

Successful slide duplication takes experimentation and patience. Just be sure your original slide is free of dust and clean. Fingerprints or smudges can be removed by carefully and evenly applying a liquid *film cleaner* with cotton after taking the piece of film out of its slide mount.

Having Fun with Infrared Films

Infrared photography can be fun as well as practical. Both black-and-white and color infrared films are available. The first has long been used in aerial and landscape photography to penetrate and eliminate haze. Such film also has been applied to scientific, medical, and technical use, including the field of criminology. As such, infrared film helps detect bloodstains, fingerprints, and forgeries. Another use is the determination of authenticity of paintings by art galleries and museums. The reason is that infrared film "sees" what normal films do not.

To help detect military use of camouflage, color infrared film was developed. Living plants and trees give off infrared rays different from those of dead or fake foliage commonly used for camouflage. An aerial photograph on color infrared film will indicate what is real and what isn't. For amateur photographers, color infrared film produces startling colors unlike those recorded by ordinary color films. The results will surprise you.

Infrared films register light rays and invisible infrared radiation. Therefore ISO/ASA film-speed ratings do not apply as they normally would because exposure meters do not react to infrared rays as they do to light rays. Only suggested exposure guides are given in the films' instruction sheets. Experience determines the best exposure for specific situations. Bracketing is always recommended. Shoot at least one f/stop on either side of the f/stop which you think will give the best exposure. Unless you are experimenting, infrared films should always be used with a filter—red for black-and-white and yellow for color. However, with infrared film, filter factors do not apply as they do with regular films. Here are more specific details for each type of film.

Infrared film that yields negatives for making black-and-white prints is Kodak High Speed Infrared film. It eliminates atmospheric haze and turns skies black while making green grass and trees white. It is available in 36-exposure 35mm size. A red No. 25 filter is recommended for general photography, although a No. 29 can be substituted. The film can be used with daylight, electronic

flash, clear flashbulbs, or photoflood lamps. With electronic flash, a No. 87 filter is best.

Pictures made in darkness without the subject being aware are possible when the infrared film is exposed by infrared flashbulbs. These bulbs provide no visible light but your subject will be recorded on film. Infrared bulbs usually must be specially ordered by your camera store. Without such bulbs, a special filter can be used over your regular electronic unit or flashbulb reflector. When using infrared flashbulbs or a filter on flash units, a No. 25 filter on the camera lens is not required.

With normal daylight and tungsten illumination, the suggested guide for making trial exposures is a film speed of ISO/ASA 50 for daylight and ISO/ASA 125 for tungsten light. But be sure to bracket. With two 500-watt reflector-type photoflood lamps, suggested trial exposures of 1/30 second are f/11 with lamp-to-subject at 3 feet, f/8 at 4½ feet, and f/5.6 when the lights are 6½ feet from the subject. Suggested guide numbers for electronic flash and flashbulbs vary according to the flash unit's output. The film's instruction sheet lists these guide numbers and gives more details.

The film must be developed in total darkness according to instructions on the same sheet. Develop it yourself or ask a custom lab to do it for you. Because of the sensitivity of this film, also load and unload your camera in total darkness. Store the film in total darkness in its sealed can, and keep it refrigerated at 55°F (13°C) or less before use.

As mentioned previously, focusing black-and-white infrared film is different from focusing regular films, since infrared rays do not focus in the same place as visible light rays. Some camera lenses have a special *infrared focusing mark,* usually a red line or R on the focusing scale. Focus your subject as you would normally, then move the focusing ring for that distance to the infrared focus mark. If no such mark is on your lens, focus on the closest point of the main subject. Or use very small f/stop openings at the normal focus mark.

For making infrared color pictures, use Kodak Ektachrome Infrared film. It is available only in 36-exposure 35mm-size cassettes and yields color slide transparencies. A yellow No. 12 filter is recommended, although the more common yellow No. 15 filter will do just as well.

Actually the colors of your subjects on color infrared film are rather unpredictable—that's the reason amateur photographers find infrared photography fascinating. As examples, some black cloth photographs dark red, faces become green, and red lips turn yellow. Scientists, however, have learned to read color distinctions carefully. For instance, to detect diseases in trees, forests are photographed with this film and studied closely. Healthy trees appear red; those that appear magenta, green, or yellow indicate they are under stress.

Like its black-and-white counterpart, Ektachrome Infrared film should be stored in its original sealed can. Keep the film in a freezer at temperatures from 0°F to -10°F (-18°C to -23°C). Let the film warm up to room temperature before use.

As a guide for trial exposures, a film speed of ISO/ASA 100 is suggested. But for cameras with built-in through-the-lens exposure meters, set the ISO/ASA dial to 200 and align the meter's exposure indicators as you normally would. Bracket exposures on the initial roll of film until you've determined the best film speed setting for your particular subject and hand-held or built-in exposure meter. Besides using sunlight for illumination, you can also use electronic flash, blue flashbulbs, and photoflood lamps to make infrared exposures. Study the film's instruction sheet for suggested guide numbers and exposure settings.

Unlike black-and-white infrared film, color infrared film records its sharpest image when the camera is focused in the normal manner. In other words, the special infrared focusing mark on some camera lenses should be disregarded when color infrared film is used.

Ektachrome Infrared film will be processed by Kodak or custom labs. Or you can develop it yourself. Total darkness is required.

If you like to experiment, get a roll of black-and-white or color infrared film and be ready for some unusual results. With the color type, any color rendition is possible, depending on the filter you use. Although No. 12 or No. 15 yellow filters are suggested, experiment with other filters, too. You'll see why many photographers find infrared films an exciting change of pace.

Making Multiple Exposures

Often pictures can be made more effective or eye-catching when the same frame of film is exposed more than one time. Sometimes the photographer inadvertently double-exposes film by using the same roll twice. Surprised as he may be by this mistake, he may find some of the accidental double exposures worth saving. Of course, a photographer should have full control over the images he combines on one piece of film.

Techniques for making double or multiple exposures vary. Some 35mm cameras have a multiple-exposure control lever, which allows you to cock the shutter without advancing the film (or the film frame counter). Because the same piece of film must be used for a multiple exposure, this seems to present a problem for the other 35mm cameras that automatically advance film when the shutter is cocked. Actually it does not; the method for cocking the shutter while keeping the same film frame in position was outlined on page 24. This works well with most 35mm reflex and rangefinder cameras, unless they're autowind models that cannot be controlled manually. With cartridge-loaded cameras the film will advance unless the cartridge is removed in the dark while the shutter is recocked.

A main consideration with multiple exposure is exposure. The meter reading must be decreased for each exposure so the film does not receive too much light and become overexposed. As a general rule for double exposures of subjects that overlap, cut the meter readings of each exposure in half. That means, reduce the metered exposure by closing down the lens opening one f/stop or increasing the shutter speed by one position.

157. *This revolving sign was photographed five times on the same frame of film with a camera equipped with a multiple-exposure control. It keeps the film from advancing when the shutter is recocked.*

Depending on the number of times the film is to be exposed, exposure of each subject must be decreased by a varying amount. For instance, with four daylight exposures overlapping on one film frame, try exposing each one for only one-fourth of the meter readings. That would mean reducing each exposure by decreasing the lens opening two f/stops or increasing the shutter speed two positions. When all four exposures are made, each overlaps to add enough light to build up to a proper exposure. Experimentation is required because some of the overlapping subject areas may record too bright or too dark.

Regardless of the number of exposures made, if the subject images are recorded against a black background (as at night) and do not overlap, the exposure for each does not have to be reduced. This is because the images do not register on top of one another and thus do not build up the light registering on the film.

Bracketing is suggested until you become familiar with exposures and techniques which work best with your particular subjects. Some photographers get better results by exposing the main subject of the total picture last.

Overlapping subject images are not only important in regard to exposure. With color film some unexpected results may occur. These happen when colors of a subject in one exposure overlap with different colors in another exposure. The results are entirely new colors. For example, a red image overlapping a green image will record on the film as yellow.

Actually, the easiest way to make double or several multiple exposures on one piece of film is at night or in a very dark room. Most any camera can be used. In this situation the shutter is kept open throughout the series of exposures and doesn't have to be recocked. After using a cable release with a lock screw to hold the shutter open in the B position, or setting it to the T position, the photographer uses a lens cap or piece of cardboard in front of the lens to block out any light between exposures.

Using this technique of multiple exposure, the light level and lens f/stop opening must be adjusted to allow the photographer time to uncover and recover his lens—usually a few seconds for each exposure is best. With electronic flash or flashbulbs, the burst of light is quite brief. The exact duration depends on the electronic unit or bulb used. (Use an electronic flash on manual instead of automatic exposure, or the picture will be overexposed.) If the room or outside area is very dark, the photographer figures the exposure and sets the f/stop, uncovers the lens, triggers the flash, and re-covers the lens while he rearranges his subjects. Or if the subjects are moving, a series of flashes can be made while the lens remains uncovered. Rapid-fire strobe-light units often are used to dramatically portray motion. The subject is recorded each time the strobe flashes. A tennis player's swing or a dancer's form can be evaluated from pictures made this way.

Of course, whether your exposures are multiple or only double, care must be given to the framing of your subjects so they are aligned on the film in the positions you planned. With the open shutter arrangement, framing of your subjects can be a problem with single lens reflex cameras, since you won't be able to see through your viewfinder. That's because the mirror which reflects the subject image to the viewfinder is flipped up out of the way while the shutter is open. So the SLR user must carefully stage the arrangement of his subjects and camera in advance of opening the shutter.

Photographers should use their imagination when making multiple exposures. Put your camera with color film on a tripod and slightly underexpose a city at twilight or sunset. Then wait until dark to reexpose the same film frame with the city's lights.

Make three or more color film exposures of one subject using a different color filter each time. Move your camera slightly between each exposure to record at least three distinct images of different colors. Try red, green, and blue filters.

158. This is a double exposure of a magician and the Magic Castle, an old mansion where magicians gather in Hollywood, California. With the camera on a tripod and the shutter opened on B, a flash was fired to illuminate the magician. Then the lens was quickly covered, the magician moved aside, the focusing ring was readjusted for the mansion, and the lens was uncovered to make a time exposure of the building.

Expose some frames of a full moon to double-expose later with a moonless night scene when you think a moon would add impact to the picture.

Ghosts are easy to create with double-exposure techniques, and here's how. Frame and expose the main subject with your camera on a tripod. Underexpose one f/stop. Without moving camera or subject, pose a sheet-covered person in your picture area and make another exposure at the previous f/stop. Your "ghost" will appear on the film.

Here's another way to make colorful abstract patterns with a series of exposures on one piece of film. Suspend a penlight on a string from the ceiling of a dark room. Place your camera on the floor, aimed at the small flashlight. Open your lens and shutter, and start the penlight swinging to record its pattern of movement on your film. Now cover the flashlight with a color filter or piece of colored cellophane and start it swinging in another direction. Change the flashlight's colors and directions a few more times. Finally close your shutter. The abstract patterns from this swinging light will fascinate you.

Even without success in combining multiple images on film, you can achieve *effects* of multiple exposures by mounting two or more negatives or slides together for printing in the darkroom or for projection. This is called *sandwiching*. Slides which have been overexposed often produce the best result because the total density of the combined slides will appear nearly normal when projected. Negatives to be sandwiched often work best when they are underexposed.

Flying with Your Camera

Aerial photography is of two basic types, one for professionals and the other for amateurs. Professional aerial photographers have specially adapted or designed cameras, films, and airplanes to get the results their clients require. Amateurs, on the other hand, usually photograph for their own pleasure with regular cameras from commercial aircraft.

Some ideas for making pictures from jetliners are given in the following chapter (see page 279). In general, you should sit on the shady side of the plane in front of the wing and engine exhausts. A fast shutter speed should be used (1/250 second or faster), and the camera should be kept from touching the window to avoid vibration. Focus is set on infinity unless part of the wing is to be included.

Make sure the inside of the window is clean. Scratches in the window plexiglass will not show in your picture, although a badly scratched window may diffuse the image slightly. To avoid distortion caused by the layers and thickness of jet plane windows, try to hold the camera perpendicular to the window and do not shoot through it at a sharp angle.

159. *Private low-flying planes are ideal for aerial photography. For the best composition, vary the format. This vertical shot was made along a bathing beach in Key Biscayne, Florida.*

160. The photographer purposely waited for late afternoon light to shoot this horizontal aerial view of a farmer's fields in southern Germany (see text).

A UV filter will help cut through any haze. A polarizing filter is not recommended, except for a bizarre touch, because the polarized light often reacts with the plane's plexiglass window to produce a rainbow effect in your photograph.

Ground subjects should be photographed soon after takeoff or just before landing, when the pilot may be banking and when the plane's altitude is low. Close to the ground, pan with your subject and shoot at 1/500 second or faster. Long shadows from subjects photographed early or late in the day give depth and texture to your pictures. Make sure you keep the horizon level. Inquire whether any mountain ranges will be passed during the flight. Clouds and sunsets also make good subjects while airborne. Be aware that in some countries photographs from aircraft are forbidden. Ask if you are uncertain. Pho-

tography from small private aircraft or helicopters can be even more exciting. A clearer view and more flexibility are allowed when the plane's door or window can be opened or removed. Fasten your seat belt. Wind velocity from the movement of the plane or its propeller will make it difficult to hold your camera outside the plane itself. Outside there also will be some danger of dust or particles blowing into your lens unless it is aimed toward the rear of the aircraft. Always use a lens hood.

Make sure the pilot can hear you so you can tell him the direction and banking angle you want. Inquire as to aviation laws regarding how close he can fly to the ground so you won't ask him to possibly jeopardize his license. Be sure to pan at very low altitudes. Many times, in exchange for pictures of the pilots and their planes, members of an aero club will take you up without charge to make some aerial photographs. Ask them.

Adventuring Underwater with a Camera

These days many snorkelers and scuba divers have given up their spearguns for cameras. Underwater photography is far less dangerous and far more challenging than hunting with weapons beneath the water's surface. Elaborate equipment is not required. Various waterproof housings are available for regular cameras, including simple pocket cameras and fully adjustable 35mm cameras. Housings are even made for disc and instant cameras.

Because pressure increases relative to the depth of the water, these housings vary as to the maximum depths in which they can be used. Inexpensive housings resembling plastic pouches are waterproof to depths of 35 feet; the other housings will all exceed normal diving limits of about 125 feet. Plastic underwater housings are good up to a maximum depth of 200 feet, while those of aluminum construction can be taken 300 to 400 feet below the surface. Manufacturers will indicate the specific depths allowed with their particular housings. In any case, a water-tight check should be made with any new or used housing before using it with your camera.

A few cameras are specifically designed for underwater photography. The best known is Nikon's Nikonos, a 35mm camera that is waterproof down to a maximum depth of 160 feet. The latest model has a very welcome feature, through-the-lens (TTL) metering for automatic exposures. You can control shutter speed and f/stops manually as well, and the lens focus also can be adjusted underwater. Because it's waterproof, many photographers like the Nikonos for shooting above the surface in wet conditions, as on boats at sea or in rain and snow. Less expensive all-weather cameras, like Minolta's 110-size Weathermatic model with built-in flash, can be taken underwater but only

to shallow depths of 10 feet or less. It's wise to limit them to occasional shots in a swimming pool or when snorkeling at surface level.

Waterproof electronic flash, flashbulb, and floodlamp lighting units and housings also are available for underwater photography, as are special exposure meters and meter housings. There is need for such equipment because light reacts much differently underwater and exposures are tricky. Even if you only intended to make pictures just beneath the surface, a flash unit is a good investment. For the most recent Nikonos model, Nikon offers two underwater TTL autoflash units.

Not only does flash provide sufficient light to make exposures, it allows colors to be recorded correctly. Without flash, most underwater subjects appear blue or green. The reason is that water absorbs colors in varying degrees at varying depths. Red is reduced quickly, and at 25 feet below the surface it tends to photograph black. Oranges and yellows lose their color at about 35 feet. After 100 feet green colors are lost and then everything photographs blue. Use of flash helps to restore color balance.

Flash is also recommended because sunlight loses its intensity as it enters the water. Much of it is reflected off the water's surface, especially when the sun is at a low angle. Sunlight penetrates water best when overhead, and for this reason underwater photography without flash often is best between 10 A.M. and 2 P.M. Of course, the clarity of the water helps determine how much sunlight will be transmitted.

Light has another characteristic important to underwater photographers. Because light refracts differently in water than in air, underwater subjects look closer and therefore larger than they really are. Generally they appear to be at least one-fourth closer than they actually are. This is important when using flash because you must figure exposure based on *actual* flash-to-subject distance, not the apparent distance.

However, focusing is just the opposite. To focus correctly underwater, you use the *apparent* subject distance rather than the actual distance. Because optical focusing in the normal manner is difficult underwater, the camera focusing ring is set according to your estimate of the apparent distance of the subject.

Unless your camera is one of fixed focus, as are some pocket cameras, most waterproof housings allow the camera's focusing ring to be adjusted. Some photographers make things easier underwater by presetting their focus to 2 or 3 feet for most small subjects such as fish, or about 6 feet if they're going to photograph larger subjects such as people. Framing is done through a sports-type viewfinder attached to the housing. Without one, aim your camera as carefully as you can.

Exposing underwater can be a guess at best. That's why bracketing is recommended. Film, depth, clarity of the water, and light source all are considerations. Most underwater photographers agree that the best results occur when you get as close to your subject as possible. This cuts down the chance that particles and bubbles in the water will block the path between your camera and subject.

For truer color rendition, flash is always suggested. It provides adequate light at close distances regardless of the sunlight which also may be present. Below depths of 30 feet, sunlight generally is so weak that flash is required anyway. Since daylight color slide films are often used underwater, an electronic flash unit is best because it is color-balanced for such films. If shooting with a flashbulb unit, blue flashbulbs are suggested for subjects closer than 5 feet. Beyond that distance, clear flashbulbs are best in order to provide the red, orange, and yellow colors that water tends to absorb. Even then, beyond 30 feet these colors will not be recorded faithfully by clear flashbulbs.

Flashbulbs will withstand pressures to depths of at least 200 feet. They can be used in flashguns without special housings and without fear of shock. Of course, the bulbs must be replaced after each shot. And litter caused by discarded flashbulbs is a problem underwater as well as above it. For these reasons, most photographers use electronic flash units.

For depth of field reasons, a small f/stop is best when making underwater pictures. Of course, a fast shutter speed also is valuable to stop the action of darting fish and also to prevent camera movement that is inherent because the photographer often finds it difficult to hold steady underwater.

There is an unwanted effect that can occur when using flash underwater. This is called *backscatter*. Light from the flash strikes tiny particles in the water which reflect back to the camera and are recorded by the film as white fuzzy spots. Where such particles are prevalent, the resulting photographs look almost as if they were taken in a snowstorm.

Correct flash positioning can help eliminate this problem. It is suggested that a flashgun be extended about a foot or more away from the camera, slightly forward, and at a 45° angle to one side. Backscatter also is reduced when the camera is as close to the subject as possible because the short distance reduces the number of particles present.

To get close to the subject to obtain the most clear and colorful picture possible is the reason most underwater photographers use wide-angle lenses. They are popular not only for depth of field reasons, but because light refracting underwater actually increases the focal length of the lens and decreases the angle of view. As such, a 35mm wide-angle lens underwater has an effective focal length of 47mm (similar to a normal lens) and its angle of view is reduced from 63° to 50°. Underwater a 21mm wide-angle lens becomes equal to one of 28mm out of the water. And its angle of view decreases from 92° to 75°. Sometimes fish-eye lenses of 7.5mm are used to overcome the problem of reduced angle of view underwater.

Here are a few more ideas and a summary of general considerations regarding underwater photography. As a photographer you must decide whether you want your subjects portrayed in their various vivid colors or in the "typical" green and blue underwater coloration. If actual colors are desired, shoot near the surface of the water or with flash. For natural light shots, use an exposure meter.

If you don't have a waterproof housing for your meter (sometimes a glass

jar will do at shallow depths), take a reading above the water's surface and increase the f/stop as follows: just below the surface open up 1½ f/stops, 6 feet below open 2 stops, 20 feet add 2½ stops, and 30 feet beneath the surface increase exposure by 3 f/stops. This is only a guide. The clarity of the water and the brightness and angle of the sun are important exposure factors. Be sure to bracket. If just under the surface, avoid shooting directly down on your subjects because the overhead sunlight behind you gives flat lighting and little detail to your subjects.

Your camera housing should allow you to set the f/stop, shutter speed, and focus underwater. Often, however, the shutter speed is preset. A range from 1/60 second to 1/250 second is good, but the faster the speed, the better. For this reason high-speed films are suggested. So are cameras with wide maximum f/stop lens openings, especially for use with natural light at medium depths. A wide-angle lens also is recommended for best depth of field and increased angle of view. Prefocusing often is best because you can concentrate on tracking your subjects or waiting until they come within your focus range.

With 35mm cameras, use 36-exposure rolls of film so you won't have to surface too often to change films. Always rinse the salt water from your housings and equipment after use. Try to remember and write down your exposures to compare them later with your results. Develop a shooting formula that works for you. With flash it is easy to standardize your flashbulb or electronic flash type, film, focus, f/stop, and shutter speed to ensure good exposures and colors every time you photograph underwater.

Of course, you should be a qualified and confident diver, or stay near the surface with only a face mask, snorkel, and swim fins. If you don't live near an ocean or a lake, practice with your camera in a swimming pool to be ready to make underwater photographs during your vacation or when any chance occurs. Although you may find your initial results frustrating, you'll discover how fascinating underwater photography can be.

For nonswimmers and those without underwater camera housing, *fish tank photography* is a good way to capture underwater life. Here are a few tips. To avoid distortion, shoot through a flat-side aquarium, not a round bowl. If your aquarium has an aerator, disconnect it if the bubbles disturb your subject or composition. Use a close-up lens to help fill your frame. A single lens reflex camera lets you focus and frame easily. To keep your subject in close focus range, place a sheet of glass in the aquarium to limit the area in which the fish are able to swim.

By placing the aquarium next to a window and using a high-speed film, you may be able to capture your subjects with only natural light. A fast shutter speed often is needed to "freeze" quick-darting fish. Of course depth of field is limited by use of a close-up lens, so try to expose with a small f/stop opening when possible.

Fish tanks also can be illuminated by photoflood lamps or flash. Electronic

161. Underwater pictures can be taken with a regular camera in a special water-proof housing or a camera, like the Nikonos, that's specifically designed for under-water photography.

flash and blue flashbulbs are color-balanced for use with daylight color films, but photofloods require film balanced for artificial light such as Kodachrome 40 (Type A). The lights should be placed above the aquarium for a natural lighting effect. Lights may also be placed at a 45° angle on each side of the camera, but care must be taken that they do not reflect off the aquarium glass back into the camera lens. On-camera flash will cause such reflections.

Make an exposure meter reading to determine exposure with natural light or photoflood lamps. Unless you're using through-the-lens autoflash, figure exposure by measuring flash-to-subject distance and dividing it into the flash unit's guide number (see page 115). If the resulting f/stop is not possible, move the flash a greater distance away or cover the reflector with a clean white handkerchief. Each layer of cloth is equal to an exposure reduction of about one f/stop.

Experiment with lighting and exposures until you find the combination which works best. If you have the chance, try a few underwater shots at larger sea aquariums, too. Stand close to the tank glass to avoid reflections. For illumination, utilize the natural light of the aquarium or hold a flash to one side of your camera at a 45° angle to the tank.

Shooting Through Binoculars

Scientists and some photographers have always wanted to record images larger than life and bring very distant subjects close to them. Microscopic and telescopic photography were the solutions. Similarly, amateur photographers have found that binoculars are an inexpensive solution to bringing a subject closer without purchasing a telephoto lens.

Of course, the sharpness of your image may vary according to the optical quality of the binoculars, as well as that of your camera lens. Also, because the angle of view of binoculars may be less than your camera's angle of view, the image often may appear circular on your film. For this reason, wide-angle binoculars usually are best.

The easiest camera to use with binoculars is a single lens reflex. Align one of the binocular's eyepieces with your normal lens focused at its closest distance. Further focusing is done by adjusting the binoculars until a sharp image is seen in your viewfinder. Either buy a special binocular-camera mount or fashion a homemade device to hold the two pieces of equipment in alignment. The place where the camera lens and binocular eyepiece meet should be made light-tight. Be careful the eyepiece does not scratch your lens. Actually a small space should be left between them to allow the eyepiece to move freely when focusing the binoculars.

With a rangefinder camera, focusing is more difficult. The focus point of the camera lens should be set at infinity. Look through only one eyepiece when focusing the binoculars. Then switch to the other eyepiece to make sure it is equally sharp. To photograph, align your camera lens with one eyepiece and look through the other for framing.

The new focal length of your camera-binocular combination can be easily

figured. Binoculars are rated by their power and the diameter of the larger lens. That means a 7 × 35 binocular has a power of 7 and lens diameter of 35mm. To find focal length, simply multiply the power of your binoculars by the focal length of your camera lens. For example, binoculars with a power of 7 multiplied by a camera lens focal length of 50mm indicates an effective focal length of 350mm, the equivalent of a rather powerful telephoto lens.

As such, camera movement can be a problem, so a tripod is suggested. Use of a cable release also will minimize the chance of camera movement. Of course, a fast shutter speed will do likewise, but a high-speed film may be required to allow this. The reason is that the *effective f/stop opening* of a binocular-camera combination usually is quite small, even with the aperture of the camera lens wide open.

The effective f/stop opening can be figured by multiplying the binocular power times the camera lens focal length (as above) and then dividing this by the diameter of the binocular lens. With the example above, a binocular power of 7 times a lens diameter of 50mm equals 350. So dividing this figure by the binocular lens diameter of 35 indicates the effective f/stop opening of the camera-binocular arrangement of f/10:

$$\frac{7 \times 50}{35} = f/10$$

The effective f/stop number is needed if you use a hand-held exposure meter to figure proper exposure. After making an exposure reading, use the effective f/stop number (such as f/10 above) to find the correct shutter speed on the hand-held meter's dial. A through-the-lens meter built in the camera will compensate for correct exposure directly. But in both cases, always set the camera for proper exposure by adjusting the shutter speed while keeping the camera's lens at its widest f/stop opening.

Trying a Telescope

Photography through a telescope allows larger subject images than do binoculars. The quality of the telescope's optics greatly determines the quality of your pictures. A single lens reflex camera with built-in light meter allows easy focus checking and exposure setting by looking through the camera's viewfinder. To focus, adjust the telescope while keeping the camera lens set at infinity.

The camera lens must be aligned carefully with the eyepiece of the telescope. Buy a telescope camera adapter or fashion a connector with a light-tight collar to join the two pieces of equipment. Rock-steady support is required. For sturdiness, often the camera must be on one tripod while the telescope is mounted on another.

When making night shots of the moon through a telescope, the earth's rotation will cause a blur on your film if the exposure is longer than a few seconds. However, a full moon is relatively bright and an exposure of 1/250 second at f/8 with ISO/ASA 64 film is possible. Of course, side lighting gives depth to the moon's mountains and craters, so a full moon won't show as many of these details as will a half- or three-quarter moon. When shooting the moon in its various phases, always bracket to determine the best exposure range for your specific telescope and film.

Stars can be photographed with a telescope-camera combination, but their light is less bright than the moon's. Since a long exposure will be required, the earth's rotation will cause the stars to leave trails in your photograph. For this reason, many photographers forego a telescope and shoot stars with a normal lens so a great number of star trails are recorded. The most interesting pattern is a circular one obtained by aiming the camera at the north star, Polaris, around which all other stars appear to revolve. In the southern hemisphere, aim at the Southern Cross.

Pick a clear, moonless night. Position the camera so extraneous light will not reach the film. Use a sturdy tripod on firm ground. Set the shutter to B or T and use a cable release to open and close it. Make an exposure of at least 1½ hours. An exposure of 3 hours will make the star trails even longer and the circle around the north star will appear fuller, brighter, and more dramatic. For 90-minute exposures, try an f/stop opening between f/2.8 and f/4 with ISO/ASA 64 or ISO/ASA 100 film. At 180 minutes, set your f/stop opening between f/4 and f/5.6. Remember to focus at infinity. And include a tree or nonmoving object in the foreground for added interest and to give a feeling of depth.

Working with a Microscope

Photography through a microscope enables an exciting, hidden world to be captured on film. For best results, a single lens reflex camera without its lens is attached directly to the microscope's eyepiece. An SLR camera lets you see and focus the enlarged specimens exactly as you want them photographed. Adapters that attach cameras to microscopes can be ordered through camera stores or photographic supply houses. Some photographers fashion their own connector, but it must be light-tight and capable of aligning the camera correctly. Rangefinder cameras with nonremovable lenses also can be used, but the camera must be removed after each picture to set up and focus the next specimen.

Exposure varies according to the light source. The microscope's regular illumination can be used. But the use of fast shutter speeds to stop the action of living specimens often requires very bright light. Some photographers use the microscope's normal illumination for framing and focusing, and then substitute an electronic flash unit for the actual exposure. Make a test roll of film and bracket exposures. Be sure your shutter is properly synchronized for electronic flash. A photoflood reflector spotlight also can be used as a light source. However, your film must be balanced for photoflood light, or a filter must be used to give correct color rendition of the subject. For untrue but striking color effects, place a polarizing filter between the light source and the specimen you're photographing. Some experimentation with films and lighting is required. Often exposures are a few seconds long, so you'll need camera support and a cable release to avoid camera movement.

Using Auto Winders, Motor Drives, and Remote Controls

Cameras with an accessory or built-in auto winder or motor drive have become more common in recent years. Their main functions are to automatically advance the film and cock the shutter after each exposure. Modern instant cameras all incorporate motors to drive the exposed film from the camera and cock the shutter for the next shot. Many small cameras, including the disc and 35mm compact models, also have a built-in autowind feature to advance the film and recock the shutter. The real rage, however, has been with 35mm SLR cameras. More and more manufacturers are designing them to accept an auto winder or motor drive unit, and some models even have one of those features built in.

Let's compare the two types. Motor drives have long been available for a few cameras, notably Nikon models, and they are preferred by professionals. They allow single or continuous exposures to be made, usually from four to six frames per second (a special Nikon motor-drive camera shoots up to nine frames per second).

Auto winders generally make it possible to expose up to two frames per second, and usually you have to press the shutter release button for each exposure. A few auto winders, like all motor drives, have a continuous exposure mode that keeps advancing the film and cocking and firing the shutter for as long as the photographer depresses the shutter release button.

Many motor drives feature rapid automatic rewind, while most auto winders require that the film be rewound manually in the usual manner. Additionally, motor drives have provisions for firing by remote control, while many

auto winders do not. Motor drives, as you might suspect, are made for heavier duty and are more expensive than auto winders.

Motor drives and auto winders help photographers be ready instantly for any action, which means they are especially valuable for sports photography. They're not like movie cameras, however, which shoot 24 or 32 frames per second, so don't hold down the shutter release button and think you're going to get the perfect picture. All too often the best action happens between exposures. Most pros set the unit for single rather than continuous exposures, then count on their expert judgment and quick reflexes for triggering the shutter release at the moments of best action.

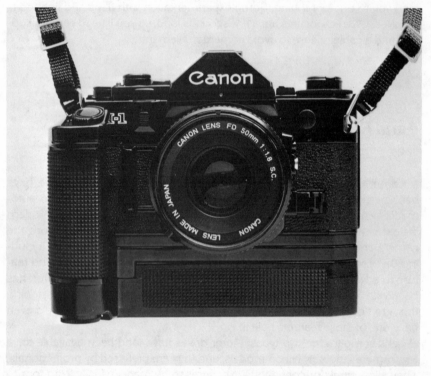

162. An accessory auto winder with a convenient handgrip attaches easily to the bottom of this single lens reflex camera. It advances the film and cocks the shutter automatically after each exposure.

Auto winders and motor drives also are useful for close-up work because there is no danger of moving the camera when you are cocking the shutter and advancing the film. And motor drives are used by scientists doing sequence and time-lapse photography. On some cameras a bulk film back is available that will hold up to 250 exposures. This is valuable when a prolonged series of continuous exposures is required, or when the action doesn't allow the photographer time to change rolls of film.

Are there reasons for not owning an auto winder or motor drive? Extra expense is one, not only for the unit but for the batteries to power it. (Motor drives require twice the number of batteries as auto winders.) Also, there is a tendency to shoot too many extra frames, so film costs can soar. Since many photograpers prefer 35mm cameras that are lightweight, adding an auto winder or motor drive cancels that benefit. The whir of the motor attracts attention, too, which limits the camera's use for candid photography. For the most versatile use, I suggest buying a camera that can be equipped with an *accessory* auto winder or motor drive, rather than one that has such a feature built-in.

Cameras equipped with a motor drive (or an advanced auto winder) are worthwhile for *time-lapse photography*. Auxiliary timers automatically trip the shutter at preset second, minute, or hour intervals. Thus a series of pictures can be made over a period of time without the photographer being present. A popular example of such use is recording the growth of a plant or flower.

Because the film does not have to be advanced or the shutter cocked by the photographer, the camera can be triggered by remote control. This allows it to be hidden from the subject's view or can be used in areas which might be physically harmful to the photographer. Wildlife and bird photographers use remotely controlled cameras extensively to keep from disturbing their prey. Criminal investigators do likewise.

Motor-driven cameras utilize remote control extension cords or audio devices to activate them. Subjects which break the beam of a photoelectric cell or touch a tripper wire also will trigger the camera's motor to release the shutter and advance the film. Cameras without a motor drive or auto winder also can be fired by remote control. A small battery-operated solenoid attached to the shutter release button is tripped on impulse by electrical, physical, or audio means. More simply, an extremely long cable release can be used to trip the shutter. Of course, the film must be advanced and the shutter cocked manually by the photographer after each exposure.

13

Traveling with a Camera

One of the main reasons for the popularity of photography is that people want to record their travel adventures at home and abroad. Some manage with just a pocket camera in a purse, briefcase, or flight bag. Others carry equipment-filled gadget bags almost as big as suitcases. Many 35mm camera users make color transparencies to share with their friends during an evening's slide show, while users of the smaller convenience cameras prefer color prints which can be kept in an album and shown to their friends.

There are many enthusiastic photographers who are well beyond the vacation snapshot stage. In fact, travel agencies often offer special tours designed for such photographers, such as Thru The Lens Tours of North Hollywood, California, which has organized photographic itineraries all over the world for more than thirty years.

There are a number of special concerns for traveling photographers. Some of these have already been discussed in detail elsewhere in the book, such as cameras, gadget bags, electronic flash, tripods, exposure meters, filters, composition, and processing. Here's a brief review of those topics, as well as others that will be of interest to photographers touring their own country or nations overseas.

Equipment to Take

Because most travelers want to record their adventures to share with others after returning home, many of them prefer 35mm cameras for making color slide transparencies. Such cameras are light, compact, and versatile. Single lens reflex cameras are usually preferred to rangefinder types because with an SLR the photographer sees through his viewfinder exactly what the film will record. There are no problems with framing and parallax.

Your camera should be in good condition. If you've been having problems with it or your exposure meter, have it checked by a repairman. But remem-

ber, when your equipment is returned, *always* shoot a roll of film to test the camera or meter readings before leaving on your trip. Sometimes other problems turn up even after you've had the camera overhauled or cleaned. Shooting a test roll also is good advice when purchasing a new camera or piece of photographic equipment with which you are not familiar. Don't take chances with something going wrong while you're traveling; test your equipment beforehand. Your camera should have a strong, well-attached neck strap, a case to protect the camera when not in use, a lens hood or sunshade, a lens cap, and a protective filter such as a UV or skylight filter.

What lenses should you take? Much depends on personal preference and the types of pictures you plan to make. Zoom lenses are very popular for travel pictures, especially for photographers making slides. The variable focal length of a zoom lens makes exacting framing very easy. The photographer doesn't have to move backward or forward to fill his viewfinder with the picture he wants; he just adjusts the zoom-lens focal length control. Because one zoom lens can do the work of a couple or more lenses of fixed focal lengths, you save time by not having to change lenses, and also cut down on the weight of the equipment you carry. If you prefer to use lenses of fixed focal length, a normal lens, about 50mm or 55mm, should be basic. I'd suggest a telephoto as a second lens, with one of 135mm focal length being a very good choice. Of course, if you're going to Africa to photograph animals, a more powerful telephoto would be recommended. A wide-angle lens would be the third lens to take. Very versatile is a 28mm or 24mm wide-angle, which covers a greater area than a 35mm lens but does not have the distortion of the more extreme 21mm wide-angle.

Some photographers prefer a macro lens, which combines normal lens or medium telephoto lens use with close-up capabilities. Alternatively, travelers who take many close-ups should carry close-up lenses and a set of extension tubes. A bellows usually is too bulky. Some photographers traveling light prefer a lens reverser ring so their normal lens can be turned around for extreme close-ups.

Cameras with automatic exposure control are of extra benefit in travel photography because you can concentrate on capturing the ever-changing subjects and scenery without worrying about setting exposures. Exposure meters built in the camera are very accurate and convenient, although some photographers prefer to carry a hand-held exposure meter as a spare or to check on their camera's meter. But don't spend so much time making meter readings that you miss the picture you intended to photograph. When traveling, many picture situations come and go quickly. Be ready. Making exposure readings should become second nature and done confidently without hesitation. If you are unsure about exposure in certain situations, be sure to bracket.

A sturdy and compact gadget bag should be part of the traveler's photo gear. It provides protection and storage for cameras and equipment. If necessary, line the bag with foam rubber to make it more shock-absorbent. Don't

163. *Most people carry a camera when they travel, but it takes thought and determination to get the best pictures possible. The photographer climbed into a tower to find a frame and get a high angle for this view of the Taj Mahal.*

be overburdened with a bulky gadget bag. If you must tote one, make sure it has a shoulder strap so your hands can be kept free. (See also page 160.)

A polarizing filter is a good travel accessory for any type of film you use. Black-and-white-film users will require other filters, too. Although pictures made by existing or natural light are most pleasing, flash may be needed where light is insufficient. Easiest to carry and use is a small electronic flash which can be set to make automatic exposures or used manually. Rechargeable units will be a problem in foreign countries if the electrical current or outlets are not compatible with your unit. Make sure your flash can be recharged at various voltages, and carry a set of adapter plugs to fit the outlets.

Units requiring replaceable batteries are more convenient, as long as your batteries are fresh. Watch that the on-off switch of such a unit is not accidentally turned on or your batteries will be worn out the next time you want to use the flash. Tape the switch in the off position to avoid this problem. Regardless of the flash type, make sure you know its range. Too many travelers expect their flash units to cover a great distance. Underexposed pictures are the result. Small electronic flash units are adequate only to maximum distances ranging from 10 to 20 feet. Don't expect more light from your flash than is possible. Read the accompanying instructions to know its limitations. Always carry an extra set of flash batteries.

A cable release and some camera support will be needed for time and night exposures. A small sturdy tripod, or a C-clamp with an adjustable head, is best. Don't forget camera lens cleaner and tissue, and extra camera batteries. A few plastic kitchen bags help protect your camera and equipment in dusty or rainy conditions. A changing bag may come in handy, too.

If you plan to record some of your travels with sound tape, a small cassette recorder with automatic recording level is best. And don't forget to pack extra tapes (120-minute capacity are most convenient), and batteries or battery recharger.

It is not unusual to see a photographer carrying two identical camera bodies. That way any of his lenses can be used on either camera, and two lenses always will be mounted and ready to shoot. And he is protected in case one camera breaks down.

Two cameras are a must if the photographer is shooting both color and black-and-white films. If the cameras do not have automatic exposure control, both films should be of the same or a similar ISO/ASA speed so the meter reading made for one film will apply to both for make calculating exposures much easier. For example, Ektachrome 400 (for color slides) and Kodacolor 400 (for color prints) and black-and-white Tri-X films have the same film speed, ISO/ASA 400, and they can be shot at identical exposures. If shooting with two films of different ISO/ASA speeds, the photographer should figure and memorize the f/stop or shutter-speed ratio between the films so he can set both exposures without making two readings. Thus, if Kodachrome 64 (ISO/ASA 64) and twice-as-fast Plus-X (ISO/ASA 125) are being used, exposures

164. A zoom lens made it easy to compose this full-frame shot of Indian elephant boys giving their animals a bath.

for the Plus-X black-and-white film will be one f/stop smaller, or one shutter speed faster, than exposures with the Kodachrome color slide film.

Identical camera bodies are best for a photographing couple because lenses and other equipment can be shared and the burden of carrying equipment reduced. There's no reason the husband should lug around one camera outfit while his wife totes a different type. Occasionally an extra or different type of camera may be necessary, as when underwater photographs are to be made. Special underwater models, such as the Nikonos, or underwater housings for regular cameras are available.

Regardless, it should be stressed that traveling photographers should pick one type of photography and stick to it. Don't load yourself down with a video camera, a still camera, and an instant camera. So much varied equipment is too cumbersome and too confusing to use successfully. Try also to concentrate on one type of film, color or black-and-white. Regarding color, decide whether you want slides or prints and choose your film accordingly. Remember, prints can be made from slides, and slides from print negatives. So choose the type of film desired most and stick to it.

165. *Some travelers carry two cameras—one with a wide-angle lens, the other with a telephoto—so they don't have to change lenses if they suddenly spot a good subject. This New Guinea warrior was caught with a telephoto as he was preparing for a tribal dance.*

Film Brands and Prices

What about film brands, speeds, and quantities? It's best to use a film with which you are familiar. Avoid spoiling your trip pictures by experimenting with a new film. Kodak films are available everywhere in the U.S. and most countries abroad. But Kodak or not, don't count on buying your favorite brand or type of film overseas. It may be available only in limited quantities or even not sold in some countries. In some cases the film may be out-of-date, so always check the expiration date on the carton. Also, sometimes film is stored under improper conditions.

Prices vary from nation to nation, too. Films in the U.S. have a suggested list price but can be bought for less at discount stores. Camera shops often reduce the price when a quantity of film is purchased. Many overseas camera stores do the same if you ask for a discount.

If you purchase Kodak film abroad, it may or may not be made in the U.S. The company has film manufacturing plants in other nations and slight differences in the results may be detected even if it is the same brand and type. To ensure consistent results, check the carton to see if the Kodak film was made in Rochester, N.Y. Many color slide films sold abroad include processing in the purchase price. Again, check the carton for this information. Kodak films including processing which were bought overseas will be processed in Kodak's labs abroad or in the U.S. without further charge. An address list of Kodak's worldwide processing laboratories is available from Eastman Kodak Co., Rochester, New York 14650. Ask for pamphlet No. XAC-16, "International Photographic Headquarters."

Which Film Speeds?

Film speed is a personal choice, too. Since you will probably be shooting in all types of lighting situations, films with faster ISO/ASA speeds will be worthwhile. Excellent color and black-and-white films of ISO/ASA 400 are available, and there are even higher-speed color print and slide films rated at ISO/ASA 1000. For color photos, however, many people prefer the quality of medium-speed films like Kodachrome 64 (ISO/ASA 64), and Ektachrome 100 and Kodacolor 100 (both ISO/ASA 100).

Some pros, however, especially like the colors of slower Kodachrome 25, which is ISO/ASA 25. (To make the slides even a bit more vivid, by slight underexposure, they rate the film at ISO/ASA 32.) For low-light situations, these

professional slide shooters carry Ektachrome 400 (ISO/ASA 400), which can be pushed to an even higher speed, ISO/ASA 800, with special processing. Another choice when you need a fast slide film is to shoot with Ektachrome P800/1600, a 400-speed push-process professional film that you also can expose at ISO/ASA 800, 1600, or 3200.

How Much Film?

How much film will you need? That depends on your photographing habits. Certainly, most photographers return home and discover they shot less than they thought. "Is that all there is?" is a common remark. My advice is to photograph a variety of subjects as often as possible. Two 36-exposure rolls of 35mm film is a good daily average for serious amateurs. Don't be burdened with 24-exposure rolls when the 36-exposure type allows almost twice as many pictures, takes up the same amount of space, and is less expensive.

Reduce the bulk of film you carry by discarding all packing cartons and all but one instruction sheet before leaving on your trip. With 35mm film, put the metal or plastic film containers in a cloth ditty bag with a drawstring. Carry another bag, preferably a different color or type, to separate exposed film from fresh film. Remember always to rewind the film leader completely into the cassette after a film is exposed to avoid accidentally reexposing it.

Protecting Film

Keep your film cool and away from humidity. In a hotel, lock it in your suitcase. Otherwise, carry it on your person when flying or using other transport where your suitcase is separated from you. Don't ruin your trip by letting your film get lost, stolen, or damaged. Protect it. A potential threat is the security check at airports where X-ray machines are used to inspect hand baggage and even suitcases that are placed in the plane's baggage compartment. X-rays *will* harm film, despite what the airport signs say. Color films and high-speed films of ISO/ASA 1000 or more are especially susceptible to fogging, color fading, shadow images, and other damage. Insist on a hand check for your film and loaded cameras.

To avoid the hassle of a hand check, some travelers put their films in lead-lined polyester bags designed to shield the contents from X-rays. However, there's still no guarantee that your films won't suffer damage, because X-rays

are cumulative, and multiple X-ray screenings during an extended trip may add up to trouble. Also, some X-ray machines in foreign countries give extra high doses of X-ray exposure. Play it safe and always ask for a hand inspection of your film. (The walk-through metal detectors used at airports to discover hijackers' weapons do not affect film.)

Mailing Film

Many travelers keep their exposed film with them until returning home to a local photofinisher with whom they are familiar. Those on extended trips often mail the film home for processing. Prepaid film mailers will work, but be sure to send via air mail from overseas.

Another good idea is to package at least six rolls to conform to international postal regulations regarding minimum package size, make sure it clears customs at the outgoing post office, and ship it air parcel post. Regular mail goes by sea and your film often is subject to a great variety of temperatures. Always make sure your package has been properly stamped and canceled, and avoid sending film from countries with unreliable postal service.

If mailing film home, remember to write on the package: "Exposed, undeveloped photographic film. No commercial value. Do not X-ray." This will avoid payment of duty to U.S. Customs and will notify airline personnel who may be using X-rays to check for lethal or dangerous packages.

Manufacturers always recommend film be processed as soon as possible after exposure. There is really no big rush if you keep it in a cool and dry place. When subjected to very hot and humid conditions, exposed film, especially color, will lose picture quality and should be processed as soon as possible.

Identifying Film

For easy sorting later, films should be identified after shooting. Some photographers keep detailed notebooks with entries listed according to numbers on the camera's film-frame counter. Others just jot down notes corresponding to the entire roll of film. Rolls can be identified according to alphabetical letters, A, B, C, et cetera, and individual frames by number. The roll can be marked by scratching the identifying letter on the film's metal cassette or on its plastic can. Before processing, these I.D. letters should be transferred to the film's return mailing label or camera store identification sticker. Alterna-

tively, the first frame of every roll can be used for identification by photograph-ing a convenient letter or number. It's always best to devise some sort of identification system so the pictures can be easily recognized and filed later. Photographers on regular tours sometimes indicate the roll letter and frame number in the tour brochure next to the description of the event or day's activity.

Government Regulations

Overseas travelers should be aware of government regulations about cam-eras and film. Some countries officially limit the number of cameras or films which can be brought across their borders by any one person. Tourists and other noncommercial photographers usually are not bothered with such reg-ulations, but it may help when entering a country not to make a big display of your photo gear. This is another good reason for reducing the apparent size of your film supply by discarding film packing cartons before leaving on your trip.

Government authorities and others sometimes forbid certain types of pic-tures to be taken. This is common in the Eastern European countries. For instance, in the U.S.S.R. officially restricted subjects include border areas, mili-tary personnel, factories, bridges, railroad stations and junctions, airports, and views from aircraft.

Other areas especially off-limits to photographers in many countries are art museums and places of religious worship. Where photography is permitted in museums, a permit or fee may be required. Tripods and flash equipment are apt to be forbidden. Tripods get in the way of other visitors or might be used to damage art objects. The bright light from flash can fade paintings. Hand-held 35mm cameras with high-speed film are most useful for casual museum photography.

U.S. Customs Considerations

U.S. Customs regulations also are a concern to photographers traveling abroad. Cameras, lenses, and equipment made overseas are subject to duty upon reentry to the U.S. unless you can prove your photo gear was purchased at home. One way is to register the equipment with U.S. Customs before leav-ing. At international airports for instance, take your cameras and lenses to the U.S. Customs office and fill out form No. 4457. Include brand names, and

model and serial numbers which are engraved on all such items. A Customs officer will check your list and equipment, and sign the form. List your tape recorder, too, if it's foreign made. Customs registration of your equipment is good forever. Allow enough time for this procedure before departing. Alternatively, proof of ownership is usually accepted by Customs inspectors when sales receipts or your camera insurance policy is shown. Such insurance is a good idea, by the way. Special camera floater policies can be included with your homeowners or renters insurance. Articles are itemized and coverage includes damage and theft.

Travelers who cannot prove their equipment was purchased in the U.S., or those who bought a camera or lens abroad, probably will pay duty. The amount depends on how much you might exceed the duty-free exemption, currently $400. The duty, which is based on purchase price, less wear and tear, is 10 percent on the next $1000 of purchases. If total purchases exceed $1400, additional duty then ranges from 7.5 percent on cameras to 12.5 percent on lenses. Don't lie about the price you paid for equipment abroad; Customs officers keep up to date on the costs of photo gear. And don't be tempted to accept a camera salesman's offer for a fake receipt with a lower price. Smuggling new camera equipment also is ill-advised; if you're caught, confiscation and fines are possible.

Buying Equipment Abroad

There are some other considerations if you plan to purchase cameras or accessories overseas. A few places have a reputation for bargain prices, including Hong Kong and Singapore as well as some international airports which offer duty-free cameras and lenses. However, the amount you might save depends on the U.S. dollar's current value in the country where you're shopping. (Also include possible U.S. Customs duties when figuring the total price.)

Carefully check the foreign cost against the U.S. price to see if an overseas purchase is really a better bargain. Many cameras in the U.S. will cost 20 to 25 percent less than their advertised price if you ask the camera store salesman for a discount or shop around at large discount houses. At any rate, be sure to bargain overseas. Check at least three stores for the lowest price offered. Always make certain you're comparing prices for *exactly* the same equipment, not just similar camera models or lenses that have different maximum f/stops.

Two more things worth considering include trademark and warranty agreements. There are restrictions on many Japanese and German cameras which prohibit their importation to the U.S. by individuals unless the brand name is

obliterated. Some U.S. Customs officials will enforce this and demand the camera name be scratched or ground off. Occasionally they'll let you get by with taping over or painting out the brand name. Or sometimes they won't even mention it. A pamphlet, "U.S. Trademark Information," is available free from U.S. Customs offices and has more details. You also can write to the Treasury Department, Bureau of Customs, Washington, D.C. 20226.

Warranty agreements are of more concern. Sometimes warranties on cameras purchased overseas will not be honored in the U.S. or other countries. Always make sure you get an *international* warranty agreement. Otherwise you may end up paying for any repairs necessary once you get back home.

Purchasers of Japanese cameras abroad should look for a small sticker stating "Passed, JCII." It indicates the camera has been approved for export by the Japanese Camera Inspection Institute, a government body. Make sure any Japanese camera has one before buying it. This sticker has nothing to do with Customs duty, so it can be removed after purchasing the camera.

Be advised that some equipment you plan to purchase abroad may not be available. Very new cameras or accessories reviewed or advertised in photography magazines may be in short supply or unavailable in some countries.

166. Always carry enough film when traveling because frequently it is in short supply or very expensive, as it was in Djibouti, Africa, where this young boy was photographed.

Some models, for instance, are made only for export and marketing in the U.S. Brand names may be slightly different, too. Always know the exact name and model number of the equipment you want. Of course, one problem about waiting to buy a camera or equipment abroad is that you may miss some great photographs en route to the foreign country where you plan to make your purchases. Regardless of where or what you buy, remember to make a test roll of film with any new equipment. And don't forget to ask for the instructions in English.

On the opposite page is a list of a few key photographic words in six languages, which should be of help abroad.

Some Practical Advice

There are some things to remember when you plan to make photographs on your trip. First, your camera should be ready to use, not buried in your gadget bag, suitcase, or the trunk of your car. Often the best travel pictures are unplanned and the photographer must be ready to act.

Carrying a camera in a car deserves special mention. Glove compartments, rear window ledges, and trunks can get extremely hot in summer, and heat is bad for your camera and film. Keep the camera on the seat beside you, and place it beneath the seat when you leave the car. Better yet, take your camera with you. If storage in the trunk is necessary, insulate the camera by keeping it in a dry styrofoam ice chest. This is a good place for film, too (see page 12).

Plastic bags can be used to keep rain and snow off your camera, although fresh water won't hurt it if all the water is wiped off after the camera is used. Salt water is quite harmful, however. So try to keep your camera protected when at sea or on the beach. Wipe off any salt spray immediately. The lens can be protected by a UV or skylight filter, and shielded from rain or snow by a lens shade. A small collapsible umbrella is a good companion if you're shooting in rainy weather. It will keep you and your camera dry.

Always wipe off your cameras and equipment at the end of the day's shooting. Dust your lenses, too, but don't keep polishing them. Use lens cleaner only when necessary, not daily.

Always keep your equipment in sight. Don't put your camera down where it can be stolen or where you'll walk off and forget it. If you leave your hotel room without your camera, lock it in your suitcase. In some countries you must be careful handing your camera to strangers who suggest taking your picture. The impromptu photographer and your camera may disappear. By the way, it's always a good idea to have your name and other identification engraved on your cameras in case of loss or theft. Taped-on labels are worthless.

English	German	French	Italian	Spanish	Japanese
Camera	kamera	appareil photographique	macchina fotografica	máquina	kamera
Battery	batterie	batterie (pile)	batteria	batería (piln)	batteri (or) denchi
Electronic flash	elektronen blitz	éclair électronique	luce portabile elettronica	flash electrónico	sutorobo
Filter	filter	filtre	filtro	filtro	fuiruta
Color slide film	dia	diapositive	diapositiva	diapositiva	karaa toransuparensii
Color print film	farbenfilm	pellicule en couleurs	pellicola a colori	pelicula	karaa fuirumu
Black-and-white film	schwarz und weiss film	noire et blanche filme	bianco e nero pellicola	rollo de negro y blanco	shirokuro-fuirmumu
Developing and printing	entwickeln kopieren	développement (traitement)	sviluppo e stampa di un film	desarrollar copiar	D.P.E.

167. *When photographing at the seashore, take precautions so cameras and equipment are not harmed by salt water or spray (see text).*

Cold may affect your camera. Very cold weather tends to slow or stick the shutter, especially leaf-type shutters. Keep the camera in its case, or under an outer layer of clothing to warm it between shots. Condensation is a problem if you go from heat to cold and back to heat. When going from one temperature extreme to another, placing the camera in a plastic bag with the end closed will cause the condensation to form on the outside of the bag, not the camera. Take care not to breathe on the viewfinder in cold weather or it will fog and make focusing and framing difficult or impossible.

Film becomes brittle in cold weather, so avoid winding the film too fast. It may break, or the sprocket holes in 35mm film may tear, and the film will not advance. If your 35mm SLR has a motor drive with a power rewind feature, switch it off or to manual and then slowly crank the exposed film back into its cassette to avoid streaks on the film caused by static electricity. For use in

arctic-like conditions, a camera can be winterized by having a repairman remove all its lubrication so it will not freeze and jam the camera. However, a winterized camera should not be used in warm temperatures, because lubrication is needed to keep camera parts from becoming worn.

Be careful of vibration, which can loosen camera or equipment screws, especially during jet plane trips. Keep your camera cushioned to lessen the vibration that occurs on such planes. Carry a small set of jeweler's screwdrivers to tighten any loose screws.

The lighter your load, the easier and more fun it will be making pictures. Depending on your photographic pursuits, you can find a convenient and safe way to carry your equipment. One couple I know, who take long hikes photographing nature, wear fishing vests with many pockets to hold their camera gear.

What to Photograph

Most photographers who travel fail to think about the pictures they'll make until they get to their destination. A little research and thought beforehand will help you get more and better photographs. Study travel books or brochures to discover the most interesting sights and landmarks to record. See what costumes are native to the area. Check the architecture, too. After you arrive, study the postcards for sale to determine what sights the locals feel are worthwhile photographing. The postcards may suggest a unique camera angle as well.

But I hope you won't buy local slides or postcards to copy. Duplicated slides are usually of very poor quality and they will stand out if inserted in your home travelogue. Postcards are good for a record but not to copy with your camera for use in your slide show. Make all your own pictures and don't count on the photography of strangers to help tell your travel story.

What story do you want to tell? Pictures should have a reason for being taken, and the types you make should contribute to your story. If I plan to organize a slide show for my friends, I try not to make it too personal. It's not necessary to say, "I did this" or "I went here"; your pictures will show what you did and saw. Instead, think in terms of topics and shoot as many pictures as possible in various categories.

Here are just a few such topics: faces of people, clothes and costumes, children, pets and farm animals, wildlife, flowers, landscapes, food, restaurants, markets, festivals, hotels, campgrounds, sports, occupations, transportation, music, handicrafts, signs and flags, water (including fountains), art and

168. Food is one of the subjects that will make travelers' slide shows more color-
ful and appealing. These freshly picked berries were photographed at an open-air
market in Scandinavia.

architecture, churches and religious subjects. Of course, I record any inter-
esting sunsets, and make some personal shots of my wife and myself, too.

Regarding people, many excellent candid pictures can be made with a tele-
photo or zoom lens in the medium focal length range. If your subject sees
you, ask or gesture whether it is okay to take his or her picture. Politeness
pays. If your subject notices what you are doing, don't grab a shot and run, or
pretend you really weren't taking his picture. Ask permission. Most times no
objection will be offered. If your subject says no, just smile and go away.

One important point is that if you promise to send your subject a copy of
the picture, do so. Get his name and address and mail the photograph. Oth-
erwise he won't be so cooperative with the photographer who follows you.
Help yourself and fellow cameramen by keeping your promises.

People pictures are important to your travel tales. Your viewers always want
to know what the people you met were like. And besides, a travelogue of only
scenic pictures and buildings is not very satisfying. Also, try to include the
local people and not make too many pictures that feature your traveling com-
panions or yourself.

Your subjects should be doing something to add interest to the picture. Try
not to let them stare into the camera. One trick is to pretend you've taken

their picture, and when they relax and drop their pose for the camera, release your shutter. Your subjects will look more natural.

People also serve as size indicators for your scenic shots, or use them in the foreground to frame your landscape pictures. Be sure they face toward your main center of interest, not toward you. For instance, when photographing a building, shoot when people are walking toward it, not away from it. When people are not the main subject of your photograph, don't get them too close to the camera or they will dominate the picture.

On the other hand, if people are your center of interest, get in close. Too many photographers fail to fill their viewfinder with their subject. Move in. And if your subject is in costume, shoot close-ups of interesting parts of the costume. Are the subject's shoes or belt buckle especially unique? Get close and photograph them. This will direct your viewer's eyes to the part of the subject you think most unusual.

Alternating between overall views and close-up pictures is a worthwhile technique to remember for any subject you photograph. Shoot the mountain range, then switch to a telephoto to capture just one interesting mountain peak. Photograph the whole building and then move in to emphasize a unique window or door. Always look for details in your overall views and then photograph them close up.

The other rules of good composition are outlined in Chapter 10 and apply to travel photography, too. Use them. Also remember that signs or famous landmarks can be used to title places you visited or to identify places, states, or countries.

You don't have to organize your slide show in the chronological order of your trip. Instead of presenting your pictures in the usual and probably boring manner of day-to-day or country-to-country, organize them according to the topics you covered. Show all the famous sights as a group, then people, flowers, animals, and so forth. To avoid showing your pictures in the order you shot them, group slides of similar subjects together.

Travelers also should be sure to make pictures of their various forms of transportation. Photograph your plane, train, bus, boat, or car. And try some pictures on the move. Aerial views are good, especially shortly after takeoff or before landing, when you are close enough to the ground to get good detail of the subjects below.

Ask the airline attendant which side of the plane will be in the shade during your flight. That way sunlight will not be shining on the window you are trying to shoot through. Pick a window seat before the wing so the heat from the jet engine exhaust does not cause a ripple effect in your photographs. Use a fast shutter speed, at least 1/250 second, and pan with your subjects on the ground if possible. Focus at infinity.

To avoid reflections of you or your camera, get close to the window. However, don't let your camera touch the window, because plane windows vibrate and may cause blurred pictures. Use a UV or skylight filter to reduce the bluish

169. *Overall views, as of this waterfall in Europe, help the traveler recall his trip, but close-up pictures should be taken, too (see text).*

light caused by atmospheric haze and to make objects on the ground more distinct. Don't use a polarizing filter, because it reacts to the plexiglass of the plane window and will produce spotted patterns in your pictures.

When flying high, cloud formations or sunsets can be photographed effectively. For a feeling of depth, try to include the plane's wing in such pictures. Always keep your camera ready during a flight. Try a few interiors, too. Hand-held existing-light pictures of the inside of the plane are possible with a high-speed film.

If you're traveling by car or bus, try to sit in the front seat and shoot through the windshield. Use it as a frame to indicate your mode of transportation, or get close enough so the windshield doesn't show. Set your exposure and prefocus for a specific zone so you'll be ready to shoot when something interesting appears.

Shooting from side windows of cars, buses, or trains is more difficult because your subjects, especially close ones, whiz past. So forget nearby objects unless the vehicle is stopped. Instead, prefocus on more distant subjects, and use a shutter speed of 1/500 or faster. Try to pan with your subject. Sit on the shady side to avoid reflections, and get close to the window. Don't touch the glass or vibrations may cause camera movement. Be aware that tinted windows can change the colors of your subject. Shoot with the window open if possible.

Travel photographers should be warned about waiting for better picture situations. Don't. Never put your camera away in poor weather, at night, or when you go inside buildings. Many excellent pictures are made under such conditions, and without these pictures there probably will be gaps in your travel story. They add variety to the usual collection of photographs made in the sunlight, too. So shoot on overcast days and when it rains. Use a camera angle that will avoid the gray skies, however.

Night pictures are very effective. Follow the exposure suggestions given in the previous chapter. Use a tripod or other camera support. Bracket for the best exposure. And make some interior shots as well. Time exposures with tripod support may be necessary. Without a tripod, place your camera on the floor or a table and use the self-timer to avoid moving the camera when releasing the shutter. Don't expect flash to cover great distances inside buildings. Know the maximum range of your electronic flash unit. And remember that existing light pictures appear more natural than those made with flash.

Travel photographs will excite your friends and bring back many memories for yourself. But save only the good ones. Edit your pictures before compiling an album or slide presentation. And whenever you take a trip, remember the following hints.

Your pictures should tell a story. Get close to your subjects. Vary your shots between overall views and close-up details. Try candid photographs of people instead of posed pictures. Don't be afraid of your subjects. When necessary, ask them for their permission to be photographed. Shoot regardless of the weather or the hour of the day. Take enough film and make more pic-

170. Always be ready to photograph, regardless of the weather. Just after a rain
shower, the photographer found this bride and groom posing for a wedding por-
trait at a resort in Hawaii, and he was ready with his camera, too.

tures than you normally do. Try to capture some humor in your photographs, too.

And it also helps if the traveling photographer has not only patience but a sense of humor. Your trip and picture making should be enjoyable.

14

Processing Films and Prints

Once you've exposed your film, what about processing? Some photographers insist on doing their own, others depend on custom processing labs, and many amateurs simply give their film to a camera shop or drugstore for development. Who processes the film is of little concern to this latter group. It should be. Too many photographers accept dust-spotted prints, untrue colors, or scratched slides without a word of protest.

The final result of your photographic efforts should be the best possible. If you've spent the money for camera, equipment, and film, and the time to take your pictures, then you should demand that your print or slide results be worth the expense. If your photofinisher is doing a poor or mediocre job, find another. Many ways of processing are available (see page 135).

Color Concerns

In many respects, with color film it is best to return the film to its manufacturer for processing. The company's reputation depends on the quality of the result. Independent photofinishers who process all brands of films are not as concerned that the prints or slides represent what the manufacturer intended. A case in point is Kodak's Kodachrome slide films. This color film is quite complex and requires careful temperature and timing control during development. Lack of attention to these and other processing requirements will produce faded colors. From your standpoint, your pictures will be ruined because they do not represent the subject as you intended. True reproduction or rendering of color is usually your desire, and poor processing can destroy your efforts by producing a washed-out photographic result.

Techniques of film and print processing vary. Developing Kodachrome, for example, requires a processing machine costing thousands of dollars, while another Kodak slide film, Ektachrome, can be developed at home with a relatively inexpensive processing kit. An increasing number of photographers, in fact, develop their own color slides and color negatives, and also are equipped to make color prints.

[284]

Black-and-White Considerations

At present, however, most darkroom hobbyists begin with black-and-white films. Investment in developing and enlarging equipment and facilities can be minimal or extensive. Film developing is simple, fast, and inexpensive. A darkroom isn't even required; a light-tight changing bag and developing tank will do. Printing and enlarging are the next steps, and a darkened room is needed. For do-it-yourself darkroom procedures, see pages 292-313.

Many photographers do their own work in order to have total control of the final result. It's less expensive than commercial processing, too. Others claim, however, do-it-yourself darkroom work is too time-consuming and prefer to pay a custom lab to do the processing. Amateurs who shoot only occasionally and require only small snapshot-size prints are content with regular photofinishers. They use machines that hourly develop hundreds of rolls of film and turn out thousands of prints. Quality control, however, varies from lab to lab. Make sure you are getting the best possible results for your money.

If you want big enlargements from your negatives, make sure they are pro-

171. *To be sure their treasured pictures of family and friends are not ruined because of careless processing by commercial labs, some photographers establish a darkroom and do their own film processing and printing. The procedures for black-and-white darkroom work are described in this chapter.*

cessed in a fine-grained developer. If you don't do your own processing, this requires special instructions to the photofinisher. Quality enlargements to 16 × 20 inches, and even larger, can be made from properly developed 35mm film.

Print Sizes

Color prints are the most popular form of finished photographs today. More than three-fourths of all pictures taken by amateur photographers are in color, and nearly three-fourths of that amount are with color negative films, which produce color prints. Currently, the most common size for 35mm films is the snapshot variety, 3½ × 5 inches, although some photofinishers offer slightly larger 4 × 6-inch prints as "standard." Disc and 110-size pocket camera negatives yield 3½ × 4½-inch prints, with enlargements to 5 × 7 and 8 × 10 inches also available from most processors. Labs will make 11 × 14, 16 × 20-inch, and even larger prints from 35mm color film, and you can do the same in your darkroom.

Print Quality

Prices for processing vary, with labs doing custom work charging the most. Photofinishers who do general processing are competitive and you can seek one giving a bargain. But don't compromise on quality in order to save a few cents or because you are in a hurry to see your prints. There's a proliferation of so-called one-hour photo processing stores, and while many have high standards, others are sloppy. If your prints are ever returned to you with dust marks, fingerprints, scratches, or other imperfections, give them back to the processor to be remade. The quality of your finished prints or slides affects your reputation as a photographer. Especially in the case of color slides, returning the film to its manufacturer for processing should assure you of the best quality results.

Choice of Results

You should also be aware that a number of things can be done with your color films. While color negative film is primarily intended for prints, slide trans-

parencies can also be made. Likewise, color prints can be made from slide film, although it is mainly designed to give positive color transparencies. Duplicate slides can be made, too. Prints can even be copied to produce color negatives for making additional color prints. And some labs will make black-and-white prints from color negatives or slide positives. Of course the best results come when you use the film designed for the results you want, black-and-white negative film for black-and-white prints, black-and-white positive film for black-and-white slides, color negative film for color prints, and color positive film for color slide transparencies.

Local and Overseas Service

Speed and convenience in processing are concerns. Many photofinishers will give one-hour, overnight, or two-day service when the film is delivered direct or to a participating camera shop. Prepaid processing envelopes for color prints or slides can be mailed directly to some processors and the finished photographs will be mailed to your home. Such envelopes often can be bought at discount prices and thus reduce your developing costs. Some films include the cost of processing in the purchase price, but this is more common in countries other than the United States.

If you do buy color film overseas, the price may include processing. A mailing envelope usually is packed with such film. This kind of mailer has no value itself and is only provided as a convenience; the film is coded to indicate whether processing has been prepaid. Often the film magazine or cassette states if processing is included, too.

Processing of film overseas is dependable in most countries. Kodak, for instance, has processing plants around the world, plus ten labs in the U.S. to handle their color films. Make sure you'll be in the city long enough to pick up the film, or give detailed instructions where to mail it. Speed of processing service overseas varies and in places without one-hour stores, color can take up to one week or longer. Black-and-white processing usually is done in two or three days.

Analyzing Faults with Your Photographs

When your negatives, prints, or slides are returned from the processor, or after you've processed your own, it's a good time to analyze your photographs.

Not only composition should be considered, but technical quality. Here are some things to check. Prints, negatives, or slides should be of good contrast, neither too light nor too dark.

Overexposure

Negatives that are dark have been overexposed; too much light has reached the film. However, corrective printing in the darkroom often allows prints of good contrast to be made from overexposed negatives. Overexposed slides (positives) are too light and colors appear washed out. Little can be done with improperly exposed slides—except to avoid the problem in the future.

Overexposed slides or negatives may be the result of using a lower, incorrect ISO/ASA film speed number with your hand-held or camera's exposure meter. Or perhaps your meter was aimed incorrectly when reading the light. The mistake might have been made by setting the lens f/stop too wide or the shutter speed too slow. Auto-exposure rangefinder cameras may have had their exposure meter windows blocked and adjusted exposure for darker lighting conditions than actually existed.

With overexposed flash pictures, the wrong flash guide number was used or the flash was too close to the subject.

Underexposure

Negatives that are light or "thin" have been underexposed—not enough light reached the film. Correction to make an acceptable print of good contrast often can be done in the darkroom during printing, however.

Underexposed slides (positives) are too dark and the colors appear too contrasty. Such underexposed slides, or negatives, could be the result of too little light being available or too high an ISO/ASA film speed number set on your exposure meter. Perhaps you read the light incorrectly with your meter. Or you wrongly set the f/stop too small or the shutter speed too fast.

With underexposed flash pictures, the wrong flash guide number was used, or the flash was too far from the subject.

No Exposure

Sometimes your slides will be completely black or your negatives completely clear. This occurs when no light reaches the film. Often the film is not properly loaded in the camera, so it did not advance as expected and no exposures were made. Sometimes unexposed film is accidentally processed. To avoid this with 35mm film, make a practice to completely rewind the film into the cassette after the final exposure so it cannot be confused with a fresh film, which has its leader still showing. Unexposed film also results if the shutter does not open, the lens cap was left on, or the flash does not go off.

Sometimes the flash is simply not synchronized to fire when the shutter is open, and an unexposed picture results. With focal plane shutters common in 35mm SLR cameras, occasionally only a portion of the film frame is exposed. Again, faulty synchronization is the problem; the shutter speed was too fast. With electronic flash at X synchronization, focal plane shutters usually should be set no faster than 1/60 or 1/125 second, according to the camera's instructions.

Flash failure, and thus unexposed film, can be caused a number of ways. Batteries may be exhausted, uncharged, or dirty and not making contact. Connecting flash cords may be broken internally or improperly attached. The bulb, cube, or electronic flash unit itself may be faulty. Or flashcubes were used on cameras designed only for battery-less magicubes.

Other Errors

Fuzzy pictures most often are the result of camera movement. The photographer failed to hold his camera steady or jabbed at the shutter release instead of squeezing it. Or the pictures may be out of focus because the photographer was too close to his subject. With fixed focus cameras, and all lenses, the camera must remain a minimum distance from the subject. Sometimes the cameraman simply focuses incorrectly or fails to consider depth of field.

Fuzzy pictures also result when the shutter speed is too slow for the speed of the action being photographed. Use a faster shutter speed or pan with a quickly moving subject. A dirty lens or filter could cause an unsharp picture, too. Keep them free of fingerprints, which will diffuse the image reaching the film.

Sometimes black spots or objects appear in your pictures. Often this is caused by dirt in the camera, including small pieces of film or lint. Dust the inside of your camera carefully. Other causes of black objects include a fin-

ger, part of the camera case, or your camera strap being in front of the lens. This happens especially with rangefinder cameras, where the photographer sees through a viewfinder while the film records the subject through another lens. Black spots on prints can be the fault of the processor who carelessly developed your film. Check the negative for clear spots; these will appear black in the print.

Light spots or streaks may show up in your prints. Occasionally this occurs when rays of the sun fall directly on the lens. Keep the lens shaded. Another reason for light streaks is that your film may be "fogged." This occurs when light accidentally reaches the film, as when the camera back comes open unexpectedly. Film should not be loaded or unloaded in direct sunlight or very bright daylight. When changing rolls, shade the film and camera with your body. Sometimes an ill-fitting lens or faulty camera back will cause light leaks within the camera and fog the film.

If images overlap on your film, the film may not have been fully advanced to the next frame before another exposure was made. The film-advancing mechanism of your camera may be at fault. Sometimes 35mm users attempt to force one more picture on a roll of film before rewinding it for development, and for this reason the last two frames may be overlapped. All 35mm cassettes are loaded with film designed for 20, 24, or 36 exposures, although one or two more exposures may be possible. However, these additional exposures can be ruined during development when the processor attaches other rolls or identification to the ends of your film. Don't try to crowd on more pictures than the number allowed and expect them all to be developed.

Color films have special considerations. If your pictures have an overall greenish or reddish cast, the film you used may have been outdated. Watch the expiration date printed on the film's carton. Another possibility is that the film was stored under hot or humid conditions. Keep film where it is cool and dry.

Color pictures that appear bluish or reddish-orange have been used with different light sources than those for which they were designed. This occurs most often when tungsten color slide films are used in daylight without a filter, or when daylight color slide films are used with regular incandescent light bulbs or other tungsten lighting.

Flash pictures need to be analyzed closely to avoid repeating the same mistakes later. Carefully study your prints and projected slides. Commonly, there are bright or glaring spots in the picture caused by the flash reflecting from shiny surfaces. Mirrors, windows, and enameled walls or woodwork reflect flash back to the camera. Avoid this by standing at an angle to the reflecting object or by moving your subjects away from it.

Objects in the foreground of flash pictures often are too bright, while subjects in the background are too dark. Unevenly lighted flash pictures can be avoided by keeping all your subjects about the same distance from the flash so they each receive an equal amount of light. Carefully study the arrangement of your subjects before making a flash picture.

172. Whatever the subject, the quality of the finished photograph depends on the condition of camera and equipment, careful handling of the film, and strict attention to processing and printing procedures (see text).

Sometimes people turn up with disturbing pink or red eyes in flash pictures. With black-and-white film, the eyes seem abnormally white. This occurs when the subject's pupils are opened widely and the flash reflects back from the inside of the eye. Avoid this by placing the flash at a higher angle, or turn on more lights to increase the room's illumination and contract the subject's pupils. For flashcubes and magicubes and some electronic flash units that normally attach directly to the camera, special extenders can be purchased to alter the angle of the flash and thus avoid the pink-eye problem.

By careful analysis of your negatives, prints, and slides, you can discover the causes of problems which diminish the quality of your photographs. And you can determine how to avoid these problems in the future. Always study your results in order to improve your photography. Some photographers like

to process their own films and prints to create images exactly as they wish. The fundamental procedures are similar for both black-and-white and color, although color processing requires more exacting procedures and takes more time.

Processing in Black-and-White

Developing and printing your own photographs will either fascinate or bore you. Darkroom enthusiasts prefer home processing because it gives them full control over their photographic results. Other camera users, especially those who shoot mostly color, usually rely on commercial processing labs to develop and mount or print their films.

Whether or not you do your own developing and printing, a rudimentary knowledge of black-and-white processing will be beneficial to your photographic efforts. It will indicate how much latitude you are allowed in purposely or accidentally overexposing or underexposing black-and-white films. Also, if you get excited about black-and-white processing, you probably will want to experiment with color processing, too.

A basic guide for developing, printing, and enlarging black-and-white film follows. More details and advanced techniques, along with information on processing color films and printing color photographs, will be found in my companion book, *The Basic Darkroom Book.*

There are three general steps in processing black-and-white photographs. The first is to develop the film, which results in the negatives from which prints are made. The second step is to make contact prints of the negatives in order to see what the image will look like as a positive. The third step is to make an enlargement which represents the final photograph as you desire it.

For photographers who learn to "read" negatives and can readily visualize the image as a positive, or for those in a hurry, the intermediate step of making a contact proof sheet often is eliminated. However, such proof sheets, if filed with your negatives, will serve as an excellent catalog of all the black-and-white pictures you've taken.

Developing black-and-white film is quite simple. Extensive or elaborate equipment is not required, nor is a special darkroom. Basically, here's what happens. A film's emulsion is a coating of light-sensitive chemicals, silver halides. When light coming through your camera lens strikes this emulsion, an image is formed. However, it is called a *latent image* because it cannot be seen until the emulsion is acted upon by another chemical, the *developer.* This developer turns the portions of light-struck emulsion black or shades of gray, depending on the intensity of the light. Where little or no light has struck, as in

dark or shadowed areas of the original scene, the emulsion is unaffected by the developer.

After a predetermined time in the developer, the film is immersed in a chemical solution called *stop bath*. As you might have guessed, this stops the action of the developer, and it rinses off the developer so it will not contaminate the next chemical in which the film is immersed, the *fixer*. The fixer preserves the image and dissolves the film's chemical coatings that are no longer needed. Water is used to wash away the fixer, and the film is then hung up to dry. The images you now see will be preserved. The dark or black areas of the original scene will be clear, while the white or bright areas will be black. That is why the developed film is now called a *negative*.

Exceptions regarding black-and-white film processing are two revolutionary black-and-white films made by Ilford and Agfa that are based on chromogenic dyes used in color negative films. As such, Ilford's XP1 and Agfa's Vario-XL must be processed in Kodak's C-41 color chemistry or special chemicals that come in kit form for each company's specific chromogenic-type black-and-white film. (See also page 135.)

To see negative images correctly as positives, a print must be made. Contact proof sheets are made by placing the negative on top of light-sensitive photographic paper which is then exposed to light. As with film, a latent image is formed. And as with film, the paper is then run through three chemicals to produce a visible image. First the paper goes in the developer (usually a different type from the film developer), then the stop bath, and finally the fixer, after which the print is washed and dried. The negative images have reversed again to become positives and reproduce the scene as you photographed it. The print, of course, is in black and white and various shades of gray.

To produce a picture larger than the size of the negative, an enlarger is used. This projects the negative image in almost any size you desire onto photographic paper. The chemicals and processing steps for enlarging are the same used to make contact proof sheets. To be sure, it is quite exciting to see the first roll of negatives you've processed, but watching an enlargement emerge in a tray of chemicals is even more thrilling. Here's the complete developing and printing process in detail.

Developing Film

Little equipment is required. For spool films, such as 35mm and 120-size, a *film developing tank* is best. A tank made of plastic is inexpensive and sufficient, although one of stainless steel is more durable and a better invest-

ment if you intend to continue developing film. An accurate *thermometer* is a must. It is used to check chemical temperatures before processing begins.

As mentioned earlier, *three chemicals* are required: film developer, stop bath, and fixer. Water can be substituted for the stop bath if desired. The chemicals can be bought as a kit for film processing or can be purchased separately. The instructions packed with your film suggest a specific developer to use for that particular film. The same type of fixer can be used for both film and paper, although usually it is diluted differently. *Running water* for washing is needed. *Film clips,* or clothespins, are used to hang up the film. A watch or *clock* for timing the processing steps is necessary, too.

A glass or plastic *graduate* for mixing and measuring chemicals is required, as well as *bottles* for storing the mixed chemicals. Special brown plastic bottles are recommended, or spray-paint regular bottles black. This keeps light from deteriorating the chemicals while stored. If 35mm film is to be processed, a pair of *scissors* and a *bottle-top opener* are other necessary items.

The two most important considerations for successful film developing are temperature and time. Chemicals must be kept within a specific temperature range, and developing times must be exact. A guide to temperatures and times is included with the chemicals, and they can be found in the film's instructions, too.

Chemicals must be mixed carefully and correctly. Some can be purchased in liquid form and used as is. Others which are available in powder form, must be mixed with water. Concentrated "stock" solutions must be diluted before use. Chemicals come in a variety of sizes. To begin, 1-quart or ½-gallon sizes are suggested.

Care must be taken to avoid chemical contamination. For instance, after mixing the developer, wash out the measuring graduate before using it to make another solution. Wash off the thermometer, too. Protect your clothes with an old shirt or an apron. Rubber gloves can be used but are more bothersome than helpful; just keep your hands washed.

Bottles holding the mixed solutions should be labeled clearly, including their caps. Because chemicals deteriorate over a period of time, indicate the date of mixing. Also mark the bottles after each use to keep track of the amount of film developed; chemicals become exhausted and must be replaced or replenished after their *useful capacity* has been reached.

Because film developing tanks are light-tight, processing can be done with room lights on once the film has been loaded into the tank. Loading film requires a *totally* dark room. Or a changing bag can be used (see page 23). To check for light leaks, wait five minutes until your eyes become accustomed to the darkened room.

Instructions for loading film come with the developing tank. Loading is relatively easy but may require practice; you may want to use an old roll of unprocessed film for this. Close your eyes or darken the room while winding the

film onto the tank's reel. The emulsion side, which is inside of the film's slight curve, goes toward the inside of the reel. Handle the film by its edges, since touching the emulsion may cause fingerprints on the negatives. Be sure your hands, and the reel and tank, are dry. The film must not touch itself while on the reel, or the chemicals will not be able to cover the entire film surface. Patience often is required when loading the reel, especially with 36-exposure 35mm film, which is more than 5 feet long.

When you think you have mastered loading the reel, get set for the actual processing. Place the tank and reel in a convenient spot on a dry work space and turn out the lights. With Kodak's 35mm film, a bottle-top opener is used to remove one end of the light-tight film cassette. This metal container cannot be used again so don't worry about damaging it. Ilford's film cassettes are reusable, and the end can be snapped off with your fingers. The film will emerge wrapped around a small plastic spool. Find the film's outer end, the leader, and cut this first 2 inches off with a pair of scissors. Load the film on the reel with the emulsion side inward. Handle the film by its edges only. When you reach the end, cut the tape which secures the film to the cassette spool. Place the reel in the tank, and make sure the tank top is properly sealed. Now the lights can be turned on and the actual processing begun.

For roll film, such as 120-size, once the lights are out, break the seal on the film's paper backing and separate this paper from the film as you load the film on the reel. Tear the piece of tape holding the film to the paper backing at one end. Handle the film by its edges only and be careful not to touch or scratch the emulsion side of the film while loading it on the reel. Once the reel has been loaded and placed in the developing tank, with the tank's top secure, the lights can be turned on.

For cartridge-type film, such as 110- or 126-size, snap the plastic cartridge in two by putting your thumbs in the middle and pulling back on the rounded ends. Separate the film from its paper backing and load it on the reel just as described above.

Check the temperature of the developer. 68°F (20°C) is recommended. Cool or warm the developer accordingly. Ice can be packed around the developer bottle, or the bottle can be placed in hot water, to adjust the temperature. Determine the developing time according to the temperature, and by following the developer's instructions. Now pour the developer into the tank. Premeasure the amount required to cover the entire film so that the tank does not overflow.

Start the timer or mark the clock immediately, and agitate the film to eliminate *air bubbles*, which sometimes occur when chemicals first cover the film. For tanks with tops that hold the liquid in so they can be inverted, rap the tank on the edge of the work area to dislodge the bubbles, then agitate it by inverting the tank back and forth for at least 15 seconds. Do this again for 5 seconds during every 30 seconds of the developing time. For tanks with the reel core extended so it can be rotated, twist the reel back and forth rapidly to

173. Here are the steps (in the dark) for loading reels with 35mm film for processing in tanks. First remove the flat end of the film cassette with a bottle-top opener (some cassettes can be snapped open with fingers).

174. Cut off the film leader with scissors.

175. Curve the film slightly, emulsion side inward, and slip it into the film clip in the reel's center.

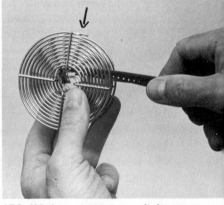

176. While maintaining a slight curvature in the film, turn the reel to wind the film into the grooves, making sure it follows the direction of the reel's spiral (arrow).

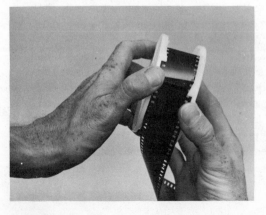

177. For loading plastic reels, place the film in the outside opening and "walk" the film into the grooves by alternately twisting each side of the reel.

dislodge the air bubbles, then agitate by rotation for 15 seconds. Reagitate by rotation for 5 seconds every 30 seconds.

When the developing time ends, keep the tank top on and drain the developer back into its bottle. Next, pour in the appropriate amount of stop bath and agitate the film by the inversion or rotation method. Drain out the stop bath after 15 seconds and pour in the fixer. (A plain water rinse of 30 seconds can be substituted for the stop bath.) Agitate the film as before and fix the film for the recommended time. Drain the fixer into its bottle. The tank top now can be removed and your results can be checked. First, however, immerse the reel in water to rinse away the excess fixer.

Film should be washed for 30 minutes in running water to ensure removal of all the fixer. Keep the film on the reel to allow uniform washing. Wash time can be reduced to 5 minutes by first bathing the film in another chemical, a *hypo clearing agent.* Finally, hang the film up to dry in a dust-free area. Drying time takes 2 to 4 hours. Forced drying with an ordinary fan may cause dust particles to adhere to the film, making rewashing necessary.

The dried negatives should be filed and stored in plastic sleeves or glassine negative envelopes. 35mm films can be cut in lengths of six exposures each for easier handling. 120-size films can be cut in three-exposure lengths for the same reason.

Printing Contact Proof Sheets

The next step toward a finished print for most photographers is making a *contact proof sheet.* This produces negative-size positive images that can be studied for content and contrast to serve as a guide in negative selection and cropping. *Cropping* eliminates the portions of the picture unwanted by the photographer. The contact sheets, when filed with their negatives, become a valuable index of all pictures you take. They can easily be checked later. In addition, they can be marked as to which negatives were printed and how many prints were made. Information about the exposure used during the enlarging process also can be marked on the proofs and utilized for subsequent printings.

Contact sheets produce positives the same size as the negatives. That's because the negatives are put in "contact" with the printing paper, and a light is turned on to make the exposure. One 36-exposure 35mm film, or one 120-size film, will fit on a regular sheet of 8 × 10-inch photographic printing paper. Thus a single exposure on one sheet of paper will produce a positive record of a complete roll of film.

The basic materials needed for contact printing can be used again for the final enlarging step. Chemicals for printing are the same—developer, stop bath, fixer—although the type and dilution usually are different from those used for film processing. The developer type depends on the type of printing paper selected. Also, you can choose between chemicals which come in powdered or liquid form. For mixing, follow the instructions packed with the chemicals. As before, be aware of the chemicals' capacities and keeping characteristics.

The stop bath can be the same type as used for film processing. The print fixer usually is more diluted than the solution used for film fixing. For volume printing, two fixing baths are often used to assure adequate fixing and to extend the life of the fixer solution.

The three chemicals should be poured into trays that are at least the size of the contact print to be made. Arrange them in order—developer, stop bath, fixer. For washing, a photographic *print washer* is recommended, or a siphon can be used to circulate the water in another tray. For drying, use an electric *print dryer* for fast results, or place prints between *photographic blotters* for overnight drying. The liquid-resistant resin-coated (RC) type of printing paper can be dried in minutes with a hand-held hair dryer.

For exposing negatives to make contact prints, a *contact printer* or *printing frame* can be used. The printer is a box, with a glass top and cover, that contains a light bulb. The negatives are placed with their emulsion (dull) side up on the glass and covered with a piece of photographic printing paper with its emulsion (shiny) side down. The top is closed tightly to hold negatives and paper in contact with one another. The light in the contact printer is then turned on to expose the paper. Exposure time varies according to the paper used and the wattage of the bulb. The paper is then removed and taken through the processing steps.

The exposure procedure is the same using a contact printing frame, although the frame does not have its own light source. Use a desk lamp or the light from an enlarger instead. If an enlarger is available, contact prints can be made with only a piece of glass. For 8 × 10-inch prints, use glass measuring about 10 × 12 inches so that it fully covers the paper. Simply put a piece of printing paper, emulsion (shiny) side up, on the enlarger's baseboard, and place the negatives on top, emulsion (dull) side down. Cover them with the glass to keep the paper and negatives flat and in contact. Then use the enlarger's light to expose the paper.

Whether you use only glass, a printer frame, or a contact printer, the glass must be clean to avoid dust spots or other marks on your prints. Negatives should be dust-free, too. Clean them with a special *antistatic brush* or cloth. Also, the negatives and paper must be in direct and even contact, or a fuzzy image will result. To keep your subjects from being printed in reverse, the negative's emulsion must be facing the paper's emulsion. Just remember to place negative and paper "emulsion to emulsion."

Because it is sensitive to light, photographic paper must be handled in darkness. However, unlike film, total darkness is not required. *Safelights,* with low-wattage bulbs and proper filters, can be used to provide illumination in the darkroom. A safelight with an OC (light amber) filter or cover will not affect most black-and-white photo papers, provided the paper is kept at least 4 feet from the light. Bulb wattage varies from $7\frac{1}{2}$ to 15 watts depending on the size of the safelight; do not exceed the manufacturer's recommended wattage, or your paper may be fogged by the safelight.

After the contact print has been exposed, processing begins. As with films, there are important considerations, including temperature, time, and chemical contamination. The *developing temperature* should be about 68°F (20°C), the same as for films.

The developer manufacturer and the paper manufacturer recommend *development time.* If photo paper has been overexposed, it will develop too fast. And if you pull it from the developer before the time recommended, the print may lack contrast or be spotted because of inadequate development. Make another print with less exposure. When a print has been underexposed and fails to develop adequately in the recommended time, there is little hope of getting a good print even by keeping it in the developer longer. Make another print with more exposure. Keep a timer or clock near the developer so that you can check the development time.

It takes some practice to determine under the safelights when a developing print looks its best and should be put in the stop bath; prints which look okay under safelights often are too light. Prints can be checked under white light after they have been in the fixer at least one minute.

Prints should be transferred from one chemical solution to another with *print tongs.* Tongs allow you to keep your hands dry and help prevent contamination of chemicals. Each tray should have a pair of tongs, and they should not be intermixed. To transfer prints, grab the corner of the print with the tongs and lift it from the tray until excess chemicals drain off. Then ease the print into the next chemical tray and use that tray's tongs to submerge and agitate the print. As with film, prints must be agitated sufficiently so that fresh chemicals come in contact with the paper's emulsion. Otherwise, uneven development and fixing will occur, resulting in spots, poor contrast, and possible discoloration.

After development, move the print to the stop bath for about 15 seconds (check the manufacturer's recommendation for exact time). Conventional printing papers remain in the fixer for 5 to 10 minutes, again depending on the brand of fixer used. Resin-coated papers are fixed only $\frac{1}{2}$ to 2 minutes, depending on the brand of paper and fixer. Prints which have been over- or underfixed may discolor with age. Wash time for conventional papers is one hour, unless the fixed print is first bathed in a hypo clearing agent, which reduces wash time to 10 minutes. RC papers require just 2 to 4 minutes of washing, without any need for a hypo clearing agent.

178. When processing a black-and-white proof sheet, or an enlargement, print tongs are used to transfer the photo paper from one solution to another: developer to stop bath to fixer to wash water.

Selecting Enlarging Papers

Once a roll of negatives has been contact-printed, and the frames for enlarging selected, the photographer has other decisions to make. An important one is what photographic paper to use for enlargements. By the way, while some papers are designed specifically for contact printing, enlarging papers work just as well, and most photographers use the same paper for making contact prints and for making enlargements.

Photographic papers are made by a number of manufacturers under a number of brand names. Choosing the ones you like best is mostly a matter of experimentation. Here are some considerations to keep in mind.

Papers are made in specific *contrast grade,* or they are of *variable contrast.* This allows you to get good contrast prints from negatives of good *or* poor contrast. When manufacture is by contrast grade, a paper often is numbered to indicate the type of negative contrast for which the paper was designed. The scale ranges from extreme to insufficient contrast. A grade 1 paper, for example, is for negatives of very high (hard) contrast, while a grade 5 paper works best with negatives of very low (soft) contrast. Grades 2 and 3 are for negatives of average (good) contrast. Not all brands of paper, however, are made in all grades of contrast.

Variable contrast (or multigrade) papers yield different contrast grades with

the use of filters. A numbered filter is placed in the enlarger to alter the light, and therefore the contrast. For its variable contrast papers, Kodak has a 7-filter set graded in half-steps from 1 to 4; Ilford's 11-filter set for its multigrade papers also is numbered in half-steps, but from 0 to 5. Good contrast negatives would take a No. 2, 2½, or 3 filter to produce good contrast prints, while high-contrast negatives require a No. 1 or lower filter, and low-contrast negatives require the higher-numbered filters.

179. *To increase a silhouette effect, as with these summer sightseers on a ski lift in Europe, some negatives can be printed on high-contrast paper to eliminate gray tones (see text).*

A variable contrast paper is a good choice because you need only buy one paper type instead of separate contrast grade papers. Of course, you must invest in a set of variable contrast filters if you use variable contrast paper. An alternative way to control contrast without such filters is by using a *dichroic color filter head* on the enlarger; its normal role is to control color balance when making color prints (see page 304).

Besides contrast grades, papers come in different emulsion *tones*. As such, the black shades of your print will be warm (brown-black), neutral (black), or cold (blue-black), depending on the paper tone you choose.

Also, you have a choice of *paper surfaces*. Textures vary, and include smooth, fine-grained, tweed, and silk. The finish may be glossy, luster, or matte. The *tint* of the paper stock may be white, cream, or even colored.

Papers also vary in *weight.* Most commonly used conventional papers are single-weight (SW) or double-weight (DW), although there are lightweight (LW) and medium-weight (MW) papers, too. With enlargements 11 × 14 inches and greater, double-weight paper is preferred for durability. All resin-coated papers are medium-weight, regardless of size.

Resin-coated (RC) photo paper is relatively new and quite revolutionary. It does not absorb liquid as conventional paper does, and thus fixing, washing, and drying times are reduced significantly. Besides saving water, this speeds up processing procedures and reduces boredom in the darkroom.

Most manufacturers have sample books of their various papers to show you the difference in brands, weights, surfaces, tints, and tones. These books list the contrast grades available, too, unless the paper is a variable contrast or multigrade type.

Photographic paper data provided by manufacturers also usually includes *paper speeds.* These indicate the paper's relative sensitivity to light; the higher the number, the more sensitive the paper's emulsion. While paper speeds do not directly relate to film speeds, the concept is similar. For instance, a paper with a speed of 500 is twice as fast as a paper of 250 speed, and thus the faster paper would require only half the exposure time. Paper speeds are provided by the American National Standards Institute (ANSI), the successor to American Standards Association (ASA), which originally set film speeds.

Choosing an Enlarger

In addition to photographic paper, the darkroom materials for making contact prints are the same as those used for making enlargements—developer, stop bath, and fixer chemicals; processing trays; print tongs; OC safelight; washing siphon or print washer; electric dryer or photographic blotters. But other equipment is needed, too.

The main item, and expense, is an *enlarger.* You should consider the various types carefully because enlargers rarely wear out and most often are a lifetime purchase.

Enlargers are built to accommodate different negative sizes. Some take only 35mm negatives, while others will handle sheet film up to 8 × 10 inches. As a guideline, you should buy an enlarger which is designed for the size of film you're shooting. A 35mm-size enlarger, for example, is best for 35mm negatives (or 126-size negatives). However, if you also shoot 2¼ × 2¼-inch film, or think you will in the future, it is a good idea to buy an enlarger that will handle that size of negative as well.

Lenses of enlargers must be considered. Better-quality enlargers come without lenses, enabling the photographer to choose his own. Unlike camera lenses,

the maximum lens opening of an enlarger lens is of little consideration, since most are f/4.5 or f/3.5, and a few are f/2.8. The widest opening is used only when focusing the negative's image; for making the exposure, the lens is always stopped down to a smaller opening. The smallest lens opening is usually f/16 or f/22.

Excellent quality lenses, such as Schneider Componon or El Nikkor, cost as much alone as some enlargers cost complete with lens. The size of enlargements you want helps determine the quality of lens to purchase; enlargements greater than 10 times the negative size (10X magnification) require a top-rated lens to get the best results possible. Enlargement of a 35mm negative to 8 × 10-inch size is about 8X magnification.

Regardless of the quality of the lens your purchase, you must get the correct focal length for the size of your negatives. It must be comparable to the focal legnth of the normal lens on your camera. That means 35mm negatives require a 50mm or 60mm enlarging lens, while 2¼ × 2¼-inch negatives need an enlarging lens with a focal length of 75mm or 80mm.

In addition to negative size and lenses, enlargers vary in their illumination systems, negative carriers, focusing, baseboard size, sturdiness, and provisions to make color as well as black-and-white enlargements.

The most common type of *illumination system* is termed *condensor-diffusion.* This type concentrates the light from a frosted enlarging bulb through twin condensor lenses. It produces the sharpest, most contrasty prints, although imperfections of the subject, or negative, show up in detail, too. True *condensor* enlargers do not use a diffused light source. *Diffusion* illumination systems scatter the light rays from the enlarger bulb through frosted or ground glass. The result is a less sharp and less contrasty image, which is popular with portrait photographers. Also, blemishes on the subject, or negative, are diffused and therefore less evident.

While most diffusion and condensor-diffusion enlargers use a frosted incandescent or tungsten-halogen bulb, some diffusion enlargers have a fluorescent light source. These are sometimes called *cold-light enlargers;* they do not work well with variable contrast or color printing papers because their light is bluish. Also remember that enlargers using incandescent bulbs require special enlarger lamps, not regular household bulbs, which may cause shadows and uneven illumination. Use only the bulb type and wattage designed for your specific enlarger.

Light from the bulb is projected through the negative and enlarging lens onto the photo paper. There are two types of *negative carriers* that hold negatives in position. Such carriers also act as masks to keep stray light from being projected onto the photo paper. One type is called *glassless* or *dustless,* while the other is a *glass negative carrier.* Glass types hold the negative flat and therefore maintain focus of the image, but they also attract dust and fingerprints, which show up in your print unless you keep the glass spotless. Glassless negative carriers eliminate dust and fingerprint problems, unless

the negatives themselves are dirty. However, with poorly designed enlargers using glassless carriers, heat from the enlarging bulb may warp your negative slightly and throw it out of focus, especially during long exposures. Both glass and glassless carriers are available for some brands of enlargers.

Focusing is another consideration. There are both manual and autofocusing enlargers. With manual focus, you adjust the enlarger head height to get the negative image to the size desired, and then you must sharpen the focus by adjusting the bellows. Autofocus models are designed to keep the negative image sharp whenever the position of the enlarger head is changed, although most autofocus types require fine-focus adjustments anyway.

Ease of enlarging-head movement, and locking, should be considered. Some require two hands to use—one to adjust the height and one to tighten the lock. Others use a one-hand crank with rack-and-pinion gears, and some models feature a one-hand clamp release with a balance weight or spring to afford easy adjustments. Also check the sturdiness of the support column; any vibration of the enlarger head during the exposure will cause a blurred image on the photo paper.

The enlarger's *baseboard* should be noted, too. It must hold the enlarger sturdy and be big enough to accommodate the largest size of prints you make most often. For extra-big enlargements, some baseboards can be turned around so the enlarger can be moved to the edge of the work table and the image projected onto the floor. Other models allow the enlarger head to be turned to a 90° angle so larger images can be projected on the wall.

Be sure your enlarger has a *filter drawer* for holding the filters required for variable contrast papers or for making color prints. Such a drawer is located in the enlarger head, below the light source and above the negative carrier. Without a filter drawer, filters can be used below the enlarging lens, but this often reduces print sharpness because the projected negative image passes through the filter, which may be dirty, scratched, or optically poor. Some of the newer enlargers are of modular design and can be equipped with a *dichroic color filter head,* which has built-in interference-type dichroic filters that are adjustable for various densities in order to control color balance in a color print or contrast in variable contrast black-and-white printing papers.

Besides an enlarger and the equipment already discussed, a few more items are helpful, if not essential, to the enlarging process. One is an *enlarger timer.* It connects to the enlarger's light cord and controls exposure time. Most will operate up to 60 seconds. Some must be reset manually for each exposure, while others return automatically to a preset exposure time. Many have luminescent dials. Some timers can be started by an accessory foot switch, leaving the photographer's hands free. A good timer is worth the investment.

An *enlarging magnifier* is also a worthwhile expenditure. It enables the photographer to focus the negative image quickly and easily. The magnifier is placed where the photo paper will be, and the enlarger is adjusted until the image is sharply focused.

Incline Box Beam Column

Position and Delta Exposure Scales

Ball Bearing Rollers

Optical Bench Pivot Shaft

Head Rotation Lock

Head Rotation Release

Caliper Brake Elevation Lock

Metal Elevation and Focus Knobs

Head Support Carriage

Adjustable Alignment/Tension Guides

Constant Force Counter Balance Springs

Interlocking Base Plate

Laminated Base Board 18" x 25"

Stainless Steel Elevation Cable

Light Baffle and Convection Cooling Vent

Adjustable Lamp Receptical

Condenser Housing Door

Adjustable Biconvex Condenser

4" x 4" Filter Drawer

Main Condenser Cluster

Negative Carrier Stage

Rotating Negative Carrier

Double Off-set Focusing Rack

Bellows

Tilting Lens Stage

Interchangeable Lens Board

Optical Bench

180. *Modern enlargers have trim features and a variety of structural and functional features.*

An *enlarging easel* should be purchased. It holds the photo paper flat so the focused negative remains sharp in the print. And an easel also provides white borders around the edge of prints. Some easels are adjustable for any print size desired, while others are fixed to make borders for common size

181. The color balance in color prints is controlled by filtering the enlarger light. With enlargers equipped with a dichroic color filter head, like this one, dials are adjusted for various amounts of magenta (M), yellow (Y), and cyan (C) filtration. They also can be adjusted to control contrast when printing black-and-white variable contrast photo papers.

prints—2½ × 3½, 3½ × 5, 4 × 5, 5 × 7, or 8 × 10 inches. An adjustable easel for prints up to 11 × 14 inches is suggested. The border width can be adjusted, as well as the other dimensions, to allow complete control in cropping negatives to the size print desired. Borderless easels also are available.

A *paper safe,* or homemade light-tight drawer, is a good time-saving darkroom accessory because you do not have to keep returning photo paper to its envelope or box when you want to turn on the room lights. Also be sure to have an antistatic brush or cloth for dusting negatives.

Making Enlargements

With the necessary equipment assembled, making black-and-white enlarge-ments is not difficult, although you become a better darkroom technician only with practice.

Arrange your equipment and materials in a convenient manner (see Illus-tration 185, page 312). Most photographers prefer having a "dry" and a "wet" area in their darkrooms so that the enlarger, negatives, and photo paper are less apt to be splashed by chemicals or wash water. The photographer must learn to keep his hands dry, too. Cloth towels should be washed after use to prevent contamination by chemicals which have dried on the towel.

To begin, select the negatives desired by studying the contact proof sheets. Check these prints with a magnifier for composition and subject content or expression. Note the negative numbers opposite the frames you've selected. Some photographers cut or punch a tiny notch in the film edge as an easy way to locate the frames to be enlarged. Do not cut the negatives into individ-ual frames.

Clean the negative, and the negative carrier if necessary. Because the en-larging lens will reverse the direction of the negative images, put the negative in the carrier upside down with its emulsion (dull) side facing down. Room lights must be turned off for focusing and kept off when any photo paper is removed from its light-tight envelope or box. Allow a few minutes for your eyes to adjust to the OC amber safelights.

Place the negative carrier in the enlarger and turn on the enlarging bulb for focusing. Open the lens to its widest f/stop so the image can be seen as brightly as possible. Turning out any safelights near the enlarger will make focusing easier. Adjust the height of the enlarger head to the image size desired, and turn the focus control until the image is sharp. Use a magnifier for quick and easy focusing.

Make sure the enlarging easel is positioned correctly for the print size and borders desired. Stop down the enlarging lens to f/8. This increases depth of field and corrects minor enlarger focusing errors. Of course, if the image on the negative itself is out of focus, reducing the enlarging lens f/stop will not make the picture any sharper.

Turn off the enlarger and insert a piece of photo paper in the easel, emul-sion (shiny) side up. Make sure the other paper is in its light-tight package or paper safe so light from the enlarger doesn't accidentally expose it. To avoid guessing at exposure and wasting several pieces of paper until you hit the correct exposure time, a *test print* is made first. This involves exposing vari-ous parts of the paper for different lengths of time.

With an 8 × 10-inch sheet, start by exposing a 1-inch-wide strip for 5 or 10 seconds; keep the rest of the paper covered with a piece of cardboard. Slide

182. An enlarger makes it possible to produce an image that is much bigger than the image on the negative.

the cardboard away another inch and make another 5- or 10-second exposure. Continue this procedure until the entire piece of paper has been uncovered and exposed. Remember the exposure times you gave each strip.

Now slip the test print into the developer and agitate it with the print tongs. Develop for the full time recommended by the paper manufacturer, or until dark areas are very black. Use tongs to transfer the print to the stop bath for 15 seconds, then move it to the fixer. After 1 minute in the fixer, turn on the room lights and check the print. (Make sure your photo paper is in its package or paper safe before switching on the lights.) Choose the strip you like best and use its exposure time for your final print.

Set the enlarger timer for the correct exposure time, leaving the f/stop the same as for the test print. Turn out the room lights, put a piece of photo paper in the easel, emulsion side up, make the exposure, and process the print in the usual manner. Fix it for the time recommended by the fixer manufacturer, usually 5 to 10 minutes, or ½ to 2 minutes for resin-coated (RC) papers. Remember to agitate. If a hypo clearing agent is used next, wash time for conventional papers can be reduced from 1 hour to 10 minutes for single-weight papers, and from 2 hours to 20 minutes for double-weight papers. Wash RC papers only 2 to 4 minutes and do not use hypo clearing agent. Use an electric dryer or photographic blotters for drying. Conventional photo papers made with a glossy surface must be squeegeed while wet to a piece of chrome-plated metal (called a ferrotype tin) to obtain a high gloss. When not dried facedown on such metal, these prints will have a semigloss finish. Glossy-type RC papers are self-glossing. All RC papers air dry in a short time; a hand-held hair dryer will do the job in a matter of minutes.

A close check of the original test print will reveal whether the contrast grade

183. Often a picture can be improved if only a portion of the negative is enlarged.

or filter you used was correct for the contrast of your negative. For most negatives of good contrast, a No. 2 or No. 3 grade or filter is best. But if the test print seems gray all over and lacks contrast, try a higher contrast paper or high-numbered filter. If the test print is too contrasty and has no detail in the dark and light areas, switch to a low contrast grade or filter, such as a No. 1.

With experience, a photographer learns the approximate exposure combinations which work best with the negatives he most often shoots and enlarges. Then, instead of exposing a full piece of paper to make a test, he cuts a strip and exposes it according to his experienced estimate. This saves time and paper. Also, he tries to keep his f/stop constant for most of his enlargements, usually f/8 or f/11, so he only has to figure exposure time.

You should remember that the same rules regarding f/stops of camera lenses apply to enlarging lenses. For instance, if an exposure of f/8 at 10 seconds yields a good print, reducing the lens opening to f/11 cuts the amount of light in half. So to get a print of equal quality, exposure time must be doubled to 20 seconds. However, remember that because of reciprocity effect, exposure increases that are 20 seconds' duration will require even more than twice the original exposure time. Charts are available to help you figure the increases in exposure correctly.

Changes in the magnification of the negative image also will alter exposure time. For a larger image, the enlarger head must be raised, and the greater the distance the light source is from the paper, the longer the exposure required.

As a practical guideline, every time you double the distance between the lens and photo paper, increase exposure 4 times. For example: The enlarging lens is 8 inches from the paper and produces a good print at f/8 with 10 seconds exposure. If the enlarger head is raised so the lens is now 16 inches from the paper (twice the original distance), exposure time will be about 40 seconds (at f/8) to get a good print. If you raised the lens 1½ times the original distance from the paper, increase exposure 2 times. Thus, using the example above, increasing the lens-to-paper distance from 8 to 12 inches will increase exposure time from 10 to 20 seconds. Charts are available to help you figure exposure time according to changes in magnification.

Another way to determine exposure time is with the use of an *enlarging exposure meter.* Called *print meters* or *photometers,* they eliminate the need for test prints or strips and thus speed up the enlarging process. Such print meters usually measure the intensity of the highlight and/or shadow areas of the projected negative. Spot or integrated (overall) readings can be made. Besides exposure time, print meters also indicate the contrast grade or filter to use.

Not all enlargements, of course, reproduce as the photographer wishes. The sky may be too light, or a face in a group picture may be too dark. The creative photographer knows that *exposure manipulation* is required to correct these faults. He uses two techniques to make his prints the best possible. One is called *burning-in,* which is done to darken an area of a print. The

184. By manipulating exposure while enlarging, the photographer is able to produce a print that has the balance he desires. Areas can be darkened and lightened by using one of two techniques: burning-in or dodging (see text).

other is *dodging,* which is done to lighten an area of a print. The skill he develops in using these two methods of exposure manipulation in many ways determines the worth of the photographer as a darkroom technician.

Burning-in involves the addition of light to an area of the print that would otherwise be underexposed. After the regular exposure is made, additional exposure time is given to a selected area. Usually a hole is cut in a piece of cardboard, and the cardboard is held between the lens and photo paper. This holds back the negative image except where it passes through the hole. To keep a circle from showing in the print, the cardboard must be kept moving slightly all during the exposure so the burned-in area blends with the rest of the print. Often the photographer uses his hands to form the size and shape of the hole desired, or he can purchase an adjustable burning-in mask. Making an exposure test strip of the area to be burned-in will help determine the extra exposure time required.

Dodging is just the opposite of burning-in. During the regular exposure, part of the negative image is held back by a dodger (most often a homemade disk of cardboard taped to the end of a thin but sturdy wire). By holding the dodger between the enlarging lens and photo paper, the selected area is kept from receiving too much exposure and becoming too dark. As with the burning-

185. *This floor plan shows a convenient darkroom that is designed to prevent contamination. One side is devoted to "dry" activities, like loading film into a developing tank and exposing photo paper with the enlarger, while the opposite side is for "wet" procedures, such as mixing chemicals and processing films and prints.*

in device, the dodger must be kept moving slightly during the exposure in order to avoid an outline of the disk or wire in the print. A test strip made of the area to be dodged will help determine the exact exposure time required. Incidentally, one of the reasons to stop down the enlarging lens to f/8 or f/11—besides helping to keep the negative in focus—is to allow sufficient exposure time for dodging and burning-in.

Once the photographer has mastered basic processing and enlarging techniques, there are many other ways he can use his darkroom to produce photographs with far-ranging effects. He can bathe finished prints in *toners* to give color and mood to his photographs. He can make prints with *multiple images* by sandwiching negatives together in the enlarger's negative carrier or by exposing different negatives on the same piece of photo paper. A *diffusion filter* will soften his print image. *Texture screens* will add patterns to his prints; even ladies' nylon hose stretched across the enlarging easel can be used to add texture to a photograph. *Solarization* of prints, reexposing them

briefly with a white light during the development stage, will produce eye-catching results. Pictures can even be made without negatives. You create such *photograms* by placing objects on photo paper and exposing the paper to light. Certainly a photographer with imagination can be creative not only with a camera but with darkroom techniques as well.

Initial steps in your own processing and printing involve understanding the procedures, purchasing the necessary equipment, and setting up a darkroom. While a permanent darkroom is more convenient, photographers with limited space find that temporary darkrooms in a kitchen or bathroom work as well. The room must be without light leaks, of course, and it is desirable to have running water available, as well as adequate ventilation. Establish separate wet and dry areas when possible so chemicals and water do not splash on your equipment or materials. A floor plan for a convenient darkroom is shown on the facing page. Whether your darkroom is elaborate or not, you'll find processing and enlarging your own pictures the best way to get the quality of black-and-white photographs you desire.

15

Showing Off Photographs

When your finished pictures are in hand, there are a number of things that can be done with them.

Editing

First, some should be filed in the wastebasket. There's no reason to bore your viewers with pictures that might have been good but are not. If the exposure is bad, focus is fuzzy, or the quality of subject and composition are poor, then throw the photograph away. Before doing so, study it by yourself to avoid such mistakes again. Don't lose friends by showing them every picture you take. Careful editing will enhance your reputation as a photographer. Share only your best pictures.

Making Display Prints

Snapshot prints are good for determining if there are some pictures that would be excellent to enlarge for display. Standard print size for 35mm color negatives or slides is 3½ × 5 inches, although slightly larger sizes can be ordered, such as Kodak's borderless Magnaprints, which measure 4 × 6 inches. A less expensive alternative is to make *contact prints,* pictures the size of the negatives, to see if some are worthy of being enlarged. Contact sheets (one 8 × 10-inch size will include a full 36-exposure roll of 35mm film) can be made from either color or black-and-white negatives.

Display prints also can be made from color slides. Viewing them through a magnifier will help in preliminary editing, but projecting the slide is a better

way to choose. Best is to project the image the size of the intended print. A piece of clean white poster board will do for an editing screen.

The photographer must decide the size of his enlargements and the finish of the print surface. Common enlargement dimensions for 35mm films are 5 × 7, 8 × 10, 8 × 12, 11 × 14, 16 × 20, and 20 × 24 inches, but they can even be made into poster-size prints, 20 × 30 inches. Small enlargements often are mounted on a larger board and then framed to increase the overall display size and the attractiveness of the photograph. Prints most commonly are made with a textured, glossy or matte (dull) finish.

There is a wide variety of paper surfaces from which to choose, especially for black-and-white enlargements. Textured surfaces like tweed or silk are examples. Check to see what paper surfaces and finishes your processor offers. Camera stores have enlarging paper samples if you intend to do the darkroom work yourself.

While some prints include a white border, many commercial processors also make borderless prints that increase your overall picture size. If you intend mounting your prints on a larger-size poster board, white borders can be trimmed off with a paper cutter. Scissors will not give a straight edge.

Cropping is possible and often preferred to printing the full negative area. Indicate how much you want left out by placing crop marks on a sample print or contact sheet. The cropped dimensions should fit the standard paper sizes. For instance, to fill an 8 × 10-inch print size, a 35mm negative must be cropped on its shortest side. If the entire area of a 35mm negative is printed on 8 × 10-inch paper, a 7 × 10-inch image will be the result; standard print size for a full-frame enlargement is 8 × 12 inches.

Slides can be marked for cropping on their cardboard mounts. Some photofinishers provide *cropping masks* which can be placed over the slide or negative to indicate the negative area desired. These masks are numbered and the selected mask number is included in the order to the processor. Negatives with good contrast (areas both dark and light) should be selected. Color slides print better when the colors are not too contrasty.

Mounting Prints

Unless you order prints to be mounted by your photofinisher, mounting finished enlargements for display is the next step. If not mounted to a strong backing, prints may curl or wrinkle. *Poster board,* available from artist supply shops, is ideal when the prints also will be framed. Use a double-thick poster board otherwise, or mount them on masonite board, which is for sale at lumber yards.

186. *Photographers who are proud of their work can display their photographs in many ways. One idea is to turn a wall at home into a picture gallery.*

Prints can best be mounted with *dry mounting tissue* or a special glue. Dry mounting tissue, sold at camera stores, is of two types: self-sticking and heat-sealing. The self-sticking type is easier to use and is preferred for color prints because excessive heat can change dye colors and damage the emulsion of the prints. After the tissue's protective coating is peeled away, and the tissue is trimmed and positioned between the print and mount board, apply pressure with your hands or a rolling pin to make a smooth, uniform bond. The more traditional dry mounting tissue resembles waxed paper and is sensitive to heat. Normally, it is used in a professional dry mounting press, but an ordinary iron can be substituted. The tissue is tacked to the back of the print with the tip of the hot iron. Corners of the print should be left free. Read the instructions packed with the tissue for correct heat settings. The overlapping edge of the tissue should then be trimmed, along with any undesirable por-

tion or border of the print itself. Use a paper cutter or trimming knife and straight-edge ruler for an even trim.

Place the print and tissue back side down and tack the tissue corners to the board. Then cover with a clean piece of paper and put in the mounting press to make a permanent bond. No mistakes in positioning are permitted because the print cannot be realigned after being put in the mounting press. If using an iron, care must be taken not to make an impression of the soleplate on the print. Heat and sealing pressure must be carefully watched. Too high a temperature can scorch a print or alter its colors. The cover paper should always be preheated to eliminate any moisture which might cause it to stick to the print.

An alternative method of mounting is with a *photo mounting glue.* The easiest to use are spray glues in aerosol cans. After the print is trimmed, its back is uniformly sprayed with the adhesive. When the glue becomes tacky, the print is positioned on the mount board and pressure is applied to make an even and permanent bond. Ordinary rubber cement and some other paper-penetrating glues are not recommended for mounting, especially with color prints.

Mounted prints can be framed for more impressive display. Ordinary or *nonglare glass* gives the photograph extra protection. Color prints should not be in direct contact with the glass. Use a *mat board* around the print to provide adequate separation. Such boards, with precut openings, can be purchased at many art stores. Otherwise, and for greater versatility in mounting your prints, buy a *mat cutter* for about $10 and cut your own mats. This way an attractive bevel-edge cut is also possible.

Choice of mat board is a concern. Standard are white, ivory, and cream. Other colors can help give your photograph greater appeal, especially if it is a color print. Make sure it is a pleasing color; the photograph's effectiveness can be ruined by a very bright or otherwise offending mat board color. Of course professional framers can mount, mat, and frame your pictures, but often it is more fun and creative—and far less expensive—to do it yourself.

There are many other ways to show off your photographs. Place them under a glass desk or coffee table top. Construct a room divider to feature them. Photographic mobiles are interesting to make and provide an ever-changing display, too. And a durable and well-planned photo album is also a good way to share your pictures.

Projecting Slides

Photographers who prefer slides can give impact to their pictures by projecting them. Careful sorting, editing, arranging, and timing are required. Bor-

ing home travelogues are notorious for making more enemies than friends. Common faults include flashing too many pictures at too long a sitting. Forty-five minutes to an hour of slides is long enough.

Prolonged commentary while holding one slide on the screen is equally disturbing. Keep the slides moving and your remarks brief. Lack of editing is another complaint often heard. Don't show your photographic failures. Pick only the best of your slides to share. Dust them before the show with a camel's hair brush or compressed air from an aerosol can. Clean very dirty slides with *film cleaner,* nothing else. Camera shops have this special cleaner.

Your slide presentation, no matter how informal, is also judged on how smoothly it runs and how well the pictures can be seen. A good projector and screen are necessary and their purchase should be carefully considered. In many respects, the types you buy are often determined by whether you'll use them only for yourself or intend to project your slides for a group of friends or even larger audiences.

There are basically three sizes of projectors to handle the different sizes of slide film. Most common are projectors accommodating 2 × 2-inch slide mounts, which hold 35mm and 126-size Instamatic-type transparencies. The smaller 110-size pocket camera slides usually are returned from the processor in 30mm-square mounts, and these work best with a smaller projector.

187. *A quiet and dependable projector, like one of Kodak's Carousel models, makes it easy to present home slide shows. The circular trays hold up to 140 slides. Some slide projectors feature autofocus and remote controls, as well as a small preview screen.*

However, slides from 110 film can also be placed in special 2 × 2-inch adapters or remounted in 2 × 2-inch mounts for use in the more common 35mm slide projectors. A larger projector is needed to show the 2¼ × 2¼-inch transparencies of 120-size film. (Slide film for disc cameras is not available.)

Regardless of the projector required for the size of your film, it should produce sharp and bright images, and there should be little chance of damage to your slides. The most popular 35mm slide projector for personal and professional use has proven to be Kodak's Carousel. Of great importance is its gravity-feed design, which does not require force to put a slide into position for viewing. With models which push or pull the slides in and out of projection position, slides can be damaged.

Besides its safe slide-feeding feature, bright images result with recent model Carousel projectors using a *tungsten-halogen lamp* of only 300 watts. This high level of brightness is maintained throughout the 70-hour rated life of this bulb, which is called an FHS projection lamp.

The older-type incandescent projector bulb (DEK) for earlier Carousels requires 500 watts to produce an image equally as bright. A DEK bulb also dims with use, losing about 70 per cent of its brightness during a rated life of 25 hours. In addition, such incandescent projection lamps get very hot and require a fast-running fan to keep them cool. Tungsten-halogen bulbs, on the other hand, produce less heat, so the cooling fan can run at a much slower speed. The result is a quiet projector that doesn't compete with your narration or your audience's conversation.

Along with reduced fan noise, Kodak's Carousels have a quiet slide-changing mechanism. Some projectors clang and bang so much during slide changes that it takes the enjoyment out of showing your photographs.

In addition to the requirements of quiet, jam-free operation and bulb brightness, a major consideration in selecting a projector is the type and capacity of the *magazine* that holds the slides for viewing. The earliest slide projectors were fed single slides manually. Improvement came with the introduction of rectangular trays, holding about 40 slides, that were inserted in the machine. Then Kodak originated a circular tray of greater capacity, 80 slides, that is placed on top of the projector. Later a 140-capacity circular tray was introduced by Kodak. The circular tray has since been adopted by most other manufacturers of 35mm slide projectors. Another slide-loading design, developed by Bell & Howell, features a cube which holds 40 slides.

Of course, slide-holding devices of large capacity are desired by photographers wanting to show an uninterrupted series of slides. For this reason Kodak's 80-slide circular tray for its Carousel projectors has proven most popular. Although another Carousel tray holds 140 slides, it accepts only cardboard-mounted slides of 1/16-inch thickness, and any slides that are slightly bent or have damaged corners will stick in the tray slot and not drop into the projector for viewing. Trays used with Kodak's small Carousel projectors designed for 110-size pocket camera films hold 120 slides.

Most trays require loading the slides in individual slots, and this can be time-consuming if you only intend to preview the slides or put them in order. Kodak's *stack loader* acts as a temporary tray and accommodates up to 40 loose slides for previewing. Kodak also makes a *slide clip* device that holds loose slides together for easier placing in the stack loader and can be used for subsequent storage. Bell & Howell's *slide cubes* are also loaded with loose slides and do not require individual placement in tray slots.

Projection lenses are yet another consideration. Focal length and aperture can vary. While a f/3.5 is standard for many 35mm projectors, Kodak's Carousels are supplied with a f/2.8 lens, which produces a slightly brighter image than the f/3.5 lens.

Focal lengths can be selected according to your needs—the smaller the focal length, the closer your projector can be to the screen to produce a large image. Focal lengths of projector lenses sometimes are given in inches rather than the millimeters that are used to designate most camera focal lengths.

For use at home in living rooms, 102mm (4-inch) or 127mm (5-inch) lenses are fairly standard. Another projection lens is a zoom type that will vary the focal length from 102 to 152mm (4 to 6 inches). With zoom lenses, the projected slide image size can be increased or reduced without changing the position of the projector. In order to keep projected images in uniformly sharp focus, the most recent Kodak Carousel lenses designated Ektanar C have a "curved field" design that takes into account the slight bow of 35mm slides in cardboard or plastic mounts.

Unless you have a zoom lens and therefore can conveniently adjust the slide's image size, the projector must be positioned manually until the image fills the screen. To avoid the usual guesswork of projector placement, once you've established the distance your projector must be from the screen, cut a length of string or cord that equals that distance. Then whenever you're going to show slides, set up the screen, stretch the measured cord, and place your projector at the cord's end.

Watch for distortion that occurs when the projector is positioned at a low angle to keep it from blocking the audience's view of the screen. If the projector is at a much lower level than the screen's center and is tilted severely upward, the projected image will be small at the bottom of the screen and wide at the top. This distortion is called *keystoning*.

Projection controls should be considered when purchasing a projector. Lenses, for instance, can be focused manually, automatically, and remotely. When working properly, *autofocus lenses* are a nice feature. Once you focus the first slide, such lenses keep subsequent slides in focus, *as long as the slides are in the same type of mount.* That's important to remember. Slides in mounts which vary—cardboard, plastic, glass—must be manually or remotely refocused; autofocus lenses will not readjust for different types of mounts.

The value of autofocus lenses is that they readjust when a slide "pops" or

buckles slightly from the heat of the projector bulb. Such buckling throws the image out of focus, which is annoying to the audience and the photographer. Slide popping can be minimized in a number of ways. Projectors which use the lower-wattage tungsten-halogen bulbs help avoid the slide popping because there is less heat from the projection lamp. In addition, some projectors reduce chances of popping by prewarming the slides before they advance into the viewing position. Also, mounts which hold the transparency securely will help prevent the slide from buckling during projection.

To eliminate popping altogether, as well as for protection, some photographers prefer to place their slides in *glass mounts*. This keeps the film flat, and thus the projected image remains in focus. However, heat from the projection bulb can also affect glass-mounted slides that are projected for too long a time or too often. The transparency eventually becomes slightly warped between the glass and causes a changing effect or rainbowlike circles or designs to appear on the screen. These are called *Newton's Rings,* and they will distract your audience. To avoid this, use what glass-mount manufacturers call anti–Newton's Rings glass.

Here's something else to consider. Inside a projector, besides the *condensor lenses,* which help focus and produce a bright slide image, there is a piece of *heat-absorbing glass.* If this cracks or shatters from age or rough handling of the projector, damage to your slides will result. When this happens, first you'll notice a much brighter image than usual, and then you'll smell smoke and see your slide image burn up on the screen. Unplug the projector and replace this heat-absorbing glass before trying to use the projector again.

In projectors using incandescent lamps instead of tungsten-halogen bulbs, another problem can occur when the bulb gets old and begins to bubble from the heat. If the bulge of the bulb touches a condensor lens, both bulb and lens may shatter. To avoid trouble, check the bulb occasionally to see if a heat bubble is developing.

By the way, it was long thought that running the projector's fan to cool the bulb after use would extend bulb life. But lamp manufacturers now suggest that such rapid cooling stresses the bulb more than if it cools off naturally. However, moving a projector while it is still hot can be damaging to the bulb, too. So if the projector is to be subjected to much handling immediately after use, the bulb should be cooled by using the fan.

In addition to regular and remote focus controls that allow the photographer to focus the image while he is at the projector or some distance from it, remote forward or reverse slide-changing controls are available with some projectors. These allow much more flexibility in presenting slide programs.

Other projector control features can include an *automatic timer* which changes slides at preset or variable intervals (the Carousel's range is 3 to 22 seconds), and connections for accessory programming units that change slides according to prerecorded signals on tape. *Dissolve unit* controls also are avail-

188. *Even for a slide travelogue shown at home, a large square screen should be used so vertical as well as horizontal shots can be projected and seen easily. Be sure the projector lens is clean and sharply focused.*

able. When two projectors are connected to a dissolve unit, the image from one projector automatically fades out while an image from the other projector fades in. The effect is very professional, and the usual and sometimes annoying black-out periods between slide changes with a single projector are eliminated.

One final consideration is ease of removal and repositioning of a slide prior to projection or when it is being projected. For instance, sometimes a slide inadvertently is put in the slide tray upside down. You should be able to retrieve it easily and reverse it. To avoid making such mistakes during a show, some Carousel projectors feature a built-in preview screen which you can use to view and edit slides without setting up a separate projection screen. To use this Slide-Scan feature, the projector's regular lens is removed and a small screen with a 45°-angle mirror is pulled out and flipped up in front of the light beam for rear-screen projection.

Whether or not you preview your pictures by projecting them, it is a good idea to mark the slides for proper projection position. To be seen right-side up, slides must be put in the projection gate upside down and with the emulsion (dull-side) facing the screen. After arranging them in this position, mark the upper right-hand corner and top of the slide mount with a felt-tipped pen. Then whenever you pick up a slide, you'll know without even looking at the image how to position it for correct projection.

Once you've purchased a projector to suit your needs, it's time to consider *projection screens* for sharing your pictures with family and friends. Bedsheets or living-room walls are not the best surfaces to show your slides on. Of the three common types of screens—lenticular, beaded, and matte—lenticular is the best and the most popular for home viewing. It costs more than the others, but the uniformly bright results are worth it. Such screens come in a roll with an attached stand and must be stretched taut for best viewing results. This screen usually has a slightly gray and ribbed plastic surface.

A lenticular screen produces an image twice as bright as a matte screen but about half as bright as a beaded screen. However, the image is seen with the same brightness by all viewers who are sitting anywhere up to 35° on either side of the projection beam. A beaded screen produces an evenly bright image only to about 25° on either side of the projection beam. That means viewers sitting at a greater angle will see a dimmer picture. The widest angle of view of a uniformly bright image is 45° on either side of the projection beam, and this is provided by a matte screen. However, with a matte screen, slight distortion of the image can be a problem for viewers more than 30° from the projection beam.

The best matte screen is of washable white plastic, but a wall painted flat white will serve instead. Remember, however, a matte surface reflects the least amount of light, so a very dark room is required to produce the brightest possible picture image.

Since it is flat, a matte screen will produce the sharpest possible image.

Less sharp are beaded screens, because they are covered with small glass beads which diffuse the image somewhat. In between are lenticular screens, which reflect a sharper projected image than beaded screens but slightly less sharp than matte types. By the way, if glass beads are accidentally scraped from the surface of a beaded screen, the damaged area will show up dark in the projected slides.

Besides surface reflecting qualities regarding sharpness and brightness, screen size must be considered. A large screen, such as 6 feet square, is the best investment if you ever want to show your slides to a large audience. For normal home viewing, a 4-foot square screen is adequate. Square screens are more practical than those of horizontal movie format since you'll want to project both vertical and horizontal 35mm slides equally as large. Also, 126-size film yields square slides, as does 2¼-inch 120-size roll film.

Make sure the room in which you show your slides is dark; stray light falling on the screen will reduce the brightness of your image and the impact of your pictures. Image brightness and sharpness also are reduced by dirty projector lenses. Be certain not only the front projection lens is free of dust and fingerprints, but that the inside condensor lenses and heat-absorbing glass are cleaned frequently, too.

The table or stand for your projector should be sturdy so the projected image does not shake on the screen. Power and remote-control cords should be placed so audience members do not trip and cause injury to themselves or your projection equipment.

To avoid shocking your viewers with a bright white screen when you turn on the projector lamp, make sure your first slide is in viewing position, or use a *black slide.* Cut a thin but opaque piece of cardboard the size of a slide mount. Put it in the first slide position of the tray or cube and advance it into the projection gate before turning on the lamp. This black slide will block the bulb's light until you are ready to advance to the first slide. Similarly, to avoid blinding your viewers at the end of a slide presentation, turn the lamp off while the last slide is still in projection position, or use another black slide after your final slide. Some projectors have a built-in black slide feature.

When planning a slide program, have some organization to your slides and vary the subject matter to maintain audience interest. Don't show poorly composed or out-of-focus slides. And consider slide density. Avoid slides which have been underexposed and are too dark. However, if your projector has a high/low lamp switch, in high position there may be enough light to allow a fairly dark slide to be used. With overexposed slides, the lamp should be switched to the low position.

To salvage overexposed slides, which project very bright even with the lamp in the low-power position, try remounting them with a neutral density (ND) filter. Gelatin filters of various densities are available in 3-inch squares at camera shops. They can be cut to size and sandwiched with the overexposed slide. The brightness will vary according to the density of the filter used. For exam-

ple, a Kodak ND filter No. 96 of .30 density cuts the light by 50 percent, while one of .60 density reduces brightness by 25 percent. When such filters are not available, brightness can be reduced somewhat by sandwiching the over-exposed slide with a clear piece of regular photographic film.

Aside from the technical considerations of using quality slides and equipment, a successful slide presentation has other important aspects. For instance, always be considerate of your audience. Before inviting them to sit down for a show, projector and screen should be in place, and the first slide should be prefocused. Make sure the room is dark, and that everyone has a good view of the screen. Ask the audience not to smoke during your presentation so the slide images will not be diffused by the smoke. Always have a spare projection lamp on hand, because the bulb always seems to burn out unexpectedly in the middle of a program. Also be sure you know how to easily retrieve a slide that might accidentally become jammed in the projector.

189. *After vacation slides are carefully edited, arrange the best ones in a brief show for neighbors and friends.*

As mentioned earlier, give a brief, well-organized program of only your best slides. This will keep your audience from yawning. It will also make them think you are an outstanding photographer, and when they say they want to see more of your slides, they will really mean it.

Careful editing and arranging is especially important. Plan your program so it tells a story. And use variety—alternate overall views with close-ups, and vertical pictures with horizontal shots. Mix scenes with pictures of people. Use night shots as well as daytime exposures. Besides pictures made out of doors, include interior shots. Arrange the slides so your story has a beginning, middle, and an end. Humorous pictures or comments will help keep the attention of your audience, too. Above all, don't introduce your slides with the obvious remark, "This is a picture of. . . ." Organize your commentary as well as you organize your photographs.

Try to avoid using the typical and trite shots, such as your family standing on the rim of the Grand Canyon or in front of the Eiffel Tower. Instead, with

190. *By including a few humorous photographs, like this one, even the story of an unsuccessful fishing trip can be enjoyable to watch.*

famous landmarks, include pictures taken from angles that are different from the photos everyone has seen on calendars, in books, or at other slide shows. This is easier if you remember when you're shooting not to duplicate well-known photographs; create your own angle and approach. By all means, keep from showing pictures that were very difficult or dangerous to take but are not especially interesting. If a slide doesn't contribute to your story, don't include it.

A *slide sorter* or light-box will make it easier to put your pictures in the best sequence. This is a large illuminated viewer that enables you to see and arrange a considerable number of slides all at once. When finally edited and in order, the slides should be projected to check their sequence and impact as large images.

A good idea is to have another person preview your slide presentation and offer critical remarks. Because photographers are so personally involved with their slides, they may often forget about the audience. Before presenting your slide show to a group, the opinions of another person or two should let you know if your pictures tell your story with order, interest, and originality. Remember, any presentation should prove to your audience that you are a creative photographer, and it should make them want to see even more of your slides.

16

Finding Yourself in Photography

Unlike many pastimes or professions, photography is something with which almost every person is familiar. Most people are only casual shooters who get out their pocket or instant cameras for birthdays and holidays. Or they may be hobby types who specialize in one kind of photography like underwater or close-up. Other photographers are serious amateurs who have good camera equipment and know how to use it to make excellent photographs. And for quite a few people, photography is an occupation.

Photography is a phenomenon of many categories for people of many interests. But whether the result is only an album snapshot or a framed museum photograph, your goal should always be to make the best picture possible. How can you improve your photography? There are many ways. Doing what you are doing just now, reading a photography book, is a good way to start learning and keep learning.

Check the library or bookstore reference guides for a list of photographic subjects and book titles, plus their authors and publishers. To start a library of your own, you might subscribe to the excellent 17-volume *Life Library of Photography,* first published in 1970–72 by Time-Life Books and since updated. Both historical and current information is included, plus unique illustrations from the earliest days of photography to the current decade.

Photographic magazines can help keep you up-to-date. However, the amount of advertising and variety of photo products touted in some of these publications may make you think your equipment is old or insufficient. Don't be intimidated. The ads can give you an indication of some accessory that could be important to your type of photography, but avoid the temptation to purchase a load of relatively useless gadgets. Your photographic pursuit should be picture-oriented, not one of owning the latest equipment or as many accessories as you can afford.

The articles in photography magazines usually are quite informative and varied, especially those in *American Photographer,* which began publication

in 1978. Others are Petersen's *PhotoGraphic Magazine, Modern Photography, Popular Photography,* and *Darkroom Photography,* plus seasonal and annual photography magazines. An increasing number of general-interest magazines also carry regular columns or features on photography, including the "Travel in Focus" column my wife and I write for *Travel-Holiday.*

A variety of excellent reference publications are produced by the Eastman Kodak Company. The material in them is constantly updated, and their yearly "Index to Kodak Information" lists hundreds of pamphlets and books. Order this free catalogue by writing Eastman Kodak Company, Dept. 412-L, Rochester, New York 14650. Ask for pamphlet No. L-5.

Another way to improve your photography and knowledge is to go to school. Special commercial photography schools, such as Brooks Institute in Santa Barbara, California, offer resident courses. In New York City, the respected International Center of Photography (ICP) is a nonprofit institution offering daily lectures, workshops, seminars, and courses in many aspects of photography. Many art institutes and general curriculum colleges and universities have degree-granting programs in photography. Or there are home-study correspondence courses.

But perhaps the most convenient schooling for amateur photographers is through high-school, college, or university extension and adult evening classes. Teachers of regular photography and specialists in certain photographic fields offer the instruction. These classes often include outside assignments which provide additional experience. Such courses can be very stimulating. They also provide a good opportunity to meet fellow photographers in your community.

Special workshops and tours organized by professional photographers, schools, and camera companies also can boost your interest in photography and help improve your results. Camera clubs or informal get-togethers of photographers in your neighborhood help do the same. Visit photo galleries and look at photographic exhibits in art galleries and museums.

Many photographers enjoy entering photo contests. These offer recognition of your photography, and perhaps enough prize money to pay for more film or some needed equipment. Such contests are especially valuable if the judges indicate why they liked or disliked your pictures.

Other amateur photographers get recognition and financial rewards by selling their work. Publications are always in the market for appropriate photographs, black-and-white and color. The major national magazines, which pay the best rates for pictures, may be difficult to please. They often have staff photographers or freelancers they use on a regular basis. But there are many regional or company magazines and area newspapers that are glad to have black-and-white photographs or color transparencies submitted for publication. Payment can range from $5 to $50 and up, a *credit line* in the publication giving your name, or both. Pictures bought for advertising use require *model releases* signed by all recognizable persons. Such releases give the

photographer and/or publisher permission to use the photograph and help prevent subsequent lawsuits by persons in the picture. Sometimes a token payment of $1 is made to the "model." You can buy standard model releases from many camera stores.

Even nonprofessional photographers can improve their skill and make expense money by taking photographs of other people. Unless you have achieved a state of confidence and proficiency, make sure those who ask you to take their pictures do not expect a more professional result than you can deliver. And if money is involved, make sure they know how much you will charge and that you expect payment upon delivery of the photographs. It seems people always are anxious to see the finished work, but once the photographs are in their hands they show no urgency to pay you. Let them know you expect to be paid immediately.

Many times recognition and payment act as stimulants toward making you a photographer. Well-known photographer Philippe Halsman, whose portraits were featured on over 100 *Life* magazine covers, puts it this way: "I drifted into photography like one drifts into prostitution. First I did it to please myself, then I did it to please my friends, and eventually I did it for money."

Regardless of your specific interests or goals, the more you photograph, the more your photographs will improve. Start making photographs, then keep making better photographs. And most of all, enjoy your photography.

Appendix A

A Glossary of
Photographic Terms

ANSI *A system of numbers determined by the American National Standards Institute to indicate the relative speed of printing and enlarging papers. See also Paper Speed.*

ASA *A system of numbers determined by the defunct American Standards Association to indicate the relative speed of films. See also Film Speed and ISO.*

Accent Light *A small light often used in portrait photography to outline or add highlights to the hair of a subject.*

Adjustable Camera *A camera where the shutter speed, lens opening, and focus can be adjusted by the photographer.*

Adjustable Focus Lens *A lens that can be focused at different distances.*

Agitation *The movement of chemicals over photographic film and paper to ensure uniform processing.*

Ambient Light *See Available Light.*

Angle of Acceptance *The area included in a light reading by an exposure meter; measured in degrees (°).*

Angle of Illumination *The area covered by an electronic flash unit; measured in degrees (°).*

Angle of View *The area included by a lens, measured in degrees (°); also called Field of View.*

Aperture *The lens opening, the size of which is usually indicated by f/stop numbers; also called Diaphragm.*

Aperture-Priority Automatic Camera *A camera with automatic exposure control; the photographer sets the desired f/stop (i.e., lens aperture) and the camera's metering system sets the shutter speed for a correct exposure. See also Shutter-Priority Automatic Camera.*

Artificial Lighting *Light from sources other than the sun, such as flash and incandescent bulbs.*

Auto-Exposure Camera *Generally, any camera that sets exposures automatically. See also Aperture-Priority Automatic Camera, Programmed Mode, Shutter-Priority Automatic Camera.*

Autoflash *A separate electronic flash or built-in electronic flash feature that automatically determines flash exposure. See also Automatic Electronic Flash and Through-the-Lens Flash.*

Autofocus Lens *Any built-in camera lens or supplementary camera lens that*

focuses automatically. Available with most 35mm compact cameras and some instant cameras, as well as with a few 35mm SLR models.

Autofocusing Camera *A camera that focuses automatically, using either an infra-red light and mirror system or sound echoing system to sense the subject's distance and activate a motor that adjusts the lens focus.*

Autoload *A camera feature that automatically advances the film to its first frame after the film cassette or cartridge is inserted in the camera.*

Automatic Aperture *A lens that automatically closes down to the preselected f/stop when the shutter release is pressed, and then reopens to its widest f/stop.*

Automatic Camera *A camera that automatically adjusts the lens opening or shutter speed or both.*

Automatic Electronic Flash *An electronic flash unit that utilizes a sensor and tiny computer to automatically determine flash exposure; the unit responds to the flash's light reflecting from the subject to control the duration of the flash. See also Through-the-Lens Flash.*

Automatic Exposure Controls *One or more of the following automatic modes that sets exposure on an automatic camera: aperture-priority, shutter-priority, programmed.*

Automatic Exposure Override *A device on an automatic camera to override the automatic exposure controls.*

Automatic Flash Operating Range *The minimum and maximum distances a sub-ject can be from an automatic electronic flash in order for its exposures to be correct.*

Autorewind *A camera feature that rewinds 35mm film into its cassette after the final frame is exposed.*

Auto Winder *A specially designed camera or camera accessory that automatical-ly advances the film and cocks the shutter, up to two frames per second; ligh-ter, less expensive, and less versatile than a motor drive. See also Motor Drive.*

Available Light *Existing illumination that is not supplemented with artificial light by the photographer; also called ambient light and existing light.*

Averaging Meter *An exposure meter that has a wide angle of acceptance; some-times referred to as a meter that gives "overall" or "integrated" exposure read-ings. See also Angle of Acceptance.*

BCPS (beam-candlepower-seconds) *A system of numbers used to indicate the relative light output of electronic flash units.*

Background *The area behind the picture's main subject or center of interest.*

Background Light *A light behind the subject, which is aimed at the background to help separate the subject from the background.*

Backlight Button *A button on auto-exposure cameras that compensates for backlighted pictures by automatically increasing the exposure by 1½ f/stops. See also Back Lighting.*

Back Lighting *Term used when the main source of illumination is behind the subject and shines in the direction of the camera.*

Backscatter *An undesirable effect in underwater photography that occurs when light from a flash reflects off tiny particles in the water and records as fuzzy white spots on the film.*

Bayonet Lens Mount *Fast, snap-lock mount for attaching a lens to a camera.*

Bellows *A flexible, accordian-like light-tight chamber; part of an extension device*

used for making close-ups; part of most enlargers connecting the lens to the enlarger body; part of some cameras connecting the lens to the camera body. See also Extension Bellows.

Between-the-Lens Shutter A shutter built in a camera lens between some of the lens elements. See also Leaf-Type Shutter and Focal Plane Shutter.

Bounce Lighting Term used when the main source of illumination is reflected off a surface (often a ceiling or wall) instead of being aimed at the subject directly; provides soft, indirect illumination.

Bracketing Making two or more exposures in addition to the one thought to be correct; can be done by changing either the f/stop or exposure time.

Breech-Lock Mount A mount featuring a ring on the lens that is turned to lock the lens to the camera.

Bulk Film Long rolls (often 100 feet) of 35mm film that are cut to desired lengths and loaded into cassettes by the photographer; a money-saving but less convenient way to purchase film.

Burning-In A technique used during enlarging to darken certain areas of the image on photographic paper by exposing those areas for an additional amount of time.

Cable Release A flexible cable that screws into the shutter release and allows the photographer to trip the shutter without pressing the release with his finger; used for time exposures to prevent camera movement.

Cadmium Sulfide (CdS) Cell A battery-operated light-sensitive cell used to make exposure readings, or to determine exposure in automatic cameras; exposure meters using such cells often are called CdS meters. See also Gallium Photo Diode and Silicon Photo Diode.

Candid Photograph An unposed picture, the success of which depends greatly on the photographer's alertness and timing.

Cartridge A light-tight film container used in pocket and subminiature-type cameras.

Cassette A light-tight film container used in 35mm cameras; called film magazines by Kodak; exposed film must be rewound into the cassette before removing it from the camera.

Celsius (C) A temperature scale being slowly adopted in North America to replace the Fahrenheit (F) scale; identical to the Centigrade (C) scale.

Center of Interest The main subject of a photograph.

Center-Weighted Meter An exposure meter that reads the full area seen by the photographer through the camera's viewfinder, but which is more sensitive to the central portion of the area.

Changing Bag A light-tight bag with access for the photographer's arms; used any time complete darkness is required, such as when opening a jammed camera to retrieve film without exposing it or when loading a daylight developing tank.

Chromogenic Black-and-White Film Novel black-and-white film that utilizes color negative film technology to produce fine-grain images with chemical dyes; must be developed with special or color negative chemicals.

Clearing Agent A chemical solution used to remove fixer from film or prints and thus speed up washing time; also called hypo neutralizer.

Close-Up A picture made with the camera close to the subject.

Close-Up Lens A lens attached in front of a camera lens to allow the camera to get closer to the subject than otherwise possible. See also Diopter.

Coated Lens A coating on lens surfaces that improves picture quality by reducing the flare caused when light strikes the lens directly; most camera lenses that have been manufactured in recent years are coated. See also Flare.

Color Balance The ability of a color film to reproduce colors as the photographer sees them; color films are designed by the manufacturer to reproduce colors accurately when used with the type of light for which they were balanced, either daylight or tungsten.

Color Negative Film Color film which produces a negative image; commonly called color print film.

Color Positive Film Color film which produces a positive image; commonly called color slide (or reversal) film.

Color Temperature A system of numbers used for measuring the color of light, which varies according to its temperature; expressed in Kelvins, abbreviated K.

Compact Camera Current generation of small rangefinder-type 35mm cameras that usually feature automatic exposure, autofocusing, and built-in autoflash.

Complementary Colors The colors produced when two primary colors are mixed; in photography, yellow (from green and red), magenta (from red and blue), and cyan (from blue and green); sometimes called secondary colors. See also Primary Colors.

Composition The arrangement of the subject or elements in a picture; carefully considered composition is the key to an effective photograph.

Condensor-Diffusion Enlarger Most common type of enlarger illumination system; twin condensor lenses used with a diffused light source or diffusion screen provide a sharper image than does a diffusion enlarger.

Condensor Lenses A pair of lenses used to concentrate a light source; common in slide projectors and condensor-diffusion enlargers.

Contact Print A print that is the same size as the negative; made by placing the negative and photographic paper together and exposing them to light.

Contact Printer A boxlike device with a light source for exposing contact prints.

Contact Printing The process of making a contact print.

Contrast The range of brightness of a subject; also, the range of density in a negative, print, or slide.

Contrast Grade Indicates different contrasts of photographic paper designed for different contrasts of negatives; paper grades are numbered 0 through 5; grade 0 has the lowest contrast and is used with high contrast negatives to produce a print of normal contrast; grade 5 has the highest contrast and is used with low contrast negatives; grade 2 or 3 is for normal contrast negatives.

Cropping Eliminating unwanted parts of a picture; a photographer crops with his viewfinder by framing only the subject he wants in his picture, or he crops during the enlarging process to print only the best portion of the negative.

Cross Lighting Term used when two sources of illumination are directed at the subject from opposite sides.

Curved Field Projector Lens A specially designed lens that produces a projected image which is uniformly sharp by taking into account the slight curvature of slide film mounted in cardboard and plastic mounts.

DIN *Abbreviation for Deutsche Industrie Norm, and refers to the European standard for film speeds.*

DX Symbol *A symbol to identify any 35mm film cassette that has been electronically coded to preset a compatible automatic camera for the film's specific ISO/ASA speed, exposure latitude, and number of exposures.*

Darkroom *A light-tight room used for developing film and making contact prints and enlargements.*

Data Sheet *The instructional information packed with films and photo papers.*

Daylight Film *A color film designed to give good color balance when used with daylight, electronic flash, or blue flash illumination.*

Dedicated Flash *An electronic flash that automatically sets the correct shutter speed for flash synchronization when the unit is inserted in the hot shoe of a compatible camera and turned on; also designed to activate the ready light and sufficient light indicators in the camera's viewfinder.*

Definition *The relative sharpness of a lens, negative, or print; the quality of detail evident in a photograph; sharpness of the image, graininess of the negative or print, and the resolving power of a film or lens contribute to a photograph's definition.*

Density *The relative darkness of a negative or print; a dense negative will not allow much light to pass through it; a dense print will not reflect much light.*

Depth of Field *The area in a photograph that is in sharp focus; figured as the distance between the nearest and farthest objects in focus.*

Depth of Field Preview Device *Stops down the lens opening to a preselected f/ stop so the photographer can visually check how much of the subject area is in focus.*

Depth of Field Scale *F/stop coordinates on a lens that indicate how much of the picture area will be in focus.*

Developer *Chemical which acts on exposed film or paper emulsion to produce an image.*

Diaphragm *The aperture mechanism, adjusted according to f/stop, which determines the size of the lens opening.*

Dichroic Enlarger or **Color Head** *An enlarger or enlarger attachment incorporating interference-type filters that are used to determine color balance when making color prints, and determine contrast when printing with variable contrast black-and-white papers.*

Diffusion Enlarger *Enlarger illumination system which scatters the light reaching the negative, resulting in an image less sharp than that possible with a condensor-diffusion enlarger.*

Diopter *An optical term used to indicate the strength of magnifying power of a close-up lens; such lenses range from + 1 to + 10 diopters.*

Disc Camera *A small automatic camera featuring a film cartridge of revolutionary design, a rotating wheel of film.*

Disc Film *A thin film cartridge for disc cameras containing a flat disc of color film that rotates to provide 15 exposures.*

Distortion *Used to describe an unnatural or imperfect image; often relates to the use of lenses.*

Dodging A technique used during enlarging to lighten certain areas of the image on photographic paper by allowing less exposure of those areas than the rest of the print receives.

Double Exposure Two separate exposures made on one film frame or piece of photographic paper.

Easel Used in the enlarging process to hold photographic paper flat, to crop the negative's images, and to make white borders on the print.

Effective f/stop Opening The actual f/stop value rather than the one indicated by the lens; a concern of photographers using hand-held exposure meters who alter the light-transmitting characteristics of a lens by adding close-up extension bellows or tubes, lens extenders, or binoculars.

Electric Eye (EE) Camera Automatic camera that uses a photocell to read the light and set the exposure by adjusting the f/stop or shutter speed, or both; more commonly called an Auto-exposure Camera.

Electronic Flash A flash unit that is capable of giving repeated flashes without changing the bulb; power for units vary from dry cell or rechargeable batteries to household (AC) current.

Emulsion The light-sensitive chemical coating of film or paper, usually silver halides held by gelatin on an acetate or paper base; identified as the dull side of a piece of film, and the shiny side of a piece of photo paper.

Enlargement A print that is larger than the size of the negative.

Enlarger A device for projecting images from a negative onto a piece of photo paper in order to make a print the size desired by the photographer.

Enlarging The process of making an enlargement.

Existing Light See Available Light.

Expiration Date The date printed on photographic film and paper boxes or packages indicating the time after which the manufacturer no longer guarantees the characteristics of the film or paper.

Exposure The amount of light acting on the emulsion of a film or paper; with cameras, exposure is controlled by the lens opening and shutter speed; with enlargers, the lens opening and enlarger timer control exposure.

Exposure Compensator A device on an automatic camera that permits the photographer to purposely over- or underexpose in a range from $1/2$ to 2 f/stops.

Exposure Index (E.I.) Numbers Numbers used to indicate the speed of a film; identical to ISO/ASA numbers; See also ISO.

Exposure Latitude The range of exposures, from overexposure to underexposure, that still will produce an acceptable picture; black-and-white film has more exposure latitude than does color film.

Exposure Meter A device, hand-held or built-in a camera, that reads the intensity of light falling on or reflected from a subject; calibrates the light intensity into f/stops and shutter speeds for the photographer; also called a light meter. See also Flash Meter.

Exposure Meter Lock A button or other locking device that "holds" the exposure reading indicated on a hand-held meter for subsequent reference by the photographer.

Exposure Setting The f/stop and shutter speed combination chosen by the photographer.

Extension Bellows *An adjustable accordian-like device attached between the camera lens and camera body to increase lens focal length and magnify the subject; used for making close-ups.*

Extension Flash *One or more flash units used in addition to the main flash. See also Slave Unit.*

Extension Tubes *One or more rigid tubes or rings used for making close-ups; inserted between camera lens and body to increase lens focal length and magnify the subject.*

f/stop *Number indicating the relative size of the lens opening; the larger the number, the smaller the opening.*

F Synchronization *Cameras or flash cord sockets synchronized for use with F class bulbs, which are fast-peaking flashbulbs no longer in common use.*

FP Synchronization *On cameras with focal plane shutters, the flash cord socket or switch synchronized for use with FP (focal plane) flash bulbs; also can be used with more common M class bulbs.*

Fahrenheit (F) *A scale of temperatures that is slowly being replaced in North America by the Celsius (Centigrade) scale.*

Fast Film *See High-Speed Film.*

Fast Lens *See Lens Speed.*

Ferrotype Tin *Chrome-plated steel sheet used for drying glossy prints, except resin-coated (RC) papers.*

Field of View *See Angle of View.*

Fill-In Flash *Light from a flash unit used to augment the existing illumination or main flash unit; often used to lighten or eliminate shadows in a picture.*

Fill-In Light *Light from any source used to augment the main illumination in order to brighten dark areas in a picture, such as shadows.*

Film *Acetate material coated with light-sensitive chemicals, usually silver halides in a gelatin base, that registers the images formed in a camera by its lens.*

Film Cleaner *A special solvent used to eliminate fingerprints and other marks from the film's surface without harming the film itself.*

Film Frame Counter *A mechanical counter built into a camera that is designed to indicate the number of film frames exposed or yet to be exposed.*

Film Leader *The narrow portion of 35mm film that extends from its cassette and is attached to the camera's take-up spool.*

Film Load Indicator *An indicator on some cameras that shows the camera is loaded with film.*

Film Pack *A set of sheets of film that are placed in a studio, view, press or instant camera as a package and give a specific number of exposures.*

Film Plane Indicator *A⊖ mark on the top of some camera bodies, which indicates the location of the film plane inside the camera; used in making close-ups when accurate measurement from the film plane to the subject or lens is required.*

Film Pressure Plate *A broad metal or plastic plate in the back of the camera designed to keep the film flat and in the proper plane for sharp focusing.*

Film Rewind Button *A recessed button on the bottom of 35mm cameras which releases the camera's take-up spool mechanism and allows the film to be rewound into its cassette.*

Film Rewind Crank *A crank or knob on 35mm cameras that pulls up to engage the film rewind mechanism for rewinding the film into its cassette.*

Film Speed *A system of numbers, commonly called ISO/ASA, to indicate a film's relative sensitivity to light; the larger the ISO/ASA number, the more sensitive the film. See also ASA and ISO.*

Film Sprockets *A twin set of sprockets in 35mm cameras designed to engage corresponding sprocket holes in 35mm film so that the film advances properly.*

Film Take-Up Spool *A built-in spool in cameras to which the leader of film is attached when loading the camera.*

Film Transport Indicator *An indicator that signals when film is being properly advanced in a 35mm camera.*

Filter *Colored or coated glass or acetate placed in front of the camera lens that alters the light reaching the film; filters also are used with enlargers for color printing and for black-and-white printing with variable contrast papers.*

Filter Factor *A number that indicates the increase in exposure required when a filter is used; the filter factor is expressed with a times sign (X).*

Fish-Eye Lens *An extreme wide-angle lens that usually produces a round, much distorted picture; has a bulging front lens element similar to a fish's eye.*

Fixed Focus Lens *A lens that cannot be adjusted for focusing; its depth of field is constant.*

Fixer *A chemical, often called hypo, which removes undeveloped silver halides from film and paper, and which fixes the image on the film or paper so it does not change density by fading.*

Flare *An often disturbing effect caused by light shining directly on the surface of the lens; reduces the contrast of the photographed subject.*

Flash *An artificial source of light used to illuminate subjects for photography; may be an electronic flash unit, a flashbulb, flashcube, magicube, flipflash, or flashbar.*

Flashbar *An oblong pack of tiny blue flashbulbs and reflectors that gives ten flashes; requires no battery power; designed for some Polaroid instant cameras.*

Flashcube *A disposable plastic cube containing four blue flashbulbs and their reflectors; requires battery power to fire the bulb; used on simple and some Instamatic-type cameras.*

Flash Guide Number *A number used when determining exposure with a flashbulb or electronic flash unit; varies according to the film's speed and type and the size of flash unit or reflector and bulb.*

Flash Meter *A hand-held exposure meter designed to read the light of electronic flash and indicate correct exposures; may be a feature or attachment on a regular ambient light meter.*

Flash Synchronization *Internal electrical and mechanical camera controls that ensure the shutter is open when the flash goes off.*

Flat Lighting *Term used when the main source of illumination is coming from the direction of the camera and falling on the front of the subject; offers uniform illumination that is relatively shadowless, and thus lacks a feeling of depth.*

Flipflash *An oblong pack of tiny blue flashbulbs and reflectors that gives eight*

flashes; requires no battery power, designed for some Kodak Instamatic and instant cameras.

Focal Length *Technically, the distance from the optical center of a lens to the point behind the lens where the light rays from an object at infinity are brought into focus; indicates the relative image size produced by a lens; the greater the focal length, the greater the image size.*

Focal Plane Shutter *A shutter built in the camera body just in front of the film plane; usually two flexible curtains which travel in the same direction; some are capable of shutter speeds to 1/2000 and even 1/4000 second; common in single lens reflex cameras. See also Leaf-Type Shutter.*

Focus *Adjusting a lens so the light rays transmitted by it are sharply defined on the photographic film or paper.*

Fog *Usually stray light that registers on the film or paper and reduces the contrast of the image.*

Fog Filter *A filter used in front of the camera lens to create the effect of fog in scenic pictures.*

Foreground *The area in focus in front of the picture's main subject or center of interest.*

Framing *The placement of the camera so that foreground objects in the picture form a natural frame at the top, side, or around the main subject.*

Front Lighting *See Flat Lighting.*

Full Stop *Indicates a change in the lens opening from one f/stop number to the next closest f/stop number, which either doubles or halves the amount of light.*

Gallium Photo Diode (GPD) *A light-sensitive cell used to make exposure readings; featured in newer cameras with automatic exposure systems; more sensitive and quicker to respond than CdS cells. See also Cadmium Sulfide Cell and Silicon Photo Diode.*

Ghost Images *Secondary images that appear in a negative or print; often caused by accidental double exposures, a faulty shutter, an optically poor lens, or too slow a shutter speed when using flash.*

Graduate *A plastic or glass vessel marked for liquid measurement and used when mixing chemicals.*

Grain *The sand grain or pebble-like appearance of some negatives, slides, or prints; more evident in films with faster ISO/ASA speeds, films which have been over-developed, or prints which have been greatly enlarged.*

Guide Number *See Flash Guide Number.*

Half-Frame Camera *A camera that uses 35mm film but makes an image only half the standard 35mm frame size; allows double the number of exposures.*

Half-Stop *An intermediate lens opening between two major f/stops; half of a full stop.*

Haze Filter *See Ultraviolet (UV) Filter.*

High Contrast *A term used when there is an extreme difference in brightness between the lightest and darkest parts of a subject, negative, or print.*

Highlight Detail *Detail that is evident in the highlight (bright) areas of a picture; a consideration when making an exposure meter reading. See also Shadow Detail.*

High-Speed Film Film with emulsion that is very sensitive to light, such as one with a film speed of ISO/ASA 400 or more; also called fast film.

Hot Shoe A built-in camera holder for flash that is connected to the camera's flash synchronization and shutter system; eliminates the need for a connecting flash cord, but limits the location of the flash unit to the hot shoe position.

Hyperfocal Distance The point of focus of a lens at which subjects from half that distance to infinity are in focus; varies according to lens focal length and f/ stop.

Hypo Neutralizer See Clearing Agent.

ISO A system of numbers determined by the International Standards Organization that indicates the speed of a film in both ASA and DIN; first number is ASA, 2nd number is DIN, designated with degree symbol (°), such as: ISO 100/21°. See also ASA and DIN.

Incident-Light Meter An exposure meter designed to read the light falling on the subject; placed at the subject position and pointed toward the camera.

Infinity The point or distance beyond which everything will be in focus; indicated by the symbol ∞ on a camera lens.

Infrared Film Special film which records heat intensity as well as light intensity; available in black-and-white and color films; for best results, filters are required while shooting such films.

Instant Camera A self-processing type of camera that produces its own color or black-and-white prints in a matter of minutes.

Kelvins The system of numbers used to indicate the relative color temperatures of light sources, abbreviated K. See also Color Temperature.

Keystoning The distortion of a projected slide image when the slide is not parallel to the projection screen; often caused when the projector is tilted upward toward a screen.

Latent Image The invisible image caused by light which registers on a film or paper emulsion when an exposure is made; the image cannot be seen until the film or paper is developed.

Latitude The extent of a film's ability to produce an acceptable negative or slide from a wide range of exposures.

Leaf-Type Shutter A shutter of overlapping metal leaves usually built within the camera lens; common in rangefinder-type cameras; mechanically limited to a maximum speed of 1/500th second; sometimes called a between-the-lens shutter. See also Focal Plane Shutter.

Lens Optical pieces of glass designed to focus rays of light into an image on film, photographic paper, or projection screen; adjustable lenses feature focusing and f/stop controls.

Lens Cleaner A special solvent used sparingly with lens tissue to clean fingerprints and other residue off the surfaces of a lens.

Lens Extender An optical accessory placed between the camera body and camera lens to increase the focal length of the lens; also called lens converter and teleconverter.

Lens Opening The light-regulating control in a lens indicated by f/stop numbers; also called aperture and diaphragm.

Lens Reverser Ring *An adapter ring which permits a camera lens to be mounted in a reverse position for making close-ups.*

Lens Shade *A metal, plastic, or rubber extension in front of a lens used to shield the lens from direct rays of light or rain; also called lens hood.*

Lens Speed *Refers to the largest f/stop opening of a lens; a lens with a very large opening (such as f/1.4) is called a fast lens because it transmits more light than a lens with a smaller maximum opening.*

Lighting *Usually refers to the type or direction of illumination falling on a subject.*

Light Meter *See Exposure Meter.*

Light Output *Generally concerns the brightness of an electronic flash unit as rated in beam-candlepower-seconds. See also BCPS.*

Long Lens *A lens with a focal length that is greater than a normal lens; a general name for a telephoto lens. See also Normal Lens.*

M Class Flashbulb *The most commonly used type of flashbulb that reaches its maximum brilliance at a medium speed.*

M Synchronization *The camera flash socket or switch position for synchronizing the shutter when M class flashbulbs are used.*

Macro Lens *Primarily designed for close-up photography, but capable of serving as a normal or telephoto lens as well; allows close lens-to-subject focusing without accessory equipment; also called micro lens.*

Magazine *See Cassette.*

Magicubes *A mechanically ignited flashcube that does not require battery power to fire the four flashbulbs it contains; commonly used on Instamatic-type cameras designed especially for magicubes.*

Micro Lens *See Macro Lens.*

Mirror Lens *A reflex-type telephoto lens of a greater focal length (500mm to 2000mm) that incorporates mirrors to reduce the length, weight, and cost of the lens; has a fixed aperture that cannot be changed.*

Modeling Light *The main light; in portrait photography, often placed at a 45° angle from the camera and closer to the subject than any other light used.*

Motor Drive *A specially designed camera or camera accessory that automatically advances the film and cocks the shutter up to five frames per second; powered by batteries or AC house current; most models also rewind the film automatically; heavier, more costly, and more versatile than an auto winder. See also Auto Winder.*

Multigrade Photo Paper *See Variable Contrast Paper.*

Multi-Image Lens *An optical filter used in front of the camera lens to reproduce the subject in three, five, or six identical images.*

Multimode Automatic Camera *A camera with automatic exposure control that offers both aperture-priority and shutter-priority exposure systems; may have other choices, including programmed modes for existing light and/or electronic flash pictures. See also Aperture-Priority Automatic Camera and Shutter-Priority Automatic Camera.*

Multiple Exposure *Two or more exposures made on the same film frame or piece of photographic paper.*

Multiple Flash *Two or more flash units used to illuminate the subject.*

Natural Light *Existing light, usually sunlight, that is not supplemented with additional light by the photographer.*

Negative *Film that has been developed in which the light and dark areas of the subject are reversed.*

Negative Carrier *A glass or glassless device in the enlarger head used to hold negatives flat and in position for making enlargements.*

Neutral Density Filters *Filters that reduce the intensity of light waves without altering their colors.*

Newton's Rings *Distracting rainbowlike circles or patterns which occasionally appear on a projection screen when glass-mounted slides are heated by the projector bulb.*

Normal Lens *The lens designed for a particular camera that produces an image similar in perspective to what the photographer sees with the naked eye; the focal length of a normal lens varies according to the film size and is approximately equal to the diagonal of the film; a normal lens of a 35mm camera usually is 50mm, of a 2¼ × 2¼-inch camera, 80mm.*

Off-Camera Flash *A flash unit that is not attached to the camera; by using a long or flexible connecting cord, the flash is held away from the camera to avoid flat lighting.*

Open-Aperture Metering *The lens remains at its widest aperture when its aperture ring is being adjusted to set the f/stop while an exposure reading is being made with the camera's built-in meter; sometimes called full-aperture metering.*

Open Flash *Technique for using a flash unit that is not connected by a cord to the camera; the shutter is kept open while the flash unit is fired manually.*

Overexposure *Excessive exposure of photographic film or paper; overexposed negatives are too dense, overexposed slides are too light, overexposed prints made from negatives are too dark, and overexposed prints made from slides are too light.*

Panchromatic *Usually used to describe black-and-white film that is sensitive to all colors of light; all black-and-white films for general photography today are panchromatic.*

Panning *Act of the photographer following the action of his subject in the camera's viewfinder and releasing the shutter while the camera is still moving; the result is a stop-action picture of the moving subject, and a blurred background; gives a feeling of motion to a photograph.*

Paper Speed *A system of numbers, established by ANSI, to indicate a photographic paper's relative sensitivity to light; the greater the ANSI number, the more sensitive the paper. See also ANSI.*

Parallax Error *A problem common in some rangefinder cameras when the subject is close to the camera because the viewfinder sees the subject at a different angle than does the lens; can be corrected by slightly changing the angle of the camera before making the exposure.*

Perspective *The appearance of objects relative to their distance and position; a necessary consideration to suggest depth in photographs, a dimension the human eye sees but which a camera lens does not.*

Perspective Correction (PC) Lens *A camera lens that can be rotated to correct distortion, such as parallel lines that appear unparallel.*

Photocell *A light-sensitive cell commonly a part of exposure meters, automatic or electric-eye cameras, and remote or automatic flash units.*

Photoflood Light *A bright source of illumination that looks like an ordinary house-hold type bulb, normally used with a metal reflector; available in two bright-nesses, and in blue; has a limited life of 3 to 6 hours.*

Photogram *A photograph made without a negative by placing objects on photo-graphic paper and exposing it to light before processing.*

Photography *Literally means "to write with light."*

Pink-Eye *The undesirable effect that occurs when flash reaches and photographs the retina inside a subject's eye; can be avoided by raising the flash off the camera.*

Pistol Grip *A hand-held device attached to the camera's tripod socket and used to give the photographer more support and steadiness with his camera.*

Pocket Camera *A small camera that uses 110-size cartridge film.*

Polarizing Filter *An adjustable filter that blocks some light rays to diminish or eliminate glare or reflection from shiny surfaces, except unpainted metal; also darkens blue skies in color photographs.*

Polaroid Camera *See Instant Camera*

Portrait Lighting *Generally used to describe the arrangement of light for making portraits.*

Positive Film *A film, such as that used for making slides, that produces a positive image rather than a negative image; sometimes called reversal film.*

Primary Colors *In photography, the three colors that combine to make white light: blue, green, and red. See also Complementary Colors.*

Print *A piece of photographic paper with a positive image produced by contact printing or enlarging.*

Printing Paper *A light-sensitive paper that produces an image when exposed to light during the contact printing or enlarging process; also called enlarging paper or photo paper.*

Prism *Optical glass in single lens reflex (SLR) cameras that inverts the image produced by the camera lens and reflects it right-side up to the photographer looking through the camera's viewfinder; more correctly called a pentaprism.*

Professional Film *Film with limited latitude and tolerances which is designed for more exacting exposure and color results; must be refrigerated and processed promptly; some data sheets give the film's effective speed, which is more pre-cise than the film's intended ISO/ASA.*

Programmed Mode *An automatic exposure control that features factory-pro-grammed exposures and automatically sets both f/stop and shutter speed according to the automatic camera's exposure reading.*

Push Processing *Developing film for a longer period of time than usual; allows the film to be rated at a higher ISO/ASA film speed than normal, which is termed "pushing film."*

RC Paper *See Resin-Coated Paper.*

Rangefinder *An optical device used for focusing images in a rangefinder camera; generally produces twin or split images until the lens is adjusted to bring such images together to indicate the subject is in focus.*

Rangefinder Camera *A camera that uses a rangefinder for focusing.*

Ready Light *A light on an electronic flash unit that signals when the unit is fully recycled and ready to be fired.*

Reciprocity Failure *A characteristic of most photographic films and papers when*

subjected to abnormally long or short exposures; the increase or decrease in exposure is no longer directly proportional to an increase or decrease in the density of the image registered on the emulsion.

Recycle Time Refers to the time it takes for an electronic flash unit, after being fired, to recharge to its full light output capacity and be ready to use again.

Reflected-Light Meter An exposure meter that reads the light reflected from the subject; pointed at the subject from the camera direction.

Reflex Camera A camera that uses a mirror or other optical device to present the scene or subject to the photographer exactly as the camera's film will record it; a single lens reflex camera uses one lens for both viewing and photographing, while a twin lens reflex uses one lens for viewing and another for filming the image.

Resin-Coated (RC) Paper Photographic paper that is liquid resistant and absorbs little of the chemical solutions during processing, thus permitting shorter washing and drying times; may be treated with a resin, plastic, or polyethylene coating.

Resolution See Resolving Power

Resolving Power Refers to the ability of a lens to form sharp images; also refers to the ability of a film to record fine detail.

Reversal Film Produces a direct positive image (i.e., transparency); often called slide film; identified by the suffix "chrome" in the name.

Ring Light An electronic flash unit that encircles the camera lens and produces no shadows; most often used for close-up work.

Roll Film Film on a spool that utilizes an opaque paper backing to prevent exposure when not in the camera.

Rule of Thirds A basic composition concept to avoid placement of the main subject in the center of the film frame.

SLR See Single Lens Reflex Camera.

Safelight A light with special filters used to illuminate the darkroom without exposing photographic film or paper.

Screw Lens Mount A camera mount for attaching lenses that have a threaded end. See also Bayonet Lens Mount.

Secondary Colors See Complementary Colors.

Selenium Cell A light-sensitive cell used in some exposure meters and early models of electric-eye cameras. See also Cadmium Sulfide Cell, Gallium Photo Diode, and Silicon Photo Diode.

Self-Timer A device, either an accessory or built in the camera, that automatically releases the shutter after a preset number of seconds.

Shadow Detail Detail that is evident in the shadowed (dark) areas of a picture; a consideration when making an exposure meter reading. See also Highlight Detail.

Shoulder Brace An object similar to a gunstock that is attached to the camera's tripod socket and used to provide the photographer more support and steadiness with his camera; often used with extreme telephoto lenses.

Shutter A device, built in the lens or camera, that regulates the length of time that light reaches the film to make an exposure.

Shutter-Priority Automatic Camera A camera with automatic exposure control; the photographer sets the desired shutter speed and the camera's metering

system automatically sets the f/stop (i.e., lens opening) for a correct exposure. See also Aperture-Priority Automatic Camera.

Shutter Speed Indicates the precise length of time that light exposes the film; usually in marked fractions of a second.

Shutter Synchronization See Flash Synchronization.

Side Lighting A term used when the main source of illumination is at the side of the subject.

Silicon Photo Diode (SPD) A light-sensitive cell used to make exposure readings; featured in newer cameras with automatic exposure systems and in some hand-held exposure meters; more sensitive and quicker to respond than CdS cells. See also Cadmium Sulfide Cells and Gallium Photo Diode.

Silver Halides The chemical components that are sensitive to light and make up the emulsion of a photographic film or paper.

Single Lens Reflex (SLR) Camera Uses a mirror and prism to allow the photographer to see the subject through the same lens that presents the image to the film; the most popular type of 35mm camera.

Skylight Filter See Ultraviolet (UV) Filter.

Slave Unit Refers to an electronic flash or flashbulb unit used to supplement the main flash illumination; often triggered by a cordless photocell; sometimes called an extension flash.

Slide A color film transparency mounted in cardboard, plastic, or glass for use in a slide projector; can also be used to make color prints.

Split Image The basis of some focusing systems in which the subject is seen in two parts until the lens is properly focused and the image becomes whole.

Spot Meter A type of exposure meter that has a limited angle of acceptance. See also Angle of Acceptance.

Stack Loader A device available for some slide projectors that allows a number of slides to be projected automatically without first inserting them in a slide tray or magazine.

Step-Up Adapter Rings Rings of varying diameters that are attached to lenses of varying diameters so single-size filters can be used.

Stop-Action The photographic effect of capturing a moving subject on film so that it can be seen clearly and in detail.

Stop Bath A chemical solution in film and print processing used to stop the action of the developer and prevent contamination of the fixer.

Stop-Down Metering The lens closes down when it is being adjusted to set the f/stop while an exposure reading is being made with the camera's built-in meter; the lens does not have an automatic aperture. See also Automatic Aperture and Open-Aperture Metering.

Strobe A term used to describe an electronic flash unit.

Studio Camera Usually a camera with a large film format(4 x 5, 5 x 7, 8 x 10-inch) that utilizes a ground glass back for focusing the subject.

Studio Light Lights normally used in a studio, whether the type is electronic flash, tungsten-halogen, or large incandescent.

Subminiature Camera Small camera which uses 16mm or smaller film.

Subject Image The subject as recorded on film.

Sufficient Light Indicator A light on an automatic electronic flash or built in a

camera's viewfinder that signals if the flash's light has been adequate enough to produce an automatic exposure.

Synchronization See Flash Synchronization.

TTL Refers to through-the-lens viewing or exposure metering, most often with a single lens reflex camera.

Teleconverter See Lens Extender.

Telephoto Lens A lens that has a greater focal length and narrower angle of view than a normal lens; produces a larger subject image than a normal lens when both lenses are the same distance from the subject.

Through-the-Lens (TTL) Flash Indicates an automatic flash exposure that's set according to the reflected flash light received by the camera's through-the-lens meter. See also Through-the-Lens Meter.

Through-the-Lens (TTL) Meter An exposure meter built in the camera that reads the light coming through the camera lens; common with single lens reflex cameras.

Thyristor Circuitry Circuitry in an electronic flash that provides faster recycling times and more flashes per set of batteries by diverting unused power back to the capacitor after every autoflash exposure.

Tilting Flash Head An adjustable head on an electronic flash that can be tilted for bounce light; some also can be twisted to direct the flash light.

Time Exposure Usually an exposure longer than 1 second; the camera's shutter is kept open by setting it at the B or T position.

Time-Lapse Photography A series of pictures of the same subject taken over a period of time without moving the camera or the subject.

Top Lighting Term used when the main source of illumination is directed at the top of the subject.

Transparency A color or black-and-white positive film that is viewed by light transmitted through it.

Tripod A three-legged device designed to give support and steadiness to the camera.

Tungsten Light Light from sources other than the sun; color films designed for use with artificial light sources (other than electronic flash) often are called tungsten films, while those balanced for sunlight are called daylight color films.

Twin-Lens-Reflex (TLR) Camera A camera which uses two lenses —one to project the subject to the photographer through the viewfinder, and the other to record the image on the film.

Ultraviolet (UV) Filter Helps eliminate the ultraviolet light to which all films are sensitive; improves skies by reducing (but not eliminating) atmospheric haze; also called haze filter or skylight filter.

Umbrella Reflector Light Used to provide less direct studio light by bouncing light into its umbrella-shaped reflector.

Underexposure Insufficient exposure of a photographic film or paper; underexposed negatives are not dense enough, underexposed slides are too dark, underexposed prints made from negatives are too light, and underexposed prints made from slides are too dark.

Unipod A single-legged camera support.

V Setting The self-timer indicator or lever on between-the-lens leaf type shutters that causes a delayed-action shutter release. See also Self-Timer.

Variable Contrast Filters *Used during enlarging to produce black-and-white prints of various contrasts on a single type of paper. See also Variable Contrast Paper.*

Variable Contrast Paper *A single photographic paper that is capable of producing normal contrast prints from negatives having a wide range of contrasts; must be used with appropriate variable contrast filters; also called multigrade paper.*

Variable Focal Length Lens *A lens adjustable to different focal lengths but which must be refocused after each focal length change is made. See also Zoom Lens.*

Variable Maximum Aperture *Refers to the maximum aperture of a zoom lens that gets smaller as the lens is zoomed to a longer focal length; the maximum opening may be reduced as much as one full f/stop.*

Variable Power Control *A control for an electronic flash unit that varies the duration of the flash and thus controls the flash's light intensity.*

Viewfinder *An optical device on a camera used by the photographer to view the subject to be photographed.*

Wide-Angle Lens *A lens that has lesser focal length and greater angle of view than a normal lens; produces a smaller subject image than a normal lens when both lenses are the same distance from the subject.*

Wratten Filter Letters *Alphabet designations given by the Eastman Kodak Company to describe types of filters; more recently, number designations are used instead of such letters to identify filters.*

X Flash Synchronization *The camera flash socket or switch position for synchronizing the shutter when an electronic flash is used. See also FP and M synchronization.*

Zero Adjustment *A screw on hand-held exposure meters used to readjust the meter indicator to zero in order to assure correct light readings.*

Zone Focusing *Predetermined distances to set on the lens's focusing ring that give a certain depth of field range when a specific f/stop is used; also, symbols on the focusing rings of simple cameras used instead of exact distances.*

Zone of Sharpness *See Depth of Field.*

Zone System *A system to help determine exposure, devised by well-known photographer Ansel Adams.*

Zoom Flash Head *An electronic flash with a reflector head that can be adjusted to provide the appropriate angle of illumination for wide-angle, normal, and telephoto lenses. See also Angle of Illumination.*

Zoom Lens *A lens that can be adjusted to varied focal lengths while keeping the subject in focus. See also Variable Focal Length Lens.*

Appendix B
Weights and Measures

Most of the weights and measures in this book have been given as used customarily in the United States (i.e., inches, feet, ounces, quarts, Fahrenheit), except in discussions of lens focal length, which is known almost universally in terms of millimeters (mm). Conversion to the metric system of weights and measures is imminent in the U.S. The following equivalents will guide you in converting the weights and measures given in this book. Some figures have been rounded off.

For photography, the major units of the metric system are the *meter* (m) for linear (length) measurement, the *liter* (l) for liquid measurement, and the *gram* (g) for weight measurement. Unit abbreviations are in parentheses.

EQUIVALENTS WITHIN THE METRIC SYSTEM

Linear Measure

1 millimeter (mm)	= 1/1000 meter
1 centimeter (cm)	= 1/100 meter, 10 millimeters
1 decimeter (dm)	= 1/10 meter, 100 millimeters, 10 centimeters
1 meter (m)	= 1000 millimeters, 100 centimeters, 10 decimeters
1 kilometer (km)	= 1000 meters

Liquid Measure

1 milliliter (ml)	= 1/1000 liter
1 centiliter (cl)	= 1/100 liter, 10 milliliters
1 deciliters (dl)	= 1/10 liter, 100 milliliters, 10 centiliters
1 liter (l)	= 1000 milliliters, 100 centiliters, 10 deciliters
1 kiloliter (k)	= 1000 liters

Weight Measure

1 milligram (mg)	= 1/1000 gram
1 centigram (cg)	= 1/100 gram, 10 milligrams
1 decigram (dg)	= 1/10 gram, 100 milligrams, 10 centigrams
1 gram (g)	= 1000 milligrams, 100 centigrams, 10 decigrams
1 kilogram (kg)	= 1000 grams

EQUIVALENTS FOR THE U.S. AND METRIC SYSTEMS

Linear Measure

U.S.	**— Metric**
1 inch	= 25.4 millimeters, 2.54 centimeters, .25 decimeters, .025 meters
1 foot	= 304.8 millimeters, 30.48 centimeters, 3.04 decimeters, .30 meters
1 yard	= 914 millimeters, 91.4 centimeters, 9.14 decimeters, .91 meters
1 mile	= 1609.34 meters, 1.61 kilometers

Metric	**— U.S.**
1 millimeter	= 0.39 inches, .003 feet, .001 yards
1 centimeter	= .39 inches, .032 feet, .011 yards
1 decimeter	= 3.93 inches, .328 feet, .109 yards
1 meter	= 39.37 inches, 3.28 feet, 1.09 yards, .0006 miles

Liquid Measure

U.S.	**— Metric**
1 ounce	= 29.57 milliliters, 2.95 centiliters, .29 deciliters, .029 liters
1 quart	= 946.35 milliliters, 94.63 centiliters, 9.46 deciliters, .946 liters
1 gallon	= 3785.41 milliliters, 378.54 centiliters, 37.85 deciliters, 3.78 liters

Metric	**— U.S.**
1 milliliter	= .033 ounces
1 centiliter	= .33 ounces, .01 quart
1 deciliter	= 3.38 ounces, .105 quart, .026 gallon
1 liter	= 33.81 ounces, 1.05 quart, .26 gallon

Weight Measure

U.S.	**— Metric**
1 ounce	= 28.35 grams
1 pound	= 453.59 grams

Metric	**— U.S.**
1 gram	= .035 ounce, .002 pounds

TEMPERATURE CONVERSION

In the U.S., temperatures usually are indicated by a Fahrenheit scale (F), while most of the world uses the Celsius (also called Centigrade) scale (C). Two methods of converting one to the other follow.

To figure Celsius, subtract 32 from Fahrenheit and divide by 1.8, *or* subtract 32 from Fahrenheit, multiply by 5, and divide by 9.

To figure Fahrenheit, multiply Celsius by 1.8 and add 32, *or* multiply Celsius by 9, divide by 5, and add 32.

A brief list of temperature equivalents follows.

Fahrenheit — Celsius

 212 = 100 Boiling point
 194 = 90
 176 = 80
 158 = 70
 140 = 60
 122 = 50
 104 = 40
 86 = 30
 68 = 20 Recommended developing temp.
 50 = 10
 41 = 5
 32 = 0 Freezing point

Index

(Page numbers set in bold face refer to illustrations.)